THE BERLIN SCHOOL
AND ITS GLOBAL CONTEXTS

Contemporary Approaches to Film and Media Series

A complete listing of the books in this series can be found online at wsupress.wayne.edu.

General Editor
Barry Keith Grant
Brock University

Advisory Editors
Robert J. Burgoyne
University of St. Andrews

Caren J. Deming
University of Arizona

Patricia B. Erens
School of the Art Institute of Chicago

Peter X. Feng
University of Delaware

Lucy Fischer
University of Pittsburgh

Frances Gateward
California State University, Northridge

Tom Gunning
University of Chicago

Thomas Leitch
University of Delaware

Walter Metz
Southern Illinois University

THE BERLIN SCHOOL AND ITS GLOBAL CONTEXTS

A TRANSNATIONAL ART CINEMA

EDITED BY MARCO ABEL AND JAIMEY FISHER

Wayne State University Press
Detroit

Library of Cataloging Control Number: 2018932938

ISBN 978–0-8143-4200-8 (paperback)
ISBN 978–0-8143-4490-3 (hardcover)
ISBN 978–0-8143-4201-5 (ebook)

Wayne State University Press
Leonard N. Simons Building
4809 Woodward Avenue
Detroit, Michigan 48201–1309

Visit us online at wsupress.wayne.edu

CONTENTS

ACKNOWLEDGMENTS

The idea for this volume goes as far back as 2010–11, when both of us were still working on our monographs on the Berlin School and Christian Petzold, respectively. Soon thereafter we decided to address more directly emerging criticism of how scholars interested in the Berlin School engage them and how the Berlin School films as such function as "good objects" in the field of German film studies. The result was the panel we organized, titled "Good Objects and Their Discontents: The Berlin School and the Current State of German Film Studies," at the 2013 Modern Language Association Conference, on which Lutz Koepnick and Nora Alter also presented. We thank both for their stimulating provocations that pushed us to pursue this project for real. "For real," then, happened in 2014 when we proposed this volume to Wayne State University Press and invited contributions. At the 2015 German Studies Association conference, for which we organized a three-day miniseminar on "The Berlin School and Its Global Contexts," we then had occasion to workshop a good number of essays that are now included herein. We want to thank *all* of our colleagues who participated in this seminar; even those participants who are not represented in this volume had a significant impact on its final shape. Furthermore, we want to thank Will Mahan for helping us with formatting the contributions as well as Annie Martin at WSUP for all the support she has lent this project. We also thank Barry Keith Grant, editor of the Contemporary Approaches to Film and Media series at Wayne State, for his expert guidance. Much gratitude goes as well to all of our colleagues, many of whom are good friends, who have supported us over the years as tireless interlocutors about the Berlin School, whether at conferences and specially organized workshops or in private conversations, offering to read materials and give feedback on work in progress. Last but not least, we want to thank our contributors for their excellent work: *The Berlin School and Its Global Contexts: A Transnational Art Cinema* would not exist without you.

INTRODUCTION

THE BERLIN SCHOOL AND BEYOND

Marco Abel and Jaimey Fisher

In late 2013, the Museum of Modern Art in New York City hosted a major exhibition of works by contemporary German directors associated with the so-called Berlin School. Given the preeminent role MoMA enjoys among cultural institutions across the world, this two-week event can be considered a milestone in the history of this filmmaking movement. That MoMA decided to commit considerable resources to promoting works by these filmmakers at that particular moment, however, was no coincidence. Over the preceding ten years, the films of the Berlin School had been increasingly acknowledged and feted across the world, as evidenced by the many retrospectives featuring the films in countries including England, Greece, Portugal, Switzerland, Brazil, Canada, and the United States; by special screenings and guest appearances at major film festivals (Cannes, Venice, Berlin, Toronto, New York, Locarno, San Sebastián, Rome) as well as by the increasing attention the filmmakers have received among film scholars in both North America and Europe (especially, but not exclusively, in France, the United Kingdom, and Spain) and the broader international cinephile community, as evidenced by the covers of the prominent Canadian film magazine, *Cinema Scope* (no. 61 and no. 67), which feature Christian Petzold's *Phoenix* (2014) and Maren Ade's *Toni Erdmann* (2016), respectively, as well as *Film Comment*, which also features Ade's widely acclaimed film that Amy Taubin views as "the 21st century's equivalent of Jean Renoir's *The Rules of the Game*" (Taubin 2016, 32).

Both the MoMA's exhibition and this burgeoning attention in the broader (film) scholarly and cinephilic community around the world were our primary inspirations for editing *The Berlin School and Its Global Contexts: A Transnational Art Cinema*. This anthology of fifteen scholarly essays analyzes the Berlin School for its simultaneous global origins and aftereffects—both to address this significant

development in global art cinema and to contextualize the movement in ways that progress European, and especially German, film studies toward more global engagement. (In fact, the role the Berlin School has played in German film studies was another important impetus for our efforts, as we will discuss in the next section.) Although our anthology builds on the published studies on the Berlin School—Marco Abel's *The Counter-Cinema of the Berlin School* (winner of the 2014 GSA Book Prize; Camden House, 2013), the coedited *Berlin School Glossary: An ABC of the New Wave in German Cinema* (Intellect, 2013), MoMA's catalog-cum-book *The Berlin School: Films from the Berliner Schule* (2013), and Jaimey Fisher's *Christian Petzold* (University of Illinois Press, 2013)—it deliberately departs from them as well. Specifically, whereas these four books primarily focus on the Berlin School as a *German* phenomenon—a group of films that these studies primarily consider in the context of German (film) history and culture—the present anthology seeks to transcend more narrowly defined national concerns and open up the debate about what is arguably Germany's most significant filmmaking moment since the New German Cinema of the 1970s to a broader, more global purview. Such an approach can, we feel, make the Berlin School a case study for contemporary art cinema around the world and thereby reciprocally illuminate where global art cinema is at the present moment, when digital production, distribution, and exhibition are transforming cinema generally.

Our anthology takes its cue not only from recent trends in film studies (the "transnational turn") but also from Christoph Hochhäusler, perhaps the Berlin School's keenest spokesperson, who, in his contribution to MoMA's publication, insists that "the Berlin School, despite what the label suggests, is not a specifically German phenomenon. All over the world there are filmmakers exploring related terrain. In Austria (Jessica Hausner), in Argentina (Lisandro Alonso, Lucrecia Martel), in the United States (Lance Hammer, Kelly Reichardt), in Japan (Naomie Kawase, Hirokazu Kore-eda), and in many other places" (Hochhäusler 2013, 25). The present volume engages some of these as well as other filmmakers from across the world, including So Yong Kim (Korea/US, essay by Hester Baer); Derek Cianfrance (US, essay by Lisa Haegele); Hausner (essay by Robert Dassanowsky); Reichardt (US, essay by Will Fech); Corneliu Porumboiu (Romania, essay by Alice Bardan); Nuri Bilge Ceylan (Turkey, essay by Ira Jaffe); Abbas Kiarostami (Iran, essay by Roger Cook); Apichatpong Weerasethakul (Thailand, essay by Michael Sicinski); Tsai Ming-liang (Taiwan, essay by Lutz Koepnick); Steve McQueen (UK, essay by Chris Homewood); the Dardenne brothers (Belgium, essay by Jaimey Fisher); Alonso and Martel (Argentina, essay by Gerd Gemünden); and Béla Tarr (Hungary, essay by Roland Vésgő). Two additional contributions draw connections between the Berlin School and

some of their predecessors in global art cinema: Michelangelo Antonioni (essay by Inga Pollmann) and François Truffaut as well as Tony Richardson (essay by Brad Prager). Given that the Berlin School directors frequently refer to these contemporary filmmakers and also a range of "classic" directors from around the world, many of whom are discussed in the School's closely associated journal *Revolver*, our hope is that covering such a broad range ends up reframing our understanding of the Berlin School by paying greater attention to its relationship with world cinema than has been done thus far.

In short, *The Berlin School and Its Global Contexts: A Transnational Art Cinema* seeks to fold German-language cinema back into conversations on *international* as well as *transnational* cinema. Since the vast majority of the films are available on DVD with English subtitles (and at times also in other languages), and since the recent publication of four well-received books on the movement has now also established critical momentum and an easily accessible scholarly archive on these filmmakers, we think this is the perfect time to branch out into new directions and infuse into the study of this exciting filmmaking movement new voices.[1] These new voices, we think, bring their considerable expertise on global cinemas to the conversation, thereby enriching our understanding of the Berlin School while simultaneously also contributing to a more nuanced understanding of art cinema around the world.

"The Berlin School": To What Degree?

The Berlin School had its tentative beginnings in the early 1990s when the movement's first generation—Christian Petzold, Angela Schanelec, and Thomas Arslan—studied at the German Film and Television Academy in Berlin (dffb) under the tutelage of Harun Farocki and Hartmut Bitomsky. These filmmakers and their films gradually acquired some aesthetic and intellectual consistency at the beginning of the third millennium, when a few German film critics coined the "Berlin School" moniker. This label has come to encompass not only the first-generation directors but also a new, slightly younger ensemble of filmmakers including Hochhäusler, Ade, Benjamin Heisenberg, Ulrich Köhler, Valeska Grisebach, Henner Winckler, and Maria Speth. Many of these directors continue to cluster around the cinephilic journal *Revolver*—a textual archive, cofounded by Hochhäusler and Heisenberg, who continue to coedit it in collaboration with others, that also provides further intriguing material for this volume and that underscores the School's global interests and inclinations, not least since many of the journal's interview subjects are leading lights of contemporary world cinema, including many of the above-mentioned directors.

Notwithstanding the existence of the term "Berlin School" and the very real effects it has had (and continues to have)—the sheer institutional weight of MoMA's exhibition has irrevocably secured its status in the history of film—one of the (perhaps inevitable) questions about the Berlin School that has accompanied it for the last decade or more is the very question of whether or not it has ever existed *as a school*. We do not want to rehearse the debate about what the Berlin School is, or whether it still exists or even existed to begin with, since much work on this issue has already been done.[2] But since it is clear from our volume's title—and its core focus—that we affirm the existence of the Berlin School, we do want to address what would seem to be the most obvious objection to the label: that it is or was a "school." What is a school, then? Most obviously, a school has teachers and students—which, in the context of the Berlin School, raises the question of who the teachers were, and who were the students? While one might, for individual directors, point to one or the other teacher—Farocki and Bitomsky for the first generation, for example; experimental filmmakers Rüdiger Neumann and Klaus Wyborny for Köhler and Winckler; or even contemporary Austrian filmmakers Michael Haneke and Uli Seidl for Grisebach—it would prove impossible to find a common "headmaster" for these directors. Indeed, as has been pointed out before, it is not even the case that the directors who find themselves categorized with the help of this critical invention attended the same film schools: although Petzold, Schanelec, and Arslan, as noted above, studied at the dffb in Berlin, Hochhäusler and Heisenberg met each other as students at the Hochschule für Film und Fernsehen München, where Ade studied as well;[3] Köhler and Winckler met as students at the Hochschule für bildende Künste Hamburg (University of Fine Arts Hamburg); Grisebach studied at the Filmakademie Wien (Film Academy Vienna) with a number of filmmakers now associated with the Coop 99 such as Barbara Albert and Jessica Hausner; and Speth attended the Hochschule für Film und Fernsehen "Konrad Wolf" Potsdam-Babelsberg (as of 2014: University of Film and Television Babelsberg Konrad Wolf). By "school," then, we surely do not mean a real existing physical institution such as the dffb, nor, for that matter, should the term "school" be taken to express a shared intellectual lineage.

Still, if we take seriously how schools actually tend to work from the perspective of those attending, we might observe that schools are rarely homogenous and instead are characterized by divergent movements: students at times take classes with each other but then also take ones in which they find themselves with different students. In other words, one way of conceptualizing "school" is by the transversal movements that cut across its institutional plane—movements that not only connect students with each other at various points, in various contexts, and at various times but also create disjunctions between them, cutting

the connecting lines off, severing students from one another, but only in order to allow for new connections to emerge, with other students, in other contexts, at other times; sometimes, one might eventually reconnect with one's "original" peer group, but the relationship within that group itself is now qualitatively different from what it used to be, having been affected—transformed—by all the new insights, knowledge, tendencies, preferences, and inclinations that emerged subsequent to the moment of separation and the period during which one found oneself becoming transversally linked to a new set of students. School, thus, does not have to be taken as an eradication of the very differences that seem to be constitutive of the relations students have with each other.

That the Berlin School directors' frequently voiced concern that such a label does little more than erase their and their films' individuality is, of course, understandable and in practice justified each time one of their films is discussed as little more than an *example* of the Berlin School tout court rather than as a singular expression that transversally crosses the schoolyard; yet, if we embrace the immanent logic, mapped out above, of what a "school" is and how it works, we might be able to consider their fear of de-individuation as simply the negative expression of what in fact is a positive logic of affinities that links the individual bodies populating the schoolyard.[4] After all, while the time of school is often defined by the desire to belong, to find one's place, it is simultaneously also characterized by the strong desire to assert one's individuality, to test out who one is. And we suggest that with regard to the Berlin School and the directors associated with it, the desire to belong—to be on friendly terms with each other because of perceived intellectual and aesthetic inclinations, not to mention shared institutional context (the German film industry and the status of German-language filmmaking in world cinema)—was always secondary to the desire to find one's place *on one's own terms*, whether on the schoolyard of the Berlin School or that of global cinema.

More often than not, commentators on the Berlin School have recourse to a purely stylistic description as a means to characterize this movement, emphasizing these films' reliance on "long takes, long shots, clinically precise framing, a certain deliberateness of pacing, sparse usage of non-diegetic music, poetic use of diegetic sound, and, frequently, the reliance on unknown or even non-professional actors who appear to be chosen for who they 'are' rather than for whom they could be," as Abel wrote in his earliest effort to offer a critical framework for how to best understand these films (Abel 2008b). And we would defend this stylistic description of the films still as appropriate shorthand one could use when someone wants to know how these films look or even what they feel like. While few if any of the films the Berlin School directors have ever made feature

all of these stylistic components, many if not most make significant use of more than one of them. For example, Hochhäusler once characterized Grisebach's and Ade's films, which frequently have recourse to long takes, by and large refuse to use extradiegetic sound, and leisurely pace their narratives' progress, as "tender realism"; then again, as Köhler has pointed out, Ade's films are somewhat un-Berlin-School-like insofar as they seem "more interested in psychology and less in the language of the cinema" than many other Berlin School films (quoted in Suchsland 2011), many of which are suspicious of the psychologizing tendency that defines so much of world cinema, mainstream or not. In this regard, Petzold's claim that the "cinema of identification gets on [his] nerves" expresses a sentiment that links many of the filmmakers associated with the group (quoted in Abel 2008a). Yet, Petzold, in turn, puts to use many of the aesthetic aspects that seemingly define the Berlin School to very different effect; unlike many of his colleagues, his films explicitly work with and within the tradition of genre cinema, as Fisher has argued (Fisher 2013). In this regard, Petzold's films resonate with those of Heisenberg, whose three films to date can also be productively considered through the lens of various genres—whether that of the buddy comedy with regard to his most recent film, *Über-ich und Du* (*Superegos*, 2014), that of the thriller for his debut, *Schläfer* (*Sleeper*, 2005), or that of the bank-robber film subgenre of which *Der Räuber* (*The Robber*, 2010) is a great example. Petzold's and Heisenberg's (somewhat) post-genre approaches diverge with those of Petzold's erstwhile dffb student-colleague, Angela Schanelec, whose films are as far removed from genre cinema gestures as any in the Berlin School oeuvre.[5] Her films, together with Arslan's, exhibit, in turn, perhaps the strongest French influence, and this not just because a number of her films, including *Plätze in den Städten* (*Places in Cities*, 1998), *Mein langsames Leben* (*Passing Summer*, 2001), *Marseille* (2004), and *Orly* (2010), are at least partly set in France; both directors draw much of their inspiration—especially in their early work—from the French New Wave's second generation, including films by Jean Eustache and Maurice Pialat, but also from someone like Robert Bresson.[6]

Henner Winckler's films, in contrast, might be the most "realistic" in a collective body of work that otherwise is only insufficiently described as belonging to the realist tradition.[7] In their reliance on nonprofessional actors, in-medias-res intimacy, a "documentary-like" rendering of everyday life, and a steadfast refusal to present their protagonists to the audience for its judgment, his two films *Klassenfahrt* (*School Trip*, 2003) and *Lucy* (2006) clearly resonate the most with Grisebach's *Mein Stern* (*Be My Star*, 2001) and *Sehnsucht* (*Longing*, 2006), but also with those of Köhler, even though Köhler's three films take place in different, namely well-to-do bourgeois, socioeconomic milieus, whereas Winckler's are lo-

cated in a lower-middle- or even working-class environment. Moreover, Köhler's *Bungalow* (2002), *Montag kommen die Fenster* (*Windows on Monday*, 2006), and *Schlafkrankheit* (*Sleeping Sickness*, 2011) arguably push further than any other Berlin School films the cinematic technique of the long take, as well as their tendency not to cater to an audience's habituated desire to receive (psychologizing) explanations for a film's characters—so much so, indeed, that his films intensify the seemingly realist mise-en-scène to such a degree that it almost imperceptibly morphs into something more mysterious; this particular quality of his films is one that links them most obviously with the films of Thai director Apichatpong Weerasethakul, who is one of Köhler's main influences.

Petzold's films, too, at times confront their viewers with subtle irruptions of "otherworldliness"—something usually marked by a crow's rook or the pronounced noise of wind, as is the case in, for example, *Yella* (2007) or *Barbara* (2012). But it is perhaps Hochhäusler who, in his oeuvre, instills most purposefully in the viewer an experience of frustration with regard to their ability to make sense. Hochhäusler structures his narratives precisely so that the viewers themselves end up creating (or, as the case may be, feeling unable to create) the "thick" narrative and, in so doing, are confronted more with their own desires than with any real understanding of the characters or the narrative itself. It was therefore only logical that he would eventually turn to the tradition of the conspiracy thriller, as he does in his most recent effort, *Die Lügen der Sieger* (*The Lies of the Victors*, 2014), which even more so than its predecessor, *Unter dir die Stadt* (*The City Below*, 2010), "takes aim at the business world, which dictates government policy thanks to a level of influence peddling that is carefully, almost scientifically honed" (Weissberg 2014).

As this summary of some of the main tendencies to be found in Berlin School films is meant to indicate, then, this "school" is indeed defined as much by the differences between the filmmakers' individual preoccupations, aesthetic predilections, and topical concerns as by any similarities, yet we can also see the nodes at which their cinematic paths come together—the ways in which their films cut across the Berlin School schoolyard, forge linkages, and express affinities with one another, as well as how these very affinities and intersections themselves become knots that end up resonating with yet other filmmakers of that group. And regardless of the particular auteurist inflection of what has justifiably or not been codified by critics as the Berlin School "look," one of the effects of this (varied) reliance on these cinematic techniques is, depending on one's own perspective, a certain (un)bearable slowness of cinematic being with which these films confront their viewers, including Arslan's latest effort, *Bright Lights*, which strongly divided critics at its premiere at the Berlin Film Festival in 2017. However, as significant

as this effect surely is, it is hardly unique in contemporary world cinema; indeed, this overriding affective sensation that one experiences when watching most of the Berlin School films very much situates them in the context of that broader moment in contemporary world cinema that our contributor Ira Jaffe has compellingly analyzed in terms of "slow cinema" (Jaffe 2014; see also Koepnick 2014). And considering some of the directors' influences—which, depending on whom one asks, include, among many others, Abbas Kiarostami (Winckler), Sang-soo Hong (Köhler), Hsiao-hsien Hou (Arslan), and of course Weerasethakul (for almost all of them)—it should be hardly surprising that these German-language films partake in more general tendencies in contemporary global art cinema, as our volume aims to demonstrate.

Perils of the "Good Object"

However, this emphasis on the Berlin School's embeddedness in the context of global art cinema is not meant to deny their films' genealogical relation to their predecessors in German national cinema. Indeed, recent essays by Fisher and Christina Gerhardt have opened up what could potentially be productive research agendas, revisiting, reimagining, and thereby revising the history of German cinema by reading it through the cinematic lens of what might perhaps be the most film-historically and film-aesthetically self-conscious group of German filmmakers since those associated with the New German Cinema of the late 1960s and 1970s. For example, just as Fisher connects the dots between Petzold's *Phoenix* (2014) and Rainer Werner Fassbinder's *Die Ehe der Maria Braun* (*The Marriage of Maria Braun*, 1979) (Fisher 2017), and Gerhardt suggests connections between the films made at the dffb during its early days and those of Berlin School filmmakers such as Petzold, Arslan, and Schanelec who were trained by some of those early dffb students such as Harun Farocki and Hartmut Bitomsky (Gerhardt 2017), one could also pick up on Hochhäusler's repeatedly acknowledged influence of Ernst Lubitsch on his films and other, perhaps more subtle, connections that connect the Berlin School filmmakers to their German predecessors, including perhaps those of the New Munich Group of the mid- to late 1960s, such as Klaus Lemke and Rudolf Thome.

Yet, while it is undeniably true that it could be productive to investigate the Berlin School as part of a much longer *German* film history, we chose to go in a different direction with this volume for two main reasons. For one, when reading interviews with the protagonists of the Berlin School, one cannot help noticing that many of them emphasize that they simply did not grow up watching many

German films (some, like Hochhäusler, even claim to have mostly ignored films altogether until relatively late in their adolescence or even young adulthood). Thus, insisting on their German connections rather than embracing the filmmakers' own emphasis on their international influences strikes us as problematic, not least given that thus far there exist hardly any analyses of the Berlin School in a global context. However, and this is the second reason why we chose to push the volume's purview away from the Berlin School's national heritage, it is also the case that insisting on the Berlin School as a phenomenon of German national cinema has already been acknowledged as a problematic intellectual framework *within* the discipline where the Berlin School's work had its greatest impact to date: that of German (film) studies.

Indeed, while our overriding hope for this volume is to open up the conversation about the Berlin School beyond the more narrowly delineated confines of *German* film studies, we would be amiss not to acknowledge the crucial role this group of filmmakers has played in and for it in the last ten years. As our volume's contributor Lutz Koepnick has polemically argued on various occasions, including in his stock-taking essay, "German Cinema Now," published in *German Studies Review*, the filmmakers associated with the Berlin School have, in German studies, become the "new good objects of academic study: a legitimate cinema refusing the formulaic and user-friendly products of the popular, American and German" (Koepnick 2013, 654). Koepnick's argument's polemical provocation lies in the possibility that the implied ascription to films by Berlin School directors as objects that are "good" has come at a cost for German film studies, an argument Sabine Hake seconds in her contribution to the same *German Studies Review* issue, "Contemporary German Film Studies in Ten Points." And we take at least part of the reason both scholars issue their discontent with this recent ascendency of the Berlin School in German film studies to derive from their recognition of the *cost* of such dominance for German film studies: that, perhaps, the scholarly attention the Berlin School has received since the mid-2000s has resulted in what might be regarded as a rearguard action on part of scholars of the Berlin School that, however unintentionally, has territorialized the collective intellectual energies permeating German film studies onto these "good objects." The worry is that in focusing so intensively on these "good objects," scholars are (unintentionally) preventing similar energy from being expended to push German film studies forward— that is, "to encourage German film studies to connect itineraries to larger debates in international art cinema studies" (Koepnick 2013, 660).

We are inclined to take Koepnick's and Hake's objections as intending to mark a twofold concern: one, that the insinuated takeover of German film

studies by collective scholarly attention to the Berlin School films has pulled German film studies back into the past of the tradition of the *Autorenkino* of 1970s New German Cinema and what may by now be anachronistic concerns with modernist film aesthetics and its ever-present question of national identity, as Hake argues when she writes that "the current work on the Berlin School, with its tendency toward close textual analysis, and the continuing preoccupation with questions of national identity, memory, and history[,] reinscribes the national as a structuring presence/absence in definitions of audiovisual style, affective mode, and social relevance" (2013, 644–45); and, two, that this effect might counteract the possibility of catapulting German film studies forward into the third millennium, of, indeed, transforming it into something other than *German film studies*—as something other, that is, than either *German* film studies or German *film* studies. As Koepnick writes, "While scholarly work was quick to discuss how Berlin School films engaged with the realities of neoliberal deregulation, the films themselves were largely greeted as part of a relatively self-enclosed and self-grown cultural project, in no real need to be situated in a larger international context" (2013, 654). For Koepnick, this scholarly failure—if not parochialism—comes at the cost of preventing German film scholars "to engage [more thoroughly] with filmic work echoing, impacting, and paralleling the work of Berlin School filmmakers beyond the horizon of German film history and culture today" (654). As becomes apparent from his contribution to our volume, for Koepnick, such analytic shortcomings have to be corrected not only by putting more pressure on the Berlin School's "relation to the shifting shapes of art cinema after the demise of the normative concept of national cinemas," but, he continues, such correction is necessary also in order to conceptualize better what "the place of the national [is] within the international traffic of more experimental and aesthetically probing work with moving images today" (654).

A bit flippantly, we might say that at least one of the discontents with the "good objects" of the Berlin School might very well result from the sneaking suspicion harbored by Koepnick and Hake (and others?) that the ongoing collective attention to the Berlin School in German film studies may represent the scholarly analogue to what "old Europe" represented to good ol' former US secretary of defense, Donald Rumsfeld: a retrograde mindset that in pretending to defend what it sells as morally superior positions merely betrays its fear of adjusting to a brave new world in which the field of relations has been reorganized to such an extent that traditional alliances, beliefs, and attitudes have lost their purchase on the present and are now merely in the way of the avant-garde of force relations "Rummy" identified as the "new Europe." In our case, of course, the analogue to this "new Europe" might be something like New Media

Studies or, more generally, Screen Studies, exciting new scholarly conversations from which, as Koepnick and Hake argue, German films studies will remain sidelined if it does not begin to "account for the wide range of locations and media that make up international art cinema today and that transcend the domain of the traditional filmic auditorium, projection, and screen" (Koepnick 2013, 654). Whereas the "old Europe" of German film studies, to stay with what admittedly is a somewhat skewed analogy, remains tied to a tradition of the big screen and its attendant aesthetic practices, assumptions, and even utopias, "new Europe" wants to take seriously the fact that for an ever-increasing number of people the big screen and the spectatorial situations characteristic of it no longer constitute the dominant environment in which we encounter and engage moving images. And if this is true (and there is, of course, much evidence supporting this claim), one might indeed have good reasons to be suspicious of any of the larger claims made about the "good objects" of the Berlin School, such as, for example, claims about these films' potentially resistive capacities (which both of us made in our respective books, for example): if most people who encounter moving images do so no longer, or at least not primarily, in the film theaters of old but instead at home, zapping through five hundred channels while also checking out YouTube videos on their computers, or on the go, sneaking peaks at their smartphones while walking or driving, not to mention strolling in and out of video installations at museums, then it stands to reason that the cutting edge of *film* studies may indeed no longer be "film" studies, German or otherwise.

But perhaps most pressing for those who feel some measure of discontent with the "good objects" of the Berlin School is *how* this kind of cinema and the critical attention it receives (at least in German films studies, but also beyond, as is evidenced by the attention MoMA has given it or the fact that the globally oriented *Senses of Cinema* has published a number of pieces on Berlin School filmmakers) might impact the future of what is arguably one of the most institutionally marginalized objects of *film* studies to begin with: German-language cinema.[8] After all, whereas just about any other national cinema finds its scholars housed in Cinema Studies departments, German-language cinema owes its academic existence almost exclusively to whatever resources German-language departments and programs have to offer. This is also evidenced by the fact that today, some three decades after the demise of the New German Cinema of Fassbinder, Wim Wenders, Werner Herzog, Margarethe von Trotta, and others, hardly any scholarship on contemporary German-language cinema finds its way into the pages of "mainstream" *cinema* studies journals—a fact that is especially but not exclusively true for

scholarship that is *not* interested in those German films that tackle the country's big historical catastrophes.

Ironically, then, what is being sold to (and perhaps eagerly bought by) German film studies at large as "cutting edge"—as, perhaps, the long-awaited good German filmic objects for the aesthetic of which scholars no longer have to sheepishly apologize when studying them, as one is arguably prone to do when saying all kinds of interesting things about what Eric Rentschler dubbed the "cinema of consensus" films (Rentschler 2000) or the latest wave of "totalitarianism" films—might currently be functioning as a Trojan horse, smuggling an insidious force right through the front door of German film studies as a means to reverse the very opening up of the discipline that the application of methodologies of, broadly speaking, cultural studies or, of late, a transnational orientation have effected since the country's unification in 1990. Prior to the emergence of the Berlin School on our critical radar, that is, German film studies had increasingly become outward looking. It investigated, for example, how German popular films relate to and indeed are part of larger international traditions and in general had been intent on de-territorializing scholarly attention away from the long-dominant habit of approaching German films as, well, *German* films that are primarily *about* Germany. This pushed the field to embrace a more rigorously transnational perspective—a laudable development that, we suspect, those harboring discontent with what they take to function as the current "good objects" of German film studies see as being undone, perhaps because Berlin School discourse has been dominated by questions of *film* aesthetics and questions of its *national* specificity, by, in other words, the possibly reductive and academically anachronistic terms of *national film* studies.[9]

Considered in this light, then, the current "good objects" of German film studies—and perhaps even more so: its systematic scholarly study—appear to mark a backlash or countermovement against this opening up, or scholarly deterritorialization, of German cinema. These "good objects" may be feared as enticing collective intellectual energies to embrace the sweet sensation of nostalgia for an older version of German film studies the critical orientation of which was more auteurist and more national in inclination, a tradition that is of course closely associated with German cinema's two so-called golden ages: of the Weimar cinema of F. W. Murnau and Fritz Lang and, more recently, of the New German Cinema. In short, then, the critical investment that has configured the Berlin School as a "good object" may well be assessed by some as a troubling *over*investment, and the urgency of such discontents marks the concern that such overinvestment might come at a significant cost: that the

"good objects" of the Berlin School are the Pied Piper of German film studies in the third millennium.

The objections Koepnick and Hake raised are excellent ones—indeed, as stated above, they inspired us to produce this volume, perhaps not least also because we agree with Hake's observation about the "insularity of German film studies [that] is evident in its marginality in contemporary film and media studies both in its established specializations and new areas of inquiry" (Hake 2013, 645).[10] We would be delighted if our volume can contribute to reversing this unfortunate state of affairs. However, we also agree with another contributor to this volume, Gerd Gemünden, who calls attention to the fact that some of the major scholarship on the Berlin School has already established that, for example, "unlike the New German Cinema, which considered itself (or was made to do so) a 'legitimate' cinema representative of 'good' German culture, the filmmakers associated with the Berlin School realize that such a stance has no purchase on the neoliberal German present"; Gemünden adds that "while the [Berlin School] movement does take stock, almost obsessively, of today's Germany, it does not understand itself as part of a national cinema" (Gemünden 2016, 548). This is why Gemünden replies to Koepnick's and Hake's interventions in the affirmative, but he does so not without adding the crucial caveat that the approach they advocate for—to "connect [German film studies'] itineraries to larger debates in international art cinema studies" (Koepnick 2013, 660)—"necessarily *builds* on previous research on the Berlin School and would be unthinkable without it" (Gemünden 2016, 548). Our volume attempts to do exactly what Gemünden has in mind: to *build on* what the scholarly conversation has been able to accomplish thus far—to wit, to connect the Berlin School to theoretical questions about the moving images and thereby reveal how responsive these filmmakers are to cutting-edge philosophical and political debates about how images distribute and redistribute the sensible, to use Jacques Rancière's phrase (Abel 2013); to counter the misconception that the Berlin School is opposed to genre cinema and thereby show how it is deeply embedded in the history of world cinema (Fisher 2013);[11] and to show how the Berlin School is hardly a monolithic group working with a unified idea of the cinema and thereby open up our view of these films to a multiplicity of themes, ideas, preoccupations, and provocations that counter reductive "auteurist" readings of these filmmakers and films—*and* to go beyond it by heeding Koepnick's and Hake's challenge to connect what the Berlin School films do (and why they are of such interest that they have become "good" objects in the first place) to global art cinema in ways that have not yet been articulated.

The Peculiar Travels of Art Cinema:
Institutional Attributes and Aesthetics Approaches

So, for the very particular purposes of this volume, how to understand the work-ings of this sort of art cinema around the world—the kind of art cinema that both Koepnick and Hake, but also the Berlin School filmmakers themselves, evoke? How to comprehend its institutional attributes and aesthetic approaches? Rosalind Galt and Karl Schoonover suggest, for one of the four key aspects of art cinema, that such films travel, that is, move beyond their home contexts to have a reception and impact elsewhere in the world (Galt and Schoonover 2010, 7). It is, however, difficult to see this traveling attribute as a sufficient definition for these films or how they function: mainstream Hollywood films undoubt-edly "travel" more and have a far greater impact in terms of audiences elsewhere. Rather, we would emphasize, so-called art films travel in very particular ways, to niche markets and highly differentiated public spheres—indeed, this notion of a differentiated yet cosmopolitan public sphere, a sphere highly specialized yet em-phatically open, is one we hold at the core of the present volume's basic endeavor, since these films, from the Berlin School and elsewhere, are in continual, consti-tutive conversation with one another. The interactions and reciprocal influences of the films in the volume indicate the relevance and workings of such a trans-national public sphere. For instance, in his essay herein, Gemünden highlights aspects of these mechanisms in the so-called New Argentinian Cinema: some Berlin School directors have been engaged in direct discussions with their Argen-tinian colleagues, and those discussions have been underpinned and/or paralleled by journals and events of various (equally public-sphere) sorts. Likewise, Robert Dassanowsky foregrounds similar processes connecting the directors of the New Austrian Film to those of the Berlin School, and Hester Baer discusses how an emergent transnational women's film and television culture seeks to respond to the specifically *neoliberal* conditions of possibility for filmmaking today by em-bracing the ethos of collaboration and revitalizing the feminist countercinema tradition. As is true for many of the films and their makers under discussion, originating from Germany or elsewhere, both film product and personnel are part of and build on a public sphere of art cinema around the globe—"around the globe" rather than "global public sphere" because these discussions, in person and in various media, are clearly specialized and do not engage the entire globe, although, on the other hand, every public sphere is specialized in some way.

Perhaps the starkest evidence for such a niche, fragmented, but nonetheless abiding public sphere around the globe is the movable feast of the "big" film festivals. The important and intimate links between art cinema and the film fes-

tival have recently been noted by Thomas Elsaesser, Dudley Andrew, Marijke de Valck as well as Galt and Schoonover, among others (in the present volume, Baer, Fisher, and Gemünden remark on this link as well).[12] We think that these scholars sense how art cinema functions around the world: festivals incorporate the simultaneously cosmopolitan and national/local character of the films and their directors (their mobility as well as their rootedness) while simultaneously celebrating both mainstream genre cinema and art cinema that frequently defines itself against the former. Festivals, to a degree not always appreciated, put mainstream genre cinema side by side with art cinema films that may or may not deliberately antagonize such genres, bringing them into dialogue as they do with cinemas from around the world. This is a notable difference from the museum world, which largely accepts its own niche (educated, affluent to very affluent) audience, whereas festivals deliberately program different sections for different constituencies. By programming films from up and down the economic as well as artistic scales and by conjuring the inevitable comparisons that highlight such scales, film festivals serve as synecdoche and allegory for both the diverse institutional attributes and aesthetic approaches of cinema, both indispensable aspects of any individual film. Not all of the filmmakers featured herein rose to prominence at festivals, but many did, and the film festival reveals the relevant mechanisms, both institutional and aesthetic, for such films. The festivals underscore what Petzold has termed the "neighborhood" for a film, that is, the production, distribution, and exhibition context for a cinematic cultural product (see Fisher 2013, 132). The neighborhood for many of these films is the niche, specialized public sphere of art-cinema productions in conversation with each other.

In addressing the continued relevance of the festival form and phenomenon, we would underscore something that B. Ruby Rich astutely observed as she considered the curious persistence of film festivals in the digital age, something we think has implications for art cinema (and the present volume) as well. Rich admits that one of the fundamental functions of festivals is now clearly outdated, namely, its status as a geographical locus where those concerned congregate with expensive-to-ship film prints at one festival swoop (Rich 2013, 157). Digital distribution, with its ubiquitous streaming video or even just DVD screeners, have rendered that former function irrelevant. But, for Rich, festivals abide because they forge a place where interested people gather and converse about a cultural product about which they care: amid ferocious competition in the attention economy, festivals focus the time, eyes, and thoughts of interested parties, even if the products engaged could be available 24-7 (Rich 2013, 164). Of course, like the screenings, the relevant conversations could be carried out online, but it is notable that they are not, or at least not in the same way: the facility of online

communication has not killed the actual act of gathering and discussing, rather parallel to how the rampant deterritorializations of information technology have not rendered the geographic place of Silicon Valley irrelevant in the so-called new economy. No matter how extensive or integrated, networks and networking still require, provide for, and yield their nodal points.[13]

Many of the films our contributors discuss made their (difficult) way to a (somewhat) wider audience and a (spotty) international consciousness through festivals and parallel modes of public discourse (also aspects of their "neighborhood"). It is notable that film trades like *Hollywood Reporter*, *Variety*, and *Screen International*, film magazines like *Cineaste*, *Film Comment*, and *Cahiers du Cinéma*, and newer, purely online venues like *IndieWire*, *Senses of Cinema*, and the German *critic.de*, not to mention blogs such as the influential http://girishshambu. blogspot.com, all cover festivals extensively, and these festival reports and reviews are contiguous with writing about, discussing, and promoting art cinema. Add to these the worldwide film-archives-cum-cinemas, *cinematheques*, *Programmkinos*, and so on, to which many of these directors have regular access and that have the clear makings and markings of a public sphere around the world. Of course, such a public sphere is now largely (and day to day) experienced online as well as through small screens, be they computer or television screens playing DVDs or streaming video, but a key part of this multifaceted public sphere is the continuing importance, as Daniel Dayan observed about his experience at Sundance (Dayan 2013, 47–48), of the written word—because, we would emphasize, public-sphere discussions about the films still matter to filmmakers, film personnel, and movie audiences (and, more obviously if more modestly, to critics and scholars). Taken together, it is a multimedia public sphere that is driven by the steady release of, and dialogue among, these cultural products. A film, or even historical film series or retrospective, might premiere at a festival, be first discussed there (initially in person, then likely online), then appear programmed at a film society, before being downloaded on a local laptop, with ever widening audience circles at each of those scales.

Elsaesser has influentially written that film festivals have come to constitute the key alternative distribution network to Hollywood (Elsaesser 2005, 93–108), one of particular import to both European and so-called world cinemas—that is, those cinemas that do not have the expansive (and expensive) corporate distribution and marketing mechanisms that Hollywood so enjoys. Elsaesser's formulation has come in for some criticism (cf. Iordanova 2013, 109, and Roddick 2013, 185–90), largely because these scholars seem to feel that "alternative distribution network" implies a kind of commercially competitive mode of distribution, which festivals (usually requiring substantial state and corporate subsi-

dies and sponsorships) most certainly do not provide. Only the naivest would suggest that art cinema, in defining itself against Hollywood as it sometimes does, could commercially compete in this fantastical struggle, at least as long as the terms of that struggle are audience numbers and box-office receipts (Wood 2007, 25). On the other hand, festival films are self-evidently "distributed" to and "exhibited" at the festival venues for audiences they would not otherwise reach—it is just a different sort of distribution and exhibition, one ruled not only by hard currency but also by rather putative artistic value, that is, by rather ethereal prestige. A case in point is the phenomenal global success of Ade's *Toni Erdmann*, which with over 900,000 viewers has become the Berlin School's biggest box-office hit in Germany to date. When it premiered at the Cannes Film Festival in its competition—a rarity for German film productions in the last few decades—Ade's third feature was quickly embraced by critics as the festival's putatively best film (it did not win the Palme d'Or, however) and subsequently earned numerous accolades around the globe, including a nomination for Best Foreign Language Film at the 2017 Academy Awards.

This sort of double bottom line for art cinema—both finances and artistic ambition and value (contentious as the latter may be)—is relevant not only in film festivals but also in the other primary neighborhood of many of these films, that of television, which has a relevance to the production and dissemination of these films frequently neglected (for example, rather amazingly, the words "television" and "TV" do not appear in Galt and Schoonover's introduction to their *Global Art Cinema*). These two neighborhoods of art cinema—the film festival and television—indicate the complex contexts of such works, emphasizing their alternative and differentiated foundations. Such alternative foundations include, as a cornerstone, artistic prestige in addition to box-office receipts, an alternative that also orients the films to the aforementioned cosmopolitan public sphere.

The Lingering, Niggling Dynamism of the Nation and "National" Cinema: Angela Schanelec's *Der traumhafte Weg* (*The Dreamed Path*, 2016)

Besides suggesting the institutional and aesthetic diversity of art cinema—and how that diversity constitutively interacts and creates—the festival also affords a useful means for comprehending the status of the nation and so-called national cinema at this historical moment. As recent political events in Britain, Russia, France, and the United States confirm, the nation is a long way from going away as either a political or cultural force; rather, it would seem, popular consciousness

of nationally based identity waxes and wanes (here too Galt and Schoonover [2010, 13] do not fully attend to a complex dynamic of films' relationship to national identity. Notably, festivals have approached the thorny matter of a film's "nationality" in different ways: in this age of rampant coproduction, Cannes has done away with associating a film with a particular nation, whereas Berlin and Locarno both provide, in many cases, a many hyphenated/slashed national identity, a telling parallel to the hyphenated identities of the world's increasingly "hybrid" people. With festivals programming a wide range of film products side by side, one can see how films can be more or less national both in audience/market sought and in content diegetically delivered (and those two aspects are usually intertwined): films might seek a local, regional, national, or international audience and adjust their forms of address accordingly (Higson 2002; Finney 2002). Such modes of address might include language and dialect but also themes, as Hjort has pointed out (Hjort 2000, 106, 111), any of which may be supranational, national, or subnational—consider, for contrasting examples, the French-English-language productions like Luc Besson's *The Fifth Element* (1997) or Pierre Morel's *Taken* (2008) or subnational Bavarian cinema in films like Thomas Kronthaler's *Die Scheinheiligen* (*The Hypocrites*, 2001) and Marcus Rosemüller's *Wer früher stirbt, ist länger tot* (*Grave Decisions*, 2006). Such mechanisms of audience address underscore the artificial, that is, discursive character of the nation, but they also underline its abiding relevance: if artists, film artists not least among them, have to calibrate modes of address based on a presumed and sought audience, they have to be self-consciously aware of forms of local, national, or transnational address and deploy them accordingly.[14] Such modes of address are certainly, as Randall Halle has observed, entwined with funding modes and mechanisms (which also operate at all these scales: local, regional, national, supranational), but such funding structures are only one aspect of this address, as Andrew Higson has observed (see Halle 2008, 22–24; Higson 2002).

One can discern these wide-ranging modes of self-consciously national and transnational address in a film like Angela Schanelec's *Der traumhafte Weg* (*The Dreamed Path*, 2016), which premiered in Locarno's international competition (Concorso internazionale) in 2016. Many reviewers commented on how elusively Schanelec's film (typically) operated, with its elliptical storytelling and Bressonian acting and editing, but one of the film's key aspects arises from the mode of national and transnational address suggested above. Regarded (as noted above) as a core member of the Berlin School's first wave, Schanelec and her films have long worked cross border, so to say, as films such as her student short film, *Prag, März 1992* (*Prague, March 1992*), *Plätze in den Städten, Passing Summer, Marseille,* and *Orly* confirm. But *The Dreamed Path* opens with an emphatic state-

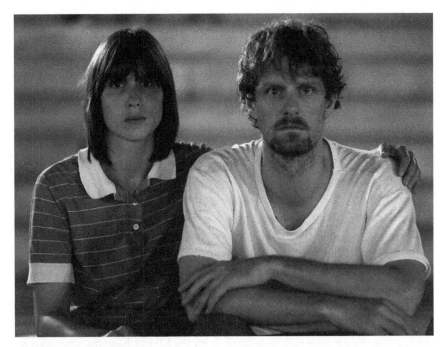

Figure 0.1 *The Dreamed Path*

ment about the interweaving of the national and transnational, with a clear form of national address that is simultaneously transnational and international, not least via the German-British couple (Theres and Kenneth) traveling in Greece in 1984. As the couple sits down on a sidewalk to perform with a guitar, presumably to earn a few extra drachmas for their (clichéd northerners-in-the-south) travels, viewers see that Schanelec is simultaneously invoking the political aspects of the nation and the transnational even more than in her previous films: around the couple swirls the riotous din of an election for the European parliament, evoking from the putative fount of Western democracy both broad election banners and sung slogans (fig. 0.1).

The election depicted in *The Dreamed Path*'s opening sequence was the second time Greece voted for the European parliament and the first time it voted with the rest of the community, after official Greek accession to the then European Community in 1981. In this way, a film conceived and made during Germany's difficult (and draconian, many thought) negotiations about the post-2010 Greek bailout foregrounds the longer history of Greece's relationship to the EU; moreover, with the couple Theres and Kenneth, the film would seem to point to two of the putative engines of the EU, Germany and the United Kingdom. Schanelec's

festival-premiering film invokes political procedure (election) as well as a public sphere (banner, slogans) around a transnational election, even as its characters (whose nationalities underscore the long-term tensions around these processes) do not explicitly discuss politics. They seem too dreamy for that. To an unprecedented degree in her own work, Schanelec's *The Dreamed Path* would seem calibrated for both national and transnational address vis-à-vis the usual art-cinema public.[15]

This dual mode of national address comes up in two important moments later in the film. About twenty minutes into the eighty-six-minute film, Kenneth has left Theres in Germany and finds himself back in the United Kingdom with his ill mother and his blind father, considering what to do about his mother's probably permanently unconscious state. The TV behind them, as they consider what to do, broadcasts a clearly audible report about German refugees seeking asylum by migrating through Hungary. The diegetic year, viewers likely realize, must be 1989, the year that East Germany started to wobble and eventually to collapse, when thousands of East Germans fled and were accepted first by Hungary, then Czechoslovakia, and eventually West Germany. Hungary's help offered to fleeing East Germans obviously contrasts with the Hungarian government's recently resistant, often brutal approach to refugees from the Middle East; the scene also reminds viewers of the long history of ethnically German refugees around the world (a topic highlighted at the same film festival in its "Piazza Grande" selection by Maria Schrader's *Vor der Morgenröte* [*Stefan Zweig: Farewell to Europe*, 2016], which follows the Austrian writer Stefan Zweig [1881–1942] to Argentina, Brazil, the United States, and then back to Brazil in his coerced wartime wanderings). By foregrounding borders and refugee mobility over them—in recalling, no matter how elliptically, Germany's history of having its own persecuted refugees helped by other nations—Schanelec is addressing the nation, its history, its territorial constitution and fluidity. In this way, *The Dreamed Path* is close to Arslan's similarly "late" Berlin School film *Gold* (2013), which is both "national" and not—or, rather, national and beyond—at the same time, as is Ade's *Toni Erdmann*, which "displaces" its central story about a father-daughter relationship from the protagonists' native Germany to Romania, where the daughter works as a neoliberal business consultant, as well as Grisebach's *Western*, which like *Toni Erdmann* investigates Germany's business presence in Eastern Europe.

Second, in its final thirty minutes, *The Dreamed Path* skips time (as a dream might) without much narrative fanfare or even diegetic indication: Kenneth sits in the sun, outside and exposed, against a subway stairwell on a broad square outside of Berlin's main train station. This station (conjured in soaring glass and steel out of the older, smaller Lehrter Stadtbahnhof) opened in 2006, so the

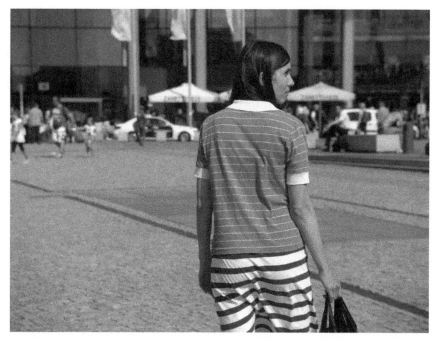

Figure 0.2 *The Dreamed Path*

film's concluding present moment seems to be at some point after then, likely during or after the 2008–9 financial crisis that has sent the EU so reeling. Due to Schanelec's provocative strategy of narrative/temporal ellipses throughout, viewers cannot be sure how the apparently homeless Kenneth came to reside here, in a central public space of what many regard as the de facto political capital of Europe (only a couple of hundred meters from the German chancellor's office and the Reichstag). But the film seems to afford a clue to his trajectory when he sees Theres approach him here, on the square in front of the train station, and is obviously moved by this physical flashback to their shared past (fig. 0.2).

Perhaps he has been waiting for her, in this densely trafficked square, some thirty years after viewers saw them in Greece? It is at this point that viewers might realize that both are wearing the same clothes and the same hairstyle they did in that opening Greek sequence in 1984: the eponymous "dreamed path" seems to wind from that crucial moment (of Greece's full participation in the Europe Community, soon to be Union) to this one, of the German-English reencountering a love from the past at the core of the former's new national capital. The collective dream heralded at the film's opening is entwined with the private one of love between this inter- and transnational couple.

In discussing the final sequences at the film's Locarno press conference, Schanelec said she has always been interested in city squares—which is to say, we would emphasize, in the form of the public forum, the echo of the Greek agora, a space of both encounter and politics. In this way, the final sequence loops back to the opening sequence, oneirically, the Greek election unfolding on a public square replaced by the private encounter on the German *Platz*, where Theres coldly walks past Kenneth. She is clearly affected at having seen him, as viewers watch her later at home, but does nothing, and he spirals subsequently downward. Any easy reading of the film's "message" may, indeed, be elusive, but its mode of national and transnational address has been clearly registered: it is a film emphatically about the "nation," evoking national politics and themes, even as it underscores the context of that nation in the wider context. A national film—that is, a film addressed to a certain audience by foregrounding national discourse—*The Dreamed Path* winds its way to the festival in the south, a national film thus open to the wider world in its production history/fate as well as aesthetic approach. It travels transnationally both literally (for its premiere) and diegetically (for its protagonists), underscoring both the cosmopolitan travel of art cinema and its abiding engagement with national tradition, histories, proclivities.

A Rich Mosaic of Contemporary Global Art Cinema

What we have done above is offer some crucial context—as we see it—for the essays that follow. While we do not mean to suggest that each of our contributors directly speaks *to* the issues our remarks above address, we do hold that each contribution included in these pages is *informed* by the two main contexts our introduction has sketched out: the role of *German* cinema in global art cinema and the role the film festival circuit has played for how the films of the Berlin School are influenced by films made across the world. That said, it is hardly surprising that our contributions are informed by these contexts in different ways, with their authors emphasizing to varying degrees matters of film aesthetics, the films' politics, their thematic concerns, or historical lineages. Likewise, as to be expected, the methodological approaches to the comparative essays—most of them are organized around two case studies, one a Berlin School film, the other a film from the realm of global art cinema—vary greatly, with some contributors approaching the films from a specific theoretical-philosophical point of view, others from a more historical perspective, while still others employ their close reading skills to shed new light on the films under discussion. Cumulatively, we believe, the fifteen contributions constitute a rich mosaic of (mostly) contem-

porary global art cinema that reveals the Berlin School as a heretofore mostly unrecognized "factor"—as an active contributor to the conversation of global art cinema because its protagonists are also active consumers of what their colleagues around the world produce (and how those films are critically received).

Hester Baer's essay approaches the Berlin School from a feminist perspective by situating directors such as Ade, Grisebach, and Speth in the context of an emergent women's film and television culture, which itself has its roots in the countercinema of the women's film in the 1970s. Linking the German filmmakers with peers in the United States, such as Kelly Reichardt and So Yong Kim, Baer argues that the work by these transnational director-producers "forms a vital contemporary movement to resignify both the representational practices and the production modes associated historically with women's cinema." Echoing other essays in this volume, Baer, too, clarifies that the films by these directors cannot be defined by a unified aesthetic, nor can they be reduced to their makers' status as women. Yet, what is common to their filmmaking efforts, Baer argues, is their struggle to combat the "ongoing (and renewed) marginalization of women in contemporary societies and cinematic representations." And this marginalization is, Baer holds, deeply embedded in the neoliberal environment that surrounds the conditions of possibility for these filmmakers to pursue their art—a point of view that resounds with both Abel's and Fisher's monographs on, respectively, the Berlin School and Petzold, but that extends, and complicates, their arguments by putting a distinct emphasis on the status of *women* in both the Berlin School and global art cinema. Ultimately, Baer suggests that "films of the Berlin School might be productively understood as contemporary media assemblages that combine multiple production and exhibition formats (analog and digital; film, television, and streaming) along with multiple transnational and national film genres and waves . . . in order to create a broad-based appeal to an international audience of cineastes. Such a model," Baer writes, "helps to conceptualize how Berlin School films—like global art cinema in general—are firmly embedded within commercial, mainstream platforms while also posing a challenge to them."

Lisa Haegele's analysis of Ade's *Alle Andren* (*Everyone Else*, 2009) and Derek Cianfrance's *Blue Valentine* (2010) resonates with Baer's argument. Haegele shows how a transnational comparative perspective on these two "postromance" films reveals how, on the one hand, both films offer alternatives to the traditional Hollywood romance film but, on the other hand, the German effort "projects new possibilities for the contemporary cinematic romance," whereas the US film ultimately comes across as a "lamentful eulogy to a well-worn genre." In Haegele's view, both films are embedded within the "commercial, mainstream platforms" of which Baer speaks in her essay; however, both illustrate how Hollywood's stable gender

prescriptions and leveling out of class divisions through romantic love have become grossly incompatible with the messy and complex truths of contemporary "relationships" in the neoliberal age. Yet, in the end it is *Everyone Else* more so than *Blue Valentine* that manages to pose a challenge to both the mainstream genre of the Hollywood romance and the neoliberal context that constitutes the condition of possibility for the genre's ongoing popularity. Subtly echoing Fisher's argument about how Petzold works with and through a host of genres rather than rejecting genre filmmaking as such—a frequent misconception not only of Petzold's films but also of that of some of his peers—Haegele's deft analysis contests the "prevailing claim that Ade's protagonists—and many others in the Berlin School—are 'alienated' and 'disconnected' from each other in the age of neoliberalism and post-industrialization." This claim's veracity, Haegele suggests, becomes available to us as a result of the transnational comparison her essay performs.

Three essays that take their cue from Abel's arguments about the specific *aesthetic* project of the Berlin School—but that productively extend it in their readings of both select filmmakers from this group and filmmakers from other parts of the world—are Robert Dassanowsky's, Will Fech's, and Alice Bardan's. Dassanowsky maps out how one of the most crucial groups of interlocutors for the Berlin School—the directors of the New Austrian Film, including Jessica Hausner and Julian Roman Pölsler—approach the vexed question of "national" cinema differently from those of their peers, such as Heisenberg, across the border. Dassanowsky shows how the New Austrian Film ultimately resists "cinematic 'nation building,' while nevertheless conceiving itself as 'national' in rejecting the subsumption of Austrian culture and film into international definitions of the 'German,'" not least by turning to different topics than those we can locate in Berlin School films, including the theme of *Alltagsfaschismus* (everyday fascism). However, even though Dassanowsky detects considerable differences between New Austrian Film and the Berlin School when it comes to their films' topics, he suggests that the Austrians' own inflection of *realism* had an impact on that of the Berlin School. As he concludes, even though "the Berlin School has drawn Austrian and Austrian-trained filmmakers into its film theoretical stratagems, there are indications that the metaphysical aspects that directly question perception and stem from Austrian Magical Realism (itself sprouting from a mix of surrealism and Catholic mysticism) have added an additional aspect to its characteristic arepresentational meditative realism," a notion that Abel (2008b) first introduced into the conversation of the Berlin School as a means to prevent their films from getting reduced to being just another "realist" cinema in the art-house vein.

Also responding to the debate about the role "realism" plays in Berlin School films as well as contemporary global art cinema is Will Fech, who offers a subtle

and richly suggestive comparison between films by Kelly Reichardt, perhaps the most celebrated of contemporary American independent filmmakers, and those by Henner Winckler, who, as Abel argues in his essay on Winckler (2015), once was part of the core of the Berlin School but has since been marginalized if not forgotten in accounts of the School. Fech situates his comparison in the context of what might have been the most influential (and controversial) intervention in the critical discourse on contemporary cinema in the last decade, A. O. Scott's proposal that we witness a resurgence of realist cinema that he coined "neo-neorealism" (2009). Fech's compelling intervention in this debate is to offer considerably more nuance in his analysis of Reichardt's work than Scott does in his discussion. Comparing hers to Winckler's films, Fech shows how their "films contain important differences attributable to the variances between de-familiarization and representational realism." In other words, Fech's analysis puts considerable pressure on the very concept of realism itself: "If realism purports to create resemblances, however imperfect or artificial, between the film world and the real world so that we can more easily identify with the characters or situations on screen, de-familiarization forces viewers to interrogate our everyday perceptions about reality, to make the familiar strange again." And according to his reading of films such as Winckler's *Lucy* (2005) and Reichardt's *Wendy and Lucy* (2008), what we find through closely attending to the films' aesthetics is that their respective (national) contexts impact how the two directors pursue a "different way of imaging struggle"—with Reichardt ultimately relying more on a form of representational neorealism in her effort to depict her protagonists' difficulties than Winkler, whose "realist" "aesthetic strategy of de-differentiation" (Abel 2015) veers more toward "de-dramatization," a tendency that we can surely observe in many Berlin School films even though by no means all of them (consider, for example, the more genre-oriented films by Petzold but also Ade's films, including *Toni Erdmann*).

Alice Bardan also closely examines the Berlin School from an aesthetic perspective by putting their films in conversation with a key example of the so-called Romanian New Wave, which has arguably been the hottest of the new Europe-based cinema movements to emerge in the last fifteen years: Corneliu Porumboiu's *Când se lasă seara peste Bucuresti sau metabolism* (*When Evening Falls on Bucharest or Metabolism*, 2013). Responding to the accusation often levied against both Porumboiu's work and that of the Berlin School directors that they are apolitical or, in any case, not overtly political enough, Bardan shows in her analysis how like many Berlin School films, including those by Petzold and Arslan, Porumboiu's "relies on series of reframings and [thus] enacts a way of seeing that ultimately makes it more political than it may first seem." Bardan

convincingly shows how for both "Porumboiu and the Berlin School filmmakers, the question of cinematic realism is understood not as a way of capturing pro-filmic events most faithfully but rather as a way of inviting viewers to engage in an aesthetics of discovery." Her argument, which resonates with Fech's analysis of the role realism plays in Reichardt's and Winkler's films, crucially links the question of these film(maker)s' aesthetics to the question of politics, ultimately defending them against their critics and arguing that their (respective) "politics must be read in relation to the view that art's capacity for the political lies in its aesthetic nature, not in its ability to communicate a (didactic) message."

Another contribution that grapples with the relationship between the films' aesthetics—and their themes—and their politics is Ira Jaffe's. Jaffe closely examines the work of the great contemporary master of Turkish cinema, Nuri Bilge Ceylan, and investigates how his films compare with those of the Berlin School, not least Petzold's, in terms of the specificity with which they engage "social, political, and economic realities" in their respective countries. Focusing especially on the prevalence of "homelessness" in Ceylan's work—not so much literal homelessness as a psychic and emotional state of being without a home, of not seeming to belong, of not seeming to be able to connect to one's family or social environment—Jaffe nicely delineates a crucial difference between Ceylan's much celebrated films, winners of many awards at the Cannes Film Festival, and those of the Berlin School, in particular Petzold's. As he argues, "while both Petzold's characters and Ceylan's seem out of place and perhaps ghostly wherever they happen to be, Petzold's appear more involved in a particular economic, social, and political order at a particular time and place—that is, neoliberalism in Germany after unification." In contrast, writes Jaffe, the protagonists in Ceylan's films "are more withdrawn, inarticulate, sluggish and adrift—more removed from society and from a specific order and ideology, with the result that their homelessness may have a more timeless and irremediable quality." It would be intriguing to put additional pressure on Ceylan's own claim that his films might be more interested in existential rather than political questions; surely, what it means and is to *exist* is shot through with political questions, which is to say: the seemingly metaphysical and ahistorical aspects of Ceylan's films might very well be quite revealing about the social or political conditions that permeate the cultural moments in which he makes his films. But Jaffe's conclusion that a filmmaker such as Petzold ultimately focuses more on "specific social conditions," whereas Ceylan shows greater interest in "the very foundations of human existence," is well taken and opens up intriguing questions about the legacy of filmmakers such as Ingmar Bergman, Carl Theodor Dreyer, Yasujirō Ozu, and Michelangelo Antonioni in the context of contemporary global art cinema.

Indeed, it is to Antonioni's work that Inga Pollmann turns in her contri-
bution to our volume's efforts to suggest, and flesh out, genealogical connec-
tions of the Berlin School within the context of global art cinema. Just as Brad
Prager turns to a historical precursor (Truffaut) in his analysis of Heisenberg's
The Robber, so Pollmann turns to Antonioni's *Professione: reporter* (*The Passenger*,
1975) to put into relief aesthetic strategies deployed by Berlin School filmmak-
ers, in particular Schanelec's *Marseille*. By mobilizing the critical concept of the
"milieu"—in the process distinguishing between milieu understood as place and
milieu understood as relation—Pollmann calls our attention to how "the Berlin
School engages with Antonioni's aesthetic strategies of transferring the expression
of an underlying crisis to the face of things, their constellation, and their inter-
action with characters who are either lost and drifting or propelled relentlessly
forward by empty drives and desires." Like Baer's contribution—as well as Abel's
and Fisher's monographs—Pollmann ultimately links the aesthetic strategies she
locates in Antonioni and sees being reactualized in a film such as *Marseille* to their
political ramifications, indeed, to their immanent political potential in the age of
neoliberalism. Drawing on a subtle and original reading of Foucault's account of
neoliberal economics—"the science of the systematic nature of responses to en-
vironmental variables"—Pollmann puts forth that in following Antonioni's aes-
thetic strategies, "Schanelec . . . creates a kind of experimental problematology
in her images, rather than a (normative) epistemology, that is, an aesthetic that
focuses on problematic frictions, misunderstandings, and ill-fittings—an aes-
thetic in line with the approach to epistemology from Canguilhem to Foucault
and Deleuze." And it is this aesthetic approach, which renders visible "the gaps
between the milieu and the protagonists' actions or lack thereof," that ultimately
requires "a different viewing on the part of the spectator": because "the narrative
does not allow for immersion, the protagonists do not allow for easy identifica-
tion, and because framing and mise-en-scène are limiting our view and access,
the spectator connects to the image regime as a whole." Consequently, viewers
are directly confronted—get to perceive—the "force of the neoliberal milieu, the
medium, the fluid in which the protagonists move, but also their unconscious
resistance to these forces." In so doing, Pollmann holds, Berlin School films, by
tapping into the genealogy of global art cinema as manifested in Antonioni's
work, "expose the contemporary [neoliberal] milieu and manifest their political
potential."

Pollmann's comparative argument, which foregrounds the neoliberal milieu
that currently distributes the sensible (what we can see, sense, and perceive, as
Jacques Rancière puts it), directly links up with Bardan's account of how Berlin
School films as well as Porumboiu's *reframe* and thus redistribute the sensible. But

her innovative reading also connects suggestively with Roger Cook's insofar as the latter, too, puts enormous pressure on "autonomous aesthetic strategies" of the films he examines by the late master of Iranian cinema, Abbas Kiarostami, and Berlin School filmmaker Ulrich Köhler; and, like Pollmann, who has suggestive things to say about the role sound plays in the films she discusses, Cook argues that the films "employ aesthetic strategies to work subversively beneath the level of not only explicit messaging but also visual perception." In other words, Cook leads us right through the visual power of the films' images to make us think about and appreciate how they operate *haptically*. Like Pollmann and Bardan, Cook takes issue with the criticism of the films' alleged apolitical nature. And like Jaffe and Pollmann, Cook reframes the established discourse on the Berlin School by turning to a filmmaker who is often considered to work in a more or less "existential" realm. Cook approaches his comparison by turning to the latest insights from neuroscience and cognitivism (and does so in ways that oppose cognitivist film studies as promoted by David Bordwell and others, whose cognitivism, Cook argues, is too invested in consciousness). Echoing Fech's differentiated account of the role realism plays in Reichardt's and Winckler's films, Cook argues that the "Global New Wave of independent filmmaking . . . exhibits a newly conceived and diversely practiced realism"—one that we fail to properly account for if we do not attend more carefully to how the films' aesthetic strategies "effect change at the level of affect." Focusing on the role "free indirect subjective discourse" plays in the films he analyzes, Cook suggests that these films' "micropolitical interventions disrupt settled sensibilities that extend downward into subphenomenal intensities and upward into the materiality of thought." Once again, an argument about how these films redistribute the sensible, Cook's account intriguingly directs us toward a change in *methodology*—one that considers film through what Abel, drawing on Deleuze, has proposed as a logic of *arepresentationalism* (2013, 14–21): to wit, films' images and sounds—and haptic force—first and foremost do not signify or "mean" but work affectively; they *do* something to the viewer. Framing this argument through the insights neuroscience has provided in the last couple of decades, Cook concludes that the "reality afforded the viewers of the Berlin School's and Kiarostami's films emanates from a virtual, prosthetic *moving image* that disrupts habitual modes of viewing at the level of affective and sensorimotor responses and alters subjectivity at the most visceral registers of the self." Cook's intervention is, then, not just one about how we view what the Berlin School is or does but also one that advocates for a specific *methodology* that in its emphasis on affect clearly intersects with but also moves in somewhat different directions from the more Deleuzean rather than neuroscience-influenced arepresentationalist approach introduced by Abel.

In his essay focusing on Köhler's *Windows on Monday* and *Sleeping Sickness*—the second of which won the Silver Bear at the Berlin Film Festival for best direction—Michael Sicinski's essay takes up the unusual degree to which Köhler has acknowledged his affinity for the Thai filmmaker and installation artist Apichatpong Weerasethakul, who won the Cannes Palme d'Or in 2010. Köhler has recounted in interviews how Apichatpong has had a "huge impact" on him, especially in the latter's play with the elusive relationship between (alleged) material realities and (often realer) mystical planes of self and world. In particular, Sicinski investigates how a central aspect of this elusive boundary between real and mystical is what James Quandt has characterized as Apichatpong's interest in "bifurcated time," which allows for the coexistence of various temporal "realities" in a single moment, while, simultaneously, denying a facile cause-and-effect logic between those same moments. Across films like *Sud sanaeha* (*Blissfully Yours*, 2002), *Sud pralad* (*Tropical Malady*, 2004), *Loong Boonmee raleuk chat* (*Uncle Boonmee Who Can Recall His Past Lives*, 2010), and *Rak ti Khon Kaen* (*Cemetery of Splendor*, 2015), Apichatpong breaks up the expected continuity of time with unanticipated temporal ruptures. Such abrupt cleavages signal as well surprising narrative shifts, including the introduction of not only different characters (à la Wong Kar-Wai) but entirely different species, epochs, and spiritual worlds. For Sicinski, one of the telling parallels between the two filmmakers concerns the films' putative politics: Köhler composed a much-cited short essay "Why I Don't Make 'Political' Films" (2007), and, with both filmmakers, the work largely circumvents conventional partisan politics in favor of a "wholesale re-envisioning of reality." In his *Bungalow*, *Windows on Monday*, and *Sleeping Sickness*, Köhler's caesurae might not be so abrupt, and ultimately otherworldly, as in Apichatpong, but they are similarly oneiric, defying classical narrative logic and expectation.

Like Sicinski, Lutz Koepnick examines in his contribution the Berlin School's links to East Asian cinema. Specifically, he focuses on the aesthetic affinities in long-take and elliptical storytelling in the films of East Asian filmmakers like Tsai Ming-liang and those of the Berlin School like Schanelec and Köhler. Koepnick explores two central aspects of this overlapping aesthetic approach of "durational looking," which he regards as residing in a transnational constellation: first, a definitive decision in favor of blandness as sketched by François Jullien and, second, the intervention of durational and observation-oriented aesthetics coming from screen installations in the gallery and museum world. Koepnick compares, for instance, a fourteen-minute take in Tsai's *Jiao you* (*Stray Dogs*, 2013) to Schanelec's refusal to abide by the familiar dictates of the classical narrative system in films like *Passing Summer*, *Marseille*, and *Orly*, demonstrating how both filmmakers avoid reverse angles

on long-take shots and prefer static frames and nonpsychologically motivated protagonists. These cinematic strategies contribute to what Koepnick terms a mode of "bland spectatorship," one that circumvents the "structuring discriminations and affective manipulations," as seen on the screens of mainstream cinema. Tsai (*Stray Dogs* as well as in *Bu san* [*Goodbye, Dragon Inn*, 2003]), Schanelec (especially in *Orly*), and Köhler (in *Bungalow*) all foreground how this bland spectator—one shared with museum and galleries spaces—can combat the mode of agitated, differentiating, judgmental, nonstop viewership fostered by contemporary media.

Other contributors address the complex, challenging, elliptical politics of the Berlin School as well. Chris Homewood takes up one of the best-known figures of contemporary European cinema, Steve McQueen, and considers the analogous politics to be found in some of the Berlin School films, particularly in Petzold's *Die innere Sicherheit* (*The State I Am In*, 2000) and Hochhäusler's *Falscher Bekenner* (*I Am Guilty*, 2005). McQueen was already a decorated video and installation artist when he made his widely praised breakthrough at Cannes with *Hunger* (2008) about the early 1980s hunger strike by Bobby Sands of the provisional IRA in Northern Ireland, and it is notable that both Petzold and Hochhäusler offer similarly counterintuitive brooding on a mode of personal nonconformity as political resistance. Although the link to Hochhäusler's *I Am Guilty* might be less obvious, Homewood sees contemporary politics and economy at play in all the films despite, with McQueen's and Petzold's work, the foregrounded working through of historical, now fading radicalism. For Homewood, all these films deploy a mode of inertia, of stillness, and simultaneously reject the political context around them while also reflecting on the demands of the contemporary economy to put us all in constant, unreflective motion.

In his essay on Heisenberg's films, Brad Prager considers not so much the politics of inertia but rather those of motion and mobility in the Berlin School's peculiar politics. Although many scholars and critics have focused on the car and its ubiquity in the Berlin School, Prager argues that the figure of the distance runner demonstrates the desire for nonconformist resistance at a historical moment when a collective politics is harder than ever to imagine, let alone conjure. Moreover, this figure links Heisenberg's cinema to the central traditions of European art cinema, including the (early) new waves of France and the United Kingdom. For Prager, the distance runner is a solitary individual who rejects adapting him/herself to prevailing politics and values, who runs in part to flee societies' gnawing demands for conformity and complicity. In European art cinema, the protagonist's pedestrian propensities served as inaugural moments in both France and the

United Kingdom: Prager foregrounds the famous running sequence and then the freeze-frame finale for Truffaut's *Les quatre cents coups* (*400 Blows*, 1959) as well as the way the runner also materializes politics amid an increasingly consumerist age in Richardson's *The Loneliness of Long Distance Runner* (1962). Heisenberg's best-known film, *The Robber*, uses a similarly running protagonist as political metaphor. But, Prager argues, the filmmaker's foregrounding of how mobility intersects politics emerges in some of his earlier work as well as in other films of the Berlin School. For example, Heisenberg's *Sleeper* makes mobility, be it in a video game or by go-karting, a key means to negotiate the political and personal relationship between an ethnic German and a colleague from the Middle East who is suspected of terrorism.

Like both Homewood's and Prager's, Jaimey Fisher's essay on the break-through work of Petzold and the Dardenne brothers takes as its point of depar-ture the failure, fading, and/or absence of conventional politics. Fisher notes the parallel in the Dardennes' and Petzold's early careers and rise to art-cinema noto-riety: they achieved their fame in work foregrounding a pervasive and prevailing sense of afterness of collective politics that had preoccupied them earlier. For the Dardennes, it was their shift from socially critical documentary to feature films set in deindustrializing Wallonia: their Belgian home region has seen not only its factories but also its organized and collective labor and politics indelibly fade (for example, in *La promesse* [*The Promise*, 1996] and *Rosetta* [1998], both of which made their marks at Cannes). For Petzold—hailing from a similarly deindustri-alizing region metaphorically and geographically not far from the Dardennes' home context—the relevant political and aesthetic background is his forma-tive collaboration with Harun Farocki and working through the afterness of 1970s radicalism (in *The State I Am In*, *Wolfsburg* [2003], and *Gespenster* [*Ghosts*, 2005]). In the work of these filmmakers, their breakthrough cinemas focus on the relationship of the body to the changing conditions of labor and the impact it has especially on young people who reach putative maturity in a rapidly, even radically transformed environment. These changes result, for both the Dardennes and Petzold, in distinctive aesthetic choices, hewing closely to cinema's haptic po-tential but one deliberately contextualized by socioeconomic transformations and their political consequences.

Gerd Gemünden brings into dialogue two recent "new-wave" movements, that of the Berlin School and New Argentinian Cinema, that have, to an un-usual degree, acknowledged mutual influences (even if the cinephilic affinities seem to run more in one direction than the other). Various Berlin School di-rectors (especially Hochhäusler and Köhler) have cited the films of Argentines Lucretia Martel and Lesandro Alonso as influences, while, on the other side,

the journal *Las naves* has cited *Revolver* as a defining inspiration. Gemünden's investigation traces telling parallels between the two loose groups of film-makers, including their institutional histories (for example, the importance of film festivals and the challenges of funding) as well as their mutual response to the explosion in neoliberal policies in the 1990s and their subsequent consequences around the world (although Argentina's and Germany's comparative fate in the wake of those developments has been very different). While Gemünden does uncover "remarkable parallels" between the two movements, he also explores the thornier question of art cinema's universality, namely, its engagement with and deployment of a universal language of cinema that translates well as it travels. On the other hand, this universality is balanced by at least a partial emphasis on the films' nationality, that is, their engagement with national histories, cultures, and themes associated with both those histories and cultures. Such national themes might overlap with some of the interests of the Berlin School, as in, Gemünden argues, Martel's *La mujer sin cabeza* (*The Headless Woman*, 2008), which, like Petzold's *Wolfsburg*, uses a hit-and-run accident, where guilt remains ambiguous, to explore larger issues of class and class realities. On the other hand, however, the themes of abrupt disappearance and concealment of crimes have different, nationally specific resonances in Argentina. With Alonso's 2014 *Jauja*, a later-career director of this formerly presentist and neorealist movement moves into the complex historical legacies of his country, apparently invoking Werner Herzog's influential New German Cinema classic *Aguirre, der Zorn Gottes* (*Aguirre, The Wrath of God*, 1972) and paralleling the Berlin School's recent turn to films examining largely neglected moments of German history, be it German nineteenth-century migration to North America in Arslan's *Gold* or the early postwar period in Petzold's *Phoenix*.

At the volume's end Roland Végső turns to another "existentialist" filmmaker whose career closely overlapped with Kiarostami's: the Hungarian Béla Tarr. Végső approaches his analysis of Tarr's films—especially his final masterpiece, *A torinói ló* (*The Turin Horse*, 2011), which he puts in conversation with *Marseille* and Arslan's *Gold*—by drawing on his own philosophical work on *worldlessness*. Like Cook, Végső pushes us not only to think about the Berlin School in comparison to other global art filmmakers but also to do so by taking considerations of methodology seriously. In his case, it is not the hard sciences but the long tradition of continental philosophy (connecting Martin Heidegger and Hannah Arendt to more recent philosophers such as Alain Badiou) that frames our purview of the films at hand. Declaring that "according to a widely disseminated thesis, the fundamental social experience of the modern age is best described

through the paradox of worldlessness"—the "shared experience of the loss of a common world" at the very moment when "modernity supposedly brought us closer to each other through various technological inventions"—Végső's intriguingly poses the question of "whether we can even speak about something like an aesthetics of worldlessness" given the "ambivalence of art as both a resistance against and an aesthetic expression of worldlessness." In other words, Végső, here and in his larger philosophical project on worldlessness, asks us to examine what the conditions of possibility for something like aesthetically grounded resistance are today, in an age where collectively people may feel a sense of no longer having a world. And, in his view, the "films of the Berlin School should be interpreted in the context of this historical thesis concerning the paradoxes of modern worldlessness. It would not be an exaggeration to claim that virtually every film produced by this group of directors is a unique attempt to come to terms with some aspects of this narrative."

Tarr serves in Végső's analysis as a productive foil for his examination of the Berlin School—especially films by Arslan and Schanelec—not only because Tarr's oeuvre may very well offer the "most consistent engagements of contemporary worldlessness" but also because Tarr's films and those of the Berlin School ultimately respond to the "same historical reality: the end of the Cold War and the rise of a new capitalist global order," notwithstanding the distinct social experiences that render Tarr's films different from those of his Berlin School colleagues. Provocatively, in his essay's concluding gesture—which doubles as the final word for our volume—Végső speculates whether it is possible that "Berlin," as something the Berlin School films share as a signifier, functions in these films as an *ontological* location in ways that echo how Tarr's cinema articulates "the concrete universality of Eastern Europe as a kind of 'ontological location.'" Through its head-on encounter with the social condition of worldlessness that defines contemporary subjectivity today, Végső holds, Berlin School films bring to the fore through their defining aesthetic strategy—namely, their "tendency toward the evacuation of the field of representation"—how "Berlin represents the specific (historically and culturally concrete) standpoint from which an existential catastrophe becomes visible for the first time." Ultimately, says Végső, they can be read as staging *as* an existential drama "the inherent split that divides German identity from itself in the age of radical worldlessness." Here, politics and metaphysics, the social and the existential, are rendered visible as simultaneously incommensurable considerations *and* considerations that cannot be thought as autonomous from each other. In so doing, his essay suggestively comments on a number of essays in our volume that discuss the Berlin School films' aesthetics and politics.

Notes

1 Adding to this growing archive is a special dossier of essays on Christian Petzold's films we coedited for *Senses of Cinema*, the long-standing Melbourne-based online film journal. Our dossier, consisting of nine contributions, appeared as part of the journal's September 2017 issue.

2 For the fullest account of what the Berlin School "is" (or was), see especially the introduction to *The Counter-Cinema of the Berlin School*, which is based on an earlier version published in *Cineaste*. As for the question of whether the Berlin School has ceased to exist, see Abel 2018 forthcoming.

3 Whereas the two men got to know each other and began to collaborate, however, no such connection was established with Ade during that time.

4 For some examples of Berlin School directors stating their dislike of or at least discomfort with the label, see chapter 4 of Abel's *The Counter-Cinema of the Berlin School* (2013).

5 *Orly* (2010), however, could be regarded as an entry in the "airport film" subgenre.

6 Arslan's cinema, however, is not free from genre influences. *Gold*, for example, is a neo-western; *Im Schatten* (*In the Shadows*, 2010) a *policier* evocative of Jean-Pierre Melville's classics; and even his early film, *Dealer* (1999), draws on Bresson's early crime genre classic, *Pickpocket* (1959). And *Helle Nächte* (*Bright Lights*, 2017) exhibits elements of the road movie genre.

7 Indeed, we also should hesitate in considering Winckler's films in terms of realism, especially "representational realism," as Abel argues. See Abel 2015.

8 In addition to our Petzold dossier, *Senses of Cinema* has also published an interview with Hochhäusler (Abel 2007), an essay on Winckler (Abel 2015), an essay on Grisebach (Richter 2002), and the multiauthored "The Berlin School—A Collage" (Baute et al. 2010).

9 To name but a few studies that approach German cinema from a transnational perspective, consider Bergfelder 2005; Gemünden 2008; Halle 2008; Hake 2012; as well as the edited volume by Schindler and Koepnick 2007.

10 Hake furthermore laments that "few film and media scholars outside German departments deal with German topics," resulting in "a noticeable absence [in German film studies] from the most interesting debates in film studies today, including the incorporation of film into screen cultures and its impact on artistic practices and forms of cultural consumption" (Hake 2013, 645). Putting this volume together, we strove to include voices from outside the confines of German departments. Given that we experienced firsthand the validity of Hake's observation, we are especially pleased that one-third of our contributors do not specialize in German film: Bardan, Fech, Jaffe, Sicinski, and Végső neither have their institutional home in German studies departments nor identify German cinema as their primary scholarly expertise.

11 In this context, it is worth mentioning that Valeska Grisebach's much celebrated third film, *Western* (2017), premiered as part of the Cannes Film Festival's "Un Certain Regard" sidebar and, as the title suggests, was inspired by the western genre.

12 See Elsaesser 2005; Andrew 2010, esp. vii–xii; Valck 2007; as well as Galt and Schoonover 2010.

13 See, however, Shambu (2014) for an analysis of how new media technologies have contributed to, if not enabled, a powerful resurgence of cinephilia.

14 Doru Pop makes just such a case for the directors of the New Romanian Wave, arguing that their considerable festival success has much to do with the fact that they are producing a fundamentally European cinema because its films are made *for* a transnational audience. As Pop argues, "This desire to blend into the European 'common market of ideas' and to react to the needs of this pan-European framework is fundamental to understanding the 'new-new wave' of Romanian directors (2010, 26). See also Bardan herein.

15 For Schanelec's own view of the matter, see her interview given on the occasion of the North American premiere of *The Dreamed Path* at the Toronto International Film Festival (https://mubi.com/notebook/posts/a-film-in-fragments-angela-schan-elec-discusses-the-dreamed-path).

Works Cited

Abel, Marco. 2007. "'Tender Speaking': An Interview with Christoph Hochhäusler." *Senses of Cinema* 42 (January–March). http://archive.sensesofcinema .com/contents/07/42/christoph-hochhausler.html.

———. 2008a. "'The Cinema of Identification Gets on My Nerves': An Interview with Christian Petzold." *Cineaste* online 33 (Summer). http://www.cineaste.com/articles/ an-interview-with-christian-petzold.htm.

———. 2008b. "Intensifying Life: The Cinema of the 'Berlin School.'" *Cineaste* 33 online (Fall). http://cineaste.com/articles/the-berlin-school.htm.

———. 2013. *The Counter-Cinema of the Berlin School.* Rochester, NY: Camden House.

———. 2015. "Henner Winckler: Filming without Predetermined Results." *Senses of Cinema* 77 (December). http://sensesofcinema.com/2015/feature-articles/ henner-winckler-and-the-berlin-school/.

———. 2018 forthcoming. "The Berlin School." In *The German Cinema Book*, edited by Tim Bergfelder, Erica Carter, and Deniz Göktürk. 2nd ed. London: BFI.

Andrew, Dudley. Foreword to *Global Art Cinema: New Theories and Histories*, edited by Rosalind Galt and Karl Schoonover, v–xii. New York: Oxford University Press, 2010.

Baute, Michael, Ekkehar Knörer, Volker Pantenbug, Stefan Pethke, and Simon Rothhöler. 2010. "The Berlin School—A Collage." *Senses of Cinema* 55 (July). http://sensesofcinema.com/2010/feature-articles/the-berlin-school-a-collage-2.

Bergfelder, Tim. 2005. *International Adventures: German Popular Cinema and European Co-Productions in the 1960s*. New York: Berghahn Books.

Dayan, Daniel. 2013. "Looking for Sundance: The Social Construction of a Film Festival (2000)." In *The Film Festival Reader*, edited by Dina Iordanova, 45–58. Saint Andrews: University of Saint Andrews Press.

Elsaesser, Thomas. 2005. "Film Festival Networks: The New Topographies of Cinema in Europe." In *European Cinema: Face to Face with Hollywood*, 82–108. Amsterdam: Amsterdam University Press.

Finney, Angus. 2002. "Support Mechanisms across Europe." In *European Cinema Reader*, edited by Catherine Fowler, 212–22. London: Routledge.

Fisher, Jaimey. 2013. *Christian Petzold*. Urbana: University of Illinois Press.

———. 2017. "Petzold's *Phoenix*, Fassbinder's *Maria Braun*, and the Melodramatic Archeology of the Rubble Past." *Senses of Cinema* 84 (September). http://sensesofcinema.com/2017/christian-petzold-a-dossier/petzold-fassbinder.

Galt, Rosalind, and Karl Schoonover. 2010. "Introduction: The Impurity of Art Cinema." In *Global Art Cinema: New Theories and Histories*, edited by Rosalind Galt and Karl Schoonover, 3–27. New York: Oxford University Press.

Gemünden, Gerd. 2008. *A Foreign Affair: Billy Wilder's American Films*. New York: Berghahn Books.

———. 2016. "Film and Media Studies." *German Studies Review* 39 (October): 541–52.

Gerhardt, Christina. 2017. "1968 and the Early Cinema of the DFFB." *The Sixties: A Journal of History, Politics, and Culture* 10 (1): 26–44.

Hake, Sabine. 2012. *Screen Nazis: Cinema, History, and Democracy*. Madison: University of Wisconsin Press.

———. 2013. "Contemporary German Film Studies in Ten Points." *German Studies Review* 36 (October): 643–50.

Halle, Randall. 2008. *German Film after Germany: Toward a Transnational Aesthetic*. Urbana: University of Illinois Press.

Higson, Andrew. 2002. "The Concept of National Cinema." In *European Cinema Reader*, edited by Catherine Fowler, 132–41. London: Routledge.

Hjort, Mette. 2000. "Themes of Nation." In *Cinema and Nation*, edited by Mette Hjort and Scott MacKenzie, 103–17. London: Routledge.

Hochhäusler, Christoph. 2013. "On Whose Shoulders: The Question of Aesthetic Indebtedness." In *The Berlin School: Films from the Berliner Schule*, edited by Rajendra Roy and Anke Leweke, 20–29. New York: Museum of Modern Art.

Iordanova, Dina. 2013. "The Film Festival Circuit." In *The Film Festival Reader*, edited by Dina Iordanova, 109–26. Saint Andrews: University of Saint Andrews Press.

Jaffe, Ira. 2014. *Slow Cinema: Countering the Cinema of Action*. New York: Wallflower Press.

Koepnick, Lutz. 2013. "German Cinema Now." *German Studies Review* 36 (October): 651–60.

———. 2014. *On Slowness: Toward an Aesthetic of the Contemporary*. New York: Columbia University Press.

Pop, Doru. 2010. "The Grammar of the New Romanian Cinema." *Acta Univ. Sapientiae, Film and Media Studies* 3: 19–40.

Rentschler, Eric. 2000. "From New German Cinema to the Post-Wall Cinema of Consensus." In *Cinema and Nation*, edited by Mette Hjort and Scott MacKenzie, 260–77. London: Routledge.

Rich, B. Ruby. 2013. "Why Do Film Festivals Matter? (2003–2004)." In *The Film Festival Reader*, edited by Dina Iordanova, 157–66. Saint Andrews: University of Saint Andrews Press.

Richter, Urs. 2002. "Everybody's Different: Valeska Grisebach's *Mein Stern*." *Senses of Cinema* 21 (July). http://sensesofcinema.com/2002/feature-articles/mein_stern/.

Roddick, Nick. 2013. "Coming to a Server Near You: The Film Festival in the Age of Digital Reproduction (2005–2012)." In *The Film Festival Reader*, edited by Dina Iordanova, 173–90. Saint Andrews: University of Saint Andrews Press.

Schindler, Stephan K., and Lutz Koepnick, eds. 2007. *The Cosmopolitan Screen: German Cinema and the Global Imaginary 1945 to the Present*. Ann Arbor: University of Michigan Press.

Scott, A. O. 2009. "Neo-Neo Realism." *New York Times Magazine*, March 17. http://www.nytimes.com/2009/03/22/magazine/22neorealism-t.html?pagewanted=all.

Shambu, Girish. 2014. *The New Cinephilia*. Montreal: Caboose.

Suchsland, Rüdiger. 2011. "Der Film als Hypothese die Frage: 'Was-wäre-wenn.'" *Artechock*, June 22. http://www.artechock.de/film/text/interview/k/koehler_2011.html.

Taubin, Amy. 2016. "Human Resources." *Film Comment* 52 (September–October): 28–32.

Valck, Marijke de. 2007. *Film Festivals: From European Geopolitics to Global Cinephilia*. Amsterdam: Amsterdam University Press.

Weissberg, Jay. 2014. "Rome Film Review: 'The Lies of the Victors.'" *Variety*, October 27. http://variety.com/2014/film/reviews/rome-film-review-the-lies-of-the-victors-1201337085/.

Wood, Mary. 2007. *Contemporary European Cinema*. London: Bloomsbury.

1

THE BERLIN SCHOOL
AND WOMEN'S CINEMA

Hester Baer

At the end of Maren Ade's debut feature *Der Wald vor lauter Bäumen (The Forest for the Trees*, 2003), schoolteacher Melanie Pröschle sits at the wheel of a car, crying uncontrollably. As her car speeds down the autobahn, Melanie suddenly climbs out of the driver's seat and settles into the back seat, where her tears dry up and she turns her face toward the sunlight filtering into the car window. By literally giving up the driver's seat, Melanie refuses participation in a social order that she has failed to inhabit properly throughout the film, one that demands an entrepreneurial model of the self that she is miserably inept at performing. As we anticipate a crash that never happens, the camera lingers on Melanie for an uncomfortably long time, breaking with the realist, documentary-like aesthetic that has characterized the film until now and creating a profound sense of insecurity and discomfort for the viewer (fig. 1.1).

The indelible image of Melanie speeding along in the back seat of a driverless car constitutes a signal moment within the emergent women's film and television culture that is the subject of this chapter. Practiced by a range of transnational director-producers, this work forms a vital contemporary movement to resignify both the representational practices and the production modes associated historically with women's cinema. Emblematic of both Melanie's refusal to perform and the obstructed agency that prevents her from developing a more active form of resistance, this scene from Ade's "situation tragedy" (Berlant 2011) exemplifies the way that contemporary women's film productions observe, contest, and above all make visible performances of gendered subjectivity in neoliberal capitalism.[1] Attention to the impact of neoliberal rationality on the lives of women and children and the changing shape of gendered experience in the twenty-first century links the work of Maren Ade and her fellow Berlin School directors Barbara Albert,

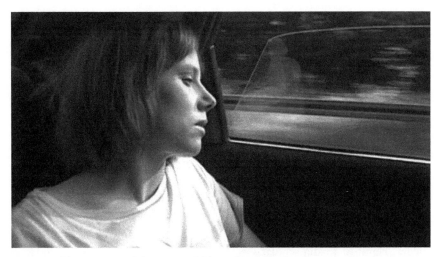

Figure 1.1 The insecurity of the present: Melanie (Eva Löbau) gives up the driver's seat in Maren Ade's *The Forest for the Trees* (2003)

Valeska Grisebach, Jessica Hausner, Angela Schanelec, and Maria Speth to their peers worldwide, including—to name only a few prominent examples—directors Andrea Arnold, Claire Denis, So Yong Kim, Lucrecia Martel, and Kelly Reichardt.[2] Their films are characterized by a commitment to telling closely observed stories, an emphasis on diverse experiences of gender, sexuality, and intimacy, and a focus on the precarity of life today, underpinned by a formal allegiance to a minimalist aesthetic and, crucially, women's access to the means of production. Neither exclusively defined by their status as women nor united in the pursuit of a singular aesthetic or political project, the work of these filmmakers nonetheless attests to and combats the ongoing (and renewed) marginalization of women in contemporary societies and cinematic representations.

Media Conglomeration and Contemporary Women's Film and Television Culture

Media conglomeration has been a key facet of neoliberalization in the Euro-Atlantic world since the 1980s, a result of the deregulation of media industries and procorporate policies paving the way for accelerated mergers and acquisitions. Dominated by US-American and European megacorporations, media conglomeration has resulted in the massive elimination of jobs in the news and culture industries, many of which had been held by women and minorities. As the Euro-

pean Union's 2009 "Women and ICT [Information and Communication Technologies] Status Report" documents, women are severely underrepresented in European media industries today, while those women who are employed suffer from a marked wage gap, drawing significantly lower salaries than their male counterparts (European Commission 2010). The situation is similar in the United States, where growing attention on the part of journalists and scholars has begun to shed light on the rampant inequality and discrimination in media companies.

Media conglomeration has exacerbated the gender gap in media industries both materially and ideologically by downsizing women and by abandoning redistributive policies. As a result, media conglomeration has restricted the number of voices participating in media industries, thereby limiting the diversity of aesthetic representations and political perspectives available in the mainstream media. Feminist media scholar Carolyn Byerly calls for a range of strategies to address the marginalization of women and minorities in media governance and participation, including "political activism, alternative media, and policy changes" (Byerly 2014, 109). As she pointedly asks, "After all, where is dissent to be voiced on any scale under corporate media hegemony? While alternative media (including women's media) have historically served this purpose, their reach has always been limited" (111). Byerly emphasizes how important the perspectives of women and minorities are for disrupting consent through mainstream media.

As in North America, a dynamic alternative feminist media scene does exist in German-speaking Europe today, but it is largely restricted to the realm of zines, blogs, and social media platforms; the recent research report "Feminist Media Production in Europe" describes this work as "mostly small scale, collaboratively produced, heterotopic, based on subcultural literacy, ironic, interventionist, and perishable" (Zobl and Reitsamer 2014, 241). Alternative feminist media productions are typically short-lived and ephemeral, produced and received by small-scale subcultural groups, and, for the most part, not dependent on external funding mechanisms. While this microlevel feminist media culture flourishes, macrolevel studies reiterate that women's overall participation in media production and decision-making is declining. In Europe today, only one-third of decision-making positions in public service broadcasting and one-fourth of positions in the private sector are occupied by women, a direct result of media conglomeration (Ross 2014, 327–28).

The situation for feature filmmaking is even more dire. In Germany, women compose nearly half of film school graduates annually, but they direct only about one-fifth of feature films. What is more, female filmmakers receive only about

10 percent of the available subvention funds that are crucial to feature film production in the Federal Republic (Prommer and Loist 2015, 3–4). While explanations for this discrepancy vary, commentators point to the fact that federal subvention schemes favor commercially oriented projects by prominent male directors over less formulaic proposals by women. As film journalist Ellen Wietstock argues, the gender disparity in film subventions is "not about women addressing particular themes, it's about them being able to work on anything: every genre, every format" (Wietstock 2014, 489).

It is within this context that I will consider the significance of the material and aesthetic work happening within the emergent women's film and television culture practiced by the Berlin School directors and their peers. Spurred on by digital technologies that have enabled new modes of access to production, distribution, and reception, these filmmakers have developed new production models. Often working collaboratively, Ade (cofounder of the production collective Komplizen-Film), Grisebach (a member of the Komplizen-Film collective), Albert and Hausner (cofounders of the production company Coop99), and Speth (founder of the production company MadonnenFilm) have written, directed, and produced award-winning films that blur the boundaries between documentary and narrative styles and engage with new modes of realism influenced by digital media aesthetics. Exhibited in multiple venues including cinemas, television, and streaming formats, these films rely on mainstream media platforms.

At the same time, these female-directed and -produced films draw on and revitalize traditions of feminist countercinema that first emerged in Germany and Austria in the 1970s and 1980s, an influence evident in their mode of production, aesthetics, and stories, which experiment with new modes of depicting gender, sexuality, race, ethnicity, and citizenship on screen. Yet, strikingly, most of these filmmakers explicitly repudiate feminism and disavow connections between the legacy of feminist cinema and their own filmmaking practices. For example, in an essay titled "Being a Feminist Was Uncool," Ade unequivocally states, "Among my favorite films, the work of male directors prevails," explaining:

> If a student had said, during my time in film school, "I am a feminist," that would have been uncool. I would have associated with that statement the idea that someone is against men in some way and feels like they have to defend themselves, in other words: be a victim. Today, I still would not describe myself as a feminist because I find the term fraught, but I have started to think more in that direction. (Ade 2014, 423)

Ade's essay documents how her experiences in the film world—especially as a producer, that is, as a woman managing large amounts of money—have convinced her that the glass ceiling exists. Nonetheless, Ade continues to disavow feminism as a self-description.[3]

This disavowal is symptomatic of what Angela McRobbie has termed the "undoing of feminism" in neoliberal societies, where the emphasis on choice, empowerment, and individualism has made feminism seem both second nature and unnecessary, even as women continue to face significant obstacles to advancement, not least in the film industry (McRobbie 2009). Feminist scholars have noted that neoliberal culture is characterized by a paradoxical intermingling of contradictory ideas and meanings, a "double entanglement" of liberalizing tendencies and neoconservative values, which manifests itself not least in relation to gender roles, sexual relations, and family structures (12). On the one hand, neoliberal discourses of individual choice, flexibilization, and mobility offer unprecedented opportunities for destabilizing normative roles and eroding traditional social formations in ways that appear empowering. On the other hand, upwardly redistributive policies create a situation of permanent insecurity that disproportionately affects minority groups. This paradoxical situation gives rise to what Rosalind Gill has called the "postfeminist sensibility" that prevails in neoliberal culture, evident in common tropes of twenty-first-century global media, including

> the notion that femininity is a bodily property; the shift from objectification to subjectification; the emphasis on self-surveillance, monitoring, and discipline; a focus on individualism, choice, and empowerment; the dominance of a makeover paradigm; the articulation or entanglement of feminist and anti-feminist ideas; a resurgence in ideas of natural sexual difference; a marked sexualization of culture; and an emphasis on consumerism and the commodification of difference. (Gill 2007, 255)

Despite their renunciation of feminism, the filmmakers under consideration here all make movies that call attention to, reflect on, and even refute the postfeminist sensibility identified by Gill. They do so in at least two ways: first, by developing a hybrid production model that allows them to simultaneously participate in *and* refuse commercial modes of media representation, and second, via formal interventions and stories that demonstrate gender nonconformity and the precarity of life in neoliberalism, in movies that often draw on the aesthetics of feminist cinema (even as they disclaim it). Characteristic of the paradoxes of neoliberal culture, this simultaneous refutation of feminism and embrace of its legacy

presents one reason for the critical inattention to questions of gender and sexuality in Berlin School films specifically and global art cinema more broadly. However, understanding both the gender politics of contemporary women's film productions and the feminist legacy that underpins them is crucial to any consideration of political filmmaking in the age of neoliberalism.

The Berlin School, Neoliberalism, and Women's Cinema

The development of the Berlin School parallels the expansion of neoliberalism in Germany and Europe, a parallel that is crucial to thinking through the transformed production and reception regimes, the formal language and narrative content, and the political investments of Berlin School films. Indeed, neoliberalism must be considered among the key global contexts for understanding the Berlin School's contribution to contemporary cinema. Due to the worldwide spread of neoliberal policies and the structural interconnections of global cinema, Jyostna Kapur and Keith B. Wagner call for an approach that explores "the ways in which any and all cinema is the localized expression of a globalized integration" (2011, 6). How does attention to the Berlin School's reconfiguration of global forces and flows within the particular local and national contexts of German cinema shed new light on its filmmaking practice?

First, it might impel us to look more closely at the Berlin School filmmakers' material interventions into film production. Approaches to the Berlin School have generally emphasized its status as countercinema, a "mode of filmmaking that questions and resists both the plotting and tempo of conventional narrative cinema and, simultaneously, the lifeworld that gave birth to it" (Cook et al. 2013, 1). Highlighting its aesthetic—and by extension political—resistance to mainstream culture, critics posit Berlin School filmmaking as fundamentally oppositional, a revitalization of the New German Cinema's revolutionary experiments with aesthetic form and collective approach to filmmaking (Abel 2013, 10). Without disputing the artistic achievements of the Berlin School, I suggest that categorizing these films as countercinema may at times lead us to overlook the successful transnational and intermedial production model that anchors their place in the neoliberal mediascape.[4] As Stuart Hall reminds us, ideology in the present is characterized by the suturing together of contradictory tendencies, demanding new approaches to thinking through the paradoxes of contemporary culture (Hall 2011, 713). Indeed, our thinking about the aesthetic forms and political investments of contemporary film is hampered by the fact that films today cannot be easily understood within the conventional binaries that have long

shaped our apprehension of culture (for example, high/low, cinema/media, art/ commerce, intellectual/popular, international/national, resistance/complicity, oppositional/hegemonic). Rather, contemporary films often exhibit seemingly opposed qualities simultaneously.

Within this context, the films of the Berlin School might be productively understood as contemporary media assemblages that combine multiple production and exhibition formats (analog and digital; film, television, and streaming) along with multiple transnational and national film genres and waves (to name just a few: new realisms, slow cinema, New German Cinema, and feminist cinema, as well as, increasingly, popular forms and genres such as the thriller, the western, the *Heimatfilm*, and even the heritage film) in order to create a broad-based appeal to an international audience of cineastes.[5] Such a model helps to conceptualize how Berlin School films—like global art cinema in general—are firmly embedded within commercial, mainstream platforms while also posing a challenge to them.

Second, a reconsideration of the global contexts of Berlin School filmmaking might impel us to rethink the strong emphasis on auteurism that has informed most approaches to these films and determined their reception. The resuscitation of auteurism—a concept that is coherent with and gains new traction through neoliberal discourses of individualism—curates these films as instances of individual aesthetic achievement grounded in a specific national-cultural context, rather than highlighting the commonalities (in terms of genre, form, style, story as well as means of production) with other film and television movements, not least with other films that depict, respond to, and contest life in neoliberalism. While undoubtedly crucial to facilitating international recognition of contemporary German cinema, concerted emphasis on the term "Berlin School" and the individual auteur-directors who may be designated as belonging within its fold may also distract attention away from the larger (transnational, political) significance of this filmmaking practice.

This is certainly true of the female director-producers of the Berlin School, whose work resonates with the global movement of nonstudio filmmaking that Patricia White has identified as a "new form of women's observational cinema." Sharing formal and aesthetic affinities as well as material connections, this work—epitomized by filmmakers like Kim and Reichardt—represents "a transnational, multigenerational, multiformat arena of women's filmmaking responsive to patterns of financing, distribution, and exhibition that challenge, even as they are determined by, commercial forms" (White 2009, 154). While highly diverse in style and approach, the aesthetic and material commonalities of these films suggest "the ongoing relevance of the concept of women's cinema—

characterized by women's access to the means of production, the commitment to telling women's stories, and an address to viewers' diverse gendered experience within a dynamic public sphere" (155). White argues that the benefits of developing a critical framework that brings films by female directors back into dialogue with each other outweigh the perceived limitations of the concept of women's cinema, which filmmakers and scholars alike have recently viewed as pigeonholing women's work or pinning it to essentialized identity categories.

Alison Butler has argued that women's cinema is "not 'at home' in any of the cinematic or national discourses it inhabits, but that it is always an inflected mode, incorporating, reworking, and contesting the conventions of established traditions" (Butler 2002, 22). While women's films are typically situated in multiple national or representational contexts (for example, American independent cinema; Berlin School), Butler argues that they "are not fully comprehended by their other contexts" (22). The category of women's cinema crucially allows distinctive qualities of these films to emerge that might otherwise remain invisible; in this way, the category can function to highlight the projection of a marginalized group, rather than the expression of an essentialized perspective.

With this in mind, considering the work of filmmakers such as Ade, Arnold, Kim, Grisebach, Reichardt, and Speth as women's cinema is crucial to comprehending the ways they engage with the neoliberal present. Their films share a commitment to exhibiting and contesting changed structures of gendered subjectivity and intimacy in the neoliberal present in ways that resonate with feminist, queer, antiheteronormative, and antiracist projects. Simultaneously, their deliberate involvement in all aspects of the filmmaking process constitutes a significant response to the ongoing obstacles facing female filmmakers in the age of global media conglomeration.

Contemporary Women's Film Productions: Material Interventions and Affinities

The production collectives Coop99, cofounded by Barbara Albert and Jessica Hausner, and Komplizen-Film, cofounded by Maren Ade, represent a significant intervention against media conglomeration by concertedly improving the material conditions for female filmmakers in German-speaking Europe. In doing so, they draw on the kinds of strategies pioneered by the German feminist film movement of the 1970s, which succeeded in increasing women's involvement at all levels of the film industry by transforming the categories of film distribution and reception. For instance, the distribution company Basis-Filmverleih insisted

on the creative freedom and rights of the individual filmmaker but established a collective context and cooperative material structures to allow her to succeed, thereby redefining the conception of the *Autorenfilm* in order to promote women's films without pigeonholing them (Elsaesser 2005, 222). Similarly, the successful nonstudio production model developed by Berlin School filmmakers promotes women's cinema as a collective filmmaking enterprise fostering artistic independence.

The Austrian company Coop99 was founded in 1999 by Albert and Hausner together with fellow director Antonin Svoboda and cinematographer Martin Gschlacht. The company positions itself as "a platform for new generations of Austrian filmmakers," describing its projects as "renowned for their authentic and individual style as well as their unyielding personal approach."[6] Coop99's overall program fosters an engagement with the changing ethnic, racial, and religious make-up of Austrian and European society, with a special focus on the history and impact of the Balkan wars. Of the thirty-three features Coop99 has produced since its inception, half feature female directors and nineteen female producers, demonstrating the company's commitment to gender equity. These include, in addition to features by Albert and Hausner, films by well-known feminist artists Pipilotti Rist and Shirin Neshat, as well as coproductions with Komplizen-Film, among them Ade's and Grisebach's most recent films.

Ade established Komplizen-Film in 2000 together with her classmate at the Munich Film Academy, Janine Jackowski.[7] The company has since produced twenty films, thirteen of them directed and fifteen produced by women. Through Komplizen-Film, Ade has established a dynamic career as a producer, which has facilitated her own filmmaking practice. In addition to producing her own features *The Forest for the Trees*, *Alle Anderen* (*Everyone Else*, 2009), and *Toni Erdmann* (2016), Ade has produced numerous contemporary films by her peers, including those of fellow Berlin School directors Benjamin Heisenberg and Ulrich Köhler and those of important female directors like Albert, Grisebach, Sonja Heiss, and Vanessa Jopp. Ade and Grisebach have collaborated extensively, with Grisebach serving as dramatic advisor for *Everyone Else* and Ade producing Grisebach's *Western* (2017).

While she does not work within a production collective, Maria Speth has followed a similar trajectory to other female directors associated with the Berlin School by founding her own production company, MadonnenFilm, in 2008. She produced her two most recent films, the documentary *9 Leben* (*9 Lives*, 2011) and the feature *Töchter* (*Daughters*, 2014), through the company, which facilitated her pursuit of a singular vision for these two interrelated projects.

Collaboration is crucial to the work of these filmmakers (and to the Berlin School in general). Ade, Albert, Grisebach, Hausner, and Speth work with the same small group of actors, cinematographers, casting directors, editors, and other technical staff. This choice reflects a concerted move to develop a collaborative team that understands and contributes to the formal-aesthetic preoccupations shared by the Berlin School, and it is also a cost-saving mechanism.

Working with their own production companies has allowed them to develop their own visions and to realize new projects by consolidating control over all aspects of their filmmaking. As Ade has explained, production collectives confound the classic director-producer relationship by allowing for creative collaboration and fostering productive exchange; participating in production becomes part of the creative process: "It's important to me that I have an overview of the situation, because I find that decisions about production—how to make something and what to spend money on—are always creative decisions as well" (Frölich 2009, 29). Producing has also allowed directors like Ade and Speth to participate in decision-making about financing and distribution deals. However, the independent model they pursue is both laborious and precarious, as evidenced by the very long periods between their feature films. They rely on a combination of funding through international coproducers, regional film boards, private investment, distribution deals, and television financing, especially through the German-French broadcaster Arte and/or German public television station ZDF's *Das kleine Fernsehspiel*, which have both played a crucial role in supporting Berlin School films. Their low-budget films (costing on average one to two million euros) have mostly played in European cinemas in limited release, where they have rarely drawn many viewers, not least due to low advertising budgets.[8] However, on television they have done exceedingly well, often topping the charts for their time slots and drawing large market shares (8–15 percent, indicating well over a million and sometimes several million viewers) (Gupta 2005).

Mostly shot on 35 mm film, these movies are not "made for television" in terms of their formal style or content. Nonetheless, television exhibition and reception are crucial to the films' production model and expand their viewership, as does their international circulation via subtitled releases first at festivals and museums and later through home video formats and digital platforms, especially streaming services. To ascertain future subvention funding in Germany and to achieve transnational circulation, festival success is particularly important, together with other award nominations. Ade's first film, *The Forest for the Trees*, won a special jury prize at Sundance and was nominated for a German Film Prize, successes that paved the way for the financing and distribution deals for

her second film, *Everyone Else*, which debuted at the Berlin Film Festival, in turn winning several awards, and her third feature *Toni Erdmann*, which debuted at Cannes and was subsequently nominated for an Oscar. Similarly, Speth's feature *Madonnas* won several festival prizes, helping her to secure funding for *9 Lives*, which in turn won the Defa-Förderpreis at the Leipzig Documentary Festival, allowing her to pursue her next film, *Daughters*.

While the production context for female filmmakers outside of German-speaking Europe is not determined by the same mix of funding sources that the Berlin School filmmakers draw on, Andrea Arnold, So-Yong Kim, and Kelly Reichardt have pursued similar strategies in order to balance individual control over the filmmaking process, intervention into mainstream media, and appeal to an international audience of filmgoers. The festival circuit is crucial to their success: British director Arnold's first two features, *Red Road* (2006) and *Fish Tank* (2009), both premiered at Cannes, where each won the Jury Prize. Like Ade, the Korean-born, US-based director Kim won a Special Jury Prize at Sundance for her first feature, *In Between Days* (2006); her subsequent features *Treeless Mountain* (2008), *For Ellen* (2012), and *Lovesong* (2016) have played at numerous festivals. Likewise, US director Reichardt's career was jump-started when she won the Grand Jury Prize at Sundance for her feature *River of Grass* (1994); her many subsequent films have become festival mainstays. As White explains, "Film festivals circulate, and to some extent sustain, forms of women's film production" (White 2009, 153). However, the goal of theatrical release—allowing reception beyond the ephemeral viewing by a small audience facilitated by the festival—is increasingly challenging due to the effects of media conglomeration, in particular the dissolution of many independent distributors.

As in the case of the Berlin School filmmakers, collaboration has played a crucial role for Arnold, Kim, and Reichardt in combating this situation, helping them to finance their productions, gain distribution deals, and reach audiences. Arnold's debut feature *Red Road* was part of the "Advance Party" series, a conceptually linked trilogy conceived by members of the Dogme 95 movement; Zentropa Entertainment, the Dogme 95–affiliated production company, coproduced the film. Arnold, who began her career as a television actress and moderator, has regularly directed for television, which helped her break into directing. Most recently, Arnold directed two episodes of the acclaimed Amazon series *Transparent*, a show that has itself intervened into discussions about contemporary women's audiovisual production as a result of creator Jill Soloway's concerted effort to employ a largely female crew and directorial staff. Soloway's media campaign has called attention to the significance of gender in the material conditions of production and has revitalized the notion of a "female gaze" in discussing the

formal-aesthetic program that underpins the feminist and LGBTQ+ themes of *Transparent*.

Without access to the same kinds of subvention schemes available to European filmmakers, Kim and Reichardt finance their films on a piecemeal basis, relying on a combination of private equity and grant funding. Kim has worked closely with other North American nonstudio filmmakers, especially her husband, director Bradley Rust Gray, who has cowritten and coproduced several of her films. While their collaboration is not facilitated by a production collective like Komplizen-Film, Kim and Reichardt have regularly shared ideas and material affiliations: Reichardt helped Kim to secure a distribution deal with Kino International, her own distributor, for *In Between Days*, and Reichardt's production team from *Old Joy* (2006) worked with Kim on *Treeless Mountain* (White 2009, 157). Like the Berlin School directors, Kim and Reichardt have shared both crew members and actors.

In terms of securing a wider audience for low-budget films (for example, *Wendy and Lucy* (2008), which cost a mere $200,000), Reichardt's work with A-List Hollywood actors, especially Michelle Williams, has proved a crucial strategy. While neither Reichardt nor Kim has worked for television, distribution deals with the Sundance Channel have been significant for the dissemination of both filmmakers' work. Kim has also pursued a wider audience by shooting "Spark and Light" for fashion company Miu Miu's "Women's Tales," a series of short films by female directors "who critically celebrate femininity in the twenty-first century," a project that also counts Lucrecia Martel and Agnes Varda among its participants.[9] By developing the material conditions and collaborative practices to facilitate women's filmmaking today, the director-producers discussed here are staging an important intervention into the transnational mediascape in the age of media conglomeration.

The Situation Tragedy: Formal and Thematic Affinities of Contemporary Women's Films

The similar production models and material affinities shared by contemporary nonstudio filmmaking by female directors underpin the aesthetic and narrative commonalities of their films. These include a formal commitment to an "aesthetic of reduction" characterized by a general economy of slowness, ample use of long takes, abrupt cuts, ambient sound, and minimal dialogue (Abel 2013, 15). These pared-down stories with few characters and little action emphasize ordinary life as it emerges in tandem with a strong sense of place, often figured

through metacinematic or self-reflexive attention to female perspectives, looks, and storytelling. Refusing closure, the films feature an open-ended polysemic form that demands the spectator's participation in making meaning. In this sense, they recall Teresa de Lauretis's description of "the aesthetic of reception" practiced by feminist filmmakers such as Helke Sander, "where the spectator is the film's primary concern—primary in the sense that it is there from the beginning, inscribed in the filmmaker's project and even in the making of the film" (De Lauretis 1987, 141). In terms of story, these films focus on young, mostly female protagonists, who struggle with the demand for self-optimization and self-management that is placed disproportionately on women in advanced capitalism: "To a much greater extent than men, women are required to work on and transform the self, to regulate every aspect of their conduct, and to present all their actions as freely chosen" (Gill and Scharff 2011, 7). By developing stories about women who try but fail to inhabit this model of the self, the contemporary women's film productions discussed below place on display the problems of aspirational normativity and suspended agency in an era defined by contradictory role expectations and requirements.

In her book *Cruel Optimism*, Lauren Berlant develops new paradigms for considering both contemporary aesthetic production and the historical present as such, focusing on the question of why people persist in attaching to normative paradigms even when these normativities do them harm. Berlant emphasizes precarity and insecurity as the dominant contemporary structures of experience, describing how in the global economy of contemporary Europe and the United States fantasies of the good life have collapsed, including particularly "upward mobility, job security, political and social equality, and lively, durable intimacy" (Berlant 2011, 3). These fantasies have been replaced with what Berlant terms "cruel optimism," a relation that exists "when something you desire is actually an obstacle to your flourishing" (1). Cruel optimism exposes the harm in the neoliberal injunction that personal empowerment, self-optimization, and an entrepreneurial attitude will lead to success.

Among the changed genres of the present described by Berlant is the hybrid "*situation tragedy*: the marriage between tragedy and situation comedy where people are fated to express their flaws episodically, over and over, without learning, changing, being relieved, becoming better, or dying" (Berlant 2011, 156).[10] In contrast to the situation comedy, where "the world has the kind of room for us that enables us to endure," the situation tragedy focuses on episodes of personality that are shaped by the stresses of ordinary life in neoliberalism (177). Berlant's notion of cruel optimism as a characteristic affect of the present helps to describe the generic affinities of contemporary women's film productions as situation tragedies tracing

Figure 1.2 Refusing responsibility: Protagonists Aimie (Jiseon Kim) in So Yong Kim's *In Between Days* (2006) and Lynn (Sabine Timoteo) in Maria Speth's *The Days Between* (2004)

their characters' attachments to aims that impede their own well-being. These films make palpable the insecurity of the present either by focusing on the effects of economic precarity, especially for young women and children, or by emphasizing the increasing precarity of gender and sexual identities and family structures, or both (and all of the filmmakers engage these intertwined modes of precarity at certain times). They trace the decline of the conventional family unit in neoliberalism and the way this decline is compounded by the lack of provisions for caregiving in the aftermath of the welfare state, making visible the effects of this paradoxical situation for women, who are especially vulnerable to neoliberal mandates. The films revolve around characters who do not conform to gender expectations, who seek out new forms of attachment because they avoid or founder in traditional relationships, and who lack the initiative or wherewithal to take responsibility for themselves, their actions, and often their children.

In terms of both content and form, these films recall the motto of the feminist film movement of the 1970s and 1980s: "to tell different stories, and to tell stories differently." Their films do not exhibit modes of political protest (for example, take back the night marches) or tackle political issues (for example, abortion or child care) in ways that directly promote emancipatory narratives, nor do the directors make political claims for their films. Nonetheless, by portraying female protagonists who fail to be interpellated into neoliberal discourses of personal responsibility and self-fashioning, these films call our attention to the paradoxes of neoliberalism (fig. 1.2).

For protagonists like Aimie in Kim's *In Between Days*, Lynn in Speth's *In den Tag hinein* (*The Days Between*, 2004), Mia in Arnold's *Fish Tank*, and Wendy in Reichardt's *Wendy and Lucy*, the pressures of ordinary life and the attachment to

good-life fantasies of intimacy or prosperity lead to repeated episodes of situation tragedy. These characters drift through the non-places of contemporary cities in single-minded pursuit of attachments and goals that do them harm. Whether trading in education or future hopes for the chimeric promise of an intimate attachment in the present, like Aimie and Lynn, or investing in the future in ways that place them in harm's way in the present, like Mia and Wendy, these characters' predicaments make clear the relation of cruel optimism by demonstrating that "choice" is an illusion when insecurity predominates. *In Between Days'* Aimie, an immigrant teenager in Toronto, withdraws from an ESL class, using the reimbursed tuition money to buy an expensive bracelet for her friend Tran, who represents her only hope of transcending linguistic and social isolation. In the similarly titled *The Days Between*, Lynn, a young woman living in Berlin, casually sets fire to a stack of boxes in her boyfriend David's apartment and steals food from her brother's family, severing ties to pursue an affair with a Japanese exchange student with whom she can communicate only in nonlinguistic ways. In *Fish Tank*, Mia pursues the dream of becoming a dancer as a path away from the British housing estate where she lives and the inertia represented by her mother, a young single parent and alcoholic. When she enlists the help of her mother's boyfriend, showing him the dance she hopes to compete with, he rapes her, and the scene of aspirational normativity is exposed as a site of harm. In *Wendy and Lucy*, Wendy travels across country to Alaska in the hopes of securing a paying job at a fish cannery, but when her car breaks down along the way, the film demonstrates not only the sheer precarity of Wendy's own situation, which forces her into harm's way, but also the cruel optimism of good-life fantasies in general, especially the dream of seeking prosperity by moving west.

All of these films make visible underrepresented populations and otherwise imperceptible gendered aspects of the present through an emphasis on unconventional female figures who are represented through cinematography and editing choices calculated neither to emotionalize nor to moralize. Speth, who, like Reichardt, edits her own films, has described how they are written and designed at the level of each shot in order "to present neither a moral judgment nor an emotionalized view . . . [T]he space, which I open up for each character, is thus a space for the viewer."[11] Speth's films map the present not by invoking formal and generic conventions calculated to produce emotions, but by generating moments of awkwardness and discomfort in the viewer that engage us affectively and intellectually, making us feel and contemplate these paradoxes.

This strategy is shared by the other filmmakers under consideration here. *In Between Days* makes tangible Aimie's longing for attachment through a series of voice-overs addressed to her absent father, accompanied by long takes of desolate

landscapes around the housing project. These postcard-style platitudes represent attempts at communication that are never reciprocated, foregrounded by the disjunction between sound and image in these sequences. In *Fish Tank*, Mia's dispassionate observation of the world, figured through her use of a video camera she has borrowed to film herself dancing, opens up viewing spaces through a metacinematic play with the female gaze. In *Wendy and Lucy*, acting style is important for resisting sentimentality and making insecurity palpable, as Reichardt describes: "I think the way Michelle plays Wendy is key—she is not socially at ease ever and that helps to keep things from getting too mushy" (Wood 2014). Indeed, generating moments of social awkwardness and/or extreme discomfort at the level of both narrative and form is crucial for the way these situation tragedies address the viewer.

Characters who are socially awkward or ill at ease abound, including in *The Days Between* and *In Between Days*, as well as Arnold's *Red Road*, Speth's *Madonnas*, Ade's *The Forest for the Trees* and *Everyone Else*, and Grisebach's *Sehnsucht* (*Longing*, 2006). Many feature extremely uncomfortable scenes with children who are abandoned or subjected to violence, including *Fish Tank*, *Madonnas*, and Kim's *Treeless Mountain*. Images of women committing violence—especially against children, but also against property, others, or themselves—represent the tragic forms that gendered refusal can take in the pressure situations depicted by films, including *The Days Between*, *Fish Tank*, and *Daughters*. Images of bodily awkwardness are also pervasive, including the uncomfortable sex scenes that are a noted characteristic of Berlin School films, as well as deployments of female bodies that break with normative regimes of representation.[12]

The mother of five children by different fathers, Rita, the central character in *Madonnas*, continues to give birth although she is generally unable or unwilling to care for her kids. In an early scene, Rita tracks down her absent biological father and his new family in Belgium. She befriends her teenage half-brother, who watches her nurse her baby son, J. T., on the couch. When he wonders what breast milk tastes like, Rita allows the teenager to try it; just as he begins suckling at her breast, his mother enters the room. As in this scene, Rita's mothering decisions prove awkward and uncomfortable on both relational and corporeal levels, within the context of the narrative and for viewers of Speth's film, who witness a number of taboos being broken. *Madonnas* depicts Rita's developing relationship with Marc, an African American soldier stationed in Germany who offers her the stability of an apartment, furniture, and regular meals, and who cares for and offers affection to her diverse brood of children. But, as with her children, Rita is also unable or unwilling to develop a truly intimate relationship with Marc, embracing the paradoxes of a precari-

ous life rather than acceding to normative regimes of self-regulation, personal responsibility, and heteronormative family relations. Rita indicates her preference for independence by refusing Marc, but this decision is an obstacle to her own and especially to her children's ability to thrive and be protected in the unwelcoming worlds and unreliable environments—the prisons, housing projects, abandoned playgrounds, and shabby parks—where they and many of the other characters that populate these films try to exist.

While the milieu of Grisebach's *Longing* is markedly different from that of the other films discussed here, *Longing* also features numerous scenes that escalate the viewer's discomfort through a combination of long takes portraying awkward or uncomfortable behavior and abrupt cuts that detract from our comprehension of the events taking place on screen. As the title *Longing* suggests, this is a film that takes affect as its central theme in its chronicle of a love triangle between locksmith and volunteer fireman Markus, his wife homemaker Ella, and the waitress Rose, characters who all seek and fail to attach their longing to an appropriate object.[13] This situation tragedy emphasizes the clash of old and new, experienced by characters in a small town in eastern Germany, where traditional and flexible family structures and gender roles quite literally collide. The film's ending is both a metacinematic reflection on storytelling, focusing on the figure of the female narrator, and an invitation to the viewer to participate in meaning-making, which explicitly invites contemplation of the awkward genre of the situation tragedy when the teenagers on the playground discuss whether they find the events narrated by the film tragic, comic, or romantic.

Ade's films are also particularly noteworthy for the way they emphasize moments of awkwardness and gendered refusal that are both inexplicable and discomfiting. In *The Forest for the Trees*, Melanie's awkward attempts to establish herself in the classroom, to make contacts with her new colleagues, and to create new friendships all meet with failure, in ways that Melanie herself seems unable to recognize. As her efforts at self-optimization falter, the viewer occupies a space of increasing discomfort, cringing at Melanie's inability to self-monitor, regulate her conduct, or fashion an identity that conforms to societal expectations. Increasingly, Melanie lacks the wherewithal to function as a teacher, a colleague, or a responsible adult: she sneaks away from school when she cannot assert authority over her class; she eats lunch in the closet to avoid confronting her colleagues; and her once carefully decorated apartment is suddenly in shambles, an external illustration of the messiness of her inner life. The film's ambivalent ending, in which—as we have seen—Melanie abandons the driver's seat as her car speeds down the highway, emphasizes her precarious position in a neoliberal

order she fails to inhabit, while also placing the viewer in a position of insecurity that escalates as the long take that marks this scene unspools.

Something similar happens in Ade's *Everyone Else*, a film that makes visible with great detail and precision both the insecurity produced by the coexistence of flexible and traditional gender norms in neoliberalism and the consequences of this insecurity for negotiating agency in the present. *Everyone Else* follows the thirtyish couple Gitti and Chris during a vacation in Sardinia, bringing into focus the way both characters struggle to adapt the more flexible gender roles they inhabit to the demands of their heterosexual relationship, their professional lives, and their friendships. When they encounter another couple, Hans and Sana, whose professional success and more normatively gendered relationship Chris aspires to, he and Gitti begin to adopt conventional gender roles. However, for Gitti, the difficulty of reconciling her own expectations with the remarkably persistent demands of heteronormativity becomes increasingly insufferable. Though she at first seeks to escape by asking the agency where she works as a music promotion executive to recall her to Germany, Chris discovers her ruse. In the final scene of the movie, Gitti collapses onto the floor and lies inert as Chris grows increasingly panicked that she has fainted or even died. Ignoring the persistent ringing of her cell phone with calls from the agency and Chris's weeping, Gitti lies limp and unresponsive on the floor of the vacation house. This scene posits Gitti's inaction in the face of personal relationships and professional demands as a form of defiance, a gendered mode of refusal that is strange and troubling. As Ade herself explains of *The Forest for the Trees*, "I didn't find an ending in realism, in reality, so I felt like I had to leave reality behind" (Abel 2013, 257).[14] By inhabiting and then departing from a realist aesthetic, Ade's films reflect on a formal level the insecurity of the present that forms the matrix of her narratives; they also work on an affective level to evince this feeling of insecurity.

The discomfiting films of the female filmmakers discussed here offer no solutions and no resolution, no progress and no catharsis. Instead, they offer awkward and troubling images that sometimes make us cringe or recoil, at other times question or doubt. By creating discomfort and insecurity in the viewer, these films make palpable the paradoxes of neoliberalism. At the same time, the transnational women's film productions described here themselves represent, both materially and aesthetically, the emergence of gendered modes of refusal that respond to the impasses of the present. The access to the means of audiovisual production engaged by these filmmakers via collaborative practices creates a platform that aims to bring awkward and uncomfortable images of gendered subjectivity to the widest possible audiences.

Notes

1 Berlant employs the genre phrase "situation tragedy" to describe "episodes of personality caught up in a form of despair not existential or heroic but shaped within the stresses of ordinary life under capitalism," a description that perfectly captures the films of Maren Ade and the other directors discussed here (Berlant 2011, 290n18).

2 My inclusion of Austrian directors Albert and Hausner derives from the close collaborative relationship, in terms of both aesthetics and financing, that they have long maintained with the German-born directors associated with the Berlin School, which I discuss in more detail further on.

3 More recently, Ade has spoken out in favor of a quota system to promote gender parity in film production, adding a powerful voice to the Pro Quote Regie movement inaugurated by a group of German and Austrian directors in 2014.

4 On this point, see Baer 2013.

5 This can be seen in the much-discussed trajectory of Berlin School filmmakers (including Thomas Arslan, Valeska Grisebach, Christoph Hochhäusler, and Christian Petzold) toward genre cinema and, increasingly, also toward historical films.

6 See "Profile" on the company's website, http://www.coop99.at/web-coop99/?page_id=124&lang=en, accessed February 5, 2016.

7 In 2010, producer Jonas Dornbach joined the production team. Komplizen-Film describes its production focus as follows: "Komplizen-Film emphasizes the development of arthouse films and international co-productions and aims to promote and establish German directors in the German and European market." See http://komplizenfilm.de/d/komplizen.html, accessed February 5, 2016.

8 Ade's *Everyone Else* is an exception, having drawn 187,000 cinema viewers upon its release in Germany, an unusually high number for a Berlin School film that her follow-up, *Toni Erdmann*, managed to top with over 860,000 viewers. Released after the initial completion of this chapter, *Toni Erdmann* exemplifies the material and aesthetic developments analyzed here.

9 See http://www.miumiu.com/en/women_tales/7/film, accessed February 10, 2016.

10 Berlant develops her conception of the situation tragedy in a reading of the Dardenne Brothers' films, which have influenced the women's film productions discussed here in formal and thematic ways. Speth has worked directly with the Dardennes, who coproduced *Madonnas*.

11 Interview with Maria Speth, DVD release of *Madonnen*. Berlin: Filmgalerie 451, 2008.

12 For an extended discussion of awkwardness and contemporary representation in the context of feminism, see Smith-Prei and Stehle 2016.

13 See also Abel's analysis of affect in the film (2013, 230–48).

14 For a discussion of this ending see also Abel (2013, 256–59).

Works Cited

Abel, Marco. 2013. *The Counter-Cinema of the Berlin School*. Rochester, NY: Camden House.

Ade, Maren. 2014. "Feministin sein war uncool." In *Wie haben Sie das gemacht? Aufzeichnungen zu Frauen und Filmen*, edited by Claudia Lenssen and Bettina Schoeller-Boujou. Marburg: Schüren Verlag.

Baer, Hester. 2013. "Affectless Economies: The Berlin School and Neoliberalism." *Discourse* 35 (1): 72–100.

Berlant, Lauren. 2011. *Cruel Optimism*. Durham, NC: Duke University Press.

Butler, Alison. 2002. *Women's Cinema: The Contested Screen*. London: Wallflower.

Byerly, Carolyn M. 2014. "Women and Media Control: Feminist Interrogations at the Macro-Level." In *The Routledge Companion to Media and Gender*, edited by Cynthia Carter, Linda Steiner, and Lisa McLaughlin. London: Routledge.

Cook, Roger F., et al. 2013. *Berlin School Glossary: An ABC of the New Wave in German Cinema*. Bristol, UK: Intellect.

De Lauretis, Teresa. 1987. "Rethinking Women's Cinema: Aesthetics and Feminist Theory." In *Technologies of Gender: Essays on Theory, Film, and Fiction*. Bloomington: Indiana University Press.

Elsaesser, Thomas. 2005. *European Cinema: Face to Face with Hollywood*. Amsterdam: Amsterdam University Press.

European Commission 2010. "Women and ICT Status Report 2009." http://www.womenandtechnology.eu/digitalcity/servlet/PublishedFileServlet/AAABINHR/women_ict_report.pdf.

Frölich, Margit. 2009. "Der nächste Film ist immer der Schwerste: Junge Regisseure in Deutschland," *epd-film* 12.

Gill, Rosalind. 2007. *Gender and the Media*. Cambridge: Polity.

Gill, Rosalind, and Christina Scharff. 2011. *New Femininities: Postfeminism, Neoliberalism, and Subjectivity*. New York: Palgrave Macmillan.

Gupta, Susanne. 2005. "Berliner Schule: Nouvelle Vague Allemande." *Fluter: Magazin der Bundeszentrale für politische Bildung*, August 31.

Hall, Stuart. 2011. "The Neo-Liberal Revolution." *Cultural Studies* 25 (6).

Kapur, Jyotsna, and Keith B Wagner. 2011. *Neoliberalism and Global Cinema: Capital, Culture, and Marxist Critique*. New York: Routledge.

McRobbie, Angela. 2009. *The Aftermath of Feminism: Gender, Culture, and Social Change*. London: Sage.

Prommer, Elizabeth, and Skadi Loist. 2015. "Who Directs German Feature Films? Gender Report 2009–2013." Institute for Media Research, University of Rostock. https://www.coe.int/t/dg4/eurimages/Source/Gender-Report-German-Film_2009-2013_2015-English.pdf.

Ross, Karen. 2014. "Women in Media Industries in Europe: What's Wrong with This Picture?" *Feminist Media Studies* 14 (2).

Smith-Prei, Carrie, and Maria Stehle. 2016. *Awkward Politics: Technologies of Popfeminist Activism*. Montreal: McGill-Queen's University Press.

White, Patricia. 2009. "Watching Women's Films." *Camera Obscura* 24 (3).

Wietstock, Ellen. 2014. "Frauenpolitik ist Filmpolitik." In *Wie haben Sie das gemacht? Aufzeichnungen zu Frauen und Filmen*, edited by Claudia Lenssen and Bettina Schoeller-Boujou. Marburg: Schüren Verlag.

Wood, Jason. 2014. "Interview with Kelly Reichardt." *Last Words: Considering Contemporary Cinema*. New York: Wallflower Press. Kindle.

Zobl, Elke, and Rosa Reitsamer. 2014. "Gender and Media Activism: Alternative Feminist Media in Europe." In *The Routledge Companion to Media and Gender*, edited by Cynthia Carter, Linda Steiner, and Lisa McLaughlin. London: Routledge.

2

GENDER, GENRE, AND THE (IM)POSSIBILITIES OF ROMANTIC LOVE IN DEREK CIANFRANCE'S *BLUE VALENTINE* (2010) AND MAREN ADE'S *EVERYONE ELSE* (2009)

Lisa Haegele

The American indie film *Blue Valentine* (Derek Cianfrance, 2010) and Maren Ade's Berlin School film *Alle Anderen* (*Everyone Else*, 2009) are centered on the troubled romantic relationships between young couples in their late twenties to early thirties. Departing from generic conventions of the Hollywood romance film, *Blue Valentine* and *Everyone Else* elicit discomfiting affective responses among viewers in their representations of love and sex, and they draw attention to the performativity of the gender roles that are prescribed to their protagonists. Rather than offer conciliatory, feel-good narratives of unwavering desire and blissful heterosexual romance, these films emphasize the messiness and ambiguity of contemporary relationships. They are therefore representative of what Antje Ascheid has identified as the "postromance" genre that began to develop in American independent cinema of the 1990s and has since become an international art cinema phenomenon (Ascheid 2013, 249). The films belong specifically to the "dystopian" mode of the postromance, which focuses on the "destructive aspects of romantic relationships" in a cynical or skeptical tone (248). While the American and German films are linked in their disquieting sense of realism and rejection of Hollywood-style love stories, I will outline in this essay important differences between the two films that, in turn, reveal the projection of new possibilities for the cinematic romance in Ade's Berlin School film. In line with Ascheid's claim that many German postromances straddle dystopian

with utopian elements (250), the transnational comparison I undertake here will bring into relief a more utopian vision of contemporary romance in *Everyone Else*, a vision that has been overlooked in some of the less optimistic readings of the Berlin School films in recent scholarship.[1]

An Impossible Romance: *Blue Valentine*

Derek Cianfrance's *Blue Valentine* depicts the failing relationship between Cindy (Michelle Williams) and Dean (Ryan Gosling), a young working-class couple struggling to make ends meet in a small Pennsylvania town. In the opening sequence, Cindy and Dean eat a rushed breakfast with their five-year-old daughter Frankie before Cindy hurries off to work. When Cindy leaves during her lunch break to see Frankie's school play, she spots Megan, the family dog who had gone missing earlier that morning, lying dead on the side of the street. She shares the bad news with Dean, who suggests that they spend the night in a "cheesy" sex motel to distract them from the reality of their dog's death. Anxious and exhausted, Cindy initially opposes the idea but eventually concedes. Here and throughout the film, flashbacks take us to Cindy and Dean's initial encounter and developing romance, which contrast sharply with the dreary and dull images of Cindy and Dean's present. Dean, a professional mover at the time, meets Cindy in a retirement home where she is visiting her grandmother. They eventually fall in love, and when Cindy discovers she is pregnant with her aggressive ex-boyfriend's child, Dean convinces her to let him be the child's father. At the end of the film, the couple marries at a courthouse, while the present-day Cindy and Dean split up after a violent argument at Cindy's workplace. In the final shot, Dean walks away from his wife and daughter as firecrackers explode around him, accompanied by the final score by indie rock band Grizzly Bear. The closing credits roll as nostalgic photographs of the younger, happier Cindy and Dean flit across the background, highlighted by graphics that emulate exploding fireworks.

Perhaps the most striking commonalities that *Blue Valentine* shares with the Berlin School are its languid pace and observational realism focusing on ordinary people leading ordinary lives. The opening sequence in particular bears a haunting quality reminiscent of the Berlin School. As the opening credits appear on a black screen, we hear crickets chirping, the caw of a crow, and a little girl desperately calling out a name that sounds like "Da-da." The first shot shows the young girl, later revealed to be Frankie, standing alone in a field on the left side of the frame with a dense forest behind her. The next cut takes us to a windy empty street as we continue to hear the girl's echoed cries from off screen. Our

view of the end of the street is shrouded by trees that cut into the top, left, and right sides of the frame, enhancing the sense of loss and alienation expressed in Frankie's cries. The camera then cuts to an eerie image of a pale pink plastic riding horse in a patch of weeds in front of a dark green forest wall. With its emphasis on barrenness and absence of human life, the opening sequence announces the disconnect and vacuity that have come to epitomize the nature of the relationship between the film's protagonists. Like the ghostly spaces that evoke the failed emotional connections and empty interpersonal relationships in the films of the Berlin School (see Kaussen 2013, 147–56), Frankie's unanswered cries in a barren landscape call forth the emotional void that now exists between her parents. Although we later discover that Frankie had not been calling out "Da-da" but "Megan," the name of the missing family dog, the sequence also foreshadows the traumatic separation of Frankie from her father when he leaves her and Cindy at the end of the film.

Blue Valentine takes a realist-based approach that *New York Times* film critic A. O. Scott has identified in recent American independent cinema in his 2009 article "Neo-Neo Realism" (2009). Like the films Scott describes, *Blue Valentine* uses "long, patient shots" to depict the ordinary lives of working-class people in real American locations. In addition to minimal lighting and the actors' ability to improvise (Silberg 2012), the absence of non-diegetic music in Cindy and Dean's present lives, frequent use of a handheld camera, and racking focus further contribute to the film's realist aesthetic. With our view often obstructed by objects situated close to the camera, the film positions us as embodied observers of the events on screen, through which it generates the uncomfortable forms of affect that drive the film. Most often we feel *too* close to the protagonists, as though we are trespassing into their private space and have no business being there. When Cindy tells Dean about their dog's death at Frankie's school play, the camera alternates between each of them in close-up, Dean staring at Cindy in shocked disbelief while Cindy rests her head in her hands, sobbing. As we watch Cindy weep in extreme close-up, Dean whispers, "How many times did I tell you to lock the fucking gate?" The children begin to sing "My Country 'Tis of Thee," forming an ironic contrast with the couple's pain that points to the challenges of and inevitable mishaps in balancing work, familial, and other domestic obligations in American working-class life.

The camera is similarly uncompromising when Dean interrogates Cindy about running into her ex-boyfriend at the liquor store. With the camera positioned between them in the car, Cindy and Dean are presented in extreme close-ups that emphasize their anxiousness about the situation. As a result, we, too, experience an intense unease and sense of embarrassment for witnessing such a

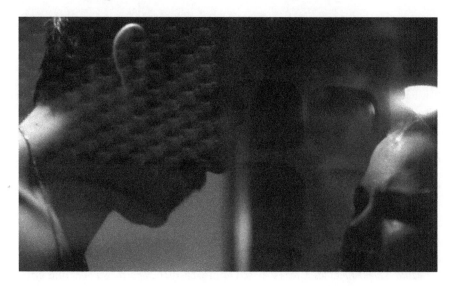

Figure 2.1 Unsexy shower scene in *Blue Valentine*

private moment in the life of the couple, one that exposes their inner vulnerabilities and insecurities at uncomfortably close range.

Not unlike the painfully awkward and unsuccessful attempts at sex in the films of the Berlin School (Richardson 2013, 41–49), Cindy and Dean's drunken sexual encounter in the space-themed motel room—tellingly called the "Future Room"—forces us to experience the failure of the couple's relationship most palpably. Dark, cramped, and disorienting, the room is dimly lit with neon blue and red lights that reflect off of the aluminum doors and walls. There are no windows, as Cindy remarks with disappointment, and the rotating bed, clashing neon colors, aluminum surface glare, and multiple layers of reflections evoke a sense of dizziness and disorientation. While preparing drinks, Cindy is pressed in by two aluminum walls in a doorway with her reflection mirrored behind her. The claustrophobic sensation persists as Dean joins her in the shower and tries to engage her in sex. When he enters the bathroom, the camera cuts to Cindy in close-up, her face separated from the shower head by a blurry blue vertical line that cuts through the middle of the shot and creates the effect of blocking her in on the left side of the frame. Walking past the camera and down into the shower, he enters the next shot from frame left and begins to caress Cindy's neck and face, his body looming over her while her eyes are closed (fig. 2.1). Cindy's vulnerability is emphasized by the lighting of the scene: while Dean's face and shoulders are cast by a dark blue shadow, Cindy's face is illuminated by the neon red light

from the shower head. With a disorienting honeycomb-patterned reflection filtering our view of the couple, Cindy, obviously uninterested in having sex with Dean, steps out of the way and moves behind him. When she turns back around, Dean bends down toward her pelvis and begins to stroke her thighs and buttocks in a close-up shot, at which point Cindy utters, "Enough." This scene forms a sharp contrast with a later scene in which the younger Cindy giggles and lovingly embraces Dean when he performs oral sex on her.

Dean's second attempt to have sex with Cindy in the motel room is even more uncomfortable, and may have prompted the MPAA to give the film its initial NC-17 rating.[2] Lying drunk on the floor, Dean pretends that he cannot get up. He calls out to Cindy for help, who is also drunk and lying on the rotating bed. When Cindy stumbles over to him to give him a hand, he pulls her down on top of him, turns her over on the floor and whispers to her, "You are so beautiful." Chuckling, Cindy spits at him and pushes his face away from hers. As in the shower scene, Dean's body overwhelms the shots in the sequence in ways that enhance Cindy's feelings of entrapment. With the camera positioned at floor level, Dean kisses Cindy in a close-up shot, to which she reacts by violently pulling his head back by his hair. He pulls away and mutters, "Ffffuck! Ouch. What are you doing? Huh? Whatsa matter. Come here," and proceeds to unbutton Cindy's blouse to kiss her exposed breast. Rather than push him away again, Cindy makes a fist and brings it up toward her chest in a self-protective gesture. In an extreme close-up, she grimaces in repulsion and silently mouths the word "Ow" while clenching her hand in a tight fist over her eyes. She then pulls Dean's head back once again and begins to slap him. Hurt and frustrated, Dean tells her that he deserves affection because he loves her and is good to her and Frankie. At that point, Cindy resigns, removing her panties to allow him to have sex with her. In awkwardly angled and bumpy close-ups, Cindy tightly closes her eyes in painful endurance. Finally, Dean pulls away and remarks: "I can't fucking do it like this. This you can have my body bullshit. I don't want that. I want you. I'm not gonna do it like this. What do you want me to rape you? Is that what you want? You want me to hit you?" Cindy urges him to stop before derisively responding, "Yeah, hit me. That's what I want, baby. Hit me." Rising from the floor, she punches and slaps him, while he calmly retorts, "I'm not gonna do it. I'm not gonna fucking do it, okay? I don't give a shit how much you want it. I'm not gonna do it. Okay? I love you." In this scene and throughout the film, we are forced to watch the dissolution of a marriage in painfully close range, invoking in us feelings of embarrassment and disgust.

While sex in the Berlin School films is awkward and unsatisfying, bad sex in *Blue Valentine* pushes our affective responses of discomfort to almost intolerable

extremes. By contrast, in the more gratifying Hollywood romance genre, sex scenes are typically sentimental or erotic. *Blue Valentine* is thus as much a eulogy to a young couple's relationship as it is to the Hollywood romance film, a well-worn genre that does not accommodate the complex and challenging realities of contemporary—and particularly working-class—romantic relationships. In contrast to the present-day story of Cindy and Dean, the story of the younger, happier couple represents the more conventional Hollywood-style romance with its colors, uplifting music, and feel-good moments but which, as the film suggests, is ultimately unsustainable. The impossibility of the generic romance, in other words, is represented by the failure of Cindy and Dean's relationship. In a conversation with his coworker about his first encounter with Cindy, Dean admits that his sense of reality is colored by movies: "Maybe I've seen too many movies, you know? Love at first sight? I just felt like I knew her." Dean's hope for a Hollywoodized reality is illustrated further when he reassures Frankie that Megan has gone off to become a "movie dog," even though he knows the dog is dead. When Frankie asks him whether he found Megan, he hesitates before responding, "No . . . but I was thinking, maybe she moved out to Hollywood and she became a movie dog. You think? Do you think she moved out to Hollywood to be a movie dog? She had the looks, don't you think?" Dean subscribes to the fantasies promised by Hollywood in holding out hope for a better and less painful reality. When he convinces Frankie that Megan went out to become a Hollywood star, the camera focuses on Cindy in the driver's seat of the car solemnly looking downward and wearing sunglasses to hide her tears. This shot emphasizes the discrepancy between the Hollywoodized reality that Dean wants to create for his daughter and the harsh truths with which the couple is confronted.

Blue Valentine illustrates how Hollywood's stable gender prescriptions and leveling out of class divisions through romantic love have become grossly incompatible with the messy and complex truths of contemporary relationships. While Dean holds on to a romanticized vision of his marriage and believes that love conquers all, Cindy holds Dean to idealistic gender-based expectations of a husband who is emotionally reserved and driven by professional ambition. When they have dinner in their motel room, Cindy interrogates Dean about his goals in life and, in a patronizing fashion, urges him to realize his "potential." Irritated, Dean asks her in return to explain what she means by "potential." Formerly an aspiring doctor, Cindy appears to resent the working-class Dean for the financially precarious situation in which they now find themselves and for her own failure to reach her "potential." Had Dean not offered to take on the role of Frankie's father, perhaps Cindy would have had the abortion that she was considering and therefore been able to realize her career goals.

Unlike Hollywood films such as the romance comedy *Pretty Woman* (Garry Marshall, 1990), class differences are not leveled out in Cindy and Dean's romantic relationship, but rather they remain firmly in place, leading to misunderstandings and resentment. In their final argument at Cindy's workplace, Cindy bitterly scolds Dean with, "I'm more man than you are," to which Dean shouts back, dejected, "What does that even mean? What does it even mean to be a man? I'll be a man, you want me to be a man?" He begins to toss things violently around the office and yells, "Here you go. I'm a man. I'm a big fucking man. Look at me," while Cindy scornfully repeats, "No, I'm the man now!" What becomes clear here in this postromance film is that the stable gender prescriptions of the old generic Hollywood romance are muddled, a notion that is reinforced by the mix of pink and blue of Cindy's scrubs, which also color the scenes in the sex motel. Neither Cindy nor Dean are "man," or they both are; the gender expectations perpetuated in so many on-screen heterosexual romances are incommensurable with the inevitably complex and unstable gender identities in real romantic relationships. Longing for a romance that has become a thing of the past—with its sunsets, unconditional love, and unwavering passion between the sexes—Cindy and Dean find themselves in a relationship that can only bring disappointment, unhappiness, and unfulfilling sex. Moments once marked with sentimentality and eroticism are now imbued with awkward and precarious forms of affect. In the closing credits, warm-colored photographs of Cindy and Dean in the early days of their relationship flit across the screen as exploding firework graphics illuminate them, representing a nostalgic—if not a bit cynical—homage to the generic Hollywood romance.

New Romantic Ventures: *Everyone Else*

Upon the release of *Blue Valentine* in 2010, American film critics immediately compared the film to Maren Ade's *Everyone Else* of the previous year. Above all, they noted the thematic overlaps between the two films, as Martin Morrow explains in an article for *CBC News*: "Like *Everyone Else*, *Blue Valentine* pins a failing relationship under the microscope and probes its every twitch" (Morrow 2011). In a *Sound on Sight* radio podcast devoted to the comparison of the two films, critics described *Everyone Else* as the "European equivalent" of *Blue Valentine* (*Sound on Sight Radio* 2011). But while Cianfrance's film, as the *Sound on Sight* critics point out, is typically "American" with its more dramatic portrayal of a romance at its dreamy beginnings and painful end with everything in between left

out, the German film offers a complex psychological portrait of a young couple's everyday interactions without dramatic or sentimental embellishment. Indeed, most critics compared *Everyone Else* favorably to *Blue Valentine* for its "quiet, observant honesty" ("Like 'Blue Valentine'" 2011) and "bracing clarity" in lieu of "cheap sentiment" (Scott 2010). Along these lines, whereas the American indie film points to the obsoleteness of the genre in a wistful homage, the German film, by contrast, suggests new avenues and possibilities for the on-screen romance. In a surprising reversal of what one might expect respectively for an American and European film, Ade's postromance offers a far more optimistic view of the relationship between its protagonists in particular and of the future of the cinematic romance in general. This comparison will call into question the prevailing claim that Ade's protagonists—and many others in the Berlin School—are "alienated" and "disconnected" from each other in the age of neoliberalism and postindustrialization (Cook et al. 2013).

Similar to the opening of *Blue Valentine*, the first scene in *Everyone Else* shows us what appears to be a young family at breakfast. While Gitti (Birgit Minichmayr) tries to convince a young girl to eat her breakfast, Chris (Lars Eidinger) plays with a baby on his lap on the living room couch. We soon discover that Chris's sister is the mother of the children and that Gitti, a band manager, and Chris, a struggling architect, are on vacation in Sardinia where they are residing in a villa belonging to Chris's mother. To Chris's dismay, the couple coincidentally runs into Hans, his more successful colleague, and Hans's pregnant wife, Sana, at a grocery store. Chris and Gitti reluctantly accept Hans and Sana's invitation to dinner that evening. The dinner leads to an argument between Hans and Gitti, who combatively defends Chris against Hans's condescending remarks. Embarrassed, Chris lashes back at Gitti and begins to alienate himself from her. The next time the two couples have dinner at the villa, Gitti remains quiet and complacent, at least until she threatens Sana with a kitchen knife and orders her to leave with Hans. Gitti begins to pack her bags the following morning, announcing to Chris that she no longer loves him. When Chris steps outside after their argument to collect himself, Gitti plays "dead" on the living room floor. In the film's last shot, Gitti turns her head toward Chris with a gentle smile and caresses his face with her fingertips in a tender and quiet moment.

In *Everyone Else*, Gitti and Chris constantly shift their gender identities in a playful and creative relationship dynamic. Unlike *Blue Valentine*'s Cindy and Dean, whose inability to imagine a happy relationship beyond Hollywood standards lead to their ultimate failure, Gitti and Chris play with and tease out their gender identities in ways that allow them to create and sustain an intimate connection. Gitti and Chris's relationship falters when they perform gender norms

in front of their peers, just as Cindy and Dean's relationship fails when they fall short of conforming to those norms. But whereas Cindy and Dean do not look for other viable solutions to their relationship, Gitti and Chris embrace alternative gender dynamics, which in turn generate new forms of affect for the on-screen postromance. Indeed, it is precisely in their failure to sustain their relationship within a heteronormative framework through which they are able to connect as a couple in meaningful ways. To this end, I would like to suggest that Gitti and Chris's play of gendered performances is hardly an indication that they are "dead inside" (Cook et al. 2013, 169) nor are they "trapped" (180) in their gestures; rather, by acknowledging that they have choices in how they define themselves, Gitti and Chris ultimately forge an intimate relationship that thrives on the blurry lines and complexities denied by Cindy and Dean.

From its opening scene, *Everyone Else* emphasizes the performativity of gender and Gitti's penchant for performing in particular. By leading us to believe that Chris, Gitti, and the two children are a small family until the children's mother arrives, the film already thwarts our expectations while stressing the performative nature of heteronormative parental roles in the nuclear family. While Chris holds her baby, his sister looks at him with admiration and remarks: "That suits you well!" Her observation that holding a baby "suits" her brother points to the performativity of the father role, which he happens to play well. In the next shot, Gitti stomps after the other little girl alongside the swimming pool, demanding her to explain why she is upset with her. In a medium close-up, Gitti glances over in the direction of Chris and his sister and then again at the girl in front of her. Now aware that she has an audience, Gitti convinces the girl to tell her how much she loathes her and then gives her permission to shoot her. The girl forms a gun shape with her hand and "shoots" Gitti, at which point Gitti lifts her arms to her chest, gasps, and stumbles backward into the pool, her eyes wide open and mouth agape. For a few quiet moments, Gitti floats listlessly in the pool as though dead. The camera cuts to Chris and Gitti napping in bed, and the film's title "EVERYONE ELSE" appears above their heads. With several levels of performance at play in the opening sequence—Chris's fatherly gestures, Gitti and the young girl's minidrama, and the misleading family portrait—*Everyone Else* already shows us that the characters in the film resist stereotyping and are more than what they may project themselves to be. Through the course of the film, Chris and Gitti perform various identities—"everyone else" or "all the others"— in ways that ultimately allow them to develop a strong emotional connection to each other by the end of the film.

In a reversal of gender expectations, Chris is coded as feminine at the beginning of their vacation while Gitti is coded as masculine. These transgressions

occur primarily on a visual level. When Gitti feeds Chris pieces of cheese as he reads, for example, Chris's bare upper body occupies the entire frame except for a small angled gap below his shoulder. Gitti extends her arm through this gap to feed him from behind. With his body on display for the camera, Chris looks down as he reads in a posture that frames him as the object of our gaze and is therefore coded as feminine. Gitti, by contrast, protrudes her arm through the gap below Chris's shoulder in a phallic gesture and, once in his personal space, gropes around his face with her hand to coax a piece of cheese into his mouth. In the following shot, Gitti, whose body remains mostly outside of the frame, applies makeup to Chris, who lies on the ground with his arms above him in a passive pose. When they hear their neighbor approaching, they run up the hill, giggling, and Chris wipes the makeup off his face. Gitti utters with disappointment, "Too bad." Smiling, Chris responds, "That's how you like me. As a girl," and Gitti confirms while gently caressing his face, "Yeah . . . I think it fits you somehow." When Chris asks Gitti whether she finds him at all manly, she suggests that he do "something manly" and she will see if she notices. As they walk back to the villa, Chris puts his arm around Gitti, prompting her to laugh. When he asks her why she is laughing, she explains, "Because you're such a bad actor!" Gitti *does* notice, then, when Chris tries to act "manly," because in her view Chris does not perform masculinity—expressed in the possessive posturing of draping his arm over his girlfriend's shoulders—as well as he performs a role that is stereotypically coded as feminine in his relationship with Gitti.

In another early scene that codes Chris as feminine, Gitti watches as Chris gives a sultry dance performance for her in his mother's porcelain bird-filled room. Disappointed that Chris did not want to go with her to the disco, Gitti, arms crossed, looks skeptically around the room before making snide comments about his mother's kitschy decor. She turns on the stereo and asks Chris to dance to the song, the overtly sentimental ballad "To All the Girls I've Loved Before," sung by Julio Iglesias and Willie Nelson. While Chris hesitates, the camera cuts to Gitti looking up at him judgingly, her arms crossed. In a medium shot, Chris slowly begins to dance but soon becomes embarrassed and blurts out, "But this [the music] is awful!" From off screen, Gitti persists, "Do it!" Chris makes another attempt and this time becomes increasingly enthusiastic. After two more cuts to Gitti smiling and giggling on the couch, the camera focuses on Chris as he dances around the room in sweeping motions, sliding down the walls and onto the floor where he rolls around and crawls on his elbows to Gitti and then into her lap. In the next shot, the couple rolls around together on the floor, laughing and kissing.

Although initially embarrassed, Chris sets his stoic ego aside and dances without abandon for Gitti and the camera in a position and with sensual body gestures that are typically coded as feminine. It is precisely in Chris's feminized dance performance—even if performed with irony—through which Chris and Gitti are able to reconnect physically and emotionally after their disagreement about their evening plans. As Marco Abel has noted in his perceptive analysis of the film, Chris and Gitti frequently resort to irony in their interactions with each other (Abel 2013, 260); rather than preclude a sincere emotional connection, however, I would argue that their ironic stance toward the room and the 1984 love song actually creates an opportunity for Chris to act unhinged and free from expectations to conform to gender norms, which allows him and Gitti to forge an intimate connection. In the final shot of the sequence, Chris and Gitti chuckle as they glance up at the tree of porcelain birds before they continue to kiss, while the song, still playing, bridges into the more serious sex scene that follows. The boundary dividing sincerity and authenticity from ironic distance and performance is not easily discernible. Not only do Chris and Gitti immediately resume kissing after laughing dismissively again at the kitschy decor, but their original skepticism of the emotionally charged song also transforms into what appears to be their unabashed and perhaps unironic embracing of it, a notion that is enhanced by the song's continuation into the more intimate sex scene. Indeed, what this scene demonstrates is that irony and performance do not bar the possibility of sincere emotional connection, nor are irony and sincerity mutually exclusive; on the contrary, Chris and Gitti are able to connect precisely in adapting alternative gender identities—even if initiated with a touch of irony—that they are willing to perform in the context of their relationship in order to achieve intimacy. In other words, Chris and Gitti are able to forge a deep emotional connection precisely *through* irony and performance in the first place. This connection between them registers with us affectively as a combination of embarrassment and vulnerability transformed into self-abandon, an unconventional and thus powerful sensation that Ade offers up as a possibility for postromantic affect.

Things take a negative turn, however, when Chris and Gitti have an audience other than each other. When in the presence of Sana and Hans, a young upper-middle-class married couple, Chris and Gitti revert to the same stereotypical gender roles performed by Sana and Hans, resulting in a series of misunderstandings and emotional disconnect between them. When Sana and Hans arrive on the scene, the Italian island transforms from an emancipatory and subversive space where Gitti and Chris can try out different identities to the hegemonic sphere of German upper-middle-class society, a society they may have

intended to escape by vacationing on the island in the first place. Hans and Sana's relationship reinforces gender stereotypes in ways that contrast sharply with Chris and Gitti's playful and unconventional relationship. While Sana, a fashion designer, makes self-deprecating comments about her pregnant body, noting that she is getting too "fat," Hans relentlessly asserts his dominance over her, "joking" that he had to impregnate her in order to keep her from surpassing him in professional success. On the first evening the couples have dinner together, Hans drapes his arm around Sana as she leans up against him, a gesture that Gitti mocked earlier when Chris tried to put his arm around her in his performance of "manly." When Gitti defends Chris against what she interprets as Hans's condescending attitude toward him, both men reprimand her for being an aggressive and dominant woman, a "Brunhilde" who must always defend her "man." Rising from the table, Hans mutters to Chris, "We don't have it easy, do we," implying that women make life difficult for men.

Responding to Chris's emotional detachment since their argument that evening, Gitti performs a stereotypically feminine gender role. She brings Chris a snack at his work desk the morning after he returns from a night of partying with Hans. On a visual level, the shot recodes Gitti and Chris in heteronormative gender roles: while Gitti is squeezed in the upper right corner of the frame with her hands behind her back, Chris leans back in his office chair in a relaxed and assertive posture with his legs loosely crossed. Soon thereafter, Gitti finally wears the brown polka-dotted dress that she finds "bougie" and takes a trip downtown where she lets a saleswoman in a department store apply makeup to her face. Uncomfortable in the dress that she already tried on twice in the film and immediately removed, Gitti, now unhappy with her new makeover, wipes the makeup off her face with a tissue as soon as she steps outside. At that moment, she spots Chris sitting in a café and hesitates briefly before joining him. The dynamic between Chris and Gitti has completely shifted at this point: while Gitti nervously plays with her hair, giggles, looks down as she speaks, and speaks only when Chris asks her something or to express her agreement with him, Chris looks at her directly with eyes that are a particularly penetrating blue in this scene, orders her a drink, leans back, and casually recounts the productive conversation he had with his colleague. When he mentions that he would like to invite Hans and Sana over for dinner, Gitti, though visibly disappointed and anxious about the idea, agrees and offers to cook something. Once Hans and Sana arrive, they each compliment Gitti on her new appearance, and later Hans commends her on her cooking skills as he looms over her at the stove expecting a taste. Later, Hans derides his wife once again when he "jokes" that he should send her to Gitti for cooking lessons, while Gitti this time remains silent and complacent throughout the dinner.

To their benefit, Gitti and Chris fail to connect in the heteronormative roles they took on since their encounter with Hans and Sana, who represent and reproduce the social norms to which Gitti and Chris are pressured to conform. In contrast to Chris and Gitti, Hans and Sana conform to gender stereotypes in ways that permit and even excuse male violence. After their dinner, Hans tosses his pregnant wife into the pool despite her attempts to resist, while Chris—with Hans's help—follows suit with Gitti. For a few quiet, painful moments, Sana and Gitti glance over at each other in shock and humiliation. In an effort to break the awkward tension and cover for her husband's violence, Sana resorts to an ironic stance by forcing out a laugh and calling the men "assholes" in a teasing tone. Gitti, however, does not laugh off the men's violence: after pulling the skirt of her dress down to cover her legs, she silently climbs out of the pool and walks away, briefly glaring back at Chris.

Earlier that evening, when Chris shows Hans and Sana his mother's birdthemed room, Sana, herself a soon-to-be mother, responds with awe and adoration, while her husband—keeping to his masculine disaffection—looks around the room with a skeptical eyebrow raise and condescending chuckle, as did Gitti when she first saw the room. Listening to Herbert Grönemeyer's simple love ballad "Ich hab dich lieb" ("I love you") on the stereo, Sana shrieks with delight and cuddles up to Hans, while Hans preserves his stoicism by announcing, "This is awful." After some minutes, he complains that the song is "torturous" and turns it off to the disappointment of Sana, who shrugs her shoulders and quietly follows him out of the room. While Sana performs a stereotypical version of femininity in admitting how she is deeply moved by the trinkets in the room, a Hans Christian Andersen quote about life and a butterfly, and an unrestrainedly emotional pop song, Hans stays true to his masculine machismo by belittling his wife's tastes and refusing to be moved by the song, turning it off despite—or perhaps because of—his wife's enjoyment of it, before it can affect him.

Gitti and Chris, by contrast, are unable to connect to each other through these traditional gender roles. With Hans and Sana cuddling off screen, Gitti sits on a chair in the bottom right corner of the frame, while Chris stands closer to the camera on frame left. Rather than imitate the heteronormative gender performances of Hans and Sana, Chris and Gitti smile as they look at each other as the song continues to play from off screen. By virtue of contrast, this image recalls Chris's unbridled dance performance for Gitti to another pop love ballad in the same room. Their smiles and mutual gazes suggest—even if the pop song again initially embarrasses them—that they are also recalling that earlier intimate moment. As in that scene, Chris and Gitti initially bear an ironic attitude toward the song but eventually give in to its affective power.

At first, they awkwardly look down and around the room, with Gitti hunched over in her chair holding tightly onto a wine bottle and Chris nervously sipping his drink. As the camera continues to linger on them, they finally lock eyes and smile at each other until Hans turns the song off. In evoking on visual and aural levels the earlier connection the couple made through Chris's dance, this scene demonstrates that Chris and Gitti connect *differently* than Hans and Sana. Neither Chris and Gitti's physical distance nor Hans and Sana's physical intimacy are indications of a sincere emotional connection or lack thereof; in fact, in recalling the powerful moment when Gitti and Chris moved through irony to sincerity through Chris's queer dance performance, the scene points to the lack of true intimacy in Hans and Sana's conventional relationship. It is precisely Chris and Gitti's inability to connect through traditional gender dynamics in the context of their relationship that allows them to reach new emotional connections, which register with us as affective difference, that is, as a kind of embarrassing sincerity that does not typically belong to the affective repertoire of more conventional on-screen (heterosexual) romances.

Unlike *Blue Valentine*'s Cindy and Dean, Gitti and Chris do not resign themselves to gender normative roles that do not work for them. In the final sequence of the film, Chris and Gitti reconnect when the performance is over in a moment that, like the earlier scenes in the bird room, elicits surprising, affective responses. In his discussion of Oskar Roehler's postromance films, Marco Abel argues that the impossible endings of the films are utopian by virtue of their striking impossibility, which registers with us affectively (Abel 2010, 97). The sensation of embarrassment and frustration we feel with every impossible ending, which is grossly inconsistent with the rest of the film and our own postromantic reality, is, for Abel, a potential political force and thus bears a utopian quality.

The last sequence in *Everyone Else* initially goes in the direction of a Roehler postromance. After declaring to Chris in the plainest language, "I don't love you anymore," Gitti begins to pack her things and, after eating a grape, falls over on the floor as though she is dead. Her sudden change of heart and sudden death are as dissatisfying as they are implausible. When Chris "reawakens" Gitti from her "death," however, the film reveals a more hopeful vision of postromance that is indeed possible. After Gitti declares that she is no longer in love with Chris, her dramatic "death," which evokes the moment in the beginning of the film when she pretends to float dead in the swimming pool, concludes the performance of the gender normative relationship in which she and Chris failed. After sobbing intermittently and desperately urging Gitti to wake up over a four-minute period, Chris lifts her up from the floor and sets her on a table. Rather than kiss her awake

Figure 2.2 Chris and Gitti's postromantic love in *Everyone Else*

like a stereotypical Prince Charming, he gently lifts her blouse to blow on her belly, causing Gitti to let out a chuckle. He plants a soft kiss on her belly where he briefly rests his head and sighs with relief (fig. 2.2). After lightly kissing her lips, he leans back slightly and whispers to her, "Just look at me." In the final shot of the film, Gitti and Chris gaze at each other in an awkward yet intimate angle: Chris's head, shoulder, and back cut into the frame on the left side, while Gitti looks back at him with a gentle smile. We first notice that Gitti is caressing his face when her fingertips emerge from in front of his head. Perplexing, hilarious, and moving all the same, this scene prompts us to experience Chris and Gitti's connection through affective modes that are atypical for more conventional romances. Rather than preclude an intimate connection, Gitti and Chris's queer performances allow them to connect to each other in refreshing new ways.

Conclusion: Toward a Postromantic Affect

Both *Blue Valentine* and *Everyone Else* offer alternatives to the Hollywood romance, which they deem obsolete. But while the former represents a lamentful eulogy to a well-worn genre, the latter projects new possibilities for the contemporary cinematic romance. This transnational comparison of two

postromance films calls into question previous claims about the inexorable alienation and empty relationships that plague the protagonists of the Berlin School. Indeed, where *Blue Valentine* cynically announces the impossibility and false promises of Hollywood romances, leaving its protagonists with no alternatives to connect to each other romantically, *Everyone Else* reconfigures that very cynicism into an earnest projection of new possibilities for emotional connection beyond the formulae that have become incommensurable with the postromantic reality of its audiences. Just as Chris and Gitti move through an ironic stance to a sincere emotional intimacy, so, too, does their romance affect us in ways that are as unexpected as they are promising.

Notes

1 See, for example, Cook, Koepnick, and Prager 2013. Emphasizing the "malaise" and "vacuity of life" that pervade the Berlin School films, the authors describe the protagonists of the films as "doleful downcasts" resigned to lives of "ponderousness and pointlessness" in the age of neoliberalism (1, 12–17). While a sense of loss and emptiness is indeed central to the Berlin School aesthetic, here I will focus on the more utopian impulses in Ade's film in its representation of romance and human emotional connection.

2 Cianfrance also believes this scene might have led to the film's initial NC-17 rating. About one month before the film's release, Cianfrance and his lawyer successfully appealed the verdict, resulting in its final R rating. See Watkins 2015.

Works Cited

Abel, Marco. 2010. "Failing to Connect: Itinerations of Desire in Oskar Roehler's Postromance Films." *New German Critique* 109 (Winter): 75–98.

———. 2013. *The Counter-Cinema of the Berlin School.* Rochester, NY: Camden House.

Ascheid, Antje. 2013. "The Romantic Comedy and Its Other: Representations of Romance in German Cinema since 1990." In *Generic Histories of German Cinema: Genre and Its Deviations*, edited by Jaimey Fisher, 243–60. Rochester, NY: Camden House.

Cook, Roger F., Lutz Koepnick, and Brad Prager. 2013. "Introduction: The Berlin School—Under Observation." In Cook et al., *Berlin School Glossary*, 1–25.

Cook, Roger F., Lutz Koepnick, Kristin Kopp, and Brad Prager, eds. 2013. *Berlin School Glossary: An ABC of the New Wave in German Cinema.* Chicago: Intellect.

Hall, Katy. 2011. "Blue Valentine: How Derek Cianfrance Destroyed Michelle Williams and Ryan Gosling's Marriage." *Huffington Post*, February 7. Accessed August 31, 2015. http://www.huffingtonpost.com/katy-hall/blue-valentine-how-derek-_b_819497.html.

Kaussen, Valerie. 2013. "Ghosts." In Cook et al., *Berlin School Glossary*, 147–56.
"Like 'Blue Valentine'? Scarecrow Video Suggests Other Breakup Movies." 2011.
 Seattle Times, January 6. Accessed August 31, 2015. http://www.seattletimes.com/
 entertainment/movies/like-blue-valentine-scarecrow-video-suggests-other-breakup-
 movies/.
Morrow, Martin. 2011. "Review: Blue Valentine." *CBC News*, January 6. Accessed
 August 31, 2015. http://www.cbc.ca/news/arts/review-blue-valentine-1.986492.
Richardson, Michael D. 2013. "Bad Sex." In Cook et al., *Berlin School Glossary*, 41–49.
Scott, A. O. 2009. "Neo-Neo Realism." *New York Times Magazine*, March 17. Accessed
 March 1, 2016. http://www.nytimes.com/2009/03/22/magazine/22neorealism-
 t.html?pagewanted=all&_r=0.
———. 2010. "Chronicling Love's Fade to Black." *New York Times*, December 28.
 Accessed August 31 2015. http://www.nytimes.com/2010/12/29/movies/29
 blue.html.
Silberg, Jon. 2012. "'Blue Valentine': Relationships, Realism, RED." *Creative
 Planet Network*, February 14. Accessed December 20, 2015. http://www.
 creativeplanetnetwork.com/news/news-articles/blue-valentine-relationships-realism-
 red/401912.
Sound on Sight Radio. 2011. "'Blue Valentine' / 'Everyone Else': Sound on Sight Radio
 #255." *Sound on Sight Radio*, January 18. Accessed August 31, 2015. http://
 www.popoptiq.com/sound-on-sight-radio-255-blue-valentine-everyone-else/.
Watkins, Gwynne. 2015. "NC-17 Flashback: Inside 'Blue Valentine's Fight for an
 R Rating." *Yahoo! Movies*, February 13. Accessed December 20, 2015. https://
 www.yahoo.com/movies/nc-17-flashback-inside-blue-valentines-fight-1108412
 40267.html.

3

COUNTERCINEMATIC REFLECTIONS AND NON/NATIONAL STRATEGIES

New Austrian Film and the Berlin School

Robert Dassanowsky

Film studies has long preferred to discuss commercial and art cinemas in isolation from each other or by insisting on one or the other being dominant or even representative within film industries using the same language, usually without sufficient stress on cultural and historical difference. However, the nature of critical postwall era German-language film makes it virtually impossible to examine films of these two categories without comprehending the important resonance and differences that exist between recent countercinematic developments in Austria and Germany. Although Austrian and German filmmakers and performers have always worked across their borders from cinema's inception on, their choices in film genre, style, and content have variously paralleled, reflected, or diverged from each other.[1]

Beginning in the late 1990s, the relatively small Berlin School shunned the choices of the postwall German "nation building" film industry (particularly the historical film) to function instead as a critical countercinema. The results have been mixed in terms of reception. Berlin School directors are not well known by the public, compared to the directors of the German genre-based entertainment cinema, but are applauded by many international filmmakers. In the same era, New Austrian Film also developed as a countercinema, but in a nation without a true commercial film industry. In a span of more than two decades, it has, however, taken on the visibility of a near-national cinema. Nevertheless, despite such different trajectories there are also strong confluences.

Both New Austrian Film and the Berlin School are identifiable from their beginnings in their responses to the destruction of Cold War national cultural

imaginaries and the realignment of their respective nation with a new political Other after the fall of the Eastern Bloc. The Berlin School focuses on social realities and individual identity two decades after German unification; New Austrian Film deals with Austria's reborn relationship with the (post-Soviet) central European region (a spectral, even mythic part of the Austrian republic's cultural/historical identity since 1919). Stylistic choices underscore the thematic ones. Both groups of filmmakers reflect what Marco Abel calls "presentism" in their critical realist visions (Abel 2013, 22), and both are cinemas of hybridity. Both have also been at odds with commercial cinema. Yet the Berlin School has lost popularity for its slow, meditative style and rejection of the financially effective commercial industry formulas (12–14). At the same time, after initially rejecting the *memory* of nation-building entertainment films, New Austrian Film approached topics of urban alienation, migration, and Nazi legacies translated into *Alltagsfaschismus* ("everyday" fascistic behavior), which infamously gave Vienna the reputation of the "world capital of feel-bad cinema" (Dassanowsky and Speck 2011, 1).

Most importantly, the Berlin School and New Austrian Film also initially found stronger critical resonance and cineastic interest outside their countries than inside, with the Austrian films, at least, recognized at international film festivals with awards. Its popularity at home has gradually increased, as it shifted away from a focus on themes of *Alltagsfaschismus* and into more varied topics and forms, including genre film with critical strategies.

Yet such characterizations do not adequately address how critical and popular cinemas may be mutually implicating in understanding a national film production culture and its evolutions. This chapter will amplify such essential comparisons and take up examples of thematic and stylistic elements that cross between the Berlin School and New Austrian Film, using Jessica Hausner's *Lourdes* (2009) and Julian Roman Pölsler's *Die Wand (The Wall,* 2012) as examples. Despite comparisons, the nonpoliticized approach of the Berlin School and its rejection of being a national cinema and the often-politicized counter-cinema-as-cultural-representation of New Austrian Film makes both difficult to tie to specific roles regarding traditional national reflection. The Berlin School positions itself as a true countercinema positioned against the German national mainstream film industry; the New Austrian Film also resists cinematic "nation building," while nevertheless conceiving itself as "national" in rejecting the subsumption of Austrian culture and film into international definitions of the "German." Its favored themes of *Alltagsfaschismus,* migrants, urban alienation, and how Vienna's central European (multicultural) heritage evolves in the post-Soviet era creates a film industry for an Austria that has

finally shed its forced neutrality and joined Europe, but which still questions national identity.

Austria's need to resist Germany and assert its own cultural characteristics is amply demonstrated by the battle between Austria and the mainstream German film industry over which country had the right to nominate Michael Haneke's Austrian/German coproduction of *Das weiße Band: Eine deutsche Kindergeschichte* (*The White Ribbon*, 2010), his *Zukunftsbewältigung* drama on pre–World War I protofascism, for Oscar consideration. Oscar-winning international actor Christoph Waltz poses another such problem. Born in Vienna, he was first claimed in German publicity and press based on his Austrian-German parentage, which the Austrian press took as yet another example of how Austrian talent gets folded internationally into what is seen as a greater German-language (and hence *German*) context. When, in contrast, the Austrian film industry claims "ownership" of transnational filmmaker Michael Haneke, it reframes itself as a national variant of the countercinema New Austrian Film. The Berlin School's identity politics is different. Their most internationally significant director is Christian Petzold, but they would not lay claim to an internationally acclaimed figure such as Haneke because, as Dennis Lim posits, "the notion of the all-encompassing Berlin School obscures the individuality of its supposed members" (Lim 2013, 89). New Austrian Film claims and promotes its visible names, even while retaining an identity as a countercinema. Both cinemas, however, avoid suggesting a tightly manifesto-based collective, as the earlier New German Film of the 1960s had.

Nevertheless, maintaining strict national division in analysis is counterproductive. These two countercinemas share many stylistic elements and narrative tropes and, as noted, take up their positions of resistance in different ways. Moreover, the directors associated with these two movements belie such divisions. For instance, Valeska Grisebach is active and influential in both the Berlin School and New Austrian Film, but she was born in Bremen, grew up in Berlin, and attended the Film Academy Vienna under the early influences of the future lights of New Austrian Film, including Peter Patzak, Wolfgang Glück, and Michael Haneke.

Even internal connections to national cinemas are tenuous. The Berlin School is often compared or contrasted with West Germany's first new wave of the 1960s, the New German Film, which strove, somewhat unsuccessfully, to appeal to audiences in ending "papa's cinema" for critical sociopolitical film. According to Abel, this is a "problematic genealogy," given generation, origin, and filmmaking skills. Moreover, Berlin School films are not always "about, or even set in Berlin" and show a "willingness to encounter spaces outside of Germany's urban centers" (Abel 2013, 11). Christoph Hochhäusler insists that

the entire movement is internationally heterogeneous, "given the elective affinities with filmmakers outside Germany" (26). But the fact remains that the movement has its primary role as countercinema to the mainstream genre (and the largely historical) films aimed at national box-office success and international acclaim, which all too often reduces Germany cinematically "to its totalitarian past(s)" (8).

Hochhaüsler's aesthetic theorization of the critical value of the Berlin School allows the initial step in the comparison between one cosmopolitan German-language countercinema—bearing "a critic's label" and based on the original trio of directors Thomas Arslan, Christian Petzold, and Angela Schanelec (Abel 2013, 151)—with another cosmopolitan German-language countercinema, New Austrian Film, bearing an academic label in rejection of the original "Nouvelle Vague Viennoise" of the 1990s that wrongly tied it both to French experimental filmmaking and the classic Viennese Film (a different set of genres than are actually part of the New Austrian Film). Despite its more political stance, it originated as a cinema of the periphery with similar principles to that of the Berlin School:

> Instead of the decisive moment, for us it is more a matter of before or after, and seldom is the main character a figure who "makes history." Rather . . . it is about characters who stand at the periphery of events, with interior lives the viewer can only speculate about. . . . It is not the plot entanglements that are the most important, but rather the vision, the view of the world. (Hochhäusler 2013, 25–26)

Hochhäusler considers that this principle "is ideally realized in Schanelec's *Marseille* (2004) and in Petzold's *Gespenster* (*Ghosts*, 2005) and *Yella* (2007), his own *Falscher Bekenner* (*I Am Guilty*, 2005), as well as in films by others, including New Austrian Film's Jessica Hausner and the crossover director Valeska Grisebach. Hochhäusler concludes that "even if we do not share a manifesto . . . we are in constant dialogue with each other" (Hochhäusler 2013, 27). Despite such attempts, however, the two film traditions remain quite different in their genealogies and practice.

I.

Like the Berlin School, New Austrian Film can be connected with an overall critical European tradition, whereas the Berlin School is also positioned against what

Eric Rentschler calls the "cinema of consensus" (Rentschler 2000, 275)—the return to a national German film tradition following unification, with distinct mainstream reference. In contrast, New Austrian Film's genealogy comprises specific attack points on Austrian society, politics, and former national film traditions. Despite these differences, both cinemas are transnational in orientation and interested in escaping voyeuristic or sensationalistic reportage, and both aim to destabilize the reductive and totalizing cinema made for the widest market. How they achieve these aims is, however, quite different.

New Austrian Film first became widely known with the unexpected international acclaim of Barbara Albert's *Nordrand* (*Northern Skirts*, 1999), Hausner's *Lovely Rita* (2002), Ulrich Seidl's *Hundstage* (*Dog Days*, 2001), Haneke's *Funny Games* (1997) and *Die Klavierspielerin* (*The Piano Teacher*, 2001), Grisebach's *Mein Stern* (*Be My Star*, 2001), and Ruth Mader's *Struggle* (2003). The filmmakers of this new wave never issued a manifesto, but they had worked on each other's projects as well as in transnational cinema projects outside of Austria (the Austrians Haneke in France and Germany and both Hausner and Albert in Germany; the German Grisebach in Austria). Some of these films also manipulated and subverted familiar genre traditions, which made their critiques more mainstream and allowed them to find success at national and regional box offices where no Austrian film had scored in decades. One of the first such products of countercinema as entertainment film was a tragicomic road picture on urban alienation by Paul Harather, *Indien* (*India*, 1993), which found audiences in Austria, Germany, and across Europe. Others include Stefan Ruzowitzky's anti-*Heimatfilm* allegory on postimperial Austria, *Die Siebtelbauern* (*The Inheritors*, 1998), Harald Sicheritz's rural family comedy, *Hinterholz 8* (1998), and Wolfgang Murnberger's skewing of the thriller genre with critical existential reflection in *Komm, süßer Tod* (*Come Sweet Death*, 2001).

What makes this eruption of socially critical and aesthetically challenging film so unique is the fact that its target production mode and audience were only a distant memory. With the Austrian studio-based entertainment film industry's collapse in the mid-1960s, there had been no mainstream filmmaking of note, and there was no youthful new wave of directors ready to fuse with or replace existing commercial narrative styles, as had been the case in France, England, and Italy. Aside from some experimentation in the mid- to late 1950s and early 1960s, Austrian narrative film had suffered from official disinterest despite Austria's important history as a film nation. Until 1981, for example, there was no national film fund, and so filmmaking moved to television, while theaters shuttered and the Viennese Actionism film of the 1960s and 1970s extinguished narrative structure and style.

West German cinema had a youth movement poised to create a manifesto against "papa's cinema" in the early 1960s. Austrian cinema lacked not only that urgency but also any voice like the New German Cinema's Alexander Kluge promoting the possibility of poststudio Austrian film as a vital national cultural/artistic identifier. In consequence, independent film production in Austria during the 1970s and '80s offered minor, local/regional attempts at neorealist aesthetics that found only small audiences. A few big-budget international coproductions recalled the opulent imperial epics of the 1950s studio era, but these set no national artistic or sustainable market example. Only in the 1980s were some critical Austrian filmmakers influenced by the West Germany's *Autorenkino* of the 1970s to fuse critical/political narratives with studio-era aesthetics in period films that first attempted to deal with political aspects of the recent past.

Valie Export's *Die Praxis der Liebe* (*The Practice of Love*, 1985) shifted a traditional Hitchcock thriller into a feminist/existentialist examination of a woman discovering her limitations in the media world; Niki List offered the postmodern neo-noir pastiche *Müllers Büro* (*Muller's Office*, 1986); and Haneke's early dystopic family dramas, such as *Der siebente Kontinent* (*The Seventh Continent*, 1989) and *Benny's Video* (1993), deconstructed familiar film genres. In short, the early New Austrian Film of the 1990s did have distant recollections of the 1950s and 1960s to use in establishing their counterpolitics but no actual dominant cinema (aside from film imports) against which to revolt. For this reason, Austrian countercinema emerged at the turn of the century as stylistically diverse and interested in topical themes of its day: *Alltagsfaschismus* and xenophobia, migrants, and urban/suburban alienation.

Nevertheless, by the early 2000s, Haneke, like Petzold in the Berlin School, revised genre film by using art house strategies to examine European social issues, and Seidl brashly attacked the sociopolitics of the suburbs. Female filmmakers—Albert, Mader, Hausner among them—emphasized a meditative and peripheral cinema to deal with the topics of migration, alienation, and personal crisis beyond politics. Dennis Lim's "feel-bad cinema" (Dassanowsky and Speck 2011, 1) rapidly became Ed Halter's New Austrian Films that are "quiet, cool, and subjective . . . [achieving] a detached, contemplative air so rarely attempted by overcompensating American cinema, communicating a bittersweet beauty through the simple evocation of interior life" (Halter 2003).

II.

The Berlin School, self-defined as a European cinema based in Germany, is indeed made in the German language and by a majority of filmmakers with

German nationality, but since it does not function as a "national" cinema, it has no pretentions of ownership regarding its transcultural artists. For instance, Benjamin Heisenberg's film *Der Räuber* (*The Robber*, 2010), a German/Austrian coproduction associated with the Berlin School, based on the life of an Austrian marathon runner and bank robber, and shot in Vienna and Lower Austria, stimulated no such territorialism. As a "member" and sometimes spokesperson for the Berlin School, Heisenberg nonetheless wishes to continue to film in Vienna, this "fantastic cinema city" (Dassanowsky 2012).

Stylistically, Heisenberg's work also shares traits with the New Austrian Film: he avoids establishing shots or focusing on recognizable landmarks to concentrate on a narrative that is both universal and specific. With this choice, he rejects the option of marketing postwall Germany for the sake of nation building, as well as the 1950s and 1960s Austrian commercial films' iconic Vienna that served Austria in the same way. Instead, Heisenberg's non-Vienna displays the "anti-Hauptstadt" strategy of the Berlin School (ambivalence toward iconic urban space, particularly in Berlin because of its association with postwall nation building) and the trope of the "Ghost" (avoiding or reframing politically overcoded historical structures) (Cook et al. 2013). Austrian spectators should scarcely recognize the film's locations; it is as if the suburban parks, faceless communities, and narrative vantage points might be anywhere in central Europe.

Even when actor Andreas Lust reenacts his character Johann Rettenberger's[2] victory at the 2008 Vienna city marathon, which concludes at the famous Heldenplatz, the shots are kept so tightly focused on the actor that the monumental Hofburg palace remains invisible. Heisenberg knows that even one quick shot of that building would undermine the intense cinematographic scrutiny of Rettenberger by diluting it with touristic familiarity and historical reference. His camera lingers instead on Rettenberger's puzzling life and self-absorbed monomania instead of gesturing toward politics. Given the necessity of the film's realism, the audience does catch a glimpse of the Burgtor entry to the Heldenplatz behind Rettenberger's arrival. But it is a "ghost," easily overshadowed by the strength of the character's visible joy in running and in his victory. It may also signal a blending of the two, as Todd Herzog explains: "At the end of the film he sits in a car on the side of the Autobahn somewhere in Lower Austria. What is he thinking? What does he want? We never learn. Rettenberger is conflicted and inscrutable—just like the Heldenplatz" (Herzog 2012, 120).

Heisenberg's *The Robber* is thus a film that can easily be considered a commentary on the Austrian topic of *Alltagsfaschismus*, sharing certain narrative

conventions and aesthetics with the New Austrian Film. In fact, the film opens in prison, with a quasi-establishing shot of the institution that can also function as a synecdoche for Austria: Rettenberger's point of view as an imprisoned Austrian signals something like Heisenberg's outsider view of New Austrian Film's position on the *Alltagsfaschismus* as a sociocultural "sentence." And unlike the cliché violence and physical and emotional destitution that so identifies prison life across commercial and Hollywood-influenced international film, his jailers have a benevolent attitude toward him, and he seems quite fulfilled by his daily training in the yard and on his personal treadmill.

But this running "nowhere" (treadmill) or in circles (prison yard) is, of course, only practice for the running of escape, which is part of his life as a bank robber. While his probationary officer (Markus Schleinzer, an Austrian actor familiar from the New Austrian Films of Haneke and Ruzowitzky) truly cares for Rettenberger's post-prison growth into a useful and employed member of society, Rettenberger's demand to be left alone and desire to escape the new patterns expected of him results in his abrupt killing of the officer. Thus, he appears as an outlaw but also someone in conflict with *Alltagsfaschismus*. Heisenberg's film destabilizes, even deconstructs, a static definition of or monolithic (Austrian) point of view regarding *Alltagsfaschismus* in the same way that he "shows" Vienna—by rupturing any possible cliché trope of the city. In such details, films from two different avant-garde cinemas both engage in what Jean-François Lyotard (1979) defines as postmodernism's multivalence—the collapse of the totalitarian theories of grand narratives, which are replaced by personal perspectives.

Both the New Austrian Film and the Berlin School desire to obliterate the modern "grand" locations of big box shopping centers, immense parking lots, decentered working and living environments, that turn so-called mass urban accessibly into alienating, even dehumanizing experiences and can "turn the loss of an automobile, or of mobility in general, into an existential crisis" (Cook et al. 2013, 104). New Austrian Film adds to this experience of dislocation the insecurity of "migrants who find themselves lost in the generic public spaces: shopping mall, subways, train stations and public parks or squares. These transient spaces foreground the impermanence and the fragility of the migrant's status" (Sathe 2012, 107).

The irony both cinemas share arises from the fact that the Austrians or other "privileged" Europeans are themselves lost in these spaces and are also targets of dehumanizing surveillance cameras, as seen in Seidl's *Dog Days*, Albert's *Northern Skirts* and *Böse Zellen* (*Free Radicals*, 2003), Jörg Kalt's *Crash Test Dummies* (2005), Haneke's *Caché* (2005), and so on. They confront the false promise of comfort and personal liberation in the kitsch "Dorfdisco," a trope in both Berlin School and New Austrian Film. There, in the nostalgia of the dated music and

decor, and evoking unresolved memories of problematic pasts, communication is stifled, and alienation rather than conviviality is built. This "entertaining" space reveals itself to be as dehumanizing and as empty of meaning as generic exterior public spaces. And while "bad sex" is considered a trope of dislocation in Berlin School film (Cook et al. 2013, 41–49), it is bad sex *exploitation* linked to the migrant theme that generates particular social criticism in New Austrian Film and that along with *Alltagsfaschismus* separates it from the Berlin School as a cinema of the nation if not a national cinema.

For example, Seidl's controversial *Import/Export* (2007) follows both a Ukrainian nurse, who supplements her meager income as an Internet sex performer, and an Austrian security guard, who is handcuffed and stripped by Turkish thugs and is forced to watch his stepfather humiliate a Ukrainian prostitute; Barbara Gräftner's *Mein Russland* (*My Russia*, 2002) features a former Russian stripper who is blackmailed by her Viennese mother-in-law, and Michael Stürminger's *Hurensohn* (*The Whore's Son*, 2004) focuses on a young Croatian migrant in Vienna who discovers that his mother's prostitution is the only thing keeping them from the Balkan wars.

Ruth Mader's *Struggle* (2003) uses the migrant sex-exploitation trope from New Austrian Film, moves into the "bad sex" trope of the Berlin School, and locates the narrative in the generic spaces of both film schools. It follows both a Polish woman (Aleksandra Justa) who has moved to Austria to work in a variety of menial jobs in order to better provide for her young daughter and a wealthy, divorced Austrian who seeks diversion from his unfulfilling life with sex and sadomasochism; the two ultimately meet in a swinger's club. Abandoning a classical narrative for the sake of an "anti-dramatic" exploration of the dehumanization and alienation of various work environments, the film also relates the collision of two classes and geopolitical worlds: the woman represents the impoverished yet hopeful Eastern Europe, the man embodies a hollow consumerist and "emotionally bankrupted" West (Dassanowsky 2005, 281).

The New Austrian Film attempts to find allegories for Vienna's new "opening" to the East (the former Soviet Bloc with its cultural memories of Austria-Hungary's imperial ethnicities) with its resonance on xenophobia; it does so, however, without romanticizing the concept of the *Kulturstaat*, which has since 1919 theoretically expanded Austria beyond its geographic/political borders through its central European cultural influences and links. In contrast, the Berlin School wrestles with the actual meanings of German unification (equally an "opening" to the East) and rejects the postwall totalization in national film culture.

III.

A direct link between the "canonical" New Austrian Film and the Berlin School is to be found in the work of Austrians Albert and Hausner and the German-born Grisebach. Catherine Wheatley (2011) asserts that Hausner has refashioned the iconography of the *Heimatfilm* in *Lovely Rita* and *Hotel* (2004). Austrian filmmaker Ruzowitzky did this as well, albeit in historical and traditional *Heimatfilm* garb in *The Inheritors*. There it functions as an allegory of political control and as a narrative based in the class struggle and violent oppression in interwar Austria moving toward fascism (Dassanowsky 2005, 241–49). It is mirrored with similar intentions by Haneke's pre-World War I allegory, *The White Ribbon*, which also uses new *Heimatfilm* structure in its depiction of small-town traditionalism and repressive social expectations as the seeds of German fascism.[3] Grisebach's *Sehnsucht* (*Longing*, 2006) should also be associated with the revised *Heimatfilm*, according to Wheatley (2011). Both Hausner and Grisebach represent a particular feminine aesthetic in New Austrian Film, with Grisebach, as has been pointed out earlier, as the German crossover talent from the Berlin School.

Hausner and Albert, the latter particularly in *Northern Skirts* and *Fallen* (*Falling*, 2006), share the concept of the nonjudgmental/voyeuristic static camera with Grisebach, refusing to support traditional or simplistic binary character traits, rejecting, for the most part, a politicization of theme and offering meditative narratives that remain unresolved (even when death seems foretold as in Grisebach's *Longing*) (Wheatley 2011, 143)—aspects that are hallmarks of the Berlin School. Both Hausner and Grisebach leave more to the imagination than their male counterparts in the Austrian new wave. As Wheatley succinctly puts it, even with the more political or "exaggerated" form of reflexivity in Mader's *Struggle*, these films "do not tell, they show" (145). Functioning essentially as a female countercinema within New Austrian Film, they demonstrate Hélène Cixous's concept of "gift economies" (Wheatley 2011, 146), in which the spectator is not expected to reach a totalizing conclusion based on the film's presumed "meaning." Such postmodern multivalence should elicit meditation rather than the victory of a theory or the obliteration of an ideology. Robert Weixelbaumer (2006), however, still posits that political "meaning" remains a general interest of New Austrian Film—as a movement that resists becoming national cinema but underscores the nation in preserving its difference from dominant German cinema, even the Berlin School. Grisebach's difference from her crossover relationship with the Austrian or "Vienna" School, so to speak, is this disinterest in supporting any thesis—or "preformatted thoughts" (Abel 2013, 230; Weixelbaumer 2006, 17). There is also a

strong female presence and gender-based thematic influence in what represents the canonical Berlin School in addition to Grisebach: Angela Schanelec, Maren Ade, Maria Speth, and the South African–born Pia Marais.

Hausner, however, shows that she can approach more deliberate "genre" film structures and be as narratively elliptical and inconclusive as Grisebach. Considered by Grisebach as her closest colleague (Abel 2013, 230), Hausner strongly displays the trait of the Berlin School's "modesty" in filmmaking even when she approaches a potentially highly melodramatic narrative, as in *Lourdes* (2009). Her focus on the postmodern Lyotardian individual or "small" narratives over the grand narratives, which continue to be the basis of commercial films the Berlin School also rejects, intentionally undermines what initially seems to be a strong pastiche of the woman's picture, the religious film, and the documentary. Despite the use of Lourdes as a subject of visual pleasure and intrigue (its structures, rituals, character traits, uniforms, colors, and such) that remind one of Hausner's previous use of Hitchcockian and Kubrickian elements, particularly in *Hotel*, the film resists establishing shots and traditional exposition. We never know who the paraplegic central character Christine (Sylvie Testud) is beyond what we glean from her ambiguous gazes or what has brought her to Lourdes beyond her desire to travel, a daunting prospect for her without the assistance of religious organizations. We only learn that she has previously made a similar religious/cultural trip to Rome, where she first met Kuno (Bruno Todeschini), the handsome Order of Malta volunteer at Lourdes and the object of her desire.[4]

As in Berlin School practice, the spectator gets to know an impressionistic present, not a past that manipulates the "political" values of that present or the suggestion of a future with closure. In an interview on *Lourdes*, Hausner suggests her influence from Austrian Magical Realist art and literature (regarding the unexplained "healing" of Christine) but also a clear methodology that demonstrates her melding of New Austrian Film topics such as Catholicism[5] and Berlin School concepts in positing a multivalent but "presentist" ambiguous realism (Hausner 2015).

Karina Longworth suggests that "part of *Lourdes*' appeal is the extent to which Hausner and Testud refrain from demystifying the mystical. . . . The word 'meaning' is often used to refer to a vague something to strive for. 'Meaning' proves to be as elusive to find as the concept is ill-defined" (Longworth 2010). A reframing of Hitchcock's strategies, particularly the plot MacGuffin, to create a collision of characters facing psychological truths is a central part of Hausner's New Austrian filmmaking, but in *Lourdes*, like in *Hotel*, she also mocks Hitchcock's visual coding (costume, color, character archetype) as a decoy that denies information and thus certainty and leaves causality untraceable.

As is the tendency in the Berlin School, the core of *Lourdes*' realism is found in the continuous and often meditative exchange of the gaze, which subverts the sparse dialogue as pure visual-intuitive language that is both highly subjective and ambiguous to the characters and the audience. The "miracle" of Christine's sudden healing from multiple sclerosis is not the film's point. It is the litany of Christine's gazes (and gazes on her and those she follows on others) of envy and desire captured by a distant, documentarian camera, that teases our spectatorial longing to understand what is behind them. Hitchcock's wheelchair-bound character of Jefferies (James Stewart) in *Rear Window* (1954) telescopes our voyeurism to a resolution point and thus mimics the very attraction and psychology of cinema. There is no certainty that can be learned in Hausner's similar link with the central character's gaze on the drama that swirls around her; there is no murder to be solved, no lover to ultimately comprehend. Nevertheless, the film's character constellation is patterned on *Rear Window*: instead of a murder, the stern Order of Malta head nurse drops dead of an unexplained illness, which she has stoically kept secret; Christine's roommate, Frau Hartl, takes on a motherly role, interceding and caring for her without having been asked to do so—both recall different aspects of Thelma Ritter's nurse characterization (maternal and adamant) in the Hitchcock film; and the exchanges of cautious desire between Christine and Kuno ultimately manifest in open attraction at the dance, just as Jefferies moves beyond his wheelchair and suggested sexual dysfunction and embraces Lisa's (Grace Kelly) seduction (fig. 3.1).

One of the film's most compelling scenes is not one that suggests the internal conflict and frustration of Christine as paraplegic, or one that occurs in the usual spaces of the film—her shared bedroom with Frau Hartl, the communal dining area, the church, or any of the external locations in Lourdes or on group excursions. It is a symbolic moment in the life of the newly "healed" Christine, captured by the usual static camera that would show her enigmatic glances aimed at those who moved around her. She is enjoying a glass of ice cream confection at a table on a terrace café. The day is clear and sunny, and as she eats, she gazes directly at Kuno, who sits at an adjacent table and is now clearly aware of her desiring glances. Christine's sensual enjoyment of her new physicality and her visual pleasure of Kuno is also a countercinematic rejection of the emotionality of romantic dominant cinema for a single minimalist, even prosaic mise-en-scène.

Christine's denouement consists of a new set of gazes that unravels what she believes she has learned in her resurrection as a physically functioning woman, and the audience is left with the unresolved question of her sudden fall dancing with Kuno and her return to the wheelchair. She is clearly suppressing disappointment and the experience of what her body is telling her. Her hand stiffens into

Figure 3.1 *Lourdes*

its previously crippled shape. Is she simply exhausted from the strain of sudden physical exertion after having been immobile so long? Has the paralysis returned? Enigmatic emotions wash over her face in the final moments of the film. Does she consider herself the Cinderella who had the dance with the "prince" and now must return to her limited, inescapable world of being the Other? *Lourdes* is in fact as metafilmic as *Rear Window*, but with existential choice problematized and the cinematic propaganda of certainty detached. This rejection of "identificatory emotionalization," as Heisenberg considers it (Cook et al. 2013, 165), makes interiority one of the key components to films following Berlin School influence. Protagonists are "both stylistically and narratively" portrayed "from the outside, so to speak, and their actions often remain unexplained—if not inexplicable—in psychological terms" (165). In Hausner, as in the films of leading Berlin School artist Christian Petzold, for example, this "aesthetics of reduction" (Abel 2013, 15) employs Hitchcockian frames to attain the opposite of Hitchcock's psychological eviscerations and thus frustrate spectatorial (in and outside the film) expectations with a lingering postfilm challenge to identify and interpret this ambiguous realism.

Hausner's *Amour Fou* (2014) is a reaction to the documentary flavor of *Lourdes*. In addition to the interiority of the characters, it locates an "anti-identificatorial emotionalization" mode in such mannered, understated performances and such a reductive visual style (sparse furnishings, tight shots, static camera) in order to avoid commercial bombast and the melodramatic qualities of the costume drama. Although not in the service of "nation building," the historical setting reflects the wider temporal range of New Austrian Film, which would

have placed the film outside the strict "presentist" characteristics of the early Berlin School. The latter movement, however, has recently also moved its gaze toward the past in such films as Petzold's *Barbara* (2012) and *Phoenix* (2014) as well as Arslan's *Gold* (2013). Hausner's film follows the formalism and slow, contemplative mood for which the female directors of New Austrian Film are known and on which the Berlin School insists. Unlike the filmic simulacrum of *Lourdes*, *Amour Fou* aims for visual pleasure in the slow unfolding tableaux of group scenes that recall the balance and harmony of neoclassical painting. It bases its narrative "truth" on writer Heinrich von Kleist's (1777–1811) obsession with finding a woman to commit suicide with him as a form of melancholic partnership in lieu of locating a satisfying love life. As an astringent period piece, Hausner shuns the emotional manipulation of contemporary commercial German period artist melodramas such as *Goethe!* (*Young Goethe in Love*, 2010), which are geared to audience identification and maintain heroic/propagandistic elements from UFA's National Socialist German-genius films (*Friedrich Schiller—Der Triumph eines Genies, Friedrich Schiller*, 1940; *Friedemann Bach*, 1941, and so on) or the Austrian nation-building biopics of the postwar era (*Seine einzige Liebe, Schubert*, 1947; *Eroica*, 1949; *Mozart, The Life and Loves of Mozart*, 1955). Hausner's dialogue is sparse ("showing" not "telling"), and most importantly, her film's station-drama of constantly distanced and alienated relationships composed of often enigmatic gazing inhibits narrative climax and avoids catharsis, thus disallowing a false nostalgia in the spectator. Irony is the central theme, reflecting the writings of Kleist, wherein nothing is certain until (as in Hitchcock) resolution of the plot conflict reveals a disturbing message couched in a pre-psychological awareness of human self-consciousness.[6] Henriette's (Birte Schnoeink) acceptance of Heinrich's (Christian Friedel) suicide pact is devalued for him when he learns that her decision is predicated simply on her terminal illness and not for any idealistic conviction. The characters' unemotionally absorbed after-the-fact discovery that Henriette was not seriously ill destabilizes the narrative to the point where, as in *Lourdes*, the audience is left to decipher the interactions and ponder human desire rather than glean moralistic lessons or, in this particular film, fictive and totalizing "knowledge" about historical figures and their times.

The work of Julian Roman Pölsler, an Austrian filmmaker not previously associated with the Berlin School and new to Vienna's cinema scene, indicates that the "female aesthetic" ("people not politics") of the New Austrian Film is not gender specific. His nearly one-woman drama of *The Wall* is a lexicon of characteristics associated with the Berlin School—visual and narrative reduction, sparseness of dialogue, interiority, intensity of landscape and forest shots, surprising violence, importance of ambient sound, including wind and aspects of

nature in general, and a disturbingly inconclusive but therefore "realistic" ending. Indeed, the film's narrative may be one of the more perfect cinematic settings for demonstrating the style's ambiguity of reality. Based on the 1963 novel by Austrian writer Marlen Haushofer, which was long deemed "unfilmable" (Presseheft 62 2012) because of its strong metaphoric nature, this Austrian coproduction with Germany has as its core an enigmatic performance by mainstream German actress Martina Gedeck.[7] Her casting seems calculated to present a "star" film to generate box-office earnings, an aspect that with few exceptions continues to elude Berlin School film and to some extent even the second wave of New Austrian Film. The simple but hauntingly apocalyptic plot regards a woman (whose name we never know) traveling with her presumed friends, an older married couple, to their lodge in the Austrian Alps; upon waking the following morning, she finds that her friends have not returned from their dinner in town. Left behind only with their dog, she discovers that her space is limited to an indefinite area isolated from the rest of the world by an invisible wall through which she can, however, see a couple frozen in time.

The film depicts the character's stages of shock and depression as she deals with isolation, her growing attachment to and identification with the animals (dog, cow, calf, cats, bird) that become her sole companions, her conflicted need to kill for food, and her adjustment to the patterns of nature and the seasons. The writing of her "diary," on scrap paper, serves as the film's voice-over narration. Her external and internal qualities are significantly altered in the period of two to nearly three years the film covers. From a fussy, stylishly attired urban woman, who has little regard for communication with her friends or appreciation for their active lifestyle, she de-socializes into an almost gender ambiguous human, garbed in the male clothing she finds in the lodge and living off the land as if she had never known civilization. After suffering through winter, her second summer spent on the high pasture with her animals brings a first calmness to her in a "return" to nature, and she writes that she has a feeling of "being absorbed into a greater whole" (Greiner 2012). The following spring, a man suddenly appears and brutally kills her cow's calf and then her dog. She shoots him with her rifle without exchanging a word, and in avenging the death of her animal companions, she ends the possibility of her only potential human contact. Mourning her beloved dog as a dead friend, she is again nearly crippled by loneliness, but her life begins to follow the patterns of the environment and she moves actively into the autumn, harvesting her fruit and potato garden. The narrative abruptly ends as she runs out of paper early the following year.

The symbiosis of the Berlin School/New Austrian Film styles in *The Wall* is effective in Pölsler's intent to undermine the audience's desire to emotionally

identify with the character for the purpose of reducing the uncertainty of the narrative, although there is initially the lure of recognition based in science fiction films dealing with intense isolation. But the strong formalism, visual language, and the meditative "presentism" disrupts any preconceived spectatorial strategies to deal with what at first might be considered an apocalyptic horror story as it concentrates on the unpredictable and inconclusive realism of the character's predicament. It is not surprising that this style and its attempt at a-representational cinematic realism (Abel 2013, 14–20) confounds American critics. The *Hollywood Reporter* praised the cinematography of the Alpine landscape as "stunningly beautiful" but expressed its disturbance by the fact that the central character was lacking in any "back story" and that the film's concluding "tonal shift is unsatisfyingly awkward" (Young 2012). *Variety* also considered the aesthetics of reduction and the interiority of the character to be "uncomfortable" and considered, no doubt with only traditional cinematic totalization in mind, that the "images and voiceover never quite fuse into a single whole" (van Hoeij 2012). German critics gave this example of a second wave New Austrian Film the same thoughtless dismissal that the Berlin School has previously suffered (Greiner 2012), but the Austrian critics, having no traditional expectations, were open to the film. They considered it a virtuoso performance in a visually stunning presentation of an important work in modern German-language literature (Presseheft 62 2012). The Fachverband der Film- und Musikindustrie subsequently voted it as Austria's entry in the 2014 Oscar foreign language film category.

What is clear is that Pölsler's film follows the Berlin School's focus on the individual human body and psyche, which is *The Wall*'s central conduit to the audience, allowing a comprehension of the central character beyond even her diary. The film ends with the interruption of that diary, but the story does not as it coolly fades out on the woman, whose situation has dissolved all previous borders of identity and life. Is this the dream world of a coma victim or catatonic patient? (fig. 3.2). Is this an allegory of purgatory, of nuclear destruction (given the year of the novel), or even of Austria's postwar "stepping out of history" to avoid *Vergangenheitsbewältigung* (coping with the past)? Like Irene disappearing into the forest in Hausner's *Hotel*, what, if any, sociopolitical meanings are to be understood from these fade-outs? This is a particularly important question in a new Austrian cinema born to confront the fantasies of nostalgia and to comprehend the multifaceted meanings of space and identity in a country that has had as difficult a history as Germany (some of it shared) and five different political iterations in the last century.

While the Berlin School has drawn Austrian and Austrian-trained filmmakers into its film theoretical stratagems, there are indications that the metaphysical

Figure 3.2 *Die Wand*

aspects that directly question perception and stem from Austrian Magical Realism (itself sprouting from a mix of surrealism and Catholic mysticism) have added an additional aspect to its characteristic a-representational meditative realism. This ranges from the "butterfly effect" that governs Albert's early *Free Radicals* to the unexplained healing in *Lourdes* and the mystery of *The Wall*. Moreover, Hausner has shown that her affinities with the Berlin School can reframe period histori-cal film (and in particular, the biopic) into providing the same level of critical challenge as contemporary narratives in *Amour Fou*.

As New Austrian Film begins to diverge from its strict core style and original topics into a genre cinema comfortable using art house critical strategies with-out embracing the status of a traditional national cinema (for example, Veronika Franz and Severin Fiala's *Ich seh, ich seh* [*Goodnight Mommy*, 2014]), there is also a renewal of the stricter countercinema quality that New Austrian Film represented in the 1990s and early 2000s. This renewed form appears to particularly embrace the meditative qualities that were already apparent in the films of female directors and that also reflects the style and form of the reductive and minimalist realism—the "spatiotemporal specificity" (Abel 2013, 297)—of the Berlin School.

Certainly, the Berlin School claims its identities through its directors, since it is not a movement in the traditional sense, but a network of artists of dif-fering modalities who are less concerned with the past and its exploitation in German national film than with a meditation on lives and the present—even as reflected through historical setting. New Austrian Film was originally concerned with both past and present, or more specifically with how the past has shaped the

Austrian present, a past that had been largely avoided in popular discourse in favor of a concentration on *Alltagsfaschismus*, social repressions, and xenophobic reception of migrants. It has moved beyond this strict canonical sociopolitical critical narrative (but may possibly renew this national critique in examining the Syrian refugee/migrant crisis) without desiring to create a dominant national cinema.

Still, New Austrian Film remains a cinema from the Austrian nation, which insists on its historical/cultural difference and uniqueness within the whole of German-language film, even with its transnational (German among them) co-production norms. It has used the cinematic language that it often shares with the Berlin School as a countercinema and directly with the aesthetics of specific Berlin School filmmakers who cross over. The strongest impulse that brings aspects of these two cinemas together remains the desire not to recreate the real but to render all forms of discourse visible, diverse, and unfixed.

Notes

1 Recent analysis cogently demonstrates, for example, that the *Trümmerfilm* or rubble cinema emerging from the collapse of the Third Reich takes on vastly different qualities in the two countries under Allied occupation, and that, despite critics' assertions, Austrian cinema did in fact *not* avoid the genre itself, even as it rejected the option of replicating the style and content of the genre used in Germany. Acknowledging such difference expands and redefines the genre by factoring in cultural difference and continuities within national cinematic contexts (Randall 2015).

2 The character is based on the 1980s Austrian criminal Johann Kastenberger.

3 This also recalls Volker Schlöndorff's New German Film treatment of the Austrian roots of fascism in pre-World War I repression and sadism in *Der junge Törless* (*Young Törless*, 1966) based on the Robert Musil novel.

4 European Order of Malta member volunteers are often members of the wealthy Catholic bourgeoisie, or the nobility, which have a tradition of service to the order.

5 Ulrich Seidl has examined this in his critical documentary *Jesus, Du weisst* (*Jesus You Know*, 2003) and in his feature, *Paradies: Glaube* (*Paradise: Faith*, 2012). Wolfgang Murnberger uses a more popular/television aesthetic in mounting Wolf Haas's novel about crime involving Salzburg's Catholic community in *Silentium* (2004).

6 Kleist considers human self-consciousness as the root of doubt and internal conflict caused by the lack of harmony between feelings (emotion/reaction) and thought (ideas) in *Über das Marionettentheater*. Consider the unexpected twist in climax/endings throughout his oeuvre in such works as *Der Zerbrochener Krug, Das Erdbeben in Chili, Die Marquise von O, Michael Kohlhaas*, etc.

7 She has appeared in four of the variously successful postwall German mainstream films: Sönke Wortmann's *Der bewegte Mann* (*Maybe . . . Maybe Not*, 1994), Sandra Nettelbeck's *Bella Martha* (*Mostly Martha*, 2001), Florian Henckel von Donnersmarck's *Das Leben der Anderen* (*The Lives of Others*, 2006), and Uli Edel's *Der Baader Meinhof Komplex* (*The Baader Meinhof Complex*, 2008). Her film work has garnered national and international awards, and she is also active in theater, television, and Germany's Green Party politics.

Works Cited

Abel, Marco. 2013. *The Counter-Cinema of the Berlin School.* Rochester, NY: Camden House.

Cook, Roger F., Lutz Koepnick, Kristin Kopp, and Brad Prager, eds. 2013. *Berlin School Glossary: An ABC of the New Wave in German Cinema.* Chicago: Intellect.

Dassanowsky, Robert. 2005. *Austrian Cinema: A History.* Jefferson, NC: McFarland.

———. 2012. Introduction to *World Film Locations: Vienna*, edited by Robert Dassanowsky, 5. Bristol: Intellect.

Dassanowsky, Robert, and Oliver C. Speck. 2011. "New Austrian Film: The Non-Exceptional Exception." In *New Austrian Film*, edited by Robert Dassanowsky and Oliver C. Speck, 1–20. New York: Berghahn.

Greiner, Ulrich. 2012. "Film 'Die Wand'": Zurück zur Natur. Zeit Online, October 11. http://www.zeit.de/2012/42/Film-Die-Wand.

Grisebach, Valeska. 2013. "The View from Here." In *The Berlin School: Films from the Berliner Schule*, edited by Rajendra Roy and Anke Leweke, 68–73. New York: Museum of Modern Art.

Halter, Ed. 2003. "Das Experiment." *Village Voice*, November 12–18. http://www.villagevoice.com/2003–11–11/fi lm/das-experiment.

Hausner, Jessica. 2015. "Interview with Dave Calhoun." *Time Out London.* Accessed December 1, 2015. http://www.timeout.com/london/film/jessica-hausner-on-lourdes-1.

Herzog, Todd. 2012. "*The Robber/Der Räuber.*" In *World Film Locations: Vienna*, edited by Robert Dassanowsky, 120–21. Bristol: Intellect, 2012.

Hochhäusler, Christoph. 2013. "On Whose Shoulders: The Question of Aesthetic Indebtedness." In *The Berlin School: Films from the Berliner Schule*, edited by Rajendra Roy and Anke Leweke, 20–31. New York: Museum of Modern Art.

Lim, Dennis. 2013. "Moving On: The Next New Wave." In *The Berlin School: Films from the Berliner Schule*, edited by Rajendra Roy and Anke Leweke 89–96. New York: Museum of Modern Art.

Lyotard, Jean-François. 1979. *La condition postmoderne: Rapport sur le savoir.* Paris: Minuit.

Longworth, Karina. 2010. "Jessica Hausner's *Lourdes* Refrains from Demystifying." *Village Voice*, February 6. Accessed December 1, 2015. http://www.villagevoice.com/film/jessica-hausners-lourdes-refrains-from-demystifying-6392978.

Presseheft 62. 2012. International Filmfestspiele Berlin. *Die Wand.* Accessed December 1, 2015. http://www.austrianfilm.at/assets/Die%20Wand/DW-PRESSEHFT-web. pdf.

Randall, Amanda Z. 2015. "Austrian Trümmerfilm?: What a Genre's Absence Reveals about National Postwar Cinema and Film Studies." *German Studies Review* 38 (October): 573–95.

Rentschler, Eric. 2000. "From New German Cinema to the Post Wall Cinema of Consensus." In *Cinema and Nation*, edited by Mette Hjort and Scott Mackenzie 260–77. New York: Routledge.

Sathe, Nikhil. 2012. "The Spaces of the Other Vienna in New Austrian Film." In *World Film Locations: Vienna*, edited by Robert Dassanowsky, 106–7. Bristol: Intellect, 2012.

van Hoeij, Boyd. 2012. "Review: *The Wall.*" *Variety*, February 18. Accessed December 1, 2015. http://variety.com/2012/film/reviews/the-wall-1117947117/.

Weixelbaumer, Robert. 2006. "Ich würde alles für dich tun: Valeska Grisebachs grosser Liebesfilm *Sehnsucht.*" *Kolik Film* 6: 15–20.

Wheatley, Catherine. 2011. "Not Politics but People: The 'Feminine Aesthetic' of Valeska Grisebach and Jessica Hausner." In *New Austrian Film*, edited by Robert Dassanowsky and Oliver C. Speck 136–50. New York: Berghahn.

Young, Neil. 2012. "*The Wall:* Berlin Film Review." *Hollywood Reporter*, February 12. Accessed December 1, 2015. http://www.hollywoodreporter.com/review/the-wall-berlin-film-review-289770.

4

"LIFE IS FULL OF DIFFICULT DECISIONS"

Imaging Struggle in Henner Winckler's *Lucy* and Kelly Reichardt's *Wendy and Lucy*

Will Fech

"What kind of movies do we need now?" asked *New York Times* film critic A. O. Scott in a March 2009 column. It wasn't a flippant question for the United States then, a country snagged in a "swirl of post-9/11 anxiety and confusion" (Scott 2009b) wrought by heightened terror threats, increased government surveillance, economic insecurity, and a sharply divided electorate. Scott's article (and his answer)—"Neo-Neo Realism"—put words to a refreshing trend in off-mainstream US cinema that he claimed could help moviegoers shake off their malaise. But the films he argued for seem unlikely candidates for collective uplift. Mostly festival darlings with limited popular circulation, they depict marginalized or downcast characters whose everyday struggles contrast sharply to Hollywood "Dream Machine" fare: Ramin Bahrani's *Man Push Cart* (2005), *Chop Shop* (2007), and *Goodbye Solo* (2008); Anna Fleck and Ryan Boden's *Sugar* (2008); Lance Hammer's *Ballast* (2008); So Yong Kim's *Treeless Mountain* (2008); and Kelly Reichardt's *Wendy and Lucy* (2008).[1]

Taking his cue from another film event born from the rubble of disaster, Scott wrote that these movies evoked well-known post–World War II Italian classics rendering precarious lives of working-class people via means commonly if problematically cataloged as "realist": the use of unknown or nonprofessional actors, unadorned on-location shooting, long-take cinematography, and so forth. By no means an organized philosophical or aesthetic movement among filmmakers, the US batch of films Scott lauds nonetheless "[expanded], modestly but with notable seriousness, the scope of American filmmaking" (Scott 2009b) by telling stories not often heard by mainstream audiences. Their subjects—whether an

immigrant athlete's difficult assimilation into new surroundings (*Sugar*) or homeless kids living among junk heaps (*Chop Shop*)—were for Scott a welcome cinematic "antidote" to "magical thinking ideologies" promoting escapism from post-9/11 fears of terror, poverty, and strife. Comic book heroes and orphan Indian millionaires[2] gave a fatigued country something to cheer for in what *Time* magazine dubbed "the Decade from Hell" (Serwer 2009). But a different cinema cast long, necessary looks at a grimy reality under the glitzy surface. "American film," Scott announced with relish, "is having its Neorealist moment, and not a moment too soon" (Scott 2009b).

Not everyone agreed with Scott's coronation (a point I'll return to), but it offered the first appraisal of a body of films operating counter to mainstream escapist releases, a position it shares with the Berlin School of Germany. The origins of the Berlin School have been discussed elsewhere, but it is worth recalling that it gradually emerged amid the release of several big-budget, internationally acclaimed projects dramatizing fascist or residual fascist chapters in German history. These films, such as Oliver Hirschbiegel's *Der Untergang* (*Downfall*, 2004) and Florian Henckel von Donnersmarck's *Das Leben der Anderen* (*The Lives of Others*, 2006), were praised by mainstream media for their high production values and appeal to mass audiences and major award bodies. US neo-neorealist films ascended during an especially heavy stream of CGI-laden sequels, prequels, remakes, and adaptations and, also like the Berlin School, adhere to an aesthetics of reduction appropriate for intimate character-based stories. They often feature unknown, local, or nonprofessional actors[3] and are shot on location, for example, in the Bronx, the rural Midwest, the Pacific Northwest, the Mississippi Delta, and so on.[4] Natural diegetic sounds are favored over non-diegetic underscoring. Dialogue can be scarce, and editing strategies make room for quotidian routine or atmospheric inserts that would elsewhere find the cutting room floor. Linear, dramatic arcs are apparent, yet it still feels like "not a lot happens" in these movies because of their preference for subtlety and slowness as opposed to melodrama and quick cuts.

That said, US neo-neorealism did not take off as a bona fide "new wave" the way the Berlin School has through scholastic and institutional recognition. There are few if any substantive studies of its films, and even recent anthologies on global realism or contemporary American cinema leave them out.[5] Directors Bahrani, Fleck and Boden, and Reichardt have moved on to larger-budgeted projects removed from their first humble ventures. The US neo-neorealist "moment" seems to have been just that. Yet the movies did not go unnoticed on the international art cinema circuit, least of all by Berlin School filmmakers looking for semblances of their own concerns. Christoph Hochhäusler, for example, in his rumination on the beginnings and echoes of the Berlin School, has

cited other national filmmakers who "are exploring related terrain [in] a certain approach to narrative and a specific concept of characters" (Hochhäusler 2013, 25), singling out Reichardt and Hammer from the US arena. For the German filmmaker and critic, what unites the Berlin School with cinemas elsewhere is less the art cinema aesthetics they employ and more an underlying philosophy toward filmic content. The three factors he delineates—attention to peripheral events rather than climactic action; dedication to inward, "antiexhibitionist" characters; and an avoidance of plot entanglements—inform many cinemas concerned with everyday people and predisposed toward narrative subtlety. But how clear is Hochhäusler's mention of US neo-neorealist directors in relation to the Berlin School? To untangle this, I want to recount some features of each movement before moving on to two emblematic films.

Two Cinemas

US neo-neorealism can be crudely situated as the lower-budgeted, lower-key evo-lution of prior gestures of American "indie" cinema.[6] The 1990s saw the launch of specialty divisions within major Hollywood studios looking to extend their audience reach to more discerning, hip crowds. These divisions were inspired by the success of several low-cost, high-reward projects released by independent dis-tributor Miramax Pictures in the late 1980s and early '90s. Fox Searchlight Pic-tures (Fox), Sony Pictures Classics (Sony Pictures Entertainment), and Warner Independent (Warner Bros.) are some of the boutique divisions started during this time, a development Geoff King dubs "Indiewood" (King and Molloy 2013). This subsection of the industry specializes in "pricey, mid-range releases appealing primarily to those with greater cultural capital . . . that synthesize in-dependent and Hollywood aesthetics" (Perren 2013, 13). These films tend to have verifiable star power and enough industrial clout to tally up Academy Award nominations. By comparison, Scott's neo-neorealist films were all produced and released by companies outside of major Hollywood studios (except for *Sugar*, distributed by Sony Pictures Classics). They garnered very modest box-office re-turns[7] and flew under the popular press radar despite high marks from critics. Less concerned with appearing cool or appealing to middlebrow audience tastes, they shine a light on disadvantaged, minority, or immigrant experiences. True, they exist within certain structures of accountability and don't radically shake up the fundamental language of cinema, but it is possible to distinguish them from the commercially driven, low-budget Oscar projects proliferated and marketed by specialty divisions of major studios.

We can also tease out general thematic features of US neo-neorealism that distinguish it from its Italian forebearer. The Italian classics took up the existential threat faced by disenfranchised people amid a shattered postwar infrastructure and bureaucratic indifference. The US films widen the aperture to cut across lines of race, gender, and nationality to render a more diverse experience about protagonists who believe they can claw out of poverty and reach the American Dream. Bahrani's parents immigrated to the States from Iran, and much of his work portrays immigrant struggles to cultivate new lives. The Senegalese cab driver in *Goodbye Solo* and the Pakistani-born pushcart owner in *Man Push Cart* work long hours to build better futures for their nascent families, while the junk-yard-dwelling Latino child in *Chop Shop* scrambles for basic necessities. *Sugar*, though written and directed by a white American couple, is another assimilation narrative about a Dominican baseball player who finds adjustment to rural Iowa strenuous. *In Between Days* (2006), from Korean American Kim, depicts a teenage Korean immigrant as she grows up in an indifferent North American city. Kim traveled back to South Korea to shoot her second feature, *Treeless Mountain*, about two children whose mother abandons them, keeping with the theme of vulnerable characters facing tough odds. Lance Hammer, a white male who worked for years as a visual effects artist on Hollywood movies, left that lucrative business and self-distributed his film, *Ballast*, about a black Mississippian family reeling from a suicide. (And to my knowledge, he did so without charges of exploitation or white paternalism.) Kim, Fleck, Reichardt, and Courtney Hunt, director of *Frozen River* (2008)—not mentioned in Scott's article but a possible outlier in the group—are female and often tell stories featuring resilient women battling hard circumstances. In short, US neo-neorealism, both in its practitioners and subject-characters, is more diverse than mainstream Hollywood or its Italian touchstone.[8] This range of visions produces a collective filmic portrait of a multifarious twenty-first-century United States where figures on the fringe of society struggle to integrate fully as social or financial equals—some more successfully than others.

While Scott and others used Italian neorealism as a common reference point for these US films, Berlin School scholars have been uneasy about citing realism as its movement's stylistic calling card. In an article explicating the work of Henner Winckler, Marco Abel has nuanced realist readings of his and other Berlin School movies by arguing that they rely not on representational strategies to replicate the highest degree of authenticity possible, nor on critiques of identifiable social problems that galvanize audience sympathies in a pedagogic manner. (This latter descriptor especially applies to Italian neorealist classics, tinged with collectivist ideology.) Abel warns that casting Berlin School films this way resorts

to an undertheorized idea of realism that does not consider the de-familiarizing effects of images of the ordinary (Abel 2015). André Bazin claimed that realism is necessarily the result of artifice and cannot be reduced to catch-all conceptions of how closely a film resembles reality. For example, instead of settling on "the long take" or "careful framing" to explain Berlin School aesthetics in line with representational realism, Abel argues that many Berlin School films' "spatiotemporal precision . . . solicit[s] audience attention so that our sense perceptions are made to tune into the extraordinary qualities of otherwise rather ordinary lives" (Abel 2012, 31). Reality is made abstract so that it can be sensed rather than corroborated with indexes of real life. Tying this back to Winckler, Abel suggests that his films do not presuppose viewers' ability to distinguish known from unknown elements of everyday life; the appearance of realism is nothing other than a "carefully modulated aesthetic strategy of de-differentiation" (Abel 2015) that affects viewers with sensations of the unregistered mysteries of normality instead of clearly hierarchized dramatic gestures. Perhaps owing to this appearance of indifference, critics have accused Berlin School filmmakers of being lackadaisically a-political. These complaints likely stem from a one-track sense of what political film looks like, that is, from a content-based premise. Abel instead argues that the movement is political because "rather than attempting to represent contemporary Germany it seeks to reinvent images for a post-Wall reality" (Abel 2010, 276). A logical question to pose, then, in an anthology placing the Berlin School within the context of global art film, is to what extent the de-differentiation effect Abel speaks of applies to other cinemas. US neo-neorealism, which on the surface captures the conditions of the contemporary United States and which has been earmarked by Hochhäusler as a cousin of sorts to the Berlin School, makes an ideal setting for such a question.

To set the stage a step further, Abel's notion of de-differentiation differs from the representational realism Scott used to describe certain contemporary US films—a realism purported to show "actual life" via "a mysterious, volatile alloy of documentary and theatrical elements" (Scott 2009b). But Scott's article was met with scrutiny that forced a crucial clarification. One rebuttal came from the *New Yorker*'s Richard Brody, who pointed out that realism has a long legacy in US cinema both in Hollywood studio projects and festival indie films (Brody 2009). Scott responded by claiming he went to pains "to use the term neo-realism loosely and somewhat expansively, to capture not a style or a school or a movement, *but rather a cinematic ethic* that has surfaced in different forms in different nations at different moments and that now seems to be flowering in some precincts of American independent cinema" (Scott 2009a, emphasis added). For Scott, the connection between postwar Italian neorealism and

post-9/11 US neorealism essentially involves not conventional stylistic attributes but a nebulous ideological kinship in sympathetic portrayals of the material existence of the working class (Brody claims this comes at the expense of interiority and ambiguity [Brody 2009]).[9]

I am less interested in declaring a winner in the Scott-Brody dust-up than in highlighting how Hochhäusler's choice of words ("a certain approach to narrative and a specific concept of characters") in reference to shared qualities between the Berlin School and US neo-neorealism links up with the point Scott made at Brody's encouraging. That is, if one were to simply chalk up each film's formal qualities, one could lump the Berlin School and US neo-neorealism together as part of a "global new wave" of cinematic realism. But I argue that these films contain important differences attributable to the variances between de-familiarization and representational realism. If realism purports to create resemblances, however imperfect or artificial, between the film world and the real world so that we can more easily identify with characters or situations on screen, de-familiarization forces viewers to interrogate everyday perceptions about reality, to make the familiar strange again. In the Berlin School, de-familiarization arises in large part because of its seeming disinterest in dramatic events or clearly articulated filmic signification—what we can specify here as *de-dramatization*.

In what follows I take up this point and examine two emblematic works from the Berlin School and US contexts: Winckler's 2006 drama *Lucy* and Reichardt's *Wendy and Lucy*. Both films present the struggles of young female protagonists: in *Lucy*, a teen mother tries raising a baby outside a stable family environment; in *Wendy and Lucy*, an Alaska-bound drifter looking for work loses her dog while bogged down in Oregon. Both films also appear similar on key formal levels: long-take cinematography, the favoring of diegetic sound over non-diegetic underscoring, on-location shooting, and other criteria of supposed realist cinema. But I want to stress how the de-dramatized nature of *Lucy* runs counter to a very much dramatized structure and rhetoric in *Wendy and Lucy*. I see important differences in terms of the narrative information each film provides—or avoids— and the associated audience sympathies or sociopolitical commentaries linked to such information. To demonstrate my point, I interrogate the films' rendering of "struggle": how each young woman's plight is depicted, how sympathies are generated, and what social commentary, if any, gets bound up in the process. I ultimately argue that thematic and formal resonances between the films notwithstanding, we must judiciously relate the Berlin School's aesthetic and political potentials to other contexts. *Lucy* and *Wendy and Lucy* adopt dissimilar approaches to their protagonists, resulting in subtle structural and formal choices that bring into relief the particularities of the Berlin School relative to US neo-neorealism.

Lucy

Henner Winckler is not a famous figure in the Berlin School, yet Abel argues that his production circumstances, professional collaborations, and traits of his films themselves "[situate him] not at the periphery [of the School] but at its core" (Abel 2015). His aesthetic, borne out in select shorts and two features, *Klassenfahrt* (*School Trip*, 2002) and *Lucy*, has been described as exhibiting a "quasi-documentary mise-en-scène" characterized by the usual suspects of cinematic realism. But Abel argues for an affect-based reading of Winckler's work, saying that strict representational realism—the homologies between "the film world" and "the real world"—do not adequately explain his films. The crucial observation Abel makes is to pin down Winckler's knack for rendering all events with the same degree of (dis)interest—a de-dramatizing strategy that does not "represent" so much as *render sensible* moments of (banal) transformation in the lives of his characters. To establish an early example, *Klassenfahrt* depicts a German high school class field trip to Poland's Baltic Sea coastline and the awkward interpersonal struggles of Ronny (Steven Sperling), an introverted student who develops a crush on fellow outsider Isa (Sophie Kempe). Although conflict appears to seep in when Marek (Bartek Blaszczyk), a well-built Polish hotel worker, also begins to court Isa's affections, the film frustrates the narrative fallout of this build-up. At one point Ronny dares Marek to cliff-dive into the sea in a challenge of masculine bravado. Marek disappears into the water, his fate uncertain even when the film ends, and Ronny does not notify authorities. As Abel points out, the film's refusal to confirm Marek's death or make anything of Ronny's failure to react to his rival's disappearance signifies Winckler's intention to present all events with the same level of dis-interest. This intention is buttressed by the film's refusal to clarify the socioeconomic background of its characters, as well as its cinematography that adopts the perspective of characters living in the diegesis rather than points of view imposed artificially—that is, dramatically—for an imagined audience. In other words, the film does not draw sharp distinctions between characters or cinematographic perspectives in ways that allow viewers to cleanly organize or hierarchize images or ideas associated with the real world. Winckler has said in interviews that he wishes more films were made this way, that is, "without predetermined results," without clear propagandistic purposes ferried along by ready-made stylistic features. His movies instead "behold everything with the same attitude: observing, curious, a-judgmental, and without discernible prejudices" (Abel 2015). What could be a familiar story of teenage courtship chased by a dramatic twist becomes a strangely affective journey where viewers are confronted with new ways of perceiving contemporary Germany.[10]

If *Klassenfahrt* invites comparisons to, but ultimately undermines, the usual representational drama in coming-of-age films, Winckler's later feature, *Lucy*, does the same for social problem narratives about youth pregnancy. The plight of Maggy (Kim Schnitzer), the teenage mother who has dropped out of school to raise her baby, Lucy, while living with her mother, who herself had Maggy at a young age, resembles on paper any number of melodramatic stories about unwed, ill-equipped teenage parents. But despite this setup, Winckler steers clear of clichés or social finger-wagging by refusing to explicitly address this situation as a problem and by aesthetically "leveling" the action on screen. The clearest examples of this approach rest not in what happens in *Lucy* but in what does not happen. Audiences have been conditioned by narrative convention to expect a crisis or dramatic moral choice at several points in the film: when Maggy tells her mother she is taking Lucy and moving in with her new, young boyfriend, Gordon (Gordon Schmidt); when Gordon becomes quietly irked by the baby's presence in his apartment; or when Gordon confronts Maggy for leaving Lucy alone in order to buy beer. "But while we are made to expect that eventually something more drastic is going to happen," notes Abel, "nothing dramatic ever transpires" (Abel 2015). The predictable question lingering throughout, "Will Maggy abandon her child?," which would drive interest forward in mainstream-minded films, also never develops as a plot point. The most serious thing she does is the above-mentioned beer run, a nonissue after some curt words from Gordon. Winckler is not interested in making thematically political films aimed at condemning social conditions or even individual actions. As he said in an interview about *Lucy*, "I think there are many films that resemble ours, and yet they explain the world rather than pose a question about it. . . . They arrive with a clear message and use their means to persuade viewers of a propagandistic image of the world" (Abel 2015).

In place of dramatic or didactic lessons about the perils of teenage parenthood, then, Winckler returns to his images, which imbue Maggy's everyday actions with consequences of a reality she herself is just discovering. Medium or wide shots of her pushing the baby carriage through large public squares highlights her isolation from her social milieu, to which she quietly wishes to return, while her attempts to lug a stroller up and down stairs or cram it into subway cars provide normalized glimpses at her new, hampered condition. Many of these scenes are shot in static camera setups with minimal or no editing, an aesthetic consequence of Winckler's de-dramatized philosophy. When Gordon encounters Maggy's mother for the first time in the kitchen, the camera records the scene from hip level, still and uninvolved. The pair exchange awkward "Good mornings" but little else. The mother's disapproval of her daughter's new "friend," sit-

Figure 4.1 The opening of *Lucy*, a static two-shot in the middle of a conversation.

ting at ease at the breakfast table, is not registered by a close-up of her face—thus it becomes difficult to make order of the scene's dramatic tenor. Conventional Hollywood editing or camera movement would make such microdramas more readable; editing and camera movement hierarchize information by directing viewers' attention to details or perspectives deemed important. By avoiding such small-but-important signifiers, Winckler makes good on his dictum to "behold everything with the same attitude" (fig. 4.1).

The banality of these actions, in contrast to high-tension dramas with sharply drawn plot points, imbues *Lucy* with a sense that life is always being discovered by its characters rather than preconstructed for the audience. Similar to Ronny in *Klassenfahrt*, who at the end of that film boards the school bus home and resumes his meek role among classmates, Maggy is not changed by the film's end. Her demeanor toward her daughter remains the same from start to finish without serious threats to her emotional or financial well-being. Gordon eventually confesses to Maggy that he does not want to play daddy to someone else's child at his age, and their subsequent breakup, which could have been constructed as a melodramatic moment of separation, is carried out by knowing glances the two young adults exchange over a parking lot. After parting with Gordon, Maggy has a one-night stand with a male bar patron whom she abandons the next morning, further dampening the effect of her breakup with Gordon and supposed social immobility as a young parent. She never cracks, never reaches an epiphany that would form the moral crux of narratives aimed at social commentary. In fact, the

closest we get to observing a shift in Maggy's thinking or a sign of maturation occurs when she gently tells the baby's father, Mike (Ninjo Borth) (who only now wants to be involved as a parent after previously shirking his responsibilities), that she "may have made a mistake" by moving in with Gordon. Mike agrees, and that's that: choices and regrets, breakups and reunions, are cast in the same tenor and shot with the same static camera setups that neither embrace nor judge the characters.

All of these details signify an approach to the film in which "dramatic moments are simply a part of daily routine" (Abel 2015) and thus serve as opportunities for viewers to encounter life in ways that do not hinge on preunderstood elements appealing to criteria of authenticity. This sentiment is satirized in the form of a poster hanging in Gordon's apartment: a collage of tightly packed alcohol bottles with the text "Life Is Full of Difficult Decisions." It's a frat boy joke but an ironic notion given the film's refusal to dwell on tough decisions that Maggy may have to make as a teenage mother—decisions that would make her plight readable and immediate to audiences. This is a different way of imaging struggle than *Wendy and Lucy*, a film that shares with *Lucy* a patient, observational approach to its protagonist but that ultimately employs (nuanced) representational methods to portray dramatic moments within a specific and trying cultural condition (fig. 4.2).

Wendy and Lucy

Scott singled out *Wendy and Lucy*'s debut at Cannes 2008 and its later theatrical release as "not so much a premonition of hard times ahead as a confirmation that they had arrived" in the United States (Scott 2009b). The film's titular (human) character, Wendy (Michelle Williams), bears out this description as a young cash-strapped drifter living in her car en route to Alaska. She has heard there is work there and has packed up her dog, Lucy, to give it a go. In an Oregon town, she runs into trouble: her car will not start, repairs are costly, she has nowhere to sleep, and, while waiting in a holding cell after being picked up for shoplifting food, Lucy goes missing. This sounds like a lot of plot, but like other neo-neorealist films, *Wendy and Lucy* adopts an observational stance toward its characters that invests viewers in on-screen conditions rather than narrative momentum. Reichardt's gentle pace, long takes, and limited use of dialogue and non-diegetic music fix our attention on Wendy as a figure for whom we develop sympathies. This observational investment maintains throughout, the camera meandering along as she searches for Lucy or hovering above her notebook where

Figure 4.2 Maggy in thought—but never an epiphany—about motherhood, perhaps?

she logs her dwindling cash reserves. But contrary to how Winckler renders the struggles of Maggy through the prism of de-dramatization, the thematic and aesthetic features of *Wendy and Lucy* operate on a fairly straightforward representational plane—albeit one nuanced by Reichardt's skill as a storyteller—that indeed dramatizes Wendy's situation. Occupying a middle ground between explicit criticism of class inequalities and formal subtlety and restraint, *Wendy and Lucy* portrays a reality *already colored by the political*—a "soft politics" aimed at depicting the country's troubled zeitgeist without arguing concrete pedagogic points about it. The *Los Angeles Times* put it well by describing Reichardt's movie "as damning as any Ken Loach film, [though] it preaches in a whisper, not a shout" (Adams 2008).

One could begin by asking if or how *Wendy and Lucy* was "pre-determined" as a portrait of struggle within an uncaring or oppressive social context, contrary to how Winckler designed characters and plotlines in *Lucy*. Many critics regard Reichardt as one of the more politically minded filmmakers of her generation.[11] Her earlier film, *Old Joy* (2006), also adopts so-called realist techniques to tell the story of two adult friends who reunite for a camping trip despite their diverging life trajectories—differences made apparent via strained conversation and half-hearted reminiscing. Although the only reference to wider social discord occurs through a car radio talk show in which pundits and callers holler about post-9/11 political divisions in the United States, some critics saw in the friends' interpersonal rift a commentary on frayed social relations

during George Bush's presidency. Any social commentary Reichardt may have intended in this earlier feature became more pronounced in her follow-up film about a lone female drifter making her way across the country. In an interview with filmmaker Gus Van Sant ("Kelly Reichardt" 2008), Reichardt acknowledged that the sociopolitical atmosphere of Bush-era America, which witnessed an uptick in look-out-for-yourself libertarianism, as well as the working-class progressivism of Italian neorealist films, shaped her and coscreenwriter Jon Raymond's approach to the film:

> The seeds of *Wendy and Lucy* happened shortly after Hurricane Katrina, after hearing talk about people pulling themselves up by their bootstraps, and hearing the presumption that people's lives were so precarious due to some laziness on their part. . . . We were watching a lot of Italian neorealism and thinking the themes of those films seem to ring true for life in America in the Bush years. There's a certain kind of help that society will give and a certain help it won't give. So we imagined Wendy as a renter; no insurance, just making ends meet, and a fire occurs due to no fault of her own and she loses her place to live. We don't know her backstory in the film but we imagined Wendy was in that kind of predicament. ("Kelly Reichardt" 2008)

Clearly, unlike Maggy in *Lucy*, Wendy in Reichardt's film is a conduit for social commentary on US culture. Armed with this framing, it is easy to connect aspects of *Wendy and Lucy* to famous Italian neorealist films depicting class struggles in precarious economic times. The clearest parallel of *Wendy and Lucy* to these narratives runs through Vittorio De Sica's *Umberto D.* (1952), the story of an aging pensioner who cannot pay rent, searches for a lost beloved dog, and contemplates suicide while roaming the streets of Rome. It is as if Reichardt and Raymond inverted the schemata of De Sica's film: rather than an old man who cannot work and worries about being evicted, they constructed a young woman who leaves home in search of work in an appropriately American gesture to "go west" and find fortune. Other similarities to Italian neorealism involve simple aesthetic homages. At one point Wendy visits the pound to look for Lucy. Reichardt uses the film's only sustained tracking shot to embody her perspective as she walks along kennel after kennel, dog after dog, in a vain search. While this is not an exact replica of De Sica's *Lardi di biciclette's* (*The Bicycle Thieves*, 1948) evocative tracking shot from Ricci's point of view as he walks along a line of black-market bicycles, looking for his own, both shots accomplish the same effect: they express the helplessness of the individual against an overwhelming and indifferent social condition—in *Wendy and Lucy's* case,

Figure 4.3 A wide tracking shot of Wendy walking along dilapidated buildings; the "Goner" graffiti casts a glum outlook.

a woman searching for a lost dog in a sea of unwanted animals, a clue of hard economic times (fig. 4.3).

I do not mean to equate the seriousness of Ricci's lost bicycle—which his family depends on for survival—with Umberto's or Wendy's lost dog; the contexts are clearly different and demand nuanced understandings. All of the aforementioned characters face severe economic threats, yet the loss of Umberto's and Wendy's dogs appears far less significant in relation to Ricci's existential dilemma if he does not find his bike. A critical Marxist reading reveals that the sentimental display of love between Ricci and his son at the end of the film will not feed or clothe the family. I take this point but also argue that in environments saturated by economic precariousness—when many people are in the same sinking boat—the drama surrounding a lost dog takes on new emotional and symbolic significance. When the fact of poverty is just that—a fact—other losses and hardships ascend to the surface and assume more dramatic weight. This added drama amplifies the economic stakes at play in *Wendy and Lucy*, aligning it more with the working-class aims of Italian neorealist classics than with the de-dramatized approach to struggle taken by Winckler's *Lucy*.

In order to give her film applicability to wider social problems, Reichardt injects the story with commentary on economic inequality. This is most explicit in the dialogue between Wendy and an older security guard she befriends in a parking lot. "Not a lot of jobs around here, huh?" she wonders, looking around.

"You can't get a job without an address anyway. Or a phone." The aging man, who works 8:00 a.m. to 8:00 p.m., hours preferable to his prior job, bemoans how the cards are stacked against the under- or unemployed: "You can't get an address without an address. You can't get a job without a job. It's all fixed." Later, he offers Wendy a parting gift, a wad of cash he insists on sliding into her hand. The camera eventually reveals the amount—six dollars—and thus the degree of their shared financial hardship. The fact of economic precariousness is also present in Winckler's *Lucy*, but it is not foregrounded like this, nor does it form the crux of any conflict. This may be because the support network for poor citizens differs between Germany and the United States, with Wendy representing one of millions of unemployed, uninsured twenty- or thirty-somethings whose chance at the "American Dream" has been put on hold if not outright snuffed out.

Since Reichardt wants to portray a particular economic reality in the United States, her stylistic and structural choices highlight Wendy's struggle rather than downplay it. Reichardt refuses, within the film itself, to psychoanalyze or fill out background details about Wendy—we only gather that she began her trip in Indiana and travels with a photo album—but she is nonetheless given sympathetic treatment in ways that Maggy in *Lucy* is not. We are talking about small details that make big differences. Take the opening dialogue sequences of both films. *Lucy* opens in medias res on a postbreakup conversation between Maggy and Mike in which viewers must connect the dots to infer orienting narrative information; *Wendy and Lucy* begins with a sequence that informs our sympathies for Wendy's unfolding situation. Wendy actually loses Lucy twice in the story, the first time during the title sequence when Lucy runs off into the woods. Wendy tracks her to a group of young drifters sitting around a campfire. One man, Iggy (Will Oldham), has also worked the fisheries in Alaska and confirms that there is good money to be made there. And yet here he squats in rural Oregon with other transients. As Iggy tells a long-winded story about accidentally destroying fishery equipment, Wendy glances around at the group, their tired faces illuminated by the flames and held still by Reichardt's camera. Before Iggy can finish, Wendy, visibly antsy, collects Lucy and shifts away. She likely glimpses what her future could look like given that these people charted her same course, and she does not like what she sees. Although this opening is aesthetically subdued like *Lucy*'s opening, it is not as dramatically "disinterested" in its content because it sets the stage for the existential stakes involved for Wendy and highlights shared economic hardship. Crucially, the opening dialogue of *Lucy* plays out in one long, static take; the transient campfire scene in *Wendy and Lucy* employs edits and close-ups that emphasize the group's condition and Wendy's apprehension about them and her future.

There are other times when the narrative information Reichardt reveals to the audience garners sympathy for her protagonist in ways Winckler does not. The phone calls in each film are instructive here. In *Lucy*, Maggy often makes phone calls to babysitters or to arrange social outings, but the audience never hears dialogue on the other end of the call; we wring sense from the scene based on her verbal responses. From a narrative standpoint, nothing particularly important hinges on any one phone call. They all carry the same emotional timbre and keep viewers at the same arm's-length away. This is different from *Wendy and Lucy* in two ways. First, Reichardt employs diegetic silence in phone calls to raise suspense and generate empathy. At several points, Wendy calls the local animal shelter to check if Lucy has been found, but, as in *Lucy*, the audience cannot hear the other end of the line, thus leaving us to study Wendy's face and wait for the (usually) negative news. Unlike in *Lucy*, however, the context of the phone call and the stakes attached to it—Did the dog turn up at the pound?—raise our emotional involvement in the conversation and add modicums of suspense. The second way Reichardt renders phone calls marks an exception to this first strategy. Shortly after her car breaks down, Wendy uses a phone booth to call her sister back in Indiana. A male partner who answers the phone, and the sister who eventually picks up another line, are completely audible to the audience. Wendy, ashamed, mentions under her breath that "things are actually pretty rough here" and "the car broke." The sister and man mumble about not being able—or wanting—to help, and the conversation soon fizzles out. In short, we have been made privy to the uncaring nature of Wendy's supposed support network. Again, this may seem like a passing detail, but moments like these tilt audience identification one way or the other: toward indifference in Maggy's case, where a phone call is a phone call is a phone call; or sympathy in Wendy's case, where the coldness or uncertainty she is met with—and which we hear or do not hear—connotes the tough row she has to hoe.

Outside of the phone calls, there are other telling moments of cinematic dramatization in *Wendy and Lucy* that are hard to imagine occurring in most Berlin School films. Two examples are worth noting. The first occurs near the one-hour mark, conventionally the turning point in classic Hollywood screenplays and the one true instance of danger in the film. Her car in the shop, Wendy finds a spot in which to sleep in the woods adjacent to some train tracks. Out of the darkness, a male drifter appears, mumbling incoherently. When Wendy lifts her glance, he warns her not to look at him. For thirty seconds (which seem to last much longer), the man curses erratically as Wendy whimpers with fear, her welling eyes fixed in frame by Reichardt's close-up. The drama of these seconds is synced

aurally to a passing train whose wheels screech on the track, smothering the man's garbled words while raising our sensory discomfort. At some point the drifter recedes, and Wendy runs into town. The threat hanging overhead, of course, is rape or murder; that neither of these outcomes occurs does not diminish the stakes of the encounter. Reichardt emphasizes this by showing Wendy hurry to a gas station bathroom where she hyperventilates, cries, and whispers into the sink, "I'm coming, girl"—a comment directed at Lucy, another lone female presumably lost and afraid in dangerous surroundings. This sequence differs from more sensational depictions of harassment or violence; in a conventional Hollywood film, we would likely see and hear the drifter more clearly, for example, to spell out the danger. Reichardt's aesthetic nuance masks the sequence under the banner of realism even while employing certain dramatic strategies. The incident with the drifter, in the understated language fastened by Reichardt, combines the struggles of Wendy and Lucy into one. A lost dog stands for more than a lost dog.[12]

A second example of cinematic dramatization is the reunion—and subsequent reseparation—of Wendy and Lucy, which is clearly constructed as the story's emotional climax, something lacking from Winckler's film. Finally tracking Lucy to a foster boarder—a friendly looking man with a big yard—Wendy plays with her while pacing back and forth. She seems reluctant, pensive, then outright sad. "I'm sorry Lu," Williams delivers through tears. "I lost the car." We quickly gather that Wendy means to leave Lucy behind. Reichardt uses tight close-ups to punctuate this decision and also shifts into slow motion when Lucy looks back, confused. She goes for the clear, but not unearned, dramatic payoff. This is nothing if not a sequence *invested* in the representation of anguish, in the painful sacrifices people make under hard circumstances. This sacrifice, importantly, is depicted as the film's true tragedy, more so than the precipitating scene prior in which Wendy learns she cannot afford to repair her car. Wendy's car, like Ricci's bike, presents a more serious threat to its owner's survival, but the emotional gut-punch occurs with the sacrifice of something else: a best friend in *Wendy and Lucy*, and a father's honor in *Bicycle Thieves* when Ricci's son witnesses his father stealing another bike. Life is full of difficult decisions (fig. 4.4).

Conclusion

Hochhäusler (2013) was correct in saying that the Berlin School shares something important with films from the so-called US neo-neorealist arena. As countercinemas to dominant film cultures, both movements provide alternative portraits of life not always given the time of day. While granting certain

Figure 4.4 Wendy makes her difficult decision.

stylistic resemblances, my goal here was to put more pressure on the two films' representations of struggling protagonists and the sociopolitical nature of such representations. I have shown how two different approaches to similar subject-characters—de-dramatization and neorealism—result in subtle structural and formal choices with wide consequences for how we receive these films. I do not disagree with Abel's praise of Winckler's and other Berlin School movies in terms of their eschewal of strict representational realism given the deluge of narratives about Germany's past(s) that have saturated the country's global film presence since 1989. Much of the excitement about the Berlin School stems from how it moved the country beyond staid representations and helped imagine new images for a new Germany. The films of US neo-neorealism, those of Reichardt, Hammer, Bahrani, and others, also responded to the call to march film culture forward, not by shying away from drama and struggle, but by spotlighting them in an age of distraction and spectacle.

Notes

1 The online version of Scott's article also ran with publicity photos of Reichardt's *Old Joy* (2006) and Boden and Fleck's *Half Nelson* (2006), ostensibly inviting these films to the neo-neorealist table.

2 This is a reference to Danny Boyle's Oscar-winning 2008 film *Slumdog Millionaire*, which Scott cites as the antithesis (in budget, in style, in spirit) to the neo-neorealist works he champions.

3 One exception is the casting of star Michelle Williams in *Wendy and Lucy*. Yet the film was consistently praised in reviews for the way she disappeared into the role of an ordinary woman.

4 Again, there is an exception here: Kim's *Treeless Mountain*, shot in South Korea.

5 In Giovacchini and Sklar (2011), there is not one mention of any of Scott's neo-neorealist films or directors; in King and Molloy (2013), Kelly Reichardt is mentioned once.

6 "Independence" like "countercinema" is of course a relative term that includes questions of industrial affiliation, financial support, star power, filmmaker autonomy, and textual or ideological radicalism.

7 The composite average domestic box-office gross of the seven films Scott features in his article totals just $445,449 per film (ranging from $36,608 to $1,082,124). Figures found on www.boxofficemojo.com.

8 There are of course other important differences between the Italian and US films, including the production circumstances facing neorealist directors in postwar Italy that informed or necessitated many hallmarks of realism.

9 For more on Brody's critiques of neorealism in direct reference to *Wendy and Lucy*, see his "Against 'Wendy and Lucy,'" *New Yorker*, December 10, 2008. http://www.newyorker.com/culture/goings-on/against-wendy-and-lucy.

10 Abel goes further here and claims that the aesthetics of de-differentiation in Winckler's film—where the German youth do not register Poland as new or different from Germany and the protagonists do not get caught up in narrative dramatics—imbue an "indifferent perspective" associated with the erasure of class distinctions in neoliberal societies. To Abel, neoliberal conditions have so permeated Germany now that its effects go unnoticed by Winckler's characters, leaving open opportunities for the film to render these conditions sensible to the audience.

11 For example, Sam Littman writes that "few filmmakers have expressed their displeasure with the Bush administration and the Iraq War in their work as consistently and eloquently as Reichardt, engaging politics in an understated manner that suits her style better than a Fahrenheit 9/11 (2004) assault" (Littman 2014).

12 Scott makes a similar point about the lost dog in *Umberto D.*, claiming that film's dog is a "symbol and symptom of an increasingly heartless society" (Scott 2009b).

Works Cited

Abel, Marco. 2010. "Imaging Germany: The (Political) Cinema of Christian Petzold." In *The Collapse of the Conventional: German Film and Its Politics at the Turn of the Twenty-First Century*, edited by Jaimey Fisher and Brad Prager, 258–84. Detroit: Wayne State University Press.

———. 2012. "The Counter-Cinema of the Berlin School." In *Cinema and Social Change in Germany and Austria*, edited by Gabrielle Mueller and James M. Skidmore, 25–42. Waterloo, ON: Wilfrid Laurier University Press.

————. 2015. "Filming without Predetermined Results: Henner Winckler and the Berlin School." *Senses of Cinema* 77 (December). http://sensesofcinema.com/2015/feature-articles/henner-winckler-and-the-berlin-school/.

Adams, Sam. 2008. "Review: 'Wendy and Lucy.'" *Los Angeles Times*, December 12. http://www.latimes.com/entertainment/la-et-wendy12–2008dec12-story.html.

Brody, Richard. 2009. "About Neo-Neo Realism." *New Yorker*, March 19. http://www.newyorker.com/culture/richard-brody/about-neo-neo-realism.

Giovacchini, Saverio, and Robert Sklar. 2011. *Global Neorealism: The Transnational History of a Film Style*. Jackson: University Press of Mississippi.

Hochhäusler, Christoph. 2013. "On Whose Shoulders: The Question of Aesthetic Indebtedness." In *The Berlin School: Films from the Berliner Schule*, edited by Rajendra Roy and Anke Leweke, 20–29. New York: Museum of Modern Art.

"Kelly Reichardt." 2008. Interview by Gus Van Sant. *BOMB* 105 (Fall). http://bombmagazine.org/article/3182/kelly-reichardt.

King, Geoff, and Claire Molloy. 2013. *American Independent Cinema: Indie, Indiewood, and Beyond*. New York: Routledge.

Littman, Sam. 2014. "Kelly Reichardt." *Senses of Cinema* 71 (June). http://sensesofcinema.com/2014/great-directors/kelly-reichardt/.

Perren, Alisa. 2013. *Indie, Inc.: Miramax and the Transformation of Hollywood in the 1990s*. Austin: University of Texas Press.

Scott, A. O. 2009a. "A. O. Scott Responds to New Yorker Blog on the Value and Definition of Neo-Realism." *New York Times*, March 23. http://carpetbagger.blogs.nytimes.com/2009/03/23/ao-scott-responds-to-a-new-yorker-blogger-about-the-value-and-definition-of-neo-realism/.

————. 2009b. "Neo-Neo Realism." *New York Times*, March 17. http://www.nytimes.com/2009/03/22/magazine/22neorealism-t.html?pagewanted=all&_r=1.

Serwer, Andy. 2009. "The '00s: Goodbye (at Last) to the Decade from Hell." *Time*, November 24. http://content.time.com/time/magazine/article/0,9171,1942973,00.html.

5

CINEMA AS DIGEST, CINEMA AS *DIGESTURE*

Corneliu Porumboiu's *Metabolism* (2013) and the Cinema of the Berlin School

Alice Bardan

I think that my country has neither understood, nor digested its past too well. It is a society permanently caught in the present, in a space of bulimia.

<div align="right">Corneliu Porumboiu</div>

Mostly viewed as deadpan comedies on the lingering effects of totalitarian authority on the Romanian people, Corneliu Porumboiu's films are rarely, if ever, discussed in relation to the Berlin School. Anyone familiar with the Berlin School films, however, will immediately recognize the numerous characteristics that the Romanian director's work shares with them, as it conceptualizes and addresses the spectator by avoiding overtly emotionalized presentations of contemporary life, by paying renewed attention to film form and aesthetics, and by experimenting with narrative time and the representation of space. Powerfully influenced by the styles of auteurs such Michelangelo Antonioni and Eric Rohmer,[1] the Berlin School films render time and space as *seen*, *felt*, and *thought*, foregrounding the power of temporal and spatial affectivity. Shifting the focus of attention away from dramatic historical events to the lives of nonheroic, lonely people, whose private dramas are not linked to Romania's public ones, Porumboiu's films similarly rely on an "aesthetic of reduction" that involves static tableaux, slow,

minimally edited narrative development, and neutral, documentary-like camera work. The deemphasized plot, the static and precise framing, the slow editing, and nondramatic acting lend these films a unique feel and look that recall the atmosphere created by the Berlin School films.

Outlining the connections between the Berlin School films and Porumboiu's work, this essay will zoom in on *Când se lasă seara peste Bucuresti sau metabolism* (*When Evening Falls on Bucharest or Metabolism*, 2013), comparing its use of mise en abyme to the ways in which it is similarly deployed in Christian Petzold's *Barbara* (2012) and Thomas Arslan's *Der schöne Tag* (*A Fine Day*, 2001). As I argue, the film enacts a way of seeing that ultimately makes it more complex and political than it may appear at first.

Porumboiu's films are best known for their humor and well-written, witty dialogue. Yet the filmmaker takes his filmmaking approach seriously, engaging with the limits of cinematic realism by exploring cinema's ability to give us an objective representation of the real. As in the case of the Berlin School filmmakers, the politics of his films are predicated on confronting spectators with static images and disjunctive sounds, forcing them to reassess their relationship to events on screen and presenting them with an open-ended, irresolute image of reality.

In various interviews, Porumboiu has emphasized that his films should be seen as a "blow up" of something—a reference to Antonioni's famous film that alerts us to an emphasis on the theme of *how* we perceive and interpret what we see. Both language and perception, therefore, are equally important for Porumboiu, as his films replace images with various processes of signification, foregrounding how experience is always mediated—whether through conflicting narratives of an event described by several witnesses, as in *A fost sau n-a fost?* (*12:08 East of Bucharest*, 2006), or through various handwritten reports, as in *Polițist, adjectiv* (*Police, Adjective*, 2009). Crucially, however, "the event" itself described by various characters is actually not shown. Central to Porumboiu's approach to filmmaking is a refusal to show the main events that drive the narrative, as the director moves the focus away from the narrative itself to the *impact* the events have on the characters, as Paul Cooke also notes in his discussion of the Berlin School films (Cooke 2012, 77). In *12:08*, for example, we do not see any images either of the revolution or of the town's square where "the event" is supposed to have happened, and in *Police, Adjective*, we do not see the teenager selling illegal drugs. In *Metabolism*, in turn, we do not see the footage of the scene that is rehearsed and shot, only the way in which it is simulated and discussed. Instead, we get a *refracted* version of reality as seen through the main characters' eyes, and, crucially, through the language they use to describe what they see.

Porumboiu makes the idea of displaced vision explicit in *12:08*, when the TV presenter, Jderescu, invokes Plato's cave allegory—only to further highlight another displacement: "What if we got into another, bigger cave, where we mistook the sun for a straw fire?" Jderescu wonders. In *Police, Adjective*, the process of substituting vision with images that are supposed to represent reality is highlighted when Cristi asks his wife whether she sees any image while listening to a popular song. For him, as for the "resistant viewers" of Porumboiu's films, the song "doesn't make any sense." With a sigh of bewilderment, he repeats the questions that it asks: "What would the field be without the flower?" "What would the sea be without the sun?" "They would still be a sea and a field!" A literature teacher, Cristi's wife explains that the song uses anaphora in order to define real love. For her, the lyrics create images that in turn become symbols, "so that the image of the sea becomes a symbol of infinity, the sun stands in for light, the field as a symbol of birth and creation, and the flower, as an image of beauty, becomes the symbol of beauty." Hence, a subjective vision, a change of name, an abstraction, a metonymy is at stake: a thing or a concept is called not by its own name but by the name of something associated in meaning with that thing or concept: a refracted rather than a represented reality.

Speaking about the Berlin School films, Marco Abel suggests that they develop an "*arepresentational realism*" that does not seek "to create immediacy with reality but with the reality of the image, so that the depicted world becomes aesthetically autonomous, abstracted from empirical reality," and this ultimately helps the viewers "rethink the very relation between what they see and *how* they see" (Abel 2013, 9). The question, then, is less what images mean than how they subject us, how they establish a mimetic relation between the depicted world and the reality from which they are abstracted, and it is "this very metonymic relation that affectively expresses the cinematically fashioned provocation for us to move as well—to forge relations with our world so that the preexisting life-world reappears as strange" (19).

The evolution of Porumboiu's work rests on an interplay between theory and practice, born out of a compulsion to discuss and demonstrate what it means to make films in and about Romania today. Like many Berlin School filmmakers, he is a "cinematic late bloomer" (to use Christoph Hochhäusler's words [2013, 23]). Before graduating from the National University of Theatre and Cinematography, where he studied film directing, Porumboiu studied management at the Academy of Economic Studies in Bucharest. The similarly belated arrival at filmmaking by members of the Berlin School has led Hochhäusler to describe their films as cinematographic palimpsests that "deliberately overwrite 'sacred' film texts—a metacinema" (24). Porumboiu's own investment in film history has made him

overwrite many such "sacred" texts: *Metabolism*, for instance, directly references Jean Luc Godard's *Le Mépris* (*Contempt*, 1963), François Truffaut's *La nuit américaine* (*Day for Night*, 1973), and Federico Fellini's *La strada* (*The Road*, 1954) among others. A scene in *Day for Night* shows Ferrand, the film director played by Truffaut himself, opening a package of books he has ordered—books on legendary directors he admires, from Alfred Hitchcock, to Godard and Robert Bresson. With an equally unabashed wink at cinephilia, *Metabolism* pays homage to film history through the prominent display of *The Essential Art House: 50 Years of Janus Film* (an expansive collectors' box set featuring fifty classic films on DVD with explanatory notes) in Paul's room. And if we take *Metabolism* as a reworking of melodrama and of the self-reflexive mode of filmmaking that underscores the process of making a film, his other films arguably work with, or rather *rework*, in their own way, popular Hollywood genres, much as the films of Berlin School directors such as Petzold and Arslan do. For instance, Porumboiu described *Police, Adjective* as an "action film without action" (quoted in Keough 2010) and *Comoara* (*The Treasure*, 2015) as "a local Western" (quoted in Reitzer 2016, 4).

Like Petzold and Arslan, therefore, Porumboiu must be seen as a filmmaker who refigures the notion of the *auteur* within, rather than against, the mechanisms of world cinema and of various genres, prompting us to reflect "not only on how they circulate, but also how they *mutate* transnationally (Fisher 2011, 191), thereby refunctioning generally apolitical genres. As Jaimey Fisher points out, the fact that a number of auteurist filmmakers have "refunctioned" (in the Brechtian sense of the term) the mechanisms of Hollywood genres should be read in terms of their political intervention within a certain contextual and historical specificity: not in terms of how they differ from Hollywood, but of how they are in dialogue with it, prompting us to rethink art cinema and Hollywood cinema as "mutually dependent and constitutive parts of a wider system of world cinema" (187).

In an interview with Graham Swindoll, Porumboiu states that, as a Romanian filmmaker, he sees himself as someone who is between East and West and that his films are about characters caught in an ambivalent state. These ghostly figures are, like the characters populating Petzold's films, "reminders of capitalism's exclusions" who represent "the mobility, rootlessness and resulting alienation of modern life" and are deeply engaged in "the spectral nature of its relationships, transactions, and exchanges" ("Ghosts," in Cook et al. 2013, 147). Moreover, when asked to comment on his rejection of classical narrative, Porumboiu explains that for him, "Cinema is a way of looking at things. Looking behind the scenes and showing the long pauses, the waiting around, seemed more important than really telling a story. I think all my films are about this in-between state" (quoted in Swindoll 2013, 3–4). The title *When Evening Falls*

on Bucharest or Metabolism, he adds, is "about a vacuum, an absence," meant to describe "the feeling of always being between things, in an intermediate state, searching" (4).

At the narrative level, the protagonists are portrayed from the outside, and their actions often remain unexplained, thwarting expectations. Like many characters populating the Berlin School films, the protagonists' struggle for subjectivity in Porumboiu's films cannot be explained either by behaviorism (which interprets behavior as willful acts of autonomous individuals) or by evolutionary psychology (which explains behavior in terms of genetic predispositions) ("Interiority" in Cook et al. 2013, 166). Instead of a melodramatic appeal to emotions, Porumboiu's approach explores the rhythms of the everyday—silences, pauses, hesitations, the anodyne discomfort of making conversation, or the strangeness of a fleeting relationship.

Porumboiu is not interested in "telling a story" that would speak *for* Romanians or *represent* them. Although the filmmaker in *Metabolism* reveals that he is making a political film to show people "how low they have stooped," the film's rejection of any didacticism indicates Porumboiu's own self-distancing from the fictional director and, indeed, from other Romanian filmmakers who adopt an overtly moralistic approach. This notwithstanding, at the film's premiere in Locarno, Porumboiu emphasized that he did indeed make a political film. His politics, however, must be read in relation to the view that art's capacity for the political lies in its aesthetic nature, not in its ability to communicate a (didactic) message. As Abel points out in relation to Petzold's work, his films are political because he makes them *politically* rather than simply making political films: they are political "not despite, but because of their affirmation of aesthetics" (Abel 2013, 107). It is this deliberate emphasis on aesthetics, the distinct stylistic characteristics through which his "plotless" films manage to foreground the characters' fruitless struggles, wasted time, and "non-events" of daily existence, that links Porumboiu's films to the Berlin School. *Metabolism* specifically refuses to show "how low" Romanians have stooped and instead gives viewers the freedom to explore the pleasure of agency in their own discovery of the film.

Porumboiu's work is therefore tied to that of the Berlin School in its attempt to produce meaning politically by investigating the "politics of the image" (Abel 2013, 18) and by foregrounding temporal and spatial affectivity. In particular, he seeks to disrupt conventional modes of viewing, putting into relief contemporary society's liminal spaces and the dead times of "in-between" actions. Like the majority of the Berlin School characters, the figures in Porumboiu's films tend to be observers rather than protagonists, preserving their mystery as they leave spectators to speculate about their interior lives. Especially with *Metabolism*,

Porumboiu adopts *an affectless aesthetic* by "representing emotions without emotionalizing" (Baer 2013, 75) and through a refusal of closure that is replaced by "the feeling that something has ended but that something new has not yet taken shape," as Hochhäusler characterizes the Berlin School films (2013, 23).

Although *Metabolism* has strong affinities with the aesthetics of Porumboiu's previous films, its very focus on a filmmaker who reflects on his filmmaking style self-reflexively highlights Porumboiu's own stylistic strategies. Paul, a young director in the middle of shooting his film, is experiencing some sort of crisis about his filmmaking. Acting out of an impulse, he invents an excuse— that he needs to see a doctor for a developing gastritis or ulcer—and tells his producer, Magda, to delay production. This delay, however, comes with financial consequences, and Magda requires him to bring proof of his endoscopy and calls a doctor to examine it on the set for insurance purposes. Paul, it seems, suddenly wants to experiment with how his film might look from the perspective of a minor character. He asks Alina, a supporting actress, "to do a nude scene," and she agrees to do it only "if it serves a purpose" (an ironic reference to Porumboiu's filmmaking style, given that his films deliberately include "purposeless" scenes). After he assures her that it does serve a purpose, they begin rehearsing the new scene, but to her disappointment she discovers she does not even have a speaking line: all she has to do is to exit a bathroom and react, through her bodily gestures, to a conversation that she overhears behind the living-room door.

Porumboiu, however, playfully deconstructs this seemingly simple scene to its most basic elements: the action-reaction that takes a few seconds in the script becomes enlarged, taking up long stretches of time in *Metabolism*. Like a marionette guided by the script, by her own impulse and understanding of how she should act and react, and by a continuously dissatisfied Paul, Alina performs and verbalizes each of her gestures at the same time: "I am in the shower, I shower, shhhhh, I take my towel, I dry myself off, I dry my hair, zzzz," and so on. The action thus doubles and folds into itself, drawing attention to how the director's camera would trace the actress's movements in slow motion. When Alina suggests that she could express her distress by forcefully rolling a lint remover up and down her imaginary dress, Paul mocks her for resorting to clichés. His emphasis on draining emotion through an affectless acting style underscores *Metabolism*'s efforts to resist emotionalization and, in turn, highlights Porumboiu's deliberate refusal to give us the characters' motives and stakes in his own film.

Since it is supposed to render a slice of life in the characters' larger trajectory, the film begins in medias res and ends abruptly, a stylistic choice that has become a trademark of the Berlin School films. Like these films, *Metabolism* was shot entirely on 35 mm, an important decision underscored by the film itself when

Paul enthusiastically endorses the art of making a film on film stock (rather than digitally), commenting on questions of realism, film form, and ontology that this choice entails.

Filmed from the back while Paul is driving Alina through the streets of Bucharest at night, the opening sequence involves a discussion about shot duration. Paul points out that working on celluloid means that a director can only film for a maximum of eleven minutes at a time. He adds that digital technologies could potentially make every scene "more detailed, more faithful, *more real*, but much longer," yet with each scene extended in order to reflect reality (for instance, a couple's fight that lasts for twenty minutes), the film itself implicitly becomes bigger and bigger, potentially endless. Bemoaning that digital processes have superseded cinema's material basis, he observes that the digital can allow a freedom in filming that risks stifling creativity. Since one cannot film more than eleven minutes at a time with a reel of film, Paul explains, working with these limits has determined a certain way of making cinema and a certain way of looking at the world and thinking about it.

Porumboiu himself seems to share this view. Even in the digitally filmed *The Treasure*, the characters' use of an advanced device to provide 3-D images of the buried treasure, rather than resorting to a simple metal detector, functions as a comment on filmmaking. The man who operates the equipment (an alter ego of the filmmaker, as Porumboiu has indicated), ultimately opts to go back to the old device, even if its magnetic sensors are not as advanced as those of the modern one.

In *Metabolism*, we do not see any excerpts from the film that Paul is shooting. Instead, the whole film revolves around one small scene (a character getting out of the bathroom and overhearing a conversation in the living room) that gets "blown up" to unrealistic proportions as the director and a minor actress obsessively rehearse it on separate occasions, even though it would only last a few seconds in the final cut. This symbolic expansion of time recalls Douglas Gordon's films such as *24 Hour Psycho* (1993) and *Five Year Drive-by* (2001), which reduce film movement to near imperceptibility. The former slows down the events taking place in the in Hitchcock's 1960 film, so that movement in the film is perceived over long stretches of time (the film is slowed down to approximately two frames a second, rather than twenty-four). The latter is conceived as a five-year projection that stretches John Ford's 1956 western *The Searchers* to the length of the film's narrative, which is supposed to be five years. Slowing the speed of the film, Gordon makes each frame of the film last for about sixteen minutes. Each second of the film takes about a working day to project so that at any moment the film appears as a still image. Movement is largely annihilated, "leaving just

enough to maintain an umbilical cord to the original films and to the worlds they are in turn bound by" (Lippit 2008a, 120).

As time (and space) are so formally connected in Porumboiu's work (at the expense of narrative), the director's opportunity to get redeemable points for funding becomes increasingly problematic, although in the 2016 contest organized by CNC, Romanian's National Center for Cinema, he did receive the largest sum of money available. One of the starting points for making *Metabolism* was the proposal of a new bill that asked directors to provide very detailed screenplays for submission to the CNC contest. While he opposed the new regulations, these new impositions reminded him of his student days when he had limited material to work with, forcing him to be precise so that he would not waste it.

This low-budget aspect also characterizes the Berlin School films, which rely on a combination of funding through regional film boards and private investment. Much like Porumboiu's films, they play in cinemas only in limited release and are more successful at film festivals than at home. However, the Berlin School directors can also rely on television funding, and their productions are underpinned by television exhibition and reception, although they are not "made for television" in terms of style and content. As Hochhäusler acknowledges, "Our films are made on very limited budgets, which is inevitably apparent in the finished product and influences the choice of material, the number of roles, the film's design. A large part of this economy of means . . . is thus simply economy. Or the result of it. We have learned to love the 'aesthetic of poverty'" (Hochhäusler 2013, 26–27).

The Romanian system of financing films is modeled after the French one. The National Center for Cinema, which in 2001 replaced The National Council for Cinema, is a state institution with a long tradition, established in 1934 with the passing of the Law for the National Cinema Fund. During socialism, the Romanian film industry was nationalized, so the state owned every item involved in the production, distribution, and exhibition of films. After several changes following the demise of socialism, the Cinema Fund (modeled after its European counterparts) was established in 1999 in order to regulate the transition from a state cinema to a private film industry able to benefit from state aid. This aid consists of interest-free loans to Romanian private production companies that have to be reimbursed in the ten years following a film's completion, with the rights to the film's negative as collateral. The money comes mostly from cable television stations, from a tax on cinema admission tickets, the sale and rental of DVDs and videotapes, and a percentage of the profit from all gambling activities (Uricaru 2012, 429–34). Unfortunately, almost all CNC competitions have until now created huge controversies due to irregularities in their criteria for selection.

Metabolism subtly emphasizes this economic aspect through the figure of the producer, Magda, who is worried about insurance and expenses. In real life, Porumboiu himself works with producer Magda Ursu, with whom he set up a production company, Km 42 Film, in 2004. In doing so, he followed a path taken by most of the prominent new Romanian directors who now have their own production companies and sometimes produce the work of fellow directors.[2] With the exception of Km 42 Film, all these companies are involved with the production of advertising and provide services to foreign companies who want to do post-production in Romania.

Metabolism also alludes to the competition between the young filmmakers of the New Wave for CNC funding and for international prizes that would qualify them to apply for additional funding. In a scene at an Italian restaurant, Laurentiu, another young filmmaker, notices Paul and Alina eating and briefly joins them at their table to make small talk. Laurentiu remarks on Alina's resemblance to Monica Vitti and invites her to audition audition at "La Strada," his production company, for his upcoming film. After he leaves, Alina observes that they each described the other as directors who *write* good scripts. Porumboiu is alluding here not only to a real production company founded by Romanian director Catalin Mitulescu, "Strada Film," but also to Federico Fellini's famous 1954 film. A notorious perfectionist, Fellini struggled to find financial backing for *La Strada* and suffered a nervous breakdown just before shooting was completed. And when Fellini's producer, Luigi Rovere, read the film's script, he famously commented that it was only a *well-written* script, but "as a film, this wouldn't make a lira. It's not cinema. It's more like literature!" (quoted in Frankel n.d.). The Italian director gained a reputation for making his actors rehearse a scene repeatedly (as Paul does with Alina), even giving them instructions during the shooting. By the time it was complete, Fellini's shooting script for *La Strada* was nearly six hundred pages long, with every shot and camera angle detailed (Alpert 2000, 93).

The entwinement of work and private life, money and love, and the vulnerability of women in the new economy, key tropes of the Berlin School films, feature prominently in *Metabolism*, linking its concerns to such films. Alina comes to Bucharest from a small town, Târgu Mureş, but she has previously lived in France for two years as a foreign language student. Her return to Romania is motivated by her desire to be an actress and by the few opportunities that France had to offer her. If Paul is mostly inscrutable, she is more vulnerable than him and eventually airs her frustrations, telling Paul that their sexual relationship is a result of their work insecurities. Paul, however, denies being stressed and reminds Alina that unlike a theater director, who might struggle to understand somebody

else's text, he creates his own text and therefore controls it. "I am the text," he insists, echoing Flaubert's famous proclamation, "I am Madame Bovary," thus implying that the actual shooting of his film is a form of writing as important as screenwriting. To underscore Alina's vulnerability, he later broaches the issue of money by asking her how she could have afforded to eat in French restaurants, and therefore forcing her to admit that her French boyfriend used to pay the bill.

The economic precariousness of Alina's profession links her to many female characters populating the Berlin School films, most notably to Deniz in Arslan's *A Fine Day* and Nina in Petzold's *Gespenster* (*Ghosts*, 2005), whose roles as actresses foreground what Fisher describes as "the necessity of performance and theatricality in modern life" (2013, 92). Moreover, Alina's controlled, standoffish demeanor is reminiscent not only of the air of detachment adopted by Monica Vitti in Antonioni's films (as Laurentiu remarks) but also of the formality and reserve of Nina Hoss, the actress who plays female protagonists in the process of migrating westward for economic opportunities in Petzold's *Yella* (2007) and *Barbara*. Petzold specifically emphasizes this attitude of reserve, as he is interested in how contemporary capitalism "refunctions" women's work and their romantic desires in a world in which they find themselves "increasingly unburdened by family and even love, thus attaining the lack of attachment and lightness of being valorized in neoliberal capitalism" (Fisher 2013, 23). Simultaneously, these female characters remain disempowered, still having to rely on men, who are the perpetual owners of the means of production. More often than not, they end up disillusioned after the initial excitement sparked by the promise of a new lover and a new job, as Alina is after her experience with Paul.

Although Laurentiu might hold the promise of new work and perhaps a new lover, midway through the film, after the scene at the Italian restaurant, when the action cuts again to the two "lovers" in the car, Alina tells Paul that she dreams of being an actress in France. Here, *Metabolism* foregrounds the character's utopian desires, even though she has already returned to Romania hoping to do the work that she loves to do. On a larger level, it captures, as Abel observes in relation to Petzold's cinema, the various *forces* that affect the characters, without explaining what causes the characters' intensely felt situations; thus, in *Metabolism*, Paul's hunched shoulders and Alina's uptight and controlled bodily movements stand out in the same way in which Julia Hummer's shoulders do in *Ghosts* and *The State I Am In*, slouched "as if they were pulled down by the weight of the whole world" (Abel 2013, 100).

Like Petzold's characters, Alina searches for an identity, but Paul forces her to *see* herself in various ways: he tells her that she looks Jewish but not French and that she definitely does not have "a German body." In response, she suggests

that she has Greek features, which give her a Mediterranean air that could make her pass as a woman from the south of France: "If I move to France, and live there, and speak and think in French, plus the energy of the people and of the place, my body could belong to that space." When Paul insists that she would still not be *herself*, Alina comments that adapting to a new place is "like when you swim in a river: you let yourself be carried by the current, otherwise you become overwhelmed." This discussion around the body recalls a similar scene in Petzold's *Jerichow* (2008), where Thomas tells the Turkish Ali, dancing on the beach, that he moves "like a Greek." For Petzold, this is a "crucial scene" (quoted in Leweke 2013, 37) that obliquely expresses Thomas's attempt to patronize Ali, which ultimately stems from his own insecurities.

Metabolism's last image shows Alina looking in the mirror at her own face freshly covered in makeup. No countershot of her reflection is revealed before the image abruptly cuts to the rolling credits. One is left to wonder at the violence of this sudden cut: is it an abrupt wake-up from a dream? Is she a ghostly figure, unaware of her status as such? To be sure, Porumboiu could have shown her reflection in the mirror, but he seems to have deliberately avoided this approach so often favored by filmmakers. The empty "non-places" (to use Marc Augé's [1995] term) that dominate the film (Paul's minimalist, sterile apartment, the eerie hotel), the film's subdued, neutral color scheme, and the song at the end of the film all seem to create a dreamlike world. The concluding lyrics imply not only an uncertainty of vision but also a ghostly element: "when evening falls / on Bucharest / I am looking at girls / but I see that you are not here / when evening falls / on Bucharest / I am *looking at you* / but I see that *you are not here.*"

Here, Porumboiu comes close to Petzold in his portrayal of characters who live in their own "bubble" spaces, as Petzold calls them, since the diegetic status of their desires often remains unclear: are they "real" or not? As Fisher suggests, "living fantasy as reality is especially true of ghosts, who are often unaware of their own spectral status and strive . . . to break through to normality" (Fisher 2013, 93). This unclear status made of fantasies and the utopian energies that they indicate have political repercussions, Fisher suggests. The spaces of private utopias that these films create are ultimately "reframed by the gaze of the other" (94), whether it is the gaze of Jeanne's mother in *The State I Am In*, of the director watching Nina and Toni dance in *Ghosts*, or Paul's gaze in *Metabolism* (fig. 5.1).

What also unites the Romanian director and many of the Berlin School filmmakers is a similar effort to expose viewers to a series of *reframings*. Like

Figure 5.1 Ghostly figures in *Metabolism*

Petzold's *Barbara* and Arslan's *A Fine Day, Metabolism* presents us with a triple mise en abyme by creating scenes in which the realistically produced sensations of identification with the characters are reframed in order to intensify the logic of their production and *readjust* our sensory capacities. *Barbara* features a scene in which André shows Barbara a reproduction of Rembrandt's *Anatomy Lesson of Dr. Nicolaes Tulp* (1632), pointing out not only that the wrong hand is being dissected but also that it is too large vis-à-vis the dead thief's frame. Rembrandt would not have made such a mistake, he comments, drawing attention to the importance of perception and visibility associated with the artist's style.

André notes that while the doctors appear to be looking at the body, they are actually directing their gaze at the anatomical textbook in front of them that offers a *representation* of the human body. Rembrandt, he suggests, redirects the viewer's gaze away from the doctors to the thief, the neglected victim of state violence with whom we are meant to emphasize. This scene offers a remarkable example of cinematic ekphrasis, acting, as Fisher notes, as a cinematic mise en abyme for the whole film and for Petzold's cinema in general, which consistently depicts marginal individuals, "those rendered spectral by continuous and fundamental socioeconomic change, ghosts, and here the ghost he archeologically exhumes might be the GDR itself" (Fisher 2013, 139).

Along similar lines, in his analysis of Arslan's *A Fine Day*, Abel draws attention to the subtle changes *with a difference* that the film provokes us to observe, arguing that these multiple "reframings of the sensible" effected in and as a result of its overt "meta" level work directly on the viewers' sensory apparatus and thus *modulate* their ability to sense and perceive. The film performs numerous reframings—of Deniz's desires; of Eric Rohmer's *Conte d'été* (*A Summer's Tale*, 1996) that Deniz is dubbing as an actress; of the established sound-image

relationship; and ultimately of itself as a film, working on a documentary-realist level that challenges viewers at an explicit *theoretical* level. These reframings are meant to make us "resee and rethink how the documentary-realist level operates" and "how our perception thereof all too quickly governed our assessment of the film's diegetic world and its relation to our own" (Abel 2013, 51).

Toward the end of the film, a repetition is at stake, with a small difference: we see Deniz dub once again, from the same Rohmer film, a scene in which a young man and a woman talk about love, relationships, and the difficulty of choosing between different love interests (topics that have dominated Deniz's own conversations with others throughout the day). Shortly thereafter, we follow her to the metro, silently looking at yet *another* young man who returns her look, as Diego did earlier. The film ends abruptly with her looking sideways toward the handsome stranger, thus intimating that the two might end up going on a date, as she did with Diego.

Moreover, the film creates another mise en abyme effect—also related to occlusion and redirected vision—in a scene where Deniz auditions for a role and is asked to talk about a film that *moved* her. Although she does not name the film, she recalls having recently watched on television what turns out to be Maurice Pialat's *A nos amours* (*To Our Loves*, 1983). First, as Abel points out, Arslan highlights the way in which the casting director frames Deniz's face, observing her as she is sitting on the chair and then looking at her image in the monitor that frames her face, simultaneously foregrounding the difference between editing within the image and between images (Abel 2013, 51–54) (fig. 5.2).

Second, Deniz recounts the story of a film about a young girl, taken from Pialat's film, which begins with her rehearsing for a play. Her lines (like the lines that Deniz herself is dubbing from Rohmer's film) are about love. The girl's boyfriend (just like Deniz's own boyfriend) senses the distance between them as they both realize that their relationship is over. The girl then goes on to have several other relationships and has a discussion about love with her father. On the bus to the airport, when she is about to leave for America to start a relationship with another man, the girl's father tells her that she is incapable of love.

The story that Deniz recounts, therefore, echoes conversations about love and work that she has had with others throughout the day—with her own boyfriend, with her sister and mother, and with a professor who tells her about the history of love. The last image of Arslan's film (of Deniz's looking sideways), moreover, takes its cue from Pialat's film, which also ends with the girl looking sideways through the bus window.

A similar mise en abyme effect operates in *Metabolism* at several levels. First, the film is rigorously structured with two scenes in the car, two restaurant

Figure 5.2 Deniz at the audition

scenes, two (off-screen) sexual acts, and two rehearsals executed through miming gestures. In the second rehearsal scene, the film itself specifically enacts, as a cinema lesson, the rehearsal scene in which Paul told Alina how she should react to what she overhears when she comes out of the bathroom. Thus, although we do not see the filmed scene that was rehearsed, we witness a mirroring situation with the same parameters sketched in the rehearsal scene: when Paul gets out of the shower, he overhears Alina talking to her boyfriend on the cell phone in the living room. He then sits on the bed, looking down for a few seconds, seemingly attentive to the conversation. He slowly puts his pants on while searching the bed for the t-shirt that Alina took when she answered the phone. We hear him open a drawer off screen and then we see him put on another t-shirt. Finally, he lights a cigarette in the living room and goes back to the bedroom to smoke while seated on the bed, his face toward the camera.

Second, Alina and Paul have a conversation about national food, different eating utensils, and sophistication, which mirrors other discussions about filmmaking and stylistic choices that the characters have: what to put in the center or leave out, the idea of mediated distance, and the issue of educated taste. The Chinese do not cook steak like the French because they could not eat it with chopsticks, reasons Paul, echoing his earlier statements about making a certain type of cinema as the result of being trained to work with the limits of

the film reel. "If the relationship between you and the food is not mediated by something," he adds, "you cannot look at the plate from a distance, you are only eating viscerally, trying merely to satisfy your hunger." This conversation echoes Ronald Barthes's claim in *Mythologies* (1991) that food possesses a quality of national collective significance,[3] and Porumboiu indirectly suggests here that an appreciation of his minimalist film, like the appreciation of European art cinema, is an acquired taste achieved by sophisticated, perceptive viewers.

Moreover, the film's premise—that a director will do a nude scene with an actress—thwarts narrative expectations and specifically mirrors a scene from Godard's *Contempt* in which Camille, played by Brigitte Bardot, gets out of the bathroom and overhears her husband, Paul, talking on the phone (figs. 5.3, 5.4).

As in Godard's *Contempt*, we do not actually see Alina naked. What we get instead is an *intellectualized* nudity that echoes the scene in which Bardot merely describes her body when she asks her husband if he likes her breasts, her butt, her shoulders, and so on. In a setup that mirrors *Contempt*, Porumboiu similarly frustrates viewers' expectations by having Paul describe for us how Alina's actual body, rather than the version preserved on celluloid, will look in fifty years' time: "Your flesh will be flaccid, your breasts will look sagging, you will have dark circles around your eyes, wrinkles."

While Godard invokes André Bazin by including a quotation from him that calls attention to our desires as spectators ("the cinema substitutes for our gaze a world more in harmony with our desires"), Porumboiu similarly alludes to Bazin's "The Ontology of the Photographic Image," which posits that the principal purpose of the filmic is the mummification of change itself. By invoking the idiom of corporeality, *Metabolism* foregrounds cinema as a form of digest. This "digest" is understood not as a kind of oversimplification of reality but, rather, as a special mode of expression that operates, as Bazin points out in an article on adaptation and "the cinema as digest," "as if aesthetic fat, differently emulsified, were better tolerated by the consumer's mind" (Bazin 2000, 26). Simultaneously, the film also reveals what Lippit calls a process of "digesture" (from the prefix *di-*, which means two, and as an abbreviation of *dis-*, an antithesis) in cinema: *two* gestures, "doubled gestures that indicate the presence of two bodies, or two bodily systems" at work (Lippit 2008a, 117). The doubling of bodies that defines movement in cinema follows two economies, namely, the generation of a doubled, absent, phantom body that is linked indexically to the body in the world and a movement that signals the presence of two bodies of distinct origin: the profilmic body and the body of the apparatus, two bodies that are both capable of producing movement in the film (117).

Figure 5.3 Brigitte Bardot in Jean-Luc Godard's *Contempt* (1963)

Figure 5.4 Paul and Alina rehearsing in the hallway

Metabolism thus illuminates the complex mechanisms of movement and gesture in cinema not only through Alina's pantomimic repetition of her gestures in the rehearsal scenes but also at a "meta" level by highlighting the difference between the director's camera and the digital camera that recorded Paul's endoscopy. The winding movements of the medical camera inside Paul's body, each read and interpreted for the viewer as it passes through the esophagus, the stomach, and the duodenum, mirror the movements of Paul's car advancing and taking turns through the streets of Bucharest.[4] In both cases, "reality" is obscured, however; just as Bucharest is barely discernable (especially in the first scene, filmed in the evening, through the shallow depth of field), so is Paul's body, whose endoscopy needs a trained doctor to "see" what for us remains visible but at the same time "invisible."

Like a doctor, Porumboiu "interprets" reality through his cinema and in so doing trains viewers to look at reality so that they relearn how to look at and see it. The film thus establishes an economy of movement that shifts between the actors' bodies, the gestures that they make through pantomime, and the movements of the two types of cameras. At one point, we learn that Paul has decided to eliminate the footage with Alina (which we never actually see) and that they will reshoot the same scene. Although Alina is quick to blame herself for having performed inadequately, he tells her that the camera was too close to her face: the aesthetic choice, he explains, changed the movie's meaning by drawing too much attention to her. This, in turn, works to make viewers aware of Porumboiu's own stylistic choices, emphasizing his refusal to use close-ups throughout *Metabolism*.

When the doctor declares that Paul's diagnosis is only gastritis and Magda asks him how he can ascertain this, he explains that "the filming has already ended" and that what they are actually looking at is the same path taken by the camera earlier, only that now it is moving backward to exit the body. Still unsure of what she has just seen, Magda reminds the doctor that he had initially thought that there was "something missing from the frame" and asks him to watch the filmed endoscopy a second time. We then witness the same scene, with a small difference. Porumboiu no longer shows us the footage but instead has the doctor verbalize what *he* sees. Like Alina in the rehearsal scene, he describes each camera action: "now it is in the esophagus, it progresses, it hasn't yet entered the stomach, that fold is the entrance to the stomach, the foam is a secretion that indicates that he is a smoker, and the wall like a snake skin means that it's a gastritis." Challenged by Magda once again to look for what is missing from the frame, the doctor exclaims, "when you're filming something that interests you, you place the camera in the center, not at the periphery!"

This conception of framing, however, becomes ironic for the viewer, as we immediately realize that Porumboiu has deliberately transgressed it throughout the film. Indeed, *Metabolism* foregrounds a number of scenes that highlight the discrepancy between sound and image, or that "waste" cinematic time by allowing carefully composed images and sequences to remain on screen beyond what is usually expected.

At one point, Paul looks off screen to Doina, Laurentiu's friend at the restaurant, but the camera refuses to show her reaction when he addresses her as she sits in the off-screen space. When Paul and Alina have sex, we only hear them through a door that is slightly ajar, as the film refuses to offer us an eroticized version of their intercourse. Given their relationship throughout the film, we are led to believe that this is yet another instance of unfulfilled sex, "a bodily manifestation of the social alienation ("Bad Sex" in Cook et al.

2013, 44) that resembles the alienation of the protagonists who populate the Berlin School films. Like these protagonists, Paul and Alina use sex "as a sort of prelinguistic communication" and "as a means of escape from the constraints of language" (44).

Porumboiu and the Berlin School filmmakers, then, understand the question of cinematic realism not as a way of capturing profilmic events most faithfully but as a way of inviting viewers to engage in an aesthetics of discovery. Realism, as Dudley Andrews points out, should be seen as a method that asks viewers to accommodate their perception to the organization of visibility in the world. Unlike digital new media, he notes, cinematic realism works by actually withdrawing information in order to incite the viewers' curiosity about the world (quoted in Cook et al. 2013, 19). To be sure, the song that concludes *Metabolism* as the credits roll reinforces this conception by alerting us to an economy of visibility and invisibility, to a trope of blindness through which one can see: "When evening falls / on Bucharest / I am looking at you, but I see that you are not here." This blindness, alluded to in an earlier scene in which Paul pulls the projector down in front of the camera, literally "blinding" the spectators with a black screen, is a special form of blindness. As Jacques Derrida would put it, "The blindness that opens the eye is not one that darkens vision" (quoted in Lippit 2008b, 246). The trope of blindness, for Derrida, emerges in the form of a paradox: blindness is the mechanism or condition through which one *sees* oneself. Blindness, therefore, does not mean the absence of sight but a particular relationship to oneself, to the image of oneself (247).

Describing the characteristics of the Berlin School, Abel suggests that the essence of these films cannot necessarily be described through a limited set of stylistic criteria. Rather, they should be conceptualized in terms of *the attitude* with which they encounter the world that they render cinematically sensible for us, in the same way that Bazin described the neorealist filmmakers when he said that "neorealism as such does not exist. There are only neorealist directors" (Abel 2013, 298). With this provocation to the viewers to (re)see themselves, Porumboiu shares with the Berlin School filmmakers a similar attitude toward the world. In *Metabolism*, reality becomes accessible only as a broken mirror that reflects it, in the same way in which Stendhal famously described the novel as a mirror being carried along the road that sometimes reflects the azure of the heavens and sometimes the mire of the mud holes. *Metabolism* is full of mirrors that refract and distort reality, but it is ultimately up to the viewers to find images of themselves in those reflections.

Notes

1 See Pollmann's contribution to this volume for a discussion of Antonioni and the Berlin School.
2 Tudor Giurgiu founded Libra Film in 1994, Cristian Mungiu Mobra Films in 2003, Cristi Puiu Mandragora in 2004, and Catalin Mitulescu Strada Film in 2004.
3 In "Steak and Chips," Barthes comments that for the French, wine, steak, and fries are able to "communicate national glamour," "part of the nation" and following "the index of patriotic values" (Barthes 1991, 63).
4 I learned about this deliberate stylistic effect in 2014, when I had the opportunity to interview Porumboiu in Bucharest.

Works Cited

Abel, Marco. 2013. *The Counter-Cinema of the Berlin School.* Rochester, NY: Camden House.

Alpert, Hollis. 2000. *Fellini: A Life.* New York: Simon and Schuster.

Augé, Marc. 1995. *Non-Places: Introduction to an Anthropology of Supermodernity.* London: Verso.

Baer, Hester. 2013. "Affectless Economies: The Berlin School and Neoliberalism." *Discourse* 35 (1): 72–100.

Barthes, Roland. 1991. *Mythologies.* 1957. Translated by Annette Lavers. Reprint. New York: Noonday Press.

Bazin, André. 2000. "Adaptation, or the Cinema as Digest." In *Film Adaptation*, edited by James Naremore, 19–27. New Brunswick, NJ: Rutgers University Press.

Cook, Roger F., Lutz Koepnick, Kristin Kopp, and Brad Prager, eds. 2013. *Berlin School Glossary: An ABC of the New Wave in German Cinema.* Bristol: Intellect.

Cooke, Paul. 2012. *Contemporary German Cinema.* Manchester: Manchester University Press.

Fisher, Jaimey. 2011. "German *Autoren* Dialogue with Hollywood? Refunctioning the Horror Genre in Christian Petzold's *Yella* (2007)." In *New Directions in German Cinema*, edited by Paul Cooke and Chris Homewood, 186–203. London: I. B. Tauris.

———. 2013. *Christian Petzold.* Urbana: University of Illinois Press.

Frankel, Mark. N.d. "La Strada." TCM.com. Turner Classic Movies. http://www.tcm.com/this-month/article/17950|0/La-Strada.html.

Hochhäusler, Christoph. 2013. "On Whose Shoulders: The Question of Aesthetic Indebtedness." In *The Berlin School: Films from the Berliner Schule*, edited by Rajendra Roy and Anke Leweke, 20–31. New York: Museum of Modern Art.

Holzapfel, Patrick. 2013. "Interview: Corneliu Porumboiu Talks about *When Evening Falls on Bucharest or Metabolism*." October 28. http://twitchfilm.com/2013/10/

interview-corneliu-porumboiu-talks-about-when-evening-falls-on-bucharest-or-metabolism.html.

Keough, Peter. 2010. "Interview: Corneliu Porumboiu." *Boston Phoenix*, January 21. http://thephoenix.com/boston/movies/95829-interview-corneliu-porumboiu/.

Leweke, Anke. 2013. "French Cancan in the DDR: An Exchange with Christian Petzold." In *The Berlin School: Films from the Berliner Schule*, edited by Rajendra Roy and Anke Leweke, 32–45. New York: Museum of Modern Art.

Lippit, Akira Mizuta. 2008a. "Digesture: Gesture and Inscription in Experimental Cinema." In *Migrations of Gesture*, edited by Carrie Noland and Sally Ann Ness, 113–31. Minneapolis: University of Minnesota Press.

———. 2008b. "Reflections on Spectral Life." *Discourse* 30 (1–3): 242–54.

Reitzer, Juliette. 2016. "Entretien avec Corneliu Porumboiu." *Trois Couleurs*, February 9. http://www.troiscouleurs.fr/2016/02/entretien-avec-corneliu-porumboiu/.

Swindoll, Graham. 2013. "When Evening Falls on Bucharest or Metabolism." Press kit for Cinema Guild. http://www.cinemaguild.com/theatrical/downloads/eveningfalls/press.pdf.

Uricaru, Ioana. 2012. "Follow the Money: Financing Contemporary Cinema in Romania." In *A Companion to Eastern European Cinemas*, edited by Aniko Imre, 427–52. Malden, MA: Wiley-Blackwell.

6

NO PLACE IS HOME

Christian Petzold, the Berlin School, and Nuri Bilge Ceylan

Ira Jaffe

Christian Petzold voiced a preoccupation of the Berlin School during interviews in 2011–12 conducted by Jaimey Fisher: "I guess I do not have a true home," said Petzold, explaining that where he "grew up was a bit like a trailer park" and that he had "always lived in transit spaces" (Fisher 2013, loc. 3024). The lack of "a true home" concerns major characters in both Petzold's films and those of other Berlin School directors, including Thomas Arslan, Christoph Hochhäusler, Ulrich Köhler, and Angela Schanelec. Their characters often exist in cars, motels, rest areas, airports, and other transit spaces. They reside, as both Marco Abel (Abel 2013, 17) and Fisher have noted, in "in-between spaces" and "non-spaces," bringing to mind a book important to Berlin School filmmakers, Marc Augé's *Non-Places: An Introduction to an Anthropology of Supermodernity*. Even when major characters such as young Armin (Constantin von Jascheroff) in Hochhäusler's *Falscher Bekenner* (*I Am Guilty*, 2005) and the conscript Paul (Lennie Burmeister) in Köhler's *Bungalow* (2002) reside in a conventional home, they seem estranged and bent on leaving it. Adrift mentally and physically, they resemble the female ghost (Candace Hilligoss) in Herk Harvey's *Carnival of Souls* (1962), a model for Petzold's *Yella* (2007), who upon realizing in a memorable scene that she is invisible and inaudible to the people around her, laments that she has "no place in the world, no place in the life around me."

Petzold possibly reverses this sequence of discovery by emphasizing to Fisher *not* that a ghost lacks a home or a place, but that such lack prompts the feeling that one is a ghost: "the ghost is not only about fear but rather this falling out of time and place, not belonging anymore, that is, to be on the margins, to be

unemployed, or even to be an unloved child—such people feel themselves to be ghosts" (Fisher 2013, loc. 3319). In any case, once Petzold's remark, "I guess I do not have a true home," is entwined with ghostliness, "falling out of time and place," and "not belonging anymore," it becomes weightier and more horrific. Its import also unfolds when Petzold describes the legendary Odysseus as an individual seeking to return home or find a home, and when he avers that "cinema always tells the stories of people who do not belong anymore but who want to belong once again" (Fisher 2013, loc. 3319).

Underscoring the physical, moral, and psychological complexity and ubiquity of homelessness in recent times, Theodor Adorno declared after World War II,

> The house is gone. The destruction of European cities and the concentration camps merely continued the processes that the immanent development of technology decided for the houses long ago. "It is part of my happiness not to be a homeowner," wrote Nietzsche in *The Gay Science*. One must add today: it is part of morality not to be at home with oneself. (Neiman 2002, 305)

Not being or feeling at home in the world or with oneself remains common today. Pope Francis's 2015 encyclical letter, *Laudato Si': On Care for Our Common Home*, for example, laments that climate change caused by human action under capitalism is making the planet unfit for human habitation (Nordhaus 2015, 26–27). Moreover, the world now faces possibly the greatest human migration crisis since the end of World War II, with as many as sixty million people displaced worldwide. In Syria alone, reports diplomat and Harvard professor Nicholas Burns, civil war has left twelve million people "homeless" (Burns and Jeffrey 2015).

Petzold's claim that "cinema always tells the stories of people who do not belong" seems borne out in films and essays originating outside the Berlin School as well as within it. That the lack of a home is central in a recent film by Jia Zhangke, for example, is highlighted in an essay by Jiwei Xiao: "In *A Touch of Sin* [2013], the road is . . . no longer a transit to transformation but has become a destiny in and of itself—for the migrants, the outcasts, and the entire group of the socially rootless. They may have families, yet they live in a perpetually homeless state" (Xiao 2015, 29). Similarly, Asuman Suner finds "themes of belonging and home" (Suner 2011, 16)—of the fragility if not complete absence of home—central to Nuri Bilge Ceylan's cinema. Moreover, Suner finds such themes significant in numerous "popular and art films" of New Wave Turkish cinema since the mid-1990s (Suner 2010, 1), and Gönül Dönmez-Colin considers "the feeling of 'not-being-at-home'"

an enduring concern of Turkish cinema (Dönmez-Colin 2008, 11). Suner adds, regarding Ceylan in particular, "Over and over . . . themes of home-coming [and] leaving" are evoked, and in *Three Monkeys* (2008), for which he won Best Director at the Cannes Film Festival, "the home at the center of the film is on the brink of falling apart, both metaphorically and physically" (Suner 2011, 20).

A decrepit home is central also in Petzold's *Jerichow* (2008), which appeared the same year as *Three Monkeys* and like this film harked back to classic film-noir depictions of social and economic frustration, love triangles, criminality, isolation, and loss. The home in *Jerichow* belongs to Thomas (Benno Fürmann), one of three main characters each of whom lacks a sense of belonging. Thomas lived in the home as a child, left it, joined the military, and now inherits the dwelling from his mother. As her funeral ends and Thomas exits the cemetery, two thugs arrive in a car and forcibly take him to the home, which they reach just ninety seconds into the film. Inside, the captors—Leon (André Hennicke) and his henchman—berate Thomas for abandoning the restaurant business they bankrolled, as they search the house for money and other valuables to settle his debt to them. As if to absolve himself, Thomas declares his intent to "fix" and "renovate" the home and make it his permanent domicile. Leon then discovers a photograph of Thomas as a child posing happily with his mother in a second abode—an old tree house still perched in the garden behind the home. As Leon proceeds to climb the tree, Thomas warns that because "the wood is totally rotten," Leon will "come crashing down." But Leon persists and finds tucked in the tree house a container filled with cash, which he seizes despite Thomas's plea that he needs the cash in order "to renovate the house."

Thus, Thomas needs both money and a home. It is the nexus of the two, rather than just one or the other, that is crucial also to the film's other main characters—Ali (Hilmi Sözer) and Laura (Nina Hoss), a married couple. Money and home figure as well in *Three Monkeys*, which I will relate to Petzold's *Yella* (2007) as well as to *Jerichow*. But the nexus in Ceylan's film is less emphatic and persistent than in Petzold's works.

As indicated earlier, homelessness for Petzold and his colleagues does not only or necessarily mean lack or loss of a physical home. Rather, it may connote the psychological disorientation induced by various global economic developments: altered communication technologies and capital flows, increased income in-equality, relocations in order to hold jobs or learn new skills, overlong sojourns in transit spaces or non-places. Amid such changes, capable individuals experience, if not losses of jobs or homes, then unsettled family lives, "exclusion . . . from wealth and power" (Castells 2011, loc. 353), heightened anxiety, puzzlement and resentment, and even moral and spiritual decline.

A further difficulty increases their sense of falling and not belonging: "a part of communal life, of the social, has been destroyed," Petzold tells Abel. "People are being forced into a terrifying independence" (Abel 2008, 11–12). In making a similar point to Fisher, Petzold attributes destruction of vital aspects of German communal life to "the transformation of . . . [East Germany's] state-socialist system into . . . [West Germany's] neoliberal system" (Fisher 2013, loc. 3124) following unification in 1989. Like other members of the Berlin School and numerous scholars, Petzold decries neoliberalism's neglect of cooperative values and policies to help citizens who fall short in competitive economic environments. David Harvey, in *A Brief History of Neoliberalism*, similarly faults neoliberal policies advanced in England by Prime Minister Margaret Thatcher in the early 1980s: "All forms of social solidarity were to be dissolved in favor of individuals, private property, personal responsibility, and family values," Harvey writes (2005, 22). Wendy Brown, in *Undoing the Demos*, sees "competitive advantage in a marketplace" (2015, 137), rather than "deliberation about common values or ends" (127), as the chief goal of neoliberal thought and governance. Consequently, she says, education under neoliberalism regards students as capital investments and seeks primarily to develop their entrepreneurial and financial skills rather than their understanding of justice and moral conduct. Equally dismayed, Steven Shaviro argues that where neoliberalism prevails, "passion is indistinguishable from economic calculation, and our inner lives are as thoroughly monetized and commodified as our outward possessions" (Shaviro 2010, 48–49).

More positive accounts of neoliberalism praise its embrace of free markets for spurring the "rise of market economies in Asia . . . [culminating in] the most rapid and widespread decline in poverty in human history" (Leonhardt 2015). Supporters of neoliberalism also stress that it encompasses various approaches to economic and social policy, some of which are less severe than others. Thus, neoliberalism in developed nations, including England, Germany, and the United States, does not always degrade communal needs for safe water, schools, roads, bridges, parks, and other public goods. Moreover, some advocates argue that neoliberalism in the Enlightenment tradition of Adam Smith stands ready to protect workers by regulating business and to help the poor and reduce inequality by taxing society's wealthy members.

Nonetheless, as I have indicated, Petzold, Harvey, Brown, Shaviro, and others regard neoliberalism as largely destructive. Concurring, Abel argues that "the true era-defining event" for Germany in recent decades has been not "the fall of the wall and the country's subsequent reunification" but "the process by which this *national* moment of exuberance almost instantaneously gave way to the emergence of the supra-national logic of neoliberalism" (2009, 4). Thus, a steep

emotional letdown, a falling not unlike Petzold's homelessness, virtually enshrouded the birth of contemporary Germany.

Whereas Petzold's films, consistent with his comments cited above, critically address—or at least keep in view—present social, political, and economic realities in Germany, rarely are Ceylan's films and comments similarly specific and critical with respect to Turkey. Instead, his films tend to be metaphysical and ahistorical—"more existential than political," as he has said regarding *Three Monkeys* (Levy 2015, 105). Petzold in *Yella* adopts dialogue drawn from recordings of actual negotiations between venture capitalists in Germany; in contrast, after shooting "a number of demonstrations and political rallies" (Andrew 2015a, 120), Ceylan dropped his plan to build *Three Monkeys* around an actual Turkish political election. Although generic images of a rally appear on a small TV in the home of the central family in *Three Monkeys,* and the voiceover states that "Erdogan's party appears to have won . . . a landslide victory," the issues at stake—and their relevance to this family—are left undefined. Further, it is doubtful that any resident of this home is watching: the son returns toward the end of the broadcast and ignores it, the mother naps, and the father is in prison.

Suner finds political and historical meaning, though, in Ceylan's avoidance of politics. For she believes this avoidance mirrors Turkish society's persistent "silence, oblivion and complicity" regarding massacres and deportations of Armenians and other ethnic and religious minorities, particularly from 1915 to 1923 as "the Turkish nation-state" was being formed (Suner 2011, 13). More recently as well, states Dönmez-Colin, Turkey has "expelled, exiled or silenced its minorities" in an effort to forge a national identity based on "homogeneity" (2008, 11–15). Violations of human rights have been widespread, targeting not only Kurds and others of divergent ethnicity, language, religion, or gender, but also various journalists, teachers, writers, musicians, and visual artists accused of "insulting Turkishness"—a crime according to the constitution forged by the military that ruled Turkey from 1980 to 1983 (Dönmez-Colin 2008, 14). As Suner notes, Turkey's "authoritarian mentality" (Suner 2010, 7) and militarized political space (coups occurred in 1960 and 1971 as well as 1980) have "left little room for voices of democratization and pluralism" (12). Yet some expression of social, political, and economic differences and discontent has survived. Thus, Turkish New Wave cinema has incorporated political films that explore "how the lives of ordinary people have been destroyed by Turkey's turbulent political climate of the recent past" (18). Further, Dönmez-Colin cites Reha Erdem's *Run for Money* (1999), a satire about Turkey's growing commitment since the 1980s to a market economy where "money became the only aim." But Dönmez-Colin also avers that Turkish cinema has been preponderantly "escapist"—removed

from "controversial issues" and "social, political and economic realities of Turkey" (Dönmez-Colin 2008, 15–17). In any case, she and Suner agree that Ceylan's films have not been political.

His films have largely avoided such controversial topics as Turkey's "authoritarian mentality" and persecution of women, minorities, and the press, as well as hostilities between Kurdish separatists and the Turkish army. In *Winter Sleep* (2014), social and economic inequality *is* of major concern, yet the film's relevance to contemporary tensions, including neoliberalism's role in the expanding chasm between rich and poor citizens, is softened by the film's exotic Cappadocian setting and its dated, if alluring, Chekhovian tone. *Winter Sleep* won the Palme d'Or at Cannes in 2014, capping a remarkable run by Ceylan, as his four previous films—*Distant* (2002), *Climates* (2006), *Three Monkeys*, and *Once Upon a Time in Anatolia* (2011)—also garnered major Cannes awards. Like other creators of New Turkish art cinema (and like the Berlin School), Ceylan has worked with small budgets and crews, drawn modest media notice, and enjoyed scant success at the box office. But he has won greater international acclaim than any filmmaker from Turkey since Yilmaz Güney, the Kurdish writer, director, and actor whose *Yol* (*The Road*, 1982) won the Palme d'Or at Cannes the year of its debut.

Güney's films in the turbulent 1970s, an era of "politicized social-realist cinema" (Suner 2010, 4), focused on the plight of workers and the poor. Written by Güney, directed on his behalf by Şerif Gören while Güney was in prison, and then edited by Güney after his escape, *The Road* portrayed "five prisoners traveling on a week's leave from prison to different parts of Turkey" who find Turkish society under military rule "no less claustrophobic and oppressive than prison" (Suner 2010, 5). Rather than travel, Ceylan's main characters in *Distant, Three Monkeys*, and *Winter Sleep* spend most of their time in their homes, and it is there they experience claustrophobia and repression, a kind of homelessness. Further, his main characters, even peripatetic ones in *Climates* and *Once Upon a Time in Anatolia*, seem oddly detached from society's political and economic struggles. Something internal rather than external gnaws at them, afflicts and absorbs their circumscribed lives.

The evasion and repression of political and historical truth in Turkey, says Suner, has led Ceylan to focus on internal life, "on subjective interrogations of the human soul" (Suner 2011, 14). Indeed, Ceylan seems inclined to focus on the soul regardless of historical events and to view the soul's modes, including its silences and amnesia, as proceeding independently of such events. His comments and films also suggest that he considers key aspects of the soul to be eternal and universal. One of many places where he casts the soul as his supreme subject is

the short, printed interview accompanying Zeitgeist's DVD of *Three Monkeys*: "I like to explore the soul of the characters, to try to understand what is generated in the deepest realm of human nature" (Ceylan 2009). Elsewhere, in discussing *Once Upon a Time in Anatolia*, he suggests that the soul has eternal features or inclinations: "I wanted to deal . . . with eternal properties of human nature" (White 2011, 70). His belief in "eternal properties" is implied as well, though perhaps less affirmatively, in his commentary on the New Yorker DVD of *Distant*: "Nothing changes a lot in life" (Ceylan 2005). Further, he indicates that certain properties of the soul are universal: "Everybody has a life and a secret violence inside them. Everybody has guilt at many things" (White 2011, 71). "People try to protect themselves; everybody has something they want to hide" (66).

The soul's homelessness and falling in *Three Monkeys*, I have suggested, is relatively free of historical and sociopolitical markers such as anchor characters and events in *Yella* and *Jerichow*. *Three Monkeys* offers little parallel to the fall of the Berlin Wall, the unification of Germany, or the triumph and expansion of neoliberalism. By contrast, neoliberalism in particular informs almost every moment of the two German films. *Yella*'s heroine hastens between the former East Germany and West Germany, between the former socialist state and, in Petzold's view, the increasingly neoliberal one, so as to make money and survive. Apparently Yella (Nina Hoss) ceased loving her estranged husband Ben (Hinnerk Schönemann) when their business failed. Her new lover Philipp (Devid Striesow), initially confident and financially successful, despairs when fired for stealing money from his employer. "You should find someone else," he tells Yella. "Not even a small-time shit bank would hire me now." Denied "competitive advantage in the marketplace," as Wendy Brown (2015) might say, Philipp judges himself unworthy of Yella's love. Hoss's Laura in *Jerichow*—a film where "there is hardly a scene that doesn't involve some reference to economic exchange" (King 2010, 13)—regards money and love much as Philipp and Yella do. Hence Laura initially deflects Thomas's love declaration with, "You can't love if you don't have money. That's something I know." Money or competitive advantage comes before love as well as home in both *Yella* and *Jerichow*; on such topics, moreover, Petzold's characters are more articulate than Ceylan's.

Three Monkeys generally presents a world of silence, confinement, and voiceless grief. Although Eyüp (Yavuz Bingöl), Servet's (Ercan Kesal) driver, accepts the promise of money from Servet to go to prison in his stead, it is hardly clear that Eyüp, unlike the central characters in *Yella* and *Jerichow*, feels a keen need or desire for money, or that, at first, he is capable of strong desire of any kind. Although he will appear more spirited when he emerges from prison, in the dark, cramped apartment at the start of the film he seems inhibited and mute, an

outsider in his own home unable to communicate his fateful decision to his wife Hacer (Hatice Aslan) and his son Ismail (Ahmet Rifat Şungar). Indeed, their life together initially seems so lacking in hope and warmth as to raise the possibility that Eyüp chooses incarceration as an escape. Later, when he leaves prison, Eyüp learns that Ismail has indirectly obtained money from Servet and purchased a car without Eyüp's knowledge or permission, while Hacer, who requested the money, has been having an affair with Servet. The betrayals enrage Eyüp and make his homecoming torturous for his wife and son as well as for him. Utterly isolated, Eyüp seethes in silence in the apartment and then by the sea. Finally, he visits a neighborhood teahouse where he had been a regular customer and where people call out to him, for the first time since he emerged from prison, "Welcome back. . . . We missed you!"

Alasdair King remarks that in *Jerichow*, "money is present in every scene, as an image, as currency, as a sign of betrayal" (King 2010, 15). In *Three Monkeys*, betrayal and self-betrayal are persistent failings of the "soul" or "deepest realm of human nature." Moreover, such failings are relatively mysterious or unexplained in Ceylan's film, whereas in *Yella* and *Jerichow*—as in *Carnival of Souls*, the American film cited at the start of this essay—betrayal seems attributable to neoliberalism's stress on economic gain. If *Carnival* helps set the stage for *Yella*, it is not simply because the heroine in both nightmarish films is a young woman who returns to life as a ghost after driving off a bridge and drowning, but because each ghost betrays its better self by elevating economic purposes above moral and spiritual ones. When in *Carnival* the minister at the church employing Mary Henry to play the organ implores her to "put your soul into it a little," as he finds her playing to be cold and mechanical, she replies, "It's just a job to me." When he speaks wistfully of an organist "capable of stirring the soul," she answers coolly, "to me a church is just a place of business."

When Thatcher promulgated neoliberal measures in England in the 1980s, Harvey reports, she declared that "economics are the method, but the object is to change the soul" (Harvey 2005, 22). Her words resonate ironically with Shaviro's cited above: "inner lives . . . as thoroughly monetized and commodified as our outward possessions." Implicit in Thatcher's statement was the belief that the human soul, rather than being immutable, is susceptible to change and in need of it. While Shaviro agrees that the soul is malleable, he opposes the changes envisioned by Thatcher. Whether one shares Shaviro's outlook or Thatcher's, "the soul" becomes pivotal in the struggle over the nature and future of humanity, and the films of Petzold and the Berlin School, more explicitly than Ceylan's, may be seen as committed to this historic combat. Further, while neoliberalism cannot be considered the only outlook

or ideology currently threatening humanity, it dominates Petzold's perception of the present historical moment. And cinema for him "is about the present," as Abel remarks, a present that, Petzold adds, "may direct us to history, to the question of the past" (Abel 2008, 8). Perhaps for such reasons, *Yella* and *Jerichow*, in the course of probing neoliberalism's hazards, depict the past as well as the present actions, desires, and dilemmas of their characters, and while hardly encyclopedic, the account in each film is more extensive and detailed than any in *Three Monkeys*.

Details about the present in relation to the past emerge in Petzold's films not least in the dialogue. Although Dennis Lim rightly suggests that Berlin School characters are "reticent" (Lim 2013, 90), and popular German director Dominik Graf states that the Berlin School has a "distrust of language, of communication" (Lim 2013, 93), characters in *Jerichow* and *Yella* talk more—and furnish more facts and explanations of their lives—than do the relatively inert, withdrawn main characters in *Three Monkeys* and in such other Ceylan films as *Distant*, with Muzaffer Özdemir as the taut, repressed commercial photographer Mahmut. Even *Winter Sleep*, which has more dialogue than any other Ceylan film, includes few details about how its loquacious central characters—the wealthy landowner, his sister, and his wife—have come to be as they are. Indeed, Jonathan Romney regards the "background of their individual grievances" as "largely hidden" (Romney 2015, 241).

In distinguishing the dialogue in Petzold's films from that in *Three Monkeys*, we might consider fragments of conversation in *Jerichow* between Thomas and Ali, his Turkish-born employer who resides in Germany and owns a chain of snack shops there. When Ali tells Thomas that he is about to visit Turkey to discuss with an architect property he has acquired in his native country, Thomas asks if Ali plans to build a vacation home on the land. "No, it's going to be forever," replies Ali, indicating he would like to reside in Turkey full time and permanently. "I was born there," he continues. "I was two when we left. Six months ago I buried my father there. . . . He wanted to be buried there." Ali shows Thomas a photograph (not revealed to the film spectator), then remarks: "First time I returned to Turkey. Fucking military draft. I couldn't be buggered with that. . . . Have you ever seen orange trees blossoming? It's unbelievable." Thus, with limited prodding, Ali reveals significant details about his life reaching back to childhood, much as the early scene between Thomas and Leon related Thomas to *his* childhood. Moreover, both scenes linking the present to the past underscore Ali's and Thomas's desires for homes on native soil precious to them since childhood. A further resemblance, of course, is that both men are destined to be disappointed. For Leon has taken Thomas's renovation money, and Ali, we

Figure 6.1 *Jerichow*: "This was not good."

soon learn, has a fatal heart condition; rather than visit Turkey, he plans to enter a German hospital for medical tests.

Ali reveals himself further in dialogue that makes little or no mention of either love or longing for a home but instead focuses on money and competitive advantage. After hiring Thomas on a trial basis, Ali stresses that his employee must be efficient when loading provisions for the snack shops onto Ali's delivery van: "You can't screw around loading up. That costs time." On the road, Ali quizzes Thomas about how to save gasoline: "Should we drive last to the furthest delivery point or the nearest?" Later, with Thomas's job secure, the two debate which corner at a traffic intersection would attract the most customers to a new snack shop Ali wants to open.

More poignant as the two men drive from one shop to another is Ali's complaint that his employees are stealing money from him. "Everyone here cheats on me," he says, and consequently he spies on everyone. Even his wife Laura cheats, by stealing from him and soon having an affair with Thomas. Like Ali, Laura explains herself in some detail, though early in the film she is mostly silent and mysterious, rather like characters in *Three Monkeys*. Laura's exposition of her past occurs after Ali has left for his medical tests and she and Thomas have feuded.

She goes to Thomas's house in the rain, they make love, and she stays the night. "I have to tell you something," she says the next morning, perhaps because she now feels more committed to him than before (fig. 6.1). Laura explains that she spent two years in prison, is thirty-four years old, and 142,000 euros in debt. One day Ali entered the bar where she worked. He was the most respectable man she had ever met and had lots of money, enabling her to stop working. Their prenuptial agreement was strict, though: "If I leave him, I get nothing . . . except my debts back." At this point in her narrative, Thomas discovers that Ali has beaten her. He sees wounds on her body attesting to her ongoing entrapment and estrangement as well as to Ali's brutality—and to his pain and distrust of all those around him. Laura's account of who she is and where she has been, like portions of Ali's account of his life, has centered on money. But if, as Laura has said, "you can't love if you don't have money," you cannot have a home either—or "belong" anywhere or to anyone. Ali's complaint, "everyone here cheats on me," entails similar consequences. Perhaps he would belong if he returned to Turkey, but for now both he and Laura are homeless and in pain.

In *Three Monkeys*, which takes place in Istanbul, Eyüp is awakened at home in the middle of the night by a phone call from Servet summoning his weary employee to meet him at once. "Okay, I'll be right there," Eyüp promptly says. The next scene finds the two men seated in darkness on a bench by the sea. Servet asks Eyüp to go to prison for Servet's hit-and-run accident earlier that evening, with which the film began. Again, Eyüp's response is swift, though he looks unhappy: "Okay, no problem." Servet promises to pay Eyüp's regular salary to his son Ismail during his incarceration, plus a bonus when Eyüp completes his sentence, yet the flat tone of Eyüp's assent bespeaks habitual deference to authority more than eagerness for money. Further, Eyüp's "Okay, no problem" are his only words during the meeting—Servet does all the talking. Eyüp does not question, for instance, Servet's assertion that he will serve no more than a year in prison, nor does Eyüp voice concern about leaving his family and home and foregoing his freedom.

In the scene following the image of the sea that concludes this meeting, Eyüp slowly approaches a bed where his wife, Hacer, lies asleep. He sits heavily on its edge and for a moment looks toward her. As she remains asleep, he turns away and sits with his back to her. A close shot of his clenched hands shows one of them opening to bare a car key Servet gave him at the end of the prior scene. Eyüp grimly looks down at the key. The blaring horn and rumbling of an off-screen train break the silence, but Hacer does not stir, and Eyüp does not turn toward her again. Apparently roused by the sounds, though, he looks up and behind him, toward frame right. Then the sounds persist across a cut to a new

shot featuring a large window that could well be the object of Eyüp's look. But the window, which affords an unobstructed view of the sky and sea (and, we note later, also overlooks a highway and railroad tracks), is in a different room (a small living and dining room), and the light is different too, indicating a later time of day. Only the strident train sounds in the new shot are unchanged; Ceylan considered calling *Three Monkeys* "The Sound of the Trains" (Levy 2015, 107). Hacer enters the frame, walks toward the window, and sets a coffee mug on a table next to it. Then she reaches through the window, which turns out to be fully open, and fondles plants on the outside ledge. The next shot fastens on Ismail's inert body in bed as Hacer enters his room, saying "Get up! You'll miss the train," and opening curtains over a window by his bed. In the following shot, about 9.5 minutes into the film, Ismail is shown eating breakfast at the table by the window overlooking the sea, and shortly he appears aboard a train conveying him to his father in prison.

Worth underscoring, besides the dearth of dialogue, is that the large window revealing the sky and sea is not the object of Eyüp's look, viewpoint, or agency. Rather than bearing us to the window, Eyüp's look is aborted. He merely starts to look, then vanishes, appearing neither in the image containing the window nor in the ensuing shots I have cited. These subsequent images instigated only *apparently* by his look introduce us to his wife and son. But what if anything has transpired between these three individuals prior to Eyüp's disappearance? Do the elided moments contain sad conversation, struggle, explanation, debate, hugs, tearful farewell? All is unknown, and remains so. Evident are simply the scarcity of human voices and Eyüp's premature absence from spaces where the spectator has expected to find him.

Ceylan's cinema virtually thrives on elisions of key facts and events related both to the sociopolitical surround and to his characters' most crucial emotions (Suner 2011, 18; Sippl 2015, 36). Of course, absence and omission are in various ways integral to art and cinema generally, including films of the Berlin School. How different Petzold's *Die innere Sicherheit* (*The State I Am In*, 2000) would be, for instance, were the reasons for the fugitive plight of Clara (Barbara Auer), Hans (Richy Müller), and their daughter Jeanne (Julia Hummer) made clear. But Hans and Clara's implicit role in the Red Army Faction, the far-left German militant group of the 1970s and '80s, is not discussed—the RAF is not even mentioned. Instead, as Fisher notes, there is "remarkable silence about the past" (2013, loc. 854). Hans and Clara may be endlessly fleeing and hiding with their daughter for any number of *apolitical* reasons; they withhold from her their past and their political ideals, perhaps because she is only fifteen, or because they are ever fearful and untrusting. The silence only heightens her frustration and

confusion as to why she is denied seemingly normal teenage comforts such as a stable home and close friends. In berating Jeanne for staying away one night without permission, Clara declares, "You have no idea what's at stake here." The daughter has "no idea" because, almost incredibly, essential facts and events have been elided by her parents as well as by the film itself.

Jeanne steals away from her parents for secret encounters with Heinrich (Bilge Bingül), a new friend, but leaves him abruptly and without explanation each time they meet. Divulging no details of her captive life with Hans and Clara, she tells Heinrich only that "we live in hiding" and "belong to a cult." He complains, "I don't know who or what you are," and in her bewildering circumstances, she may not know either. Thus, she somewhat resembles the conscript Paul in Köhler's *Bungalow*, who cannot say why he joined the military or why he has now become a deserter. Yet, though Jeanne is entangled in her parents' mystery, she does have an idea of the normal life she wants. Paul, by contrast, is blank, without clear desire and emotion, unknown to himself and others. "I don't know anything, anymore," he says. His parents are mentioned but do not appear. Silence reigns over his past. Not unlike *The State I Am In*, *Bungalow* omits potentially illuminating facts and events, and its final shot highlights its penchant for omission and indeterminacy. After Paul phones to surrender to the military police, *Bungalow* closes with a long-held, high-angle long shot in which both a military vehicle and a yellow commercial truck pull up in front of his small figure standing in an open space. When the vehicles drive off, he is no longer visible, but we cannot determine whether he has entered the military conveyance or the commercial one. In the film's first scene, he arrived at an eatery alongside other soldiers in a military truck, then deserted by hitching a ride on a commercial vehicle. He subsequently failed to keep a promise to surrender to the military. The closing long take elides whether he now fails again.

From the moment young Ismail first appears in *Three Monkeys*, he looks as estranged and indifferent as *Bungalow*'s Paul. On Ismail's way to the bathroom after Servet's phone call summoning Eyüp to meet him, the son ignores his father despite the unmistakable worry and need on Eyüp's face. Ismail's discovery of his mother's affair with Servet prompts unwonted expressions of vulnerability and anger. But then Ismail reverts to his inert state, which persists despite his murder of Servet, an event that, like Servet's hit-and-run accident, occurs off screen. What accounts for Ismail's generally uncaring, enervated condition? He seems yet more alienated than Armin in *I Am Guilty*—though he is spared Armin's impersonal job interviews and fantasies of rough homoerotic encounters reminiscent of moments in Kenneth Anger's *Fireworks* (1947). Perhaps, as commentators have suggested, neither Ismail nor his parents have recovered from the death

Figure 6.2 *Three Monkeys*: "Did you miss me?"

years earlier of Ismail's little brother, possibly in a drowning accident. Although that tragedy, like others in *Three Monkeys*, is neither shown nor discussed, the dripping, nearly naked ghost of the child (Gurkan Aydin) approaches Ismail at one point and later drapes an arm over Eyüp's shoulder, as if to ease the father's grief after his return from prison. Ismail himself arrives home one day bloodied from a fight—yet another off-screen event and one that motivates Hacer to ask Servet for money.

What of Eyüp and Hacer? Although she has Ismail deliver pastries to him in prison, she and Eyüp converse not at all until late in the film when Eyüp asks about her relationship with Servet (fig. 6.2). At this point Eyüp has just emerged from prison, where Hacer has visited him not once during his nine-month stay (while Ismail has visited him but three times), and Eyüp's inquiry proves too explosive for them to talk at length. Further, we are told nothing about how Hacer and Eyüp met, or about their life together, including the effect of their little boy's death. Equally unknown is the romantic trajectory of Hacer and Servet. We hear no words between them from the moment Servet, having given her a lift in his car, tells her he would do anything for her—she need only ask—to the moment they madly confront each other by the sea at the end of the affair. Here in extreme

long shot she clings to him, begging him not to reject her. "Get off, you pest," he responds, and hence they threaten to kill each other. Since particulars of their romance have been omitted, the spectator cannot easily understand Hacer's plunge into suicidal despair despite her beauty and earlier composure. Her woeful state is all the more unsettling because Servet seems but a fatuous egotist, less worthy of her affection than Eyüp—who, as I have indicated, emerges from prison more spirited and discerning than previously. Indeed, it may be consistent with the disconnect between Eyüp and Hacer that his imprisonment has enhanced him while destroying her.

Probably discord or disconnection between major characters is central to most narrative films. Yet in works such as *Jerichow* and *Yella* there are also moments, however short-lived, when characters open up and connect with each other, even if they do not fully achieve a home together or enjoy a sense of belonging. Such moments occur in *Jerichow* not only between Laura and Thomas when, for instance, she confides details of her past the morning after they make love, but also between Laura and Ali at film's end, when he tells her that he needs her—and that he is dying and making provision for her welfare after his death. Similar moments of connection are hard to find in *Three Monkeys*, not least because of what Ceylan terms his "dark side" (Andrew 2015b, 206), the sad tendency he finds in people generally as well as in himself to hide the truth or hide *from* it, to deceive the self and others, and, in a sense, to shut down rather than open up. Hence truth for Ceylan somehow resides in silence more than in spoken words. "The truth lies in what's hidden, in what's not told," he says. "Reality lies in the unspoken part of our lives" (White 2011, 66). This view is echoed by other distinguished contemporary filmmakers. Lisandro Alonso, for instance, says, "I just don't have any confidence in words. I do have confidence in what I see . . . I don't believe that I need to have recourse to words in order to explain how my characters feel" (Jaffe 2014, 126). And Russian writer and director Andrey Zvyaginstsev avers that "words are like traitors . . . things are best expressed with silence" (2012).

Yet do human beings achieve communion or ample connection without spoken words? Silence is telling in other Ceylan films besides *Three Monkeys*. The first ten minutes of *Distant*, for instance, contain no dialogue—"as Ceylan establishes," writes Jonathan Romney, "a mood of silence and failed communication" (Romney 2015, 232). In *Climates*, says Romney, Ceylan "prefers silence[s]"—most "affecting" are moments where the heroine's "feelings suddenly become wordlessly apparent" (235–36). Dönmez-Colin agrees that the heroine's "point of view . . . her feelings and . . . dilemmas, are felt through the silences" (Dönmez-Colin 2008, 166–67). Regarding *Winter Sleep*, widely considered

Ceylan's most theatrical film partly because its characters seem to talk endlessly, Romney states, "it's in their silence that these performances are often the most eloquent" (Romney 2015, 242). Nonetheless, even eloquent silences do not remove the barriers between Ceylan's characters.

Words fail as well, though. When characters exchange words in *Three Monkeys*, it is often to reprove or reject each other. Even less angry exchanges suggest frustration more than hope, as characters resist connecting with each other and articulating their desires (Suner 2011, 20). Consider, for instance, this segment between Hacer and Ismail:

H: Of course you're bored. Find yourself something to do.

I: I did. But you turned up your nose.

H: At what?

I: Forget it.

H: Come on! What was it?

I: Just forget it. As if you didn't know.

H: I don't know. If I did, why would I ask?

I: I told you the other day.

H: What did you tell me?

During most of this exchange, moreover, Ismail looks through the living room window rather than toward his mother, as if to underscore that he and Hacer diverge. Finally, he tells Hacer to ask Servet for money—the bonus Servet promised Eyüp—so that Ismail can buy a car for work he wants to pursue.

Thus, the conversation between Ismail and Hacer does arrive at a destination, though only after stops and delays that contribute, as do the prolonged silences and meager explanations, to *Three Monkeys*' often painful and suspenseful slowness. Adding to this slowness, the characters are largely sedentary. "From the first scene to the last," writes Fisher about *Yella*, Petzold's heroine "is . . . a woman on the move" (Fisher 2011, 201). No person or ghost in *Three Monkeys*—a film of duration rather than movement—quite fits this description. Burdened by sorrow, Eyüp moves slowly and hesitantly, except in the first moments following his release from prison. The initial images of Hacer and Ismail have them lying in bed. The dead child's ghost engages Ismail and Eyüp while each is in bed. Servet until late in the film is usually seated—on a bench or in his car or office. Even cars and trains in *Three Monkeys* move slowly and heavily compared to vehicles in

Jerichow and *Yella*. The editing, too, is slower than in Petzold's films, as the shots last longer.

The slowness, immobility, and speechlessness of *Three Monkeys* yield slightly near the film's end to spoken words that sound more truthful and warm, more suggestive of communion, than any previously. "We missed you," says young Bayram (Cafer Köse), as he welcomes Eyüp and brings him tea when the ex-convict, seeking refuge from his family, enters the teahouse. Then the young man tells Eyüp about his struggle to survive, and Eyüp in close-up, amid whorls of cigarette smoke, nods with understanding. Bayram has no parents; his relatives treated him badly when he tried living with them; now he lives and works at the teahouse. "I get peace here," he says, but laments, "it's so far from home." After learning that Ismail has murdered Servet, Eyüp returns to the teahouse another night and wakens Bayram to persuade him to go to prison instead of Ismail. There is a note of sad fellowship in Eyüp's voice as he promises the young man "a lump sum" when he gets out—and speaks about home: "OK, this teahouse is your home. That place can be too . . . What's the difference? . . . There's heating there . . . Three meals a day . . . What do you say?"

Like Bayram and the main characters in *Jerichow* and *Yella*, Eyüp, his wife, and his son lack what Petzold might call "a true home" and a sense of belonging, and they scarcely feel at home with themselves. But while both Petzold's characters and Ceylan's seem out of place and perhaps ghostly wherever they happen to be, Petzold's appear more involved in a particular economic, social, and political order at a particular time and place—that is, neoliberalism in Germany after unification. Ceylan's characters are more withdrawn, inarticulate, sluggish, and adrift—more removed from society and from a specific order and ideology, with the result that their homelessness may have a more timeless and irremediable quality. Robin Wood, in an essay about Ceylan's cinema, broached a distinction I have applied to Ceylan *in relation to* Petzold: "are we unhappy because of specific social conditions, Ceylan repeatedly asks, or because of some deeper, less definable unsatisfactoriness in the very foundations of human existence?" (Wood 2015, 59). It may be the case that Petzold and the Berlin School underscore "specific social conditions," while Ceylan stresses "the very foundations of human existence."

Works Cited

Abel, Marco. 2008. "The Cinema of Identification Gets on My Nerves: An Interview with Christian Petzold." *Cineaste* 33 (3): 1–15. http://www.cineaste.com/articles/an-interview-with-christian-petzold.htm.

———. 2009. "German Desire in the Age of Venture Capitalism." Booklet accompanying the *Yella* DVD. New York: Cinema Guild.

———. 2013. *The Counter-Cinema of the Berlin School.* Rochester, NY: Camden House.

Andrew, Geoff. 2015a. "It's All about Vertical Lines: Nuri Bilge Ceylan in Conversation (2009)." In *Nuri Bilge Ceylan: Essays and Interviews*, edited by Robert Cardullo, 111–23. Berlin: Logos Verlag.

———. 2015b. "Journey to the End of Night: An Interview with Nuri Bilge Ceylan (2012)." In *Nuri Bilge Ceylan: Essays and Interviews*, edited by Robert Cardullo, 200–208. Berlin: Logos Verlag.

Brown, Wendy. 2015. *Undoing the Demos: Neoliberalism's Stealth Revolution.* New York: Zone Books.

Burns, Nicholas, and James Jeffrey. 2015. "The Diplomatic Case for America to Create a Safe Zone in Syria." *Washington Post*, February 4.

Cardullo, Robert, ed. 2015. *Nuri Bilge Ceylan: Essays and Interviews.* Berlin: Logos Verlag.

Castells, Manuel. 2011. *The Information Age: Economy, Society, and Culture.* Vol. 1, *The Rise of the Network Society.* 2nd ed. Cambridge, MA: Wiley-Blackwell. Kindle.

Ceylan, Nuri Bilge. 2005. "Interview with the Director." *Distant* DVD. New York: New Yorker Video.

———. 2009. "Melodrama, Method, and Mayhem: An Interview with Nuri Bilge Ceylan." Booklet accompanying *Three Monkeys* DVD. New York: Zeitgeist Video.

Dönmez-Colin, Gönül. 2008. *Turkish Cinema: Identity, Distance, and Belonging.* London: Reaktion Books.

Fisher, Jaimey. 2011. "German *Autoren* Dialogue with Hollywood? Refunctioning the Horror Genre in Christian Petzold's *Yella* (2007)." In *New Directions in German Cinema*, edited by Paul Cooke and Chris Homewood, 186–204. London: I. B. Tauris, 2011.

———. 2013. *Christian Petzold.* Urbana: University of Illinois Press. Kindle.

Harvey, David. 2005. *A Brief History of Neoliberalism.* Oxford: Oxford University Press. Kindle.

Jaffe, Ira. 2014. *Slow Movies: Countering the Cinema of Action.* London: Wallflower Press.

King, Alasdair. 2010. "The Province Always Rings Twice: Christian Petzold's Heimatfilm noir *Jerichow*." *Transit* 6 (1): 1–22. http://escholarship.org/uc/item/3r61h87r.

Leonhardt, David. 2015. "Sunday Book Review: 'Chicagonomics' and 'Economic Rules.'" *International New York Times*, November 17. http://www.nytimes.com/2015/11/22/books/review/chicagonomics-and-economics-rules.html.

Levy, Emanuel. 2015. "*Three Monkeys*: An Interview with Turkish Director Nuri Bilge Ceylan (2008)." In *Nuri Bilge Ceylan: Essays and Interviews*, edited by Robert Cardullo, 104–11. Berlin: Logos Verlag.

Lim, Dennis. 2013. "Moving On: The Next New Wave." In *The Berlin School: Films from the Berliner Schule*, edited by Rajendra Roy and Anke Leweke, 88–100. New York: Museum of Modern Art.

Neiman, Susan. 2002. *Evil in Modern Thought: An Alternative History of Philosophy*. Princeton, NJ: Princeton University Press.

Nordhaus, William. 2015. "The Pope and the Market." *New York Review of Books*, October 8, 26–27.

Romney, Jonathan. 2015. "Nuri Bilge Ceylan: Four Reviews, from *Distant* to *Winter Sleep* (2004–2014)." In *Nuri Bilge Ceylan: Essays and Interviews*, edited by Robert Cardullo, 228–44. Berlin: Logos Verlag.

Shaviro, Steven. 2010. *Post-Cinematic Affect*. Winchester, UK: Zero Books.

Sippl, Diane. 2015. "Ceylan and Company: Autobiographical Trajectories of Cinema (2005)." In *Nuri Bilge Ceylan: Essays and Interviews*, edited by Robert Cardullo, 34–58. Berlin: Logos Verlag.

Suner, Asuman. 2010. *New Turkish Cinema: Belonging, Identity, and Memory*. London: I. B. Tauris.

———. 2011. "A Lonely and Beautiful Country: Reflecting upon the State of Oblivion in Turkey through Nuri Bilge Ceylan's *Three Monkeys*." *Inter-Asia Cultural Studies* 12 (1): 13–27.

White, Rob. 2011. "Nuri Bilge Ceylan: An Introduction and Interview." *Film Quarterly* 65 (2): 64–72.

Wood, Robin. 2015. "*Climates* and Other Disasters: The Films of Nuri Bilge Ceylan (2006)." In *Nuri Bilge Ceylan: Essays and Interviews*, edited by Robert Cardullo, 58–66. Berlin: Logos Verlag.

Xiao, Jiwei. 2015. "China Unraveled: Violence, Sin, and Art in Jia Zhangke's *A Touch of Sin*." *Film Quarterly* 68 (4): 24–36.

Zvyaginstsev, Andrey. 2012. Interview on *Elena* DVD. New York: Zeitgeist Video.

7

THE FORCES OF THE MILIEU

Angela Schanelec's *Marseille* and the Heritage of Michelangelo Antonioni

Inga Pollmann

Michelangelo Antonioni's films are famous for their depiction of modern alienation and the corrupting effects of wealth, capitalism, colonialism, and the media in postwar society. These topics are conveyed by means of a refusal of straightforward plotlines in favor of drifts and tangents that defy goal-oriented, coherent, and logical action. Plots get lost, and protagonists lose themselves. In *L'Avventura* (1960), a woman disappears on a small volcanic island and those searching for her become increasingly distracted; in *La Notte* (1961), we witness the death of a relationship when a woman becomes aware of the emptiness of her and her partner's decadent intellectual existence; in *L'Eclisse* (1962), after ending a relationship, a woman drifts aimlessly and eventually stumbles into a new relationship; and in *Il Deserto Rosso* (*Red Desert*, 1964), a mentally unstable woman in an industrial setting becomes alienated from her husband and son and lets herself be coerced into an affair by her husband's coworker. The drifting protagonists—often aimless, sometimes confused, and at times destructive—and the porous plots dislodge the films' images from their function of conveying information and shift the creation of meaning from words and actions to mise-en-scène, that is, the visual constellation and appearance of people and things in the image.

Antonioni's mise-en-scène alternates between a focus on the protagonists' trajectory through and physical encounter with certain environments and the direct confrontation with this environment itself, be it specific cityscapes—Rome in *L'Eclisse*, Milan in *La Notte*, Barcelona in *Professione: Reporter* (*The Passenger*, 1975)—or natural landscapes such as the volcanic island in *L'Avventura* and

desert landscapes in *Red Desert, Zabriskie Point* (1970), and *The Passenger*. Many of these environments are directly expressive of modern predicaments (the stock exchange, impersonal office spaces, the geometrical abstractions of modern architecture, or the empty expanses of certain urban or rural landscapes). Mise-en-scène, cinematography, and editing further emphasize the abstract qualities of these environments, such that they become as expressive of "modernity and its discontents," "the crisis of postwar bourgeoisie," and "emotional alienation" as the protagonists.[1] In Antonioni's searching images, every surface becomes face, every constellation of landscapes, buildings, and things becomes expression.

Along with Robert Bresson and Jean-Luc Godard, Antonioni constitutes one of the most consistent film-historical reference points for the filmmakers associated with the Berlin School. While Christoph Hochhäusler has often claimed that Antonioni is of utmost importance for him, for the so-called first Berlin School generation of Angela Schanelec, Christian Petzold, and Thomas Arslan, the influence of Antonioni, Bresson, and Godard can be traced back to their studies at the dffb (Deutsche Film- und Fernsehakademie Berlin).[2] In the late 1980s and early '90s, they all became eager participants in the small theory seminars offered by Hartmut Bitomsky, Harun Farocki, and Helmut Färber, where they spent weeks working on just one film, including Antonioni's *The Passenger*—films they would analyze shot by shot, scene by scene, moving back and forth between regular film projection and the dissecting work at the editing table (Baute n.d.).

In this essay, I explore how the Berlin School engages with Antonioni's aesthetic strategies of transferring the expression of an underlying crisis to the face of things, their constellation, and their interaction with characters who are either lost and drifting or propelled relentlessly forward by empty drives and desires. Antonioni's films are configured around the absence of values, purpose, stability, moral and legal guidelines, family cohesion, and identity connected to tradition or work. The ultimate expression of these absences in his films is the absence of a bond between protagonists and their milieu, a natural "fitting in"; that is, characters are lacking a configured place in the sense of Walter Benjamin's bourgeois leather fauteuil that perfectly conforms to the contours of its occupant's bottom, or in the sense of a stable ecological niche that allows a perfectly adapted species to thrive. The protagonists thus find themselves in environments that deny them a place and comfort, spaces that either turn toward them suspiciously, exhibiting them and stripping them of any protection (for example, Rome's EUR quarter in *L'Eclisse*, the desert in *The Passenger*), or turn their back to them, refusing legibility (for example, the volcanic island in *L'Avventura*, the stock exchange in *L'Eclisse*). I argue that this confrontation of protagonists with environments that act as autonomous milieus reappears in Berlin School films and that we can

better understand the logic of this film language (in both Antonioni and Berlin School films) by bringing it into conversation with the history of milieu theory and especially by distinguishing between milieu understood as place and milieu understood as relation.

Although I see a number of connections between Antonioni's films and various Berlin School films, I focus here primarily on Antonioni's *The Passenger* and Schanelec's *Marseille* (2004). I argue that *Marseille* features a mise-en-scène that, similar to Antonioni's, tries to capture contemporary life by shifting the balance from narrative and action to drift, active passivity, and sounds and images that make visible the forces of the milieu in their conflicted encounter with characters. While classical narrative cinema subjugates setting and mise-en-scène to the requirements of action, intention, and the spectator's attention, in Schanelec's films (as in Köhler's and Arslan's) the milieu exists independently from any action. We pay attention to it not only because the protagonists' inscrutability has us searching for clues but also because places and things are present in their own right, without being subjugated to the economy of a plot or a coherent stylistic regime. The resulting images require a different viewing on the part of the spectator, too: since the narrative does not allow for immersion, the protagonists do not allow for easy identification, and because framing and mise-en-scène are limiting our view and access, the spectator connects to the image regime as a whole. I follow others in suggesting that neoliberalism is the relevant contemporary environment for *Marseille* and other Berlin School films but draw on Foucault's description of the environmental logic of neoliberalism as a means for understanding the political dimensions of Schanelec's appropriation of Antonioni's aesthetic strategies.[3]

Milieu as Medium

Milieu, the French word for "middle," originally denoted a *place* located in the middle. Beginning in the renaissance, milieu was used in the sense of an intermediary, that is, something that *mediated* between two poles.[4] Milieu is thus closely related to medium, especially when the focus is on a relation rather than a location. As the term milieu migrated from physics to biology (and finally to sociology), it became conjoined with life: it is that on which organic life depends, including not only surrounding fluid or air but also all external circumstances. For Jean-Baptiste Lamarck, for example, writing in the early nineteenth century, the milieu is a dynamic, ever-changing entity, yet "the life and the milieu that is unaware of it are two asynchronous series of events" (Canguilhem 2001, 12). The movement of life is thus ignored, unregistered by the milieu, which remains

indifferent to it. Auguste Comte, by contrast, stressed the harmony of milieu and life, since the former protected and benefited the latter. Subsequent sociological, medical, and literary appropriations of the term by Hyppolite Taine, Claude Bernard, and Émile Zola took a sharp mechanist turn and denied agency to life. Taine, for example, focused on the power and mindlessness of a milieu whose product man is. For him, milieu is completely severed from the perceptions and actions of life, untouched by it. The living being is molded by the forces the milieu exerts on it, and these forces are mechanical and static in nature.

Beginning in the late 1910s, new dynamic models for milieu-life interaction emerged. A new generation of biologists such as Kurt Goldstein, Jakob von Uexküll, and Frederik J. J. Buytendijk developed theories of a dynamic and mutually constituting relationship between organisms and environments.[5] According to this paradigm, as Georges Canguilhem put it, the milieu poses a problem and often "proposes" but never imposes a solution; the solution can only be found by the living being, through the activity of living in the world (Canguilhem 2001, 17). Over the course of the nineteenth and twentieth centuries, the term *milieu* thus loses its denotation of a concrete place and instead describes the force field, the interrelations between an individual and her surroundings (the *medium*). In this essay, I thus distinguish this sense of milieu as medium from "environment," by which I mean the spatial and material configuration of the surroundings, the ensemble of natural and built structures and things—that which the mise-en-scène can capture and that points toward the world of the film at large.

Milieu (as medium) itself cannot be directly depicted, since it is the sum of all circumstances (social, political, physical) for the protagonists. But its force can be read on the formation of buildings and streets, the design of coffee shops and arcades, the bodies and clothes of people, and so on—that is, the surfaces that build the interface of milieu and life. The Berlin School films in general systematically explore nondescript places, such as urban and suburban sprawl (much better described by the German term *Zersiedelung*, literally "settling apart") or commercial, anonymous places like hotels, chain stores, and gas stations (see Wolf 2011). These spaces are foregrounded by an extensive use of long or full shot lengths, that is, shot lengths that focus on the character *in* an environment, rather than the expression of a character in itself. Futhermore, the camera lingers on locales before characters appear or after they have left; it augments or contrasts our sense of the space by complex off-screen and ambient sounds; and unusual, deliberate framings and long takes allow us to inhabit the space differently than efficient, action-oriented continuity editing would allow.

Protagonists such as Sophie in *Marseille*, Paul in Köhler's *Bungalow* (2002), and Trojan in Arslan's *Im Schatten* (*In the Shadows*, 2010) pass time aimlessly,

often in the suspended state of waiting, and never have an overarching plan: their actions are dependent upon unforeseeable impulses and often appear arbitrary. We regularly get to see the "ornaments" of action, the prelude or afterthought, the in-between or interval, rather than the act itself. As a consequence, we are forced to pay closer attention to body language, posture, and, where they are granted to the viewer, facial expressions. Our access is further complicated by the characters' affectlessness, that is, their lack of expressivity—a technique of "representing emotions without emotionalizing" (Baer 2013, 75). Our attitude is often similar to that of watching animals: we neither have access to these characters' inner states nor assume we do; we watch their behavior, which often is simply a reaction to external impulses.

By disrupting the linkages between spectator and protagonists (through affectlessness and inactivity), between spectator and film world (through elliptical editing and a restrictive mise-en-scène), and between protagonists and their environment (through a focus on what de Certeau [1984] has called "non-places" and a mise-en-scène that foregrounds the setting), *Marseille* is able to make visible the force of the neoliberal milieu, the medium, the fluid in which the protagonists move, but also their unconscious resistance to these forces. In these films, an almost zoological drama, of which the spectator becomes a part, plays out. As spectators, we are unable to suture the protagonists into the milieu, and so the world the films present remains open and unfinished. Rather than being enveloped by the mood or atmosphere of a coherent cinematic world, we are forced to engage with the conflicting encounter among protagonist and environment, ourselves and the film. But by exhibiting the gaps between the milieu and the protagonists' actions or lack thereof, *Marseille* is able to carve out a tentative space of possibilities for both protagonists and spectators, even if these possibilities are not seized by the characters themselves.

The Pathologies of Professional Observers

Two men are smoothing the soft, wet concrete into a gap that runs diagonally across a vast, empty square with gray paving stones. The camera pans to the right and up, revealing the square in its entirety. On the right, the glass and concrete facades of modern apartment buildings cascade down to the square. In the background, we see the dilapidated front of an old brick building. At the far end of the square, a mother is playing with her child. Suddenly, David Locke (Jack Nicholson) enters the frame from the right and begins walking across the square. A cut, and the camera looks up a staircase with the apartment building looming

behind. Nicholson swiftly descends the stairs as the camera tracks his path past several people lounging on the steps. He stops and looks; another cut shows us a woman (Maria Schneider), the object of his gaze, in the foreground, reading a book on a sunlit park bench, while Locke stands in the background, momentarily transfixed by her. She looks up, briefly, and returns to her book. He exits the screen to the right, while the camera turns toward Schrader as she puts down her book, spreads out her arms across the bench's backrest (in a gesture that will significantly return later in the film), leans her head back toward the sun, and closes her eyes (fig. 7.1).

These three shots from *The Passenger* are no more than casual inserts, hardly noticeable in this film full of memorable plan sequences that bend time and space. Yet they occur at a significant moment in the plot: they are the first shots that show investigative journalist Locke back in London after his trip to Africa, where he decided spontaneously to switch identities with a fleeting acquaintance, the businessman David Robertson, after finding him dead on his hotel bed. Locke has returned, but in a ghostly in-between state, still uncertain of what to do next while everybody else assumes he has died. Everything is open: he may simply abandon the identity play or at least reveal himself to his wife; or he may remain undercover, traversing familiar spaces one last time. At his old house, he moves through the rooms, gaze and hands wandering over familiar items. The cinematography foregrounds items that intimately connote his wife's presence and Locke's familiarity with her—the bed posts, a stole hanging over a chair—but then also shows the signs of her life since he left. A newspaper article on the bed discusses Locke's death and a note on the bedroom door by a man named Stephen suggests a love affair. While Locke is still in the presence of his past, time has moved on without him. He has already become dislodged from his life and will not be able to go back. He takes a few documents before leaving swiftly.

There is no narrative reason for showing Locke traversing this particular square. There is an obvious contrast between the geometrical lines of the glass-and-concrete architecture in the first two shots and the grand nineteenth-century houses in Locke's neighborhood in the heart of Notting Hill. The modernist architecture in the first two shots, and the mise-en-scène that emphasizes its barrenness and abstraction, seems symbolic of Locke's erasure of his identity, reflecting his ghostly invisibility and nonexistence—not least because the square is still under construction, the concrete still wet. Antonioni is continually drawn to locations like this, as exemplified most memorably in the neighborhood of Rome that provides the setting for *L'Eclisse*, the EUR district built and planned by Mussolini for the World's Fair in 1942 (which never took place there).[6] Yet the environment is not reducible to a symbolic function, nor does it determine

Figure 7.1 David Locke enters an empty, modern square in a shot that signals his return to London. *The Passenger* (Michelangelo Antonioni, 1975).

and sufficiently describe Locke's state like a naturalist milieu. Instead, the film visualizes the milieu as expressive, eloquent actant, engaged in reciprocal interplay with the characters.

The plot of *Marseille* bears several similarities to *The Passenger*. Sophie (Maren Eggert), a female photographer from Berlin, swaps apartments with a stranger from Marseille and explores the city. After her return to Berlin and a few strained encounters with her closest friends there—professional photographer Ivan (Devid Striesow), his wife, actress Hanna (Marie-Lou Sellem), and their son—Sophie returns to Marseille only to be robbed on her way from the train station. In both films, then, there are protagonists who observe and document (a photographer in the former, a reporter in the latter), and for whom the boundaries of work and private life are blurred. Sophie, just like Locke, catapults herself into a stranger's life and abandons, for a while, all ties to her normal existence. This spontaneous identity switch and decoupling from all that is familiar, together with the professional habit of observing and recording, results for both Sophie and David in a distanced mode of observing one's own existence without ever managing to reflect on it.

In a set of shots that mirror those from *The Passenger* described above, Sophie ventures out into Marseille for the first time, a stranger with heightened senses yet distanced from her surroundings. She walks down a quiet street with dense rows of houses, the camera panning to follow her. In the background, the glass and concrete facades of two adjacent high-rises loom large, illuminated by the

golden light of the setting sun. The next shot shows her descending a public stair-case down to a lower-lying street. The image is suffused by the grinding noise of mechanical tools and the murmuring conversation between men. As the camera pans again to follow Sophie, we see her pass between several cars sitting in front of a small car repair shop nestled right next to the staircase, cross the street, and after a brief hesitation enter a produce store. She quickly reemerges and walks down the street to the left, a piece of fruit in her hand. Throughout the long take, the sound is dominated by noise from the garage, passing cars, and a bus. In the foreground, out of focus, we see a mechanic polishing a car. He briefly turns his head to look at the passing Sophie, who likewise glances at him quickly after leaving the store (fig. 7.2).

Just as the scene from *The Passenger* stages a fleeting encounter between Locke and "the woman" (credits), only to have them cross paths again later in Barcelona where they become lovers, the brief moment of casual registration between Sophie and the car mechanic continues into a tentative friendship during subsequent meetings. Yet the encounters remain open in their direc-tion and potential and never congeal into a story, let alone a romantic love story. They conjure up modern tropes of the conjunction of alienation and eroticism in the city, poignantly expressed in Baudelaire's poem to a passer-by, in which the fleeting glance at a woman on the street ("Lightning . . . then darkness!") refracts time and space into an open territory of possibilities ("But where is life—not this side of eternity? / Elsewhere! Too far, too late, or never at all! / Of me you know nothing, I nothing of you—you / whom I might have loved and who knew that too!" [Baudelaire 1982, 98]). While this effect of an opening of the narrated world by means of romantic possibilities also holds true for the narrative organization of *Marseille* (in contrast to the gradual closure of possibilities over the course of conventional, and conven-tionally narrated, love stories), what is missing is a protagonist who could still project and collect possibilities and thus organize them into a story. In-stead of a male projecting voice, *Marseille* portrays a woman who cannot pin herself down. She does not know what she is looking for in Marseille, nor whether she is finding anything.

Indeed, both Sophie's wanderings in Marseille and her life in Berlin (as a sat-ellite to her friend Hanna's family) are more reminiscent of the later incarnations of flânerie by Walter Benjamin, Siegfried Kracauer, and Franz Hessel, whose street texts are, like Schanelec's film, tinged by a heightened awareness of the pre-carity of past, present, and future and likewise engage with the dissolution of the subject in the encounter with a heterogeneous cityscape.[7] In the 1920s and '30s, both Kracauer and Benjamin traveled to Paris and Marseille, cities in which they

Figure 7.2 Sophie passes the car mechanic and enters a produce store. *Marseille* (Angela Schanelec, 2004).

found more refuge from the forces of capitalism and progress than in Berlin and a more insistent lingering of the past.[8] Kracauer in particular subjects himself to the lure and force exerted by cityscapes, his eye and body passive conduits ready to be seduced and led astray, bare of intentions or other rational impositions. This state is the precondition for him for an epistemological undertaking of deciphering the "hieroglyphs" of *Raumbilder* or space-images and urban landscapes, which he conceives as "dreams of society" (Kracauer 1987b, 52; Kracauer 1987a, 41). These texts are directly reflective of then-contemporary theories of milieu and *Umwelt*, since the subject is no longer determined by the milieu but rather seeks to open herself to its impulses.

Marseille presents the architecture, spatial arrangements, objects, and people in Marseille and Berlin with the same tectonic precision, anxiety, and tenderness as Kracauer (a former architect) does in his texts. But in contrast to Kracauer (that is, the unencumbered, seismographic male flaneur), Sophie's errant wanderings and photographs are not in service of an epistemological project, nor part of a *strategy* to be dominated and seduced by mood, cityscape, people, and things in order to let them speak. Already in Antonioni's films, the dissolution of the subject as a result of an inability to adapt to the conditions of late modernity is pathological, rather than an epistemological strategy.[9] *Marseille* likewise depicts Sophie's attitude as pathological rather than a voluntary openness—an inability to seize or realize possibilities presented to her by the milieu.

Strategies of Mise-en-Scène

Marseille makes visible the milieu in the interface between Sophie and her environment by means of long takes, a prevalence of long or medium-long shot lengths, an often-static camera, a frame that relegates important aspects of the setting or space of action to the off-screen, and complex compositions in depth. Both long take and longer shot lengths have been identified as hallmarks of "slow cinema," a global art film movement of which Schanelec's films could be considered a part.[10] The long take has been the subject of important film-theoretical debates, from realist film theory (André Bazin and Siegfried Kracauer, for example) to later work on the openness of an image (Paul Schrader and Gilles Deleuze).[11] Yet the particularity of the long shot has received less attention, since cinema seems to come into its own in the more extreme shot lengths—a tendency supported not only by classical film theory's enthusiasm for the close-up, from Béla Balázs and Jean Epstein to André Bazin, but also by a reconsideration in contemporary film scholarship of the close-up, on the one hand, and the extreme long shot, on the other hand.[12]

The long shot seems to be the most anthropocentric of all shot lengths, taking the full human body as its measurement. Yet I argue that it is important to Schanelec and other Berlin School directors because it allows them to focus on the *interface* between a character and her environment—an interface most often characterized by habit, absorption, disorientation, or goallessness. Schanelec herself put the relationship between character and space as follows:

> I have such and such characters, and now I tell something about their hobbies, their passions, their neuroses . . . all of that can be expressed by means of spaces, and I try to avoid that. Of course, one always narrates by means of space—but because this is so obvious, it is more important to also grant the space a neutrality, in which many things are possible, and which doesn't determine the characters, make them small and reduce them to what one has to say about them. (Boehm and Lucius 2010, translation mine)

Both character and surrounding space should remain somewhat autonomous and not be reducible to each other or simply imply each other. This is particularly palpable in Schanelec's strategy of *either* showing Sophie looking off-frame *or* showing her simply being in the city without suturing either shot register into a coherent structure. Deleuze has argued that sound and image in postwar cinema (Italian neorealism, Bresson, Antonioni, Fellini) were uncoupled from the protagonist's actions and turned into pure optical and sound images,

resulting in a protagonist who herself turns into an observer (Deleuze 1989, 1–13). Extending these practices, Schanelec's films pry protagonist and environment even further apart by withholding countershots or adding an image where sound supplies information and thus opens the view onto the milieu as force field.

This aesthetic strategy also applies to Schanelec's editing practice. As Reinhold Vorschneider, Schanelec's cameraman for most of her films, explains: "There is no 'master' and no 'slave,' that is, no hierarchy among the shots, but shots remain relatively autonomous in relation to each other" (Hochhäusler and Wackerbarth 2005, 27, translation mine). In shots that observe Sophie experiencing or observing the city, there are hardly any clues of the spatiotemporal connection between shots. Minutes, days, or weeks might have passed in the interval, and in one case, only a switch from French to German indicates that Sophie must now be back on the streets of Berlin. Shots are self-contained units in this film; each insists on its autonomy from a structural before and after by telling a story about a moment in time and space that derives its significance from that which is present—whether from the architecture, objects, sounds, and light or from the tensions between protagonists and things or people. Past and future become palpable in the dense visual description of these moments and our overarching sense of lack or yearning on Sophie's part, but they are formally dislodged from the film's structure and exist outside of a rational, chronological connection—they are images of time that have fallen out of (narrative, chronological) time, and images of space that deny it structural, formal, and perceptual coherence.[13]

In the shot sequence following Sophie's first walk past the car repair shop, the film's strategies of handling protagonist and environment within a shot become even more evident. We see Sophie pay at a cash register through the glass front of a store and then follow her, the camera traveling with her in medium and close-up ranges, as she walks slowly through an open glass-and-concrete arcade. The soundscape is filled with the loud, echoing voices of quarreling kids or young men. The next shot is static, showing Sophie from behind in a long shot as she stares from the second level of the open construction of the arcade at something off screen. We hear loud traffic and glimpse a busy highway in the background. A security guard enters the image from screen right, asks her not to photograph, and leaves. A few moments later, he returns with two colleagues. They rephrase their request and exit the frame again. The third shot shows Sophie in close-up as she stares out the window. From the window and the soundtrack, we can infer that she is sitting on a bus. The bus comes to a halt, and the motor is turned off. The film cuts to a medium shot of the bus's front window, where we see the bus

driver unfold a newspaper. We see Sophie get off and observe her through the window as she crosses the street and walks away (fig. 7.3).

Each of these shots shows Sophie in various states of absorption, characteristic of moving through an unknown space by oneself.[14] Her senses are opened to the unfamiliar environment and its impulses, yet at the same time turned inward, since she is not aiming at engaging anyone or anything. Her attitude is that of an active passivity—the precise attitude Kracauer has described with respect to the state of mind of the Weimar Republic intellectual in "Die Wartenden" (1921), the film spectator in *Theory of Film* (1950), and the historian in *History: The Last Things before the Last* (1960). It appears as a kind of model behavior for the spectator. In fact, whenever Sophie engages, or is forced to engage, in direct, personal communication, she fails.[15]

This attitude is reinforced by the mise-en-scène, in particular the relationship between sight and sound. In all three shots, as in the shots discussed earlier, sound is privileged as a means to establish space. In contrast to vision as active, directed sensory impression (looking *at* something), sound is more akin to Sophie's state, enveloping her and entering her without her having to actively listen to it or being able to shut it out. Both the nature of the sounds and their resonance in space give us crucial information that the image does not seek to double or reinforce; rather, as Schanelec herself often confirms, she tries to avoid these overlappings. This primacy of sound over image opens up the image, even if Schanelec's frames are usually very restricted and static, since sound is immune to the borders of the frame. The first shot, for example, establishes the place as a somewhat rough, empty, echoing, and enclosed exterior (the open-air arcade close to the highway), even though Sophie is initially cut off from the sound we hear (and we from the sounds surrounding her) as she is still inside a store. Once she steps out, we see her reacting to the sound and the light filtered by the roof construction of the arcade (which we can only infer by strips of light across her face). As the camera tracks with her, she turns her head to the source of the arguing voices, and a group of young men and kids briefly comes into view in the background, yelling and pushing each other.

The second shot completely conceals from us Sophie's view, and she herself remains at a distance. She is visible as a *Rückenfigur*, a figure seen from behind, and the long, static shot recalls Caspar David Friedrich's Romantic landscape paintings. Yet in contrast to Friedrich's paintings, Schanelec's images do not use Sophie as an entry point to harmonically engage with a landscape—there is nothing sublime about the background, and what captures her attention is kept from us. Rather, the setup and our relationship to the main character—her absorption, our inability to see her face and read her expression, our attempt to comprehend

Figure 7.3 At an open-air arcade, Sophie is fixated by a view inaccessible to us. *Marseille* (Angela Schanelec, 2004).

her state of mind and what it is she is seeing—emphasize that there is no environment that would ever congeal into a comprehensive, holistic landscape to be beheld.

While Schanelec realizes this effect by means of static long takes that continually refer us compositionally and aurally to what is off screen, Antonioni accomplishes the same effect by means of camera movements that undo a fixed sense of a space. When Locke is venturing out into the desert early in *The Passenger* on a quest for someone to lead him to the guerilla fighters he seeks to portray (a boy in his truck, who remains mute, gives him directions by means of gestures), the camera pans across the empty, sandy expanse and the rocky hills. We hear Locke's van approaching but do not see it and have no sense of the direction from which it will enter the image—until it does. As the van gets stuck in the sand, a number of long-held *Rückenfigur* shots convey how lost Locke is: looking out into the hot, empty landscape, he finds no sign, no indication of what might be here for him, nor is he sure what he should be looking for. As in Schanelec, the *Rückenfigur* arrangement emphasizes the distance between character and environment, a relationship of mutual query in which both environment and person call each other into question—Köhler has fittingly called these types of shots Antonioni's "false subjective perspectives" (Köhler n.d.). When Locke hopes for a sign from a man passing on a dromedary, the camera looks over his shoulder as he gazes after the man who ignored his expectant greeting. A cut shows us the rider now in the far distance, and the image arrangement lets us believe we are still watching from Locke's position. A slight camera pan to the right reveals a straw construction in the foreground, at the border of the frame. Suddenly, a man steps into the image out of what we now presume must be a hut. He looks screen left, and his gaze sets a camera pan to the left in motion, until, in the far distance, Locke and his car come into view. With each onscreen and camera movement, we have to adjust our knowledge of where we are and reorient ourselves. Editing, mise-en-scène, and

camera movement undo any certainty we might have felt regarding this place and turn the empty landscape into an opaque and disorienting environment (fig. 7.4).

The Politics of Milieu

In both Antonioni's and Schanelec's films, the environment never appears as a coherent setting we can apprehend in one view and decipher. No shots present the setting, whether city or natural landscape, as a comprehensive unit; the environment congeals into neither a landscape that receives unity from the eye of the beholder nor a milieu with unilaterally formative forces.[16] Instead, the images depict the fraught relation between character and environment and thus render visible the milieu as medium. Theories of biology over the course of the twentieth century increasingly complicated the relationship between organism and milieu. The determinism of mechanism and positivism was tempered by a propositional model that affords differences and choices to the living being: the relationship "is like a debate (*Auseinandersetzung*) in which the living brings its own norms of appreciating the situation, where it is in command of the milieu and accommodates itself to it" (Canguilhem 2001, 21). Milieu is never an unstructured plane with countless influences but always only exists in relation to the interests and problems of a living being. Schanelec's images make visible the gap between protagonist and environment and present it as a relationship that needs to continually be negotiated and interrogated. Schanelec, following in Antonioni's footsteps, thus creates a kind of experimental problematology in her images, rather than a (normative) epistemology, that is, an aesthetic that focuses on problematic frictions, misunderstandings, and ill-fittings—an aesthetic in line with the approach to epistemology from Canguilhem to Foucault and Deleuze.[17]

Schanelec's film builds on the reflexive image aesthetics of post-neorealist filmmaking, which sought to insert the mode and conditions of presenting a cinematic image into the image itself. These images do not allow the spectator to simply contemplate "filmed reality" but rather let her experience ways in which an image *refers* to reality. This aesthetic can also be understood in terms of a modern subject-milieu relation. Deleuze described the relation of a film image to a world it evokes, with which it surrounds itself, as its ability to split into two components that continually refer to each other as in a crystal—a real and an imaginary, an actual and a virtual image (Deleuze 1989, 68). These crystal images have taken various forms in films by Antonioni, Kristof Zanussi, Max Ophüls, or Alfred Hitchcock: film image and the world it conjures up might refer to each

Figure 7.4 As his truck gets stuck and he is abandoned by his guide, David is searching for signs in the desert. *The Passenger* (Michelangelo Antonioni, 1975).

other in external mirror images in which one image is virtual, the other actual, or one limpid and the other opaque, or alternatively, in the internal relation between seed and environment (*milieu*).[18] The seed contains, internally, the conditions of the milieu; it *refers* to the milieu. At the same time, the environment contains the possibility of this seed, conditions it. This circuitous relationship becomes visible in both Antonioni and Schanelec as the dynamic of a propositional milieu, in their *Rückenfigur* shots as well as in those images that search the landscape (Antonioni) or let a drifting protagonist explore a foreign city (Schanelec). In these images, milieu and protagonist continually refer to and mutually constitute each other, while concurrently calling each other into question and throwing each other out of time.

However, between Antonioni and the Berlin School films lies the rise of neoliberalism, and with it, as Foucault has argued, the internalization of governmentality by subjects that have become entrepreneurs of the self. Neoliberalism, in Foucault's account, also entails a new kind of environmental regime. Governmentality in neoliberalism has become "environmental" (rather than juridical or disciplinary); that is, it works through an "environmental [*environnementale*] type of intervention instead of the internal subjugation of individuals" (Foucault 2008, 259–60).[19] The neoliberal subject "responds systematically to modifications in the variables of the environment [*milieu*], appears precisely as someone manageable, someone who responds systematically to systematic modifications artificially introduced into the environment [*milieu*]." She is "the correlate of a governmentality which will act on the environment [*milieu*] and systematically modify its variables" (270–71). In neoliberalism, self-interested subjects are not independent partners of an exchange anymore; rather, as entrepreneurs of the self, person and human capital have become inseparable, such that every aspect of life is permeated by a neoliberal market logic (Dilts 2011, 136). As a consequence, "any conduct which is sensitive to modifications in variables of the environment and which responds to this in a non-random way, in a systematic way,"

can count as rational in neoliberal economics, since it has become "the science of the systematic nature of responses to environmental variables [*variables du milieu*]" (Foucault 2008, 269).[20]

The environmental logic of neoliberalism in Foucault's account—the variation of environmental factors to which the neoliberal subject responds in a calculable way—describes one of the more recent turns of a subject-environment relation that has historically been captured by the term "milieu": systematic, market-driven alterations of the environment that produce calculated changes in the systematically calculable—and thus rationalizable—responses of irrational subjects. Crucial to *Marseille*'s depiction of the milieu is thus not only the visualization of the gap between protagonist and environment, which enables the film to reveal the mi-lieu, the middle-place, that force field in itself, which in most films disappears in the seamlessness of tight links between action, perception, and environment. What is just as important—and should be understood as aesthetic act of political resistance—is the undermining by sound and image of the "norm" (in Canguilhem's sense) of a harmonic interaction with the forces of the milieu in favor of a refusal to realize that which the neoliberal milieu provides, since this milieu has already calculated and encompassed the supposedly free and individual decisions of the subject. It is in this tension between the indifferent environment and indifferent protagonist—in their fraught interaction that nevertheless leaves traces and bears consequences, in this relationship in which both sides are facing each other yet avert their gaze—that Berlin School films such as *Marseille* expose the contemporary milieu and manifest their political potential.

Notes

1 All three descriptions are frequently used to describe Antonioni's films, in particular his work from 1960 to 1964. See, for example, Antonioni 1996; Benci 2011; Rascaroli and Rhodes 2011; and Rosenbaum 2014.

2 On the importance of Antonioni for Hochhäusler, see the interviews in Boehm and Lieb (2010) and Abel (2007): "For me, one of the most important films in terms of aesthetics is, as I already mentioned, Antonioni's *L'Eclisse*" (n.p.). Antonioni also regularly makes an appearance in *Revolver* (edited by Hochhäusler, Benjamin Heisenberg, Nicolas Wackerbarth and others); see, for example, "Meisterklasse Antonioni," *Revolver* 4. Schanelec has listed Bresson, Antonioni, and Godard as major influences (Baute n.d.). Both Valeska Grisebach and Ulrich Köhler have listed a film by Antonioni (*L'Eclisse* and *Professione: Reporter*, respectively) in their polls for the ten best films of all times, conducted by the British Film Institute's journal *Sight and Sound*. See http://www.bfi.org.uk/films-tv-people/sightandsoundpoll2012.

3 On the Berlin School and neoliberalism, see Abel 2013; Baer 2013; and Fisher 2013.

4 For the French history of the term, see Spitzer. The development of meanings in English and German is quite similar; see OED 2016 and Feldhoff 1971.

5 Uexküll sought to establish the term "Umwelt" as scientific concept, in contrast to milieu. On Uexküll and film theory, see Pollmann 2013.

6 On the significance of the EUR for Antonioni, see Benci 2011, 47–51.

7 In preparation for the film script, Schanelec herself embarked on aimless walks through Marseille. In her description of these ten days of flânerie she repeatedly quotes Benjamin on wandering through (and consuming hashish in) Marseille (Schanelec 2002).

8 Schanelec's choice of Marseille in the early 2000s is also interesting because of the transformation of Marseille's cityscape and identity due to a number of city initiatives in the past few years. See Jeffries 2015.

9 See Henderson (2011) on the crisis of individuation and subject formation in Antonioni.

10 On the aesthetics of "Slow Cinema," see Koepnick 2014, Jaffe 2014, and Luca and Jorge 2015.

11 Schrader's work on the transcendental style in global postwar art cinema highlights elements that reverberate strongly with Schanelec's cinema: "Disparity: an actual or potential disunity between man and his environment, which culminates in a decisive action" (Schrader 1972, 42); "Stasis, a frozen view of life, which does not resolve the preceding disparity but transcends it" (49).

12 On reconsiderations of the close-up, see Doane 2003 and Steimatsky 2007; work on cinema and ecology, geological time, and the Anthropocene has yielded several studies on slowness and extreme long shots; see Rust, Monani, and Cubitt 2013.

13 Schanelec's indebtedness to some of the main protagonists of Deleuze's film philosophy—Bresson, Antonioni, Godard—thus allows us to view her films in line with, or even continuing the paths Deleuze traces in *Cinema 2: The Time-Image* (1989).

14 Michael Fried (1980) argued that eighteenth-century paintings featuring figures in a state of absorption—oblivious to the possibility of being seen—seek to overcome the irreducible theatricality of painting.

15 Abel has worked out the central role of failed communication in Schanelec's work, particular in *Nachmittag* (2010). See Abel 2013, 111–48.

16 This stylistic hallmark is even more apparent in Arslan's "western" *Gold* (2013), which mostly refuses to give us glamorous panoramic shots so typical of westerns and instead sticks to long and medium long shots. For more on *Gold*, see Gemünden's and Végső's contributions to this volume.

17 On the history of problematology in French thought and the role of Canguilhem's *The Normal and the Pathological*, see Osborne 2003.

18 Deleuze uses the term "milieu" in the French original. See Deleuze 1985, 96.

19 Foucault seems to distinguish between "milieu" and "environment" in a way similar to my use of the terms. Neoliberalism is "une intervention de type environnemen-

tal" or "technologie environnementale," since it intervenes *in* the environment as a place, it is *located* there. "Milieu" is used in the sense of medium and describes the neoliberal form of influence. See Foucault 2004, 264–65.

20 The shift in the configuration of subjectivity and the subject's relationship to market and capital can be measured narratively and visually by comparing Antonioni's *L'Eclisse* with Hochhäusler's *Unter dir die Stadt* (*The City Below*, 2010). In *L'Eclisse*, the stock market features prominently as place where Vittoria (Monica Vitti) drifts into a superficial relationship with stock broker Piero (Alain Delon), while in *The City Below*, manager-wife Svenja (Nicolette Krebitz) and executive manager Roland (Robert Hunger-Bühler), two successful entrepreneurs of the self, move through the glass architecture of Frankfurt's financial buildings in which power (and money) have become invisible.

Works Cited

Abel, Marco. 2007. "Tender Speaking: An Interview with Christoph Hochhäusler." *Senses of Cinema* 42. Accessed February 2016. http://sensesofcinema.com/2007/cinema-engage/christoph-hochhausler/.

———. 2013. *The Counter-Cinema of the Berlin School*. Rochester, NY: Camden House, 2013.

Antonioni, Michelangelo. 1996. *The Architecture of Vision: Writings and Interviews on Cinema*. Edited by Marga Cottino-Jones. Chicago: University of Chicago Press.

Baer, Hester. 2013. "Affectless Economies: The Berlin School and Neoliberalism." *Discourse* 35 (1): 72–100.

Baudelaire, Charles. 1982. *Les fleurs du mal*. Translated by Richard Howard. Boston: David R. Godine.

Baute, Michael. N.d. "'Berliner Schule' an der dffb 1984–95. Teil 1: Die Akademie." Accessed April 16, 2016. https://dffb-archiv.de/editorial/berliner-schule-dffb-1984–95-teil-1-akademie.

Benci, Jacopo. 2011. "Identification of a City: Antonioni and Rome, 1940–62." In *Antonioni: Centenary Essays*, edited by Laura Rascaroli and John David Rhodes, 21–63. London: Palgrave Macmillan for the British Film Institute.

Boehm, Felix von, and Constantin Lieb. 2010. "Interview mit Christoph Hochhäusler: Christoph Hochhäusler über Architektur." *Cine-Fils*, August. Accessed April 16, 2016. http://www.cine-fils.com/interviews/christoph-hochhaeusler.html.

Boehm, Felix von, and Julian von Lucius. 2010. "Interview mit Angela Schanelec: Angela Schanelec über Räume." *Cine-Fils*, February. Accessed March 8, 2016. http://www.cine-fils.com/interviews/angela-schanelec.html.

Canguilhem, Georges. 2001. "The Living and Its Milieu." *Grey Room* 3: 7–31.

Certeau, Michel de. 1984. *The Practice of Everyday Life*. Berkeley: University of California Press.

Deleuze, Gilles. 1985. *Cinema 2: L'image-temps*. Paris: Les Éditions de Minuit.

————. 1989. *Cinema 2: The Time-Image*. Minneapolis: University of Minnesota Press.

Dilts, Andrew. 2011. "From 'Entrepreneur of the Self' to 'Care of the Self': Neo-liberal Governmentality and Foucault's Ethics." *Foucault Studies* 12 (Summer): 130–46.

Doane, Mary Ann. 2003. "The Close-Up: Scale and Detail in the Cinema." *differences* 14 (3): 89–111.

Feldhoff, J. Milieu. 1971. *Historisches Wörterbuch der Philosophie*, edited by K. Gründer, 1393–95. Basel: Schwabe.

Fisher, Jaimey. 2013. *Christian Petzold*. Urbana: University of Illinois Press.

Foucault, Michel. 2004. *Naissance de la Biopolitique: Cours au Collège de France (1978–79)*. Paris: Seuil/Gallimard, 2004.

————. 2008. *The Birth of Biopolitics: Lectures at the Collège de France, 1978–79*. New York: Palgrave Macmillan.

Fried, Michael. 1980. *Absorption and Theatricality: Painting and Beholder in the Age of Diderot*. Berkeley: University of California Press.

Henderson, Christine. 2011. "The Trials of Individuation in Late Modernity: Exploring Subject Formation in Antonioni's *Red Desert*." *Film-Philosophy* 15 (1): 161–78.

Hochhäusler, Christoph, and Nicolas Wackerbarth. 2005. "Interview: Angela Schanelec, Reinhold Vorschneider." *Revolver* 13: 6–42.

Jaffe, Ira. 2014. *Slow Movies: Countering the Cinema of Action*. New York: Wallflower Press.

Jeffries, Stuart. 2015. "In Praise of Dirty, Sexy Cities: The Urban World According to Walter Benjamin." *The Guardian*, September 21. Accessed March 8, 2016. http://www.theguardian.com/cities/2015/sep/21/walter-benjamin-marseille-moscow-cities.

Koepnick, Lutz. 2014. *On Slowness: Toward an Aesthetic of the Contemporary*. New York: Columbia University Press.

Köhler, Ulrich. N.d. "Revolver Live! Marie Vermillard." *Revolver* 27.

Kracauer, Siegfried. 1969. *History: The Last Things before the Last*. Princeton, NJ: Markus Wiener Publishers.

————. 1987a. "Aus dem Fenster gesehen." In *Straßen in Berlin und anderswo*, 40–41. Berlin: Das Arsenal.

————. 1987b. "Über Arbeitsnachweise." In *Straßen in Berlin und anderswo*, 52–59. Berlin: Das Arsenal.

Luca, Tiago de, and Nuno Barradas Jorge. 2015. *Slow Cinema*. Edinburgh: Edinburgh University Press.

Osborne, Thomas. 2003. "What Is a Problem?" *History of the Human Sciences* 16 (4): 1–17.

Oxford English Dictionary. 2016. "medium, n. and adj." OED Online, March. Oxford University Press. http://www.oed.com/view/Entry/115772?redirectedFrom=medium. Accessed May 11, 2016.

Pantenburg, Volker. N.d. "Wie Filme sehen—Harun Farocki als Lehrer an der dffb." Accessed April 16, 2016. https://dffb-archiv.de/editorial/filme-sehen-harun-farocki-lehrer-dffb.

Pollmann, Inga. 2013. "Invisible Worlds, Visible: Uexküll's Umwelt, Film, and Film Theory." *Critical Inquiry* 39 (4): 777–816.

Rascaroli, Laura, and John David Rhodes. 2011. "Interstitial, Pretentioius, Alienated, Dead: Antonioni at 100." In *Antonioni: Centenary Essays*, edited by Laura Rascaroli and John David Rhodes, 1–17. London: Palgrave Macmillan for the British Film Institute.

Rosenbaum, Jonathan. 2014. "A Vigilance of Desire: Antonioni's *L'Eclisse*." In *L'Eclisse: Dual-Format Blu-Ray and DVD edition*, Criterion Collection.

Rust, Stephen, Salma Monani, and Sean Cubitt. 2013. *Ecocinema Theory and Practice*. New York: Routledge.

Schanelec, Angela. 2002. "Marseille 1.—10. März." *New Filmkritik*, March 12. Accessed April 14, 2016. http://newfilmkritik.de/archiv/2002–03/marseille-1–10-marz/.

Schrader, Paul. 1972. *Transcendental Style in Film: Ozu, Bresson, Dreyer*. New York: Da Capo.

Spitzer, Leo. 1942. "Milieu and Ambiance: An Essay in Historical Semantics." *Philosophy and Phenomenological Research* 3 (2): 169–218.

Steimatsky, Noa. 2007. "What the Clerk Saw: Face to Face with the Wrong Man." *Framework* 48 (2): 111–36.

Wolf, Sabine. 2011. "Neues Sehen: Urbane Landschaft in aktuellen deutschen Spielfilmen." *film-dienst* 19: 10–12.

8

NEW GLOBAL WAVES

Abbas Kiarostami and the Berlin School

Roger F. Cook

Since the breakup of the Soviet Union and related upheavals in Asia twenty-five years ago, there has been an emergence worldwide of film movements that offer an alternative to the dominant Hollywood style of cinema. Echoing what numerous critics have written about this development, I would characterize it as a Global New Wave of independent filmmaking that exhibits a newly conceived and diversely practiced realism. Some of the most prominent directors responsible for its success are from Iran, Korea, Romania, and South America as well as the more traditional cinema strongholds of western Europe and North America. In a 2009 article in the *New York Times* that mentions the new impulses in these countries, A. O. Scott suggests labeling this movement a "neo-neo-realism." Drawing parallels to early postwar Italian cinema, his article invokes questions about how the new style relates to its famous predecessor as well as the more fundamental issue of how one defines realism of any kind, whether it is Italian neorealism or a more recent variety. Although Scott does not mention the Berlin School, it displays realist tendencies similar to those of the filmmakers he includes in this Global New Wave. Berlin School directors too have struggled to identify those attributes that compose their form of realism and questioned whether their approach should even be called realism (Cook, Koepnick, and Prager 2013, 13–18).

With the tag of independent realist filmmaker often comes the expectation that one's films engage in political debates or oppose ideological forces that wield national or global power. Taking the issue of political engagement as an entry point into a broader analysis of the realist aesthetics of the Global New Wave, I will focus here on similarities between the Berlin School films and those of the Iranian director Abbas Kiarostami. In both cases, their detractors

have often hammered them for being preoccupied with mundane occurrences and dodging controversial topics. German critics from different ends of the ideological spectrum have criticized the Berlin School for failing to address social or political issues. On the left are those who want these filmmakers to develop a style of independent filmmaking that continues the tradition of the New German Cinema of the 1960s and 1970s or the avant-garde documentary approach of Harun Farocki and Hartmut Bitomsky, who taught the first trio of Berlin School directors at the Deutsche Film- und Fernsehakademie Berlin (dffb).[1] Others associated with the recent commercial success of the German film industry have blasted them for not making more accessible films whose stories provide valuable lessons about the German past and cultivate a renovated national identity. Ulrich Köhler's fiery response to both in his 2007 essay "Why I Don't Make Political Films" testifies to the pressure exerted on Berlin School filmmakers to address political issues directly. In it he adamantly rejects this approach in favor of autonomous aesthetic strategies that do not try to change viewers' minds through content but rather work to alter their way of seeing through art (Abel 2013, 274–78).[2]

Kiarostami has faced similar criticism in his homeland. He ventured into commercial cinema in 1977 with *Gozaresh* (*The Report*) at a time of severe economic crisis and high political tension as the shah's regime was facing increasing opposition. This was his entry into the Iranian New Wave movement that had breathed new life into a moribund national cinema at the end of the 1960s with creative films that exposed the rampant corruption of Iranian society under the oppressive reign of the shah. However, as the First Wave of new Iranian cinema came under strict state censorship, its directors turned to a style of nonpolitical avant-garde filmmaking influenced by the French New Wave, and Godard and Bresson in particular. Only with the end of the devastating eight-year Iran-Iraq war did a Second Wave of new Iranian cinema begin to make its presence felt at international film festivals. With the support of the minister of culture and Islamic guidance, Mohammad Kahtami, incentives were created for domestic film production and censorship was curtailed. Exhibiting the influence of Italian neorealism, some films of the Second Wave advocated forcefully for social and cultural reform, while explicit criticism of the state remained off limits. While directors such as Samira Makhmalbaf and Jafar Panahi made films critical of women's position in Iranian society (Saeed-Vafa and Rosenbaum 2003, 49), Kiarostami has been criticized for steering clear of "the most highly censorable themes, such as political or social criticism" (Farahmand 2002, 99) and making art cinema films that appeal to the international film festival circuit.

This criticism of apolitical filmmaking serves as the fulcrum point for my comparative analysis of the Berlin School and Kiarostami. In "Why I Don't Make Political Films," Köhler rejects the idea that tackling political or social issues in fiction film is a productive way to bring about change. Topical filmmaking, he argues, usually results in neither good art nor effective politics. To the contrary, "art that only wants to be art is often far more subversive" (Köhler 2009, 12). Although Köhler is arguing only for himself, the Berlin School as a whole has embraced this position in practice. Its rejection of films that serve up cultural messages or engage in ideological politics is in part a reaction to the wave of historical narratives about the nation's troubled past. Köhler rails against these so-called German heritage films (Koepnick 2002), claiming that they are reactionary in the way that they exonerate the German public from its historical guilt without providing any critical perspective on the present.

Kiarostami has not given a comparable explanation for the lack of explicit political or social issues in his films, nor has he defended it on the basis of state censorship. In her afterword to an important collection of essays on the Iranian New Wave, Laura Mulvey presents a nuanced response to Azadeh Farahmand's claim that Kiarostami ignores political issues and prefers to feature exotic aspects of traditional Iranian culture that intrigue Western audiences. Her explanation of "why it might be that films with little or no overt political content may still raise important issues for the politics of cinema" (Mulvey 2002, 260) applies to the way both the Berlin School and Kiarostami engage their audience on a micropolitical level. Mulvey situates Kiarostami's work within a history of art or avant-garde cinema that has set itself off against the dominant forms of popular film promoted by Hollywood. The former has always been concerned not only with the "what," she maintains, but also, and often predominantly, with the "how." As a medium that is constantly creating new ways of situating the viewer in relation to the image, cinema raises questions about the effects and limits of its mode of representation. Asserting that Kiarostami's films insistently explore the nature of cinema as a medium, Mulvey contends that they pose the questions "what can be represented?" and "who can see what?" This exposes the openness and contingency of the image and generates uncertainty. In doing so, she argues, they exert a political force, purely because they are "at odds with the certainties of any dominant ideological conviction—in the case of Iran, of religion" (260).

I agree with Mulvey on all these points, but I want to define the micropolitical agency of cinema in a more expansive manner. Her oft-cited account of Kiarostami's "uncertainty principle" emphasizes the visual, gesturing at times back to her own critical origins in issues of the gaze and identification, even while she also invokes a broader view of the cinema as medium. Still, her argument

remains singularly fixed on vision: "cinema is 'about' seeing and the construction of the visible by filmic convention" (Mulvey 2002, 257). Like Mulvey, I also contend that the political force of Kiarostami's films, as well as those of the Berlin School, resides in cinematic technique rather than topical content. In the following I explore how they employ similar aesthetic strategies to work subversively beneath the level of not only explicit messaging but also that of visual perception. The tendency has been to conceive of film viewing as an almost exclusively visual experience, as if an intact film world has been suspended before our eyes and can be grasped almost exclusively by self-contained optical receptors. However, an understanding of how the other senses and sensorimotor systems work in conjunction with vision during film viewing provides a more comprehensive view of the film experience. Drawing on recent insights from neuroscience and cultural theory about the relation between automatic bodily processes and conscious mental representations, I explore how the films of Kiarostami and the Berlin School effect change at the level of affect. Their micropolitical interventions disrupt settled sensibilities that extend downward into subphenomenal intensities and upward into the materiality of thought.

I begin with a concept that derives from Italian neorealism and has been applied to the postrevolutionary Second Wave of new Iranian cinema (Chaudhuri and Finn 2003). In his 1976 essay "The Cinema of Poetry," Pier Paolo Pasolini proposes the idea of a cinematic "free indirect subjective discourse" that is analogous to interior monologue in literature. He compares a POV shot with direct discourse in literature and an objective shot from a neutral camera perspective with indirect discourse. He then attributes to neorealism the construction of a new perspective that lies in between the two, what he calls the free indirect subjective shot. In the case of auteur cinema, such as Italian neorealism, the free indirect subjective emerges out of the interplay between two readily recognized perspectives. One is a diegetic point of view linked to characters in the film, often to the protagonist. The other is associated with the auteur filmmaker and manifests an obsessive aesthetic vision. But the *free* indirect subjective maintains a certain distance to both. By virtue of a dynamic constellation of shifting subjective perspectives, the viewer is liberated first and foremost from the control of the (allegedly) objective third-person point of view that prevails in mainstream cinema. At the same time, the filmmaker actively resists establishing control through authorial vision. This enables a viewer-centered engagement with the image.

For an example of how Kiarostami achieves this effect we can take a scene from *Bad ma ra khahad bord* (*The Wind Will Carry Us*, 1999). On one of his hurried trips to the hill outside of the village where he can get better cell phone

Figure 8.1 Behzad tipping the tortoise over with his foot in *The Wind Will Carry Us*

reception, the engineer protagonist Behzad (Behzad Dorani) spies a tortoise. Kiarostami presents this seemingly insignificant episode in a series of subjective shots that establish a free indirect subjective point of view. The camera fixes first on Behzad as he gazes curiously toward the ground and then cuts for a few seconds to the subjective shot of the tortoise from his point of view. In the third of a series of such coupled shots we see his foot come into the frame and tip the tortoise onto its back (fig. 8.1).

Then, as he goes to his car he looks again at the tortoise both before and after climbing in. In these last two instances, there is no subjective shot of the animal. Only after he turns the car around and drives off does the camera return to the shot of the tortoise from the same perspective as before. But now the point of view is suspended somewhere between the previous subjective one and the camera's objective controlling eye. As the tortoise is gradually able to turn itself back onto its feet and then continue on the same path as before, the camera follows it in what is now a free indirect subjective shot. However, Kiarostami does not draw attention to the aesthetic strategy he has employed to create this alternative point of view. Rather, the freedom accorded by this series of shots enables a multitude of potential emotional responses and cognitive associations to come into play. Behzad does not seem to have any malicious intent but simply acts mindlessly without considering the effect on the tortoise. Because this episode is disassociated from both the character and any authorial message, it can generate free associations with political or social overtones. In particular, Behzad's actions may

stir a visceral connection to living in an oppressive regime that rejects an open, benevolent spirit of Islam in favor of ideological religious doctrine.

In *Yella* (2007), Christian Petzold also employs a subjective camera in a complex series of shots to produce a viscerally charged instance of the free indirect subjective. Having just arrived in Hanover, Yella (Nina Hoss) leaves the train station on foot and is walking along the sidewalk in a nondescript neighborhood when she suddenly stops and looks around eerily, clearly alarmed by some inexplicable sensation. Then, with the camera fixed on her face, we see her stare intently at something that seems to be the cause of her unease. The camera then shifts around 180 degrees to provide us a subjective shot of what she is looking at—a couple greeting each other with a kiss in their driveway as the husband climbs out of his car, followed by their young daughter. However, the camera is situated behind Yella, so that we see her in the foreground of what would otherwise be a conventional subjective shot that shows us what the character is observing (fig. 8.2).

The camera then shifts back to show Yella's face from the point of view of the couple as she continues to stare at them with a bewildered look. This is followed by a sequence of shot reverse shots in which the subjective positions are never firmly established. In the sequence's final shot we see Yella turn and walk on uneasily, glancing back once toward the house with a look that signals what she has seen is important in some inexplicable sense.

The film too moves on, leaving this moment as an isolated episode that has no connection to the story, that is, until much later in the film when there is a similar scene that refers back to this one and evokes again the uncanny sensation conveyed through the face and gaze of the two women. This is but one example of how Petzold creates a free indirect subjective point of view that enables generative associations in both visceral and cognitive registers.[3] In this case it serves to establish this scene as a psychically charged moment in a dream or vision that Yella is having just before her ex-husband deliberately crashes the car they are in into the Elbe River. It presents a microcosmic view of the object of desire that is driving her to pursue a career in Western venture capitalism—that is, the notion of a good bourgeois life replete with successful husband, expensive home and car, and happy child. The free indirect subjective point of view is reinforced in the first reverse shot, which is from the wife's point of view but occurs before she is even aware that Yella is observing them. As we observe Yella watching them in this medium close-up, there is a sudden loud cawing of a crow in the trees overhead. As she turns quickly toward the sound, the camera cuts to a shot up into the trees and follows what would be the crow's flight, except we see only branches and leaves. Harking back to the foreboding moment before she climbed into the

Figure 8.2 An uncanny exchange of looks in *Yella*

car with her ex-husband, this shot is a dream figuration of what happened then. A sonic boom preceded the sound of a jet streaking overhead. Then too Yella looked skyward and the camera followed her look and the path of the jet but did not catch sight of it. The subjective shot of Yella looking up toward the crow is the first of several instances where reconfigured bits of real experience intrude into the dream narrative and threaten to jar her back into reality (Fisher 2013, 103–4). Although formally a subjective shot, as a filmic moment that marks psychic intrusions that disrupt the dream work, it constructs a point of view more in line with the free indirect subjective.

Most Berlin School directors use subjective shots more sparingly but have developed other means to establish the free indirect subjective. Even when the camera does not directly assume their protagonists' perspective, alternate techniques imbue the viewer with their disaffected view of and feel for life. As the camera embodies the feel of the protagonist without visually assuming her perspective, the viewer may link this disaffection with any number of affective or cognitive experiences. The long take at the freeway rest stop at the beginning of Köhler's *Bungalow* (2002) works in this way. The languid pan of the camera as it follows first the military convoy from the freeway exit into the rest stop parking lot and then the soldiers climbing out of the trucks, entering the restaurant through the front, and exiting on the side establishes a sense of detachment and ennui that becomes embodied in the posture, gestures, and expressions of the protagonist, Paul (Lennie Burmeister), as he slouches into the chair at the patio table. The result is that we assume the listless attitude and bodily state that Paul projects throughout the film without being drawn into conventional patterns of identification that are generated by a subjective camera and serve character development as prescribed by the narrative.

Pasolini's concept of the free indirect subjective gained prominence when Gilles Deleuze drew on it to explain neorealism's role in the historical transition from the movement-image to the time-image. However, an important shift occurs in Deleuze's discussion of it. The multiple, open-viewing positions are no longer elements in a semiotic system structured according to different points of view (first-, second-, or third-person) and modes of discourse (direct or indirect). Whereas Pasolini employs a literary analogy to describe the free indirect subjective, Deleuze likens it to the bodily process that produces out of individual moments of perception the stream of images that compose consciousness. He writes, "we are no longer faced with subjective *or* objective images; we are caught in a correlation between a perception-image and a camera-consciousness which transforms it" (Deleuze 1986, 74). In his account, all the bodily processes that generate consciousness out of a surplus of affective and sensorimotor images (perception, memory, affect, action) are activated in the production of this autonomous camera-consciousness. In conventional narrative cinema, sensorimotor responses are subject to a narratively (pre-)constructed scheme of action and causality (the movement-image). According to Deleuze, the time-image liberated film from the causal, representationalist network of classical cinema and restored its power to directly engage the viewer-as-body.

The embodied spectatorship involved in Deleuze's reworking of Pasolini's concept requires the lifting of narrative control as it is exercised in classical cinema. The tight organization of mainstream cinema diverts attention away

from the technical craft employed to produce a seamless film world. Continuity editing, synchronous sound, spatial unity, smooth transitions between scenes and other classical aesthetic principles are designed so that the viewer perceives the screen image as a given, intact reality. An alternative style of filmmaking that wants to involve all the bodily systems of the spectator more actively in the film experience must deconstruct the conventional patterns of narrative integration. This does not mean that narrative is abandoned altogether but rather that it is organized alternatively such that the viewer reacts to what would normally be considered ancillary components of the image. Cinematic technique is not ignored, but rather it is employed strategically to produce different effects. The failure to recognize the aesthetic design required to produce the counternarratives of the Berlin School has contributed to it being labeled realism or neorealism. In a *Revolver* forum dedicated to the question of realism, Berlin School filmmakers dismissed the notion that their "realist" approach means that they are not concerned with aesthetic questions. Sören Voigt countered, "Realism means *more* attention to form" (*Realismus heißt* mehr *gestalten*) ("*Revolver* Live" 2006, 356). In a similar vein, when probed about the realist quality of his filmmaking, Kiarostami has affirmed his commitment to depicting reality but also asserted: "reality cannot be encompassed. In my opinion, the camera cannot register reality" (Gow 2011, 20). *Khane-ye doust kodjast* (*Where Is the Friend's Home*, 1987), one of the films often cited as an example of his realism, displays this idea in practice. Although Ahmad's (Babek Ahmed Poor) search for his friend's house seems to offer a visual tour through a remote village in the Gilan province, Kiarostami actually constructed sets for all the scenes (Elena 2005, 72).

In keeping with this view of realism, the aesthetic strategies of the Berlin School are commonly characterized by what they do not do, rather than by the innovative style elements they have developed. Scholars and critics have cited a lack of narrative continuity, de-dramatization, exclusion of diegetic music, and minimal character development (Kopp 2010, 288–90). Kiarostami has employed similar tactics to disrupt classical narrative integration and has also been treated harshly by critics for doing so. In 1999, he recounts that after he was criticized for lack of narrative integration in one of his early short films, *Zang-e Tafrih* (*Breaktime*, 1972), he resorted to a more conventional style in subsequent films. Once he had become more confident in his filmmaking, he returned to the bold alternative form of this early film, achieving his greatest international success in *T'am e guilass* (*Taste of Cherry*, 1997), a film marked by what Kiarostami called "avoidance of storytelling" and an "indeterminate ending" (Elena 2005, 21). As he expanded his artistic repertoire in the course of the 1990s, what he describes here in negative terms became increasingly a sophisticated set of alternative

techniques, many of which he invented himself. Kiarostami, like some Berlin School directors, often uses lay actors. In *Taste of Cherry* and his next film, *The Wind Will Carry Us*, he had them speak their lines not to the actors playing other characters in the film but rather to him as he was filming them. For example, in all the scenes in both films where we see a character speaking to another inside a car, they are speaking to Kiarostami, who with his camera was the only other occupant in the car. In a 2003 interview conducted by Köhler and Benjamin Heisenberg for the Berlin School magazine *Revolver*, Kiarostami reveals how in working with lay actors he does not have them learn prescribed lines but rather uses covert techniques to get them to produce dialogue in their own words ("Interview: Abbas Kiarostami" 2006, 292–93).

These tactics are part of a larger practice of ellipsis that extends from the behind-the-scenes filming process to the finished film. In *The Wind Will Carry Us* we never see the three members of Behzad's film crew who accompany him to the village and stay in the same house with him. Several times we hear them conversing with Behzad, but they are always off screen, either in another part of the car, inside the house where they are staying, or simply out of the frame. Berlin School filmmakers also employ narrative ellipsis, frequently leaving out pieces of the story that conventional filmmaking would require for the sake of narrative integration and a full causal explanation of the relation between characters and events. One of the most distinctive instances of this is a cut in Angela Schanelec's *Marseille* (2004) that shifts the location from Marseille to Berlin without any prior indication or subsequent explanation.[4] When the film cuts from the protagonist Sophie (Maren Eggert) in a bar at night to her on a street, also at night, the assumption is that she has simply left the bar. The coat she is wearing provides the only clue that she is no longer in Marseille. And only in the following scene does the viewer gradually learn that she is now in Berlin. What until then had been a loosely woven account of her stay in Marseille is thrown out of joint. The audience becomes unsure which parts of any given shot may be important for piecing together the film. As a result, the viewer becomes more attuned to the film's effects at the subphenomenal level of affect and begins to investigate the image in its own right.

Kiarostami's films do not feature stunning caesurae like the one in *Marseille*, but they are, like many Berlin School films, structured as loosely woven narratives that drift aimlessly and provide little context or motives for their characters' actions. Although there are instances of narrative ellipsis in his films, Kiarostami employs more commonly a technique that I would call *reverse ellipsis*. This refers to the inclusion of action that happens in what is considered dead time and thus not normally shown in a film. In *Taste of Cherry* and *The Wind Will Carry Us*

we see relatively long and sometimes repeated takes of Badii (Homayoun Er-shadi) and Behzad, respectively, driving through desolate landscapes with little else happening. These sequences have the effect that Deleuze attributes to the time-image of Italian neorealism. They suspend the question that hangs over each image in conventional narrative cinema, "What is there to see in the next image?" and induce the viewer to explore, "What is there to see in the image?" (Deleuze 1989, 272).

This technique denies the audience the narrative connections to which they are accustomed and impedes the narrative's forward movement. When this happens, other forms of movement and action that may seem inconsequential have a stronger impact. They activate real-time embodied responses in the viewer that are almost identical to the bodily processes that produce and guide our physical actions outside the movie theater. These *action-images*, to use Henri Bergson's terminology, are part of a vast array of affects that are called into play between every two thoughts and every two instances of consciousness. When a film image gains sufficient autonomy from the narrative, moments of unfettered affect (*perception-images, memory-images,* and *action-images* in Bergson's usage) circulate more productively and become involved in the formation of consciousness, thought, and judgments (Bergson 1991, 79–90 and 116–31). Cinematic technique, those choices that guide "how we see," is thus directly involved in shaping our conscious experiencing of the screen image and influencing *how we think*. To the extent that a film provides moments of unencumbered affection that are not plotted with respect to narrative, it works against the predisposition to perceive the film world as a recorded reality and film viewing as the passive intake of information. Signification is not just packed into a message that is conveyed to the viewer through "what we see" but also arises out of the multitude of affective and cognitive impulses spurred by the image. Through these effects cinema can exert a micropolitical influence at the subphenomenal level. This mode of intervention does not generate ideas to counter those held by an opposing ideology but rather enables a new mode of perception and new patterns of thought. In this way, alternative cinematic techniques also produce corresponding changes in the mental selection processes and routines that generate ideas and arguments. They work their influence on an ethical sensibility that may be open to affective and sensorimotor flows while remaining resistant to argument and deliberation.

Films do not need to address issues explicitly via content or story in order for them to factor significantly in the viewing experience. Seemingly incidental bits of action, events, gestures, sounds, texts, or dialogue can evoke memory-images that are imbued with specific social or cultural associations. Whether these are registered consciously or not, they infect both our visceral responses to

the image and the thought process it provokes. Drawing on Bergson's account of how perception-images, memory-images, and action-images operate in relation to one another, Deleuze describes how cinema extracts the images that compose consciousness out of the temporal flow of lived experience and enables us to encounter them in moments of crystalline isolation. They circulate as part of a set of virtual memories, which he calls "sheets of past" (Deleuze 1989, 99–125), that are quickly assembled beneath conscious awareness as the body assesses any given situation to determine how it should respond. All modes of bodily responses (sensorimotor, perception, emotion, cognitive, and so on) serve to construct this virtual assembly that serves as an operational interface between a present event and the subsequent one. And even though the moviegoer recognizes the on-screen world as a simulation that requires no action to be taken, the full palette of images is always activated.

Kiarostami's films work effectively at this level. Often, they call up questions or issues more through their absence than direct address. Critics have observed that as Badii drives around offering rides to men and then asking them to assist with his suicide scheme there are innuendos of a homosexual pick-up (Naficy 2012, 215). This is particularly pronounced in his encounter with the soldier, the kind of inexperienced young person that an older, more sophisticated man might be able to seduce more easily. When, after riding around with Badii for almost twenty minutes, the soldier suddenly jumps out of the car and runs off down the hill, there is a palpable sense that he suspects Badii of wanting to have sex with him. And yet there is no explicit indication of this during their encounter. Just as the film hints in this way at what would be a forbidden topic in the Islamist Republic, the absence of women in the film also activates the issue of a woman's place in Islamic culture. When asked about the lack of a female character in the film, Kiarostami acknowledged that because the film gives no hint of why Badii wants to commit suicide, "the woman would in any case be present in an indirect way, in the background of the film" as a possible cause for his despondency. And he adds, "I thought the woman's absence would be a way to give her more significance and relevance than a fleeting glimpse would have done" (Elena 2005, 134). As Kiarostami suggests here, a thematic element can become active in the sheets of past that form in the mind of viewers through its absence as much as through its presence. The insinuation of a homosexual encounter brings the viewer's inclinations, biases, and drives into the reception of the film without stirring the resistance that usually sets in when such topics are addressed through narrative content or discussion.

Berlin School directors have addressed volatile topics in a similarly indirect manner. A good example is the theme of terrorism, both with respect to the

homegrown terrorism in Germany in the 1970s and the contemporary fear of radical Islamic terrorist attacks. When we hear an explosion and see a column of smoke rising on the other side of the small town in *Bungalow*, Paul and his brother suspect a terrorist attack and dash off in their car to see what has happened. But a traffic jam created by the many thrill seekers blocks the streets. And later we learn that it was merely an explosion at the indoor swimming pool caused by a gas leak. At the end of Schanelec's *Orly* (2010), a bomb threat closes down the airport but serves only as the reason why two of the characters take a taxi back to the city in the film's final, uneventful scene. This mode of engaging the topic serves implicitly as a critique of recent German cinema's exploitation of it in action-filled features designed primarily to entertain, such as Hans Weingartner's *Die fetten Jahre sind vorbei* (*The Edukators*, 2004) and Uli Edel's *Der Baader Meinhof Komplex* (*The Baader Meinhof Complex*, 2008). Other Berlin School filmmakers have made films where terrorism figures centrally in the plot, but their films deconstruct the mystique and allure associated with the subject. In *Die innere Sicherheit* (*The State I Am In*, 2000), Petzold tells the story of a married couple who had been members of the RAF in the 1970s and are now living a clandestine life in Portugal with their teenage daughter. However, the terrorist issue serves as little more than historical backdrop that complicates their efforts to raise their daughter successfully. In Benjamin Heisenberg's *Schläfer* (*Sleeper*, 2005), Johannes (Bastian Trost) exploits unfounded suspicion about a terrorist sleeper cell to eliminate his professional and romantic rival. Here too the film stirs the viewer's desire for the stimulation associated with terrorism, only to have the story focus on Johannes's state of mind as it is affected by his career as a scientist and his devotion to his sick, devoutly religious mother.

My account of how New Wave realist aesthetics works on the micropolitical plane is based on the way associative memory-images are activated beneath the level of conscious awareness. This is of course by no means unique to independent or avant-garde/art cinema. Films of all kinds have always relied on this kind of effect. However, Kiarostami and Berlin School filmmakers engage memory in a way that alters how it is involved in the generation of consciousness substantially. Other scholars who have brought Deleuze's concept of the crystalline time-image to bear on Kiarostami and his fellow Second Wave directors have emphasized the role of memory in a similar manner. In describing how their films loosen the chains of narrative and produce "crystalline open images," Shohini Chaudhuri and Howard Finn offer this description: "the moving image of real-time duration will be broken down by memory into discrete images of moments and then synthesized or reconstructed into a privileged static image or a series of quasi-static images" (Chaudhuri and Finn 2003, 53). Their analysis recalls Alison Landsberg's

(2004) account of how cinema generates prosthetic memories that we can appropriate and use to construct new identities. The open-image in Kiarostami's films, and I would argue of the Global New Wave more generally, does not claim to be more authentic than the image of mainstream narrative cinema in its ability to represent reality. In fact, it relinquishes any claim to such authenticity and embraces its function as a prosthesis that assists in the affirmative construction of a viewer-centered reality. It is prosthetic not in the sense of an artificial replacement making up for a missing original but rather in the positive mode of an enabler of and material for the construction of a new, more autonomous consciousness.

In this sense, the image of free indirect subjective discourse is neither objective nor subjective but rather free-floating within a relational constellation of multiple possible points of view that it can assume. However, the characterization of it as a static memory image undervalues its range of effect. Memories are not isolated mental representations, as Landsberg infers (2004), but rather an integrated complex of body states that are associated with past events. They compose a constellation of neural activity distributed across the full bodily range of physical and mental processes, and are not just visual or cognitive representations (LeDoux 2002, 97–133). Arguing for the primacy of emotional and motor affectation in all our mental operations, Antonio Damasio explains the relational character of memory in this way: "The records we hold of the objects and events that we once perceived include *motor adjustments we made to obtain the perception in the first place* and also include the emotional reactions we had then" (Damasio 1999, 147–48; emphasis added). The free indirect subjective brings the viewer into relation with the image in a way that activates all those aspects of our memories and transforms them. This is what Deleuze means when he says: "we are caught in a correlation between a perception-image and a camera-consciousness which transforms it" (Deleuze 1986, 74). This is a transactional process and not a representational construct where memories can simply be extracted from one complex and plugged into another.

This is particularly true of the role memories play in film reception. The notion that, once released from its narrative enclosure, the film image becomes static, serving much like a snapshot, is a conception that photography has reinforced. The widespread circulation of countless photographs since the middle of the nineteenth century has constantly put this idea before our eyes. Conversely, the invention of film was an advance in technology that has the potential to rectify the misconception that memory consists of individual still images. And it is my contention that the realist aesthetics of Global New Wave filmmaking acts to support this effect of the moving image even when intuitively we sense that the opposite is the case; that is, due to the lack of narratively framed action and the ensuing sense of boredom we tend to think of these films in terms of stasis. However, when fixed frames and

long takes impede the forward movement typical of narrative film, other forms of movement and action that may seem inconsequential exert a different kind of force on the viewer. There are numerous instances of movement in and of the image in Kiarostami and Berlin School cinema that function in this manner. Early in Kiarostami's *Nema-ye Nazdik* (*Close-Up*, 1990), when the reporter goes to the family's house to take some photos for his magazine article, the taxi driver steps out of his vehicle and mills about to kill time. Rummaging around aimlessly in a pile of yard waste, he dislodges an empty spray can that the camera follows for several seconds as it rolls down the street making a metallic clinking sound. Shortly later, the reporter walks past where the can had stopped and gives it a thoughtless kick. As the camera again follows it as it rolls farther down the street, the spray can assumes a certain degree of agency. Like the much-discussed dancing plastic bag in *American Beauty* (Sam Mendes, 1999), it takes on a life of its own, against which the confused, harried actions of the writer seem ludicrous by comparison. The shift in perspective it produces reverberates through the viewer at all levels of affect and refreshes the camera consciousness that has formed in the mind of the viewer.

Throughout Kiarostami's films, sound and movement infuse sequences of dead time with an energy that sustains a dynamic, alternative form of interaction with the image. In *Taste of Cherry*, as Badii seems to be killing time talking with the security guard at a desolate excavation site, we see repeated shots of rocks being dumped by a front loader onto a mound of debris. As they roll down the slope, making a crashing sound, they stir up dust. This seemingly inconsequential action triggers kinesthetic responses that disturb our normal concatenation of thoughts and enables new lines of thinking. Kiarostami enhances this effect with a sequence of shifting subjective and objective camera perspectives that establish the free indirect subjective in much the same way as Petzold does in the scene in *Yella* described above (fig. 8.3).

And when Badii returns to the site after driving around with the theology student, another series of shots of the rocks stirring up dust reactivates the embodied response from the earlier scene. Drawing on a common trope in Persian poetry, Kiarostami shoots in ruins or areas of barren desolation such as the excavation site to convey a sense of depression (Saeed-Vafa and Rosenbaum 2003, 59–60). In *Taste of Cherry* this cultural association combines with the dynamics of the moving image to call up sheets of past that connect Badii's personal situation with a collective national state of mind.

Berlin School films also feature frequent periods of dead time that function similarly. As in Kiarostami's work, movement and sound work together to disrupt normal patterns of reception. In *Bungalow*, the frequent rumbling of heavy trucks physically shakes the viewer, preventing the film experience from falling

Figure 8.3 Rolling rocks and debris in *Taste of Cherry*

into the conventional pattern of a detached visual reception of a film reality. The embodied response to the trucks is introduced in the opening shot of Paul and his fellow soldiers huddled in the back of a military transport. The deep rumbling noise on the soundtrack simulates the vibrations produced by the heavy truck. The physical state this induces in the viewer is reactivated intermittently throughout the film by the sight and sound of trucks passing by on the highway near the bungalow. Then in the final scene it is evoked again when a tractor trailer blocks our view of Paul as he decides not to return to his unit and then pulls out noisily onto the highway, presumably with Paul onboard. In Christoph Hochhäusler's *Falscher Bekenner* (*I Am Guilty*, 2005), motion and sound also serve to convey the disturbed internal state of Armin (Constantin von Jascheroff) as his ordinary life with his middle-class family begins to unravel. When he makes his puzzling excursions to the restroom at the freeway rest stop, the sound and streaks of cars whizzing by produce a frenzied kinetic energy that is all the more disorienting because we do not get a clear visual picture of the traffic.

The instances of movement I cite here disrupt both the underlying assumption that a realist film offers a representation of reality as well as the actual mode of viewing predicated on this idea. According to the realist aesthetic at work in the Global New Wave, the reality experienced through the film image must be felt, lived, and constructed. It is no longer conveyed through the characters and the narrative but rather generated directly through engagement with the image (Abel 2013, 59–60). The image activates affective and sensorimotor systems in the body that give rise to consciousness (Deleuze's *free* camera consciousness). The film experience is not so much a simulation of the process that produces consciousness outside the theater as a particular occurrence of it. This shift in the subjective character of the image also entails a new mode of objectivity. The objects in the film gain a measure of autonomy, such that the viewer is now in the position of responding to them rather than being situated as a master who is deemed to have control over them. This is one aspect of what Marco Abel has designated the "response-ability" granted the spectator of Berlin School films (2013, 22). We might call this a new objectivity, one that places the viewer, the filmmaker, and the object viewed on equal footing. Not only the objects in the image gain this status, but the image itself does as well. Freed from not only its enclosure in narrative but also its place in a prefabricated camera consciousness, it takes on a life of its own and acquires the ability to infuse life into the spectator. The reality afforded the viewers of the Berlin School and Kiarostami's films emanates from a virtual, prosthetic *moving image* that disrupts habitual modes of viewing at the level of affective and sensorimotor responses and alters subjectivity at the most visceral registers of the self.

Notes

1 For more on the origins, evolution, and the contested name of the Berlin School see Abel (2013, 9–12) and Cook, Koepnick, and Prager (2013, 1–6).
2 See also Sicinski's contribution to this volume for another take on Köhler's argument.
3 I have described elsewhere how this baffling feeling that has no clear narrative connection conveys a wide range of political and social implications (Cook 2015, 166–69).
4 See also Baer's contribution to this volume.

Works Cited

Abel, Marco. 2013. *The Counter-Cinema of the Berlin School*. Rochester, NY: Camden House.

Bergson, Henri. 1991. *Matter and Memory*. Translated by Nancy Margaret Paul and W. Scott Palmer. New York: Zone Books.

Chaudhuri, Shohini, and Howard Finn. 2003. "The Open Image: Poetic Realism and the New Iranian Cinema." *Screen* 44 (1): 38–57.

Cook, Roger F. 2015. "Embodied Simulation, Empathy, and Social Cognition: Berlin School Lessons for Film Theory." *Screen* 56 (2): 153–71.

Cook, Roger F., Lutz Koepnick, and Brad Prager. 2013. "Introduction: The Berlin School—Under Observation." In *Berlin School Glossary: An ABC of the New Wave in German Cinema*, edited by Roger F. Cook, Lutz Koepnick, Kristin Kopp, and Brad Prager, 3–37. London: Intellect.

Damasio, Antonio. 1999. *The Feeling of What Happens: Body and Emotion in the Making of Consciousness*. San Diego: Harcourt.

Deleuze, Gilles. 1986. *Cinema 1: The Movement-Image*. Translated by Hugh Tomlinson and Barbara Habberjam. Minneapolis: University of Minnesota Press.

———. 1989. *Cinema 2: The Time-Image*. Translated by Hugh Tomlinson and Roberta Galeta. Minneapolis: University of Minnesota Press.

Elena, Alberto. 2005. *The Cinema of Abbas Kiarostami*. Translated by Belinda Coombes. London: SAQI.

Farahmand, Azadeh. 2002. "Perspectives on Recent (International Acclaim for) Iranian Cinema." In *The New Iranian Cinema: Politics, Representation, and Identity*, edited by Richard Tapper, 86–108. London: I. B. Tauris.

Fisher, Jaimey. 2013. *Christian Petzold*. Contemporary Film Directors. Urbana: University of Illinois Press.

Gow, Christopher. 2011. *From Iran to Hollywood, and Some Places In-Between: Reframing Post-Revolutionary Iranian Cinema*. London: I. B. Tauris.

"Interview: Abbas Kiarostami." 2006. In *Revolver: Kino muss gefährlich sein*, edited by Marcus Seibert, 291–97. Frankfurt am Main: Verlag der Autoren.

Koepnick, Lutz. 2002. "Reframing the Past: Heritage Cinema and Holocaust in the 1990s." *New German Critique* 87: 47–82.

Köhler, Ulrich. 2009. "Why I Don't Make Political Films," translated by Bettina Steinbruegge. *Cinema Scope* 38 (Spring): 10–13.

Kopp, Kristin. 2010. "Christoph Hochhäusler's *This Very Moment*: The Berlin School and the Politics of Spatial Aesthetics in the German-Polish Borderlands." In *The Collapse of the Conventional: German Film and Its Politics at the Turn of the Twenty-First Century*, edited by Jaimey Fisher and Brad Prager. Detroit: Wayne State University Press, 2010.

Landsberg, Alison. 2004. *Prosthetic Memory: The Transformation of American Remembrance in the Age of Mass Culture*. New York: Columbia University Press.

LeDoux, Joseph. 2002. *Synaptic Self: How Our Brains Become Who We Are*. New York: Penguin.

Mulvey, Laura. 2002. "Afterword." In *The New Iranian Cinema: Politics, Representation, and Identity*, edited by Richard Tapper, 254–62. London: I. B. Tauris.

Naficy, Hamid. 2012. *A Social History of Iranian Cinema*. Vol. 4, *The Globalizing Era, 1984–2010*. Durham, NC: Duke University Press.

Pasolini, Pier Paolo. 1976. "The Cinema of Poetry." In *Movies and Methods: An Anthology*, Vol. 1, edited by Bill Nichols, 542–58. Berkeley: University of California Press.

"*Revolver* Live: Neue Realistische Schule?" 2006. In *Revolver: Kino muss gefährlich sein*, edited by Marcus Seibert, 342–63. Frankfurt am Main: Verlag der Autoren.

Saeed-Vafa, Mehrnaz, and Jonathan Rosenbaum. 2003. *Abbas Kiarostami*. Urbana: University of Illinois Press.

Scott, A. O. 2009. "Neo-Neo-Realism." *New York Times Magazine*, March 17. http://www.nytimes.com/2009/03/22/magazine/22neorealism-t.html.

9

BIFURCATED TIME

Ulrich Köhler / Apichatpong Weerasethakul

Michael Sicinski

In 2009, Cinematheque Ontario conducted a poll of international film programmers and curators to assay the best films of the previous decade. World cinema went through many significant shifts between 1999 and 2009, among them the ascendency of the Berlin School. This period saw the release of many key films of the "movement." In fact, one of the very best German films of the decade, Valeska Grisebach's *Sehnsucht* (*Longing*, 2006), did make the Cinematheque poll, coming in at number thirty. This certainly reflects some degree of validation for both Grisebach and the Berlin School as a whole. It seems inevitable that when the group (now known as TIFF Cinematheque) conducts this same poll in 2019, Petzold's *Phoenix* (2014) will place, probably very high.

But if we look back at the Cinematheque Ontario poll, one filmmaker is a commanding presence. Thai filmmaker Apichatpong Weerasethakul topped the poll with his fifth feature film, *Sang Sattawat* (*Syndromes and a Century*, 2006). Apichatpong (referred to formally by his given name, as per Thai custom) also placed in the top ten of the poll with his fourth feature, 2004's *Sud Pralad* (*Tropical Malady*, 2004), and came in at number thirteen with his second feature, *Sud Sanaeha* (*Blissfully Yours*, 2002). Considering the fact that *Syndromes* received fifty-three votes, *Malady* thirty-eight votes, and *Blissfully Yours* twenty-nine votes, one could say that Apichatpong "won" the poll rather handily. In practical terms, three of his four eligible features placed in the top one-third of the survey. If the curators who voted in the poll were asked to look ahead, to attempt to discover in the present those films and filmmakers that were setting out possible paths for the future of the medium, then one could certainly argue that Apichatpong is such a figure.

And in fact, one of the most innovative of all the Berlin School filmmakers, Ulrich Köhler, would seem to be in complete agreement. Köhler, like

Apichatpong, began by making short experimental films. His three feature films, *Bungalow* (2002), *Windows on Monday* (2006), and *Sleeping Sickness* (2011), are among the most significant contributions to the Berlin School. In various ways, Köhler has cited Apichatpong as a major new voice in world cinema. For example, Köhler's ballot for the British Film Institute's 2012 poll of the greatest films of all time included *Blissfully Yours*, alongside works by Fassbinder, Godard, and Murnau.

At other times, Köhler has both implied and stated directly that Apichatpong's approach to film represents a way out of certain crises that consistently befall so-called political filmmaking. This is partly because Apichatpong's films avoid simplistic message-mongering and didacticism and instead provide a way to consider a wholesale reenvisioning of reality. As Köhler has observed, this pertains to Apichatpong's exploration of the relationship between mystical and material planes of existence. But, as James Quandt has explained, this is also because of Apichatpong's use of what we might call split or bifurcated time. Quandt writes, "The co-existence of various times, the frequent refusal to connect incidents temporally, the abrupt displacement of narrative space through quick edits: Apichatpong treats time as malleable, flowing rather than fixed and linear, subject to the abeyances of wonder, memory, desire" (Quandt 2009, 26). It is this unique temporal dimension that Köhler will adopt from Apichatpong and, perhaps in his latest work, that Apichatpong will borrow back from Köhler.

Köhler and Apichatpong on "Political Film"

At first glance, *Sleeping Sickness* would appear to be a paradigmatic example of political cinema. In it, Köhler engages with questions of colonialism, racial stereotyping, misplaced white liberal charity, and the domination of two-thirds of the world by Western NGOs. However, Köhler has explained that his films are not political as such, even though they may broach political topics. To understand this distinction, we can turn to the director's own critical writings.

Köhler summed up his artistic program with admirable specificity in an essay titled "Why I Don't Make 'Political' Films" (2007b). In it, Köhler was careful to place the adjective "political" in scare quotes because he was speaking of a very particular kind of cinema, one that placed its political rhetoric above other considerations, especially aesthetic ones. At the start of the essay, Köhler performs a rather intriguing rhetorical trick himself, identifying a single film by British social realist Ken Loach as his primary negative example. The film is a 1971 BBC "Wednesday Play" production called *Family Life*, written by journeyman

dramatist David Mercer. Rather than dismissing *Family Life* completely, Köhler interprets the film as a work divided against itself, contrasting "scenes of unsurpassed psychological depth and complexity," which result from "the freedom Loach gives to his actors," with the good-and-evil determinism of Mercer's screenplay.

Put another way, we might say that an artist who sets out to deliver an already-formulated political message will not only fail on the aesthetic front. He or she will most likely fail to achieve a lasting political impact as well. This, Köhler contends, is because the message, a rather noise-free exchange of data between a sender and a receiver, has no staying power. What we tend to linger over in an artwork, by and large, are its suspensions, its ambiguities, the disjunctures and *faux raccords*. In other words, Köhler believes that cinema can make a lasting political contribution through its *excess*. In order to do this, cinema must function as an aesthetic object, in a para-Kantian sense, having no "purposiveness," at least when understood as means-end rationalism.

In his interview with Rüdiger Suchsland in the Munich-based journal *Artechock*, Köhler discusses his attitude toward the current state of international cinema and in particular the contemporary filmmakers with whom he feels a particular affinity (Suchsland 2011). During the course of the interview, Suchsland and Köhler single out the Thai director Apichatpong Weerasethakul as a particular influence. They cite Apichatpong as a major touchstone not only in Köhler's overall cinematic thinking but also in relation to his most recent film, *Sleeping Sickness*, which at the time of the interview had just won the Silver Bear for Best Director at the Berlinale. Although there are traces of Apichatpong's visual style evident in Köhler's previous film, *Windows on Monday*, it is with *Sleeping Sickness* that Köhler imbibes the Thai filmmaker's influence most fully and in doing so locates his own unique cinematic voice, distinct from his Berlin School cohort.

As Köhler explains to Suchsland, "Weerasethakul of course has had a huge impact on me, even if our ideological background is completely different. I studied Western philosophy and am primarily influenced by rationalism. I do not believe in ghosts, and as the son of a school physician, I never turn to homeopathy. . . . Cinematically speaking, he is a director who works very, very freely with the medium and succeeds in creating a mystical level, although he qualifies that perspective, ironizing it and calling it into question" (Suchsland 2011). This particular interpretation of Apichatpong is worth exploring, not only because it helps to clarify Köhler's "way in" to the Thai director's oeuvre but also because it may provide a provisional answer to the problem of "political film," in a manner that Köhler would find both valid and heuristically productive.

For Köhler, Apichatpong's cinema never resolves the fundamental tension between ordinary life and the spirit world. At times, the films even seem to invoke the mystical in order to serve rational ends. As Köhler explains, "perhaps due to the influence of Buddhism, Weerasethakul succeeds in connecting a mystical level with the experiences of modern life. Weerasethakul is a Buddhist, but he is also the son of doctors" (Suchsland 2011). Köhler sees this duality in Apichatpong's cinema and pinpoints it within the director's own biographical history, which is not surprising. Since both he and Apichatpong were the children of physicians, one can understand that Köhler would feel a particular affinity for the Thai filmmaker on a personal level.

Nevertheless, this unresolved tension between the spirit world and material existence is a dominant formal element in Apichatpong's cinema, one that can be analyzed and discussed on the basis of the films alone, without recourse to authorial history. The particular ways in which Apichatpong uses cinema as a creative tool for producing tactile analogies for the spiritual realm, and in particular the intermixing and "tug" of ghostly presences on (otherwise) ordinary lived existence, is perhaps this filmmaker's major contribution to twenty-first-century aesthetic discourse. Apichatpong has accomplished this by reconfiguring conventional notions of cinematic and historical time. In this respect, he has offered a rather bold example of how to make "political film" without didacticism or simplistic illustration of partisan positions. These are the interventions that have clearly influenced Köhler quite deeply.

Apichatpong's Bifurcated/Folded Time

The films of Apichatpong Weerasethakul are dense, multilayered, often poetically organized rather than driven by narrative, and they tend to emphasize visual and sonic motifs rather than affording primacy to the spoken word. In terms of both pacing and organization, the films can at times feel oneiric, even seeming to induce a kind of drift of consciousness, as though they were bypassing the viewer's usual capacities for "making sense" out of cinematic stimuli. Nevertheless, there are aspects of Apichatpong's practice that are forcefully apparent, so much so that they have become his authorial signature. Ever since his second feature, *Blissfully Yours*, Apichatpong's films have featured one distinct characteristic that even the most casual viewer inevitably notices.

At around the midway point, the film stops, "reboots," and takes on a radically different quality. This can entail a shift from a more conventional social realism to a Warholian avant-garde sex portrait (*Blissfully Yours*); a love affair between two men breaking down into a primal battle between a huntsman and a

tiger-spirit (*Tropical Malady*); a mysterious hospital from the past, seen first from a woman doctor's point of view, then from a man's (*Syndromes and a Century*). By the time Apichatpong made his 2010 Palme d'Or–winning film *Loong Boonmee raleuk chat* (*Uncle Boonmee Who Can Recall His Past Lives*), he was no longer bisecting his films. Rather, he had taken the disruptive rhythm of the reboot and made it the primary focus on the film itself, focusing on a lead character whose past lives (and spirits from various points in his life) were producing multiple temporal and cinematic disruptions, rather than just one in the middle. Apichatpong carries this more staccato approach to disrupted time through in his latest feature film, *Rak ti Khon Kaen* (*Cemetery of Splendor*, 2015).

So, in a sense, the director's trademark move has become more complicated over the years, no doubt in part because, like any great artist, Apichatpong does not want to repeat himself or lapse into a formalist rut. But I think that if we examine the broader purposes to which Apichatpong has put this halving of his films, it will become clear why he has expanded the practice rather than abandoning it. In almost every case, the "split" is a way for Apichatpong to cinematically organize a shift from one reality to another. Usually these realities represent the commonplace world of material existence, on the one hand, and the spiritual world of ghosts, monsters, supernatural beings, folklore, and even the human unconscious, on the other. Although Apichatpong's division is never absolute, the films have often used this temporal cleavage as a way of demarcating this divided world for the benefit of viewers who are unaccustomed to seeing two distinct realities depicted in ostensibly narrative films.

But there is quite a bit more at stake in Apichatpong's representation of material reality alongside the spirit world. It is a formal endeavor, and it is it a way for Apichatpong to depict the influence of Buddhism on daily life in Thailand, but it is also something else. The primary function of ghosts, spirits, and mythological beings in Apichatpong's cinema has a great deal to do with a unique approach to cinematic time, and the director's interest in exhuming otherwise hidden, politicized layers of time within Thai history.

Temporal Ruptures: *Blissfully Yours* and *Tropical Malady*

In his second and third feature films, Apichatpong explored bifurcated time in a manner that allowed him to examine liminal desires and sexualities and the ways that those desires intersected, unavoidably but without any firm conclusion, with the political fortunes of those subjects depicted in the films. *Blissfully Yours*, for example, focused much of its first half on a love story between two young people,

Roong (Kanokporn Tongaram) and Min (Min Oo). Roong is a Thai girl and Min an illegal Burmese immigrant, and we see them hanging out but also trying to get forged papers for Min, as well as visiting a doctor to try to get him relief for the full-body rash that plagues him.

The film does not specify whether Min got into some form of corrosive algae or pollution when he crossed into Thailand. But the subtext is clear: the constant anxiety of trying to live and work as an underclassed immigrant in Thailand "produces" the rash. Min is in crisis because of who he is, and Roong cannot help him despite her deep affection for him. But in the second half of the film, Apichatpong allows the lovers to retreat to a lake in a thicket, where they swim and make love. We are invited to luxuriate in the textures of the lovers' bodies, the play of sunlight on the water, and the natural beauty of their surroundings. In short, *Blissfully Yours* "absolves" Min's crisis of identity by creating a literal clearing—spatially as well as temporally—for an experience of pleasure and desire, an altogether different "politic" that Apichatpong displays the lovers inscribing on each other's bodies. As per the title, Min no longer belongs to Burma, Roong to Thailand; they belong to each other, in the alternate time frame generated by bliss.

As a filmmaker well versed in the history and techniques of avant-garde cinema, he is of course aware that multiple "times" or profilmic events can be presented simultaneously, through superimposition, multiple frames, or other approaches. And Apichatpong has engaged in such methods himself in his experimental short films. His "sketch" for *Uncle Boonmee*, *Phantoms of Nabua* (2009), for instance, contains frames within frames. He expanded on this idea to some extent in the *Uncle Boonmee* feature, which is organized with layered and digressive storytelling, more than an absolute split.

But for his feature films up through *Syndromes*, Apichatpong has preferred to adopt the bifurcated approach, with fascinating results. For instance, *Tropical Malady*'s "break" between the quotidian and the mythic occurs at a particular moment of rupture. The flirtation between country boy Tong (Sakda Kaewbuadee) and the soldier Keng (Banlop Lomnoi) is tentative and chaste throughout the first half of the movie. We witness such gentle gestures as the offer of a mixtape, or teasing flirtations like Keng asking if he can rest his head on Tong's lap, Tong saying "no," and then responding to Keng's hurt expression with, "I was going to say, 'no problem.'" But when the affection between the two men becomes undeniably sexual, Apichatpong sets in motion a montage that has complicated implications both within and outside of the diegesis. All of these implications speak to a radical disruption that necessitates a "move" to another reality.

At first we see Tong urinating outside while Keng watches. Then, once they are together again, Keng takes Tong's hand. "I haven't washed my hands," Tong

Figure 9.1 *Tropical Malady*: Keng licks Tong's hand

says, at which point Keng begins kissing and then licking Tong's hand and arm (fig. 9.1).

Excited, Tong indicates that they will see each other again, and wanders off into the night. Keng is elated; he gets on his motorbike and rides from the country into the city with a huge smile. A pop song plays on the soundtrack. We alternate from Keng's mobile point of view to a traveling shot of Keng, wind in his hair, feeling free.

As the dark of the hinterlands gives way to the lights of the town, we see Keng pass by, seemingly without noticing four men stomping and kicking another man, huddled on the ground in a near-fetal position. Apichatpong gives us no information about this situation, but in context, it is difficult for the image not to immediately register as a gay-bashing. But as the camera follows behind Keng's bike, two of the guys break from the pack to throw rocks at the camera, signifying Keng's departing vehicle. From here there is an immediate cut to daytime and a vehicle moving the opposite way: a military truck carrying soldiers down a country road. One of them jokingly caresses Keng's arm.

The sequence ends with a reverse shot from the back of the truck, which is leaving a cloud of smoke in its wake. Entering a gate, the military truck's exhaust obscures the green mountain landscape. Keng's "real" life (soldiering, urban) begins to obliterate the pleasures he has found with Tong in the country. In the next shot, Keng awakens in a private bedroom. (Had he been dreaming? We do not know.) He hears a man and an older woman talking and notices a small photo

album. While flipping through it, he sees a photo of Tong with another young man, who is wearing a shirt that reads "Infantry." At this point, half the screen goes dark, while the other is "ignited" by the kind of end-flare commonly seen in Brakhage or Warhol films. And then, nothing.

At this precise moment, the film is restarted with a painting of a tiger and a title card, explaining that the remainder of the film will be about a shaman who can turn himself into various creatures, tricking the people of the forest. From this point on, *Tropical Malady* will feature the same two actors, Banlop and Sadka, in different roles. Banlop is a hunter, and Sadka is a tiger-being who is trying to both elude and seduce the hunter.

What is Apichatpong trying to accomplish here? This myth-laden passage is somewhat more elusive in its meaning than the body politics of *Blissfully Yours*, in part because Apichatpong is addressing constraints external to the film itself. He has experienced consistent difficulties with Thai censors, and several key passages of *Blissfully Yours* (mostly in the alfresco sex scene) had to be cut for local release. In the case of *Tropical Malady*, explicit homosexual activity was never going to make it past censors, and so when Tong and Keng become physical, the film's capacity to be displayed in Thailand—and by extension, the very representability of gay desire—becomes a crisis. Apichatpong "solved" this dilemma by taking the action to another plane of existence.

But the rupture in *Tropical Malady* should be understood as more than a film-maker's clever solution to the external problem of censorship. As Köhler noted about Apichatpong's work, he consistently orchestrates connections between the material and the mystical planes, while at the same time ironizing or challenging any conventional notion of dualism or a facile "heaven and earth" relationship between the two. The move from two men in love in the real world to a myth-ological situation is not just a cop-out, or a decision based on the juridical con-straints of Thailand (which have only gotten more difficult for Apichatpong and other artists since the 2014 military coup).

Instead, we can consider the two parts of *Tropical Malady* as mutually in-forming, or even temporally simultaneous, in an ironic or imaginative manner. Since the rupture in the film occurs at the moment when Keng sees a photo that may imply that he is but the latest in a series of soldier boyfriends for Tong, his desire experiences a rupture that instigates a kind of "reset" of their courtship. Now, instead of a gentle respite from his own stresses as a soldier, Keng sees Tong as a prize to be won, as his quarry. However, Apichatpong offers the possi-bility that this mythological element may have been in play all along. During the first half of the film, there are discussions of a creature that has been mutilating cows. Whether or not this is Tong the tiger-spirit, we can understand that this

second-order perception of the Keng-Tong relationship, once initiated, has been rewritten as a subtext that has always been there. This retroactive time frame can perhaps best be explained as an instance of Freud's concept of "deferred action" (*Nachträglichkeit*) (Laplanche and Pontalis 1974).

Stated more directly, we could say that once Apichatpong introduces the mythological subcurrent into Keng and Tong's story (for both the lovers themselves and the spectator), it does more than retroactively recode their earlier courtship. It henceforth becomes something that is understood to have always already been there. In psychological terms, this mystical level is an interpretive frame for Keng's frustrated desire, for the gay desire between the two men in a society that is less than hospitable to homosexuality, and a retroactive means for engaging with or processing those aspects of their desires that are not readily available to the conscious mind. In fact, Apichatpong's "replacement," intentional or otherwise, of dominant Western mythic topoi such as the oedipal narrative with a story specific to Thai culture is a bold revision of Freud. *Tropical Malady* maintains the fundamental structures of psychoanalysis while making the appropriate postcolonial adjustments to its particular context.

Köhler and Apichatpong in Space: "Primitive" and *Windows on Monday*

In later films, Apichatpong treats the mystical world much more directly as a means for addressing political rupture and upheaval. Although these later films never entirely abandon questions of interiority and subjectivity, those matters tend to become subsumed within much wider, transindividual social concerns, particularly in relation to Thai history. In this shift, we can perhaps most clearly see the tension or irony between material and spiritual considerations that Köhler has found most suggestive in Apichatpong's work. Furthermore, this broader sociopolitical zone is the space in Apichatpong's work that has been most influential in Köhler's own work, in particular his films *Windows on Monday* and especially *Sleeping Sickness*.

Köhler mentioned his particular affinity for *Syndromes and a Century*, Apichatpong's semibiographical film exploring the early relationship between his two physician parents. *Syndromes* is perhaps unique in the Apichatpong filmography for the degree to which it makes certain key dichotomies its primary subject matter: materialism versus spirituality, faith versus reason, East versus West, and country versus city. Nevertheless, in Apichatpong's subsequent films, those composing the "Primitive" project, we really begin to see a new directness

in examining Thai history as an ongoing battle between reason and superstition, with neither one necessarily producing a wholly desirable outcome.

The "Primitive" project was a multimedia, multipart artwork that contained two self-contained video works, *A Letter to Uncle Boonmee* and *Phantoms of Nabua* (both 2009), and that then culminated in the feature film *Uncle Boonmee Who Can Recall His Past Lives*. Although all of these films are quite rich and complex, the animating idea behind them pertains to the village of Nabua, a place that was effectively destroyed during the military occupation of the 1960s (Newman 2009). Anyone even suspected of being a communist was murdered, and so the entire village was effectively wiped out of existence.

In the "Primitive" project works, Apichatpong asked surviving descendants of the dead to return to the place where Nabua once stood, not to recollect but to "conjure ghosts." Using Uncle Boonmee as a figure of infinite memory, the films assert the impossibility of absolute erasure of history. Something always remains; even the landscape bears silent witness to those events that official documents scrupulously omit. When we meet Boonmee in the feature film that bears his name, he is a dying old man with kidney failure. His body literally cannot purge the by-products of its own processes. As he is visited by numerous ghosts, he reflects on his bad karma, wondering aloud, "maybe I killed too many communists."

Apichatpong asks us to take Buddhist precepts seriously and to consider the problem of past lives and troubled karma. But he insists on framing this spiritual crisis as an unavoidably political one, something that can only play out in the theater of material relations. What we are given is a hard, literal insistence—one that goes beyond mere metaphor—that present time is vertically organized, weighted by history and traversed by the spirits of those not yet reckoned with.

If we think about how we see Köhler adopting these ideas into his own films, and how this borrowing from Apichatpong represents a strong articulation of Köhler's own program for cinema, we can look at the marked development between his second and third features. While *Windows on Monday* bears certain marks of Apichatpong's formal elegance and conceptual organization, in *Sleeping Sickness* Köhler brings those aesthetic traits to bear on an explicitly historical problem, with striking results.

Windows on Monday is in some senses very much in line with a particular strain in the Berlin School. The film is about a family trying and to some degree failing to live through a transitional moment—in this particular case, a highly disruptive and protracted home renovation. The film focuses on the bour-

geois family unit in transition and on what happens when a member of that unit begins to "malfunction" or behave in ways that cannot be squared with habitual notions of duty, morality, or Western psychology.

As Köhler, along with cinematographer Patrick Orth, frame and reframe *Windows'* wife, husband, and daughter, all of whom are inside a house without windows (they are being replaced) and in a substantive state of disrepair, the film eventually settles on the woman, Nina Buchner (Isabelle Menke), as its primary focus. She is a doctor, a loving but exhausted mother, and in a moment of frustration she temporarily abandons her family and begins wandering through the surrounding woods. Köhler, in keeping with his own relatively antipsychological approach to filmmaking, does not really ask us to "understand" Nina's decisions, so much as we are asked to *observe* them, and note the degree to which they seem at times an apposite response to her physical circumstances, at other times not. As she barges in on her brother and his wife, and eventually wanders into a sports hotel and rather aimlessly acquiesces to a tryst with one "David Ionesco" (Romanian tennis great Ilie Nastase), Nina's is a journey not of desperation or even boredom so much as ennui.

In *Windows*, it is in the formal organization of space, and the always-complex interpenetration of interior and exterior, architecture and the landscape, that we find Köhler drawing most direct inspiration from Apichatpong. One of the hallmarks of this director's visual style is his use of light, which is derived in part from the particularities of houses and other structures in the Thai countryside. The tropical climate demands a high degree of permeability and air circulation, and this tends to be achieved with large windowless portals that can be screened off in the event of foul weather. In Apichatpong's films, this results in a highly idiomatic form of indoor illumination. At the same time, many domestic functions, particularly dining, are conducted outdoors. Focused, limited lighting contributes to a play of hypervisibility and concealment. We see this very dramatically in the dinner scene in *Boonmee*, as ghosts and creatures materialize on screen before the viewer can even notice.

Scenes in *Tropical Malady* and several sequences in *Syndromes and a Century* show activity in the foreground, slightly darker than normal and always offset by the bright, verdant outdoors, framed like a living mural. Köhler takes a direct cue from this method of framed light and indistinct boundaries in *Windows on Monday*, to a large extent making it the film's very subject matter. One might even go so far as to say that this is the film in which Köhler is sketching out or intellectually processing, on a highly formalized level, his own relationship to Apichatpong's methods. The lack of windows in Nina's house serves as a structural anomaly—a disruption of the very public/private divisions on which

bourgeois European society is established. But it also offers a kind of invitation, allowing Nina (and to some extent Köhler) the freedom to wander outside the family home in order to explore alternative spatial relationships.

Double Time: *Syndromes, Uncle Boonmee,* and *Sleeping Sickness*

As Köhler has noted with respect to Apichatpong, his work provides new creative avenues in large part because he has found ways to productively collide the mystical and the material planes within his films. This is attributable in no small part to Apichatpong's Buddhism, which the filmmaker takes very seriously. But Köhler also sees in the Thai master's films an ability to regard its precepts with a degree of humor and skepticism. This allows for a certain formal playfulness that dovetails with the problems of late modernism: how to use the plastic capacities of art to produce analogs to nonnormative psychic states. To a great extent, for both artists this comes down to a question of time.

As discussed above, Apichatpong often employs a bifurcated temporal structure in his films, and, although the demands of a linear time-based art such as single-screen narrative cinema require that one strand of time will precede the other, it is indeed possible to read these "times" as parallel or coterminous. *Tropical Malady*, for instance, may very well display two simultaneous strands of meaning or existence with respect to the same love relationship. They may be on two different planes of reality; one could be the unconscious mirror to the other; or the second narrative could be the retroactive revision or deferred-action retro-present of the first. In any case, straightforward linearity seems to be the least satisfactory explanation.

This is perhaps most explicit in *Syndromes and a Century*, possibly the film of Apichatpong's that operates in the most recognizably surrealist vein. Its dual structure is rather clear, relative to Apichatpong's unusual cinematic practice. A movie about the filmmaker's doctor parents, the two halves correspond to the memories of his mother and then his father. The two halves are set approximately forty years apart, the first segment in a rural hospital, the second in a modern, urban one. Not unlike a contemporary Korean comedy by Hong Sang-soo, much of the action and dialogue in *Syndromes* repeats directly, but the perspective has shifted. But unlike the standard "he said / she said" premise, Apichatpong has chosen to separate the story of his parents' courtship with an additional layer of history: the advancement of medicine and the urbanization of Thailand.

Where *Tropical Malady* sets forth two different modes of the same basic material, *Syndromes* goes a bit further in the same direction. We understand that the

primary actions depicted are fundamentally simultaneous. However, by dividing the two perspectives artificially, across "objective" time, Apichatpong shows us how factors such as cultural development, economic shifts, feminism, urbanization, and the pull of tradition will reframe the same people, even if only by contrast. In a sense, this is a move that Apichatpong simultaneously expands and contracts when he produces his "Primitive" feature, *Uncle Boonmee Who Can Recall His Past Lives*. Boonmee (Thanapat Saisaymar), the dying man in the present, is the antenna for multiple, very different histories to touch down in the present. That is, an otherwise singular timeline is subject to historical intrusion because Boonmee's nearness to death permits his previous lives to well up within him and for the ghosts of his past to materialize in the here and now.

This continual shift in Apichatpong's practice, particularly how the filmmaker uses the mystic or otherworldly as a totem for historicity, helps us understand the broader inspiration that Köhler has taken from him, most dramatically in *Sleeping Sickness*, which is Köhler's most unusual and accomplished film. In it, we see certain hallmarks of the Apichatpong style—most obviously, the bifurcated structure and a collision between "civilized" and "jungle" lifeworlds. However, Köhler takes these elements in a distinctive direction, inscribing them with what, ironically, we could only call political content in the conventional sense. *Sleeping Sickness* is, among other things, a film about colonialism and the unintended by-products of European liberal aid initiatives, a kind of crisis of mutual dependency. However, from his engagement with Apichatpong, Köhler has clearly found a way to address these concerns without lapsing into the didacticism he so detests.

Sleeping Sickness begins at night, with Dr. Ebbo Velten (Pierre Bokma) driving from the airport with his wife Vera (Maria Elise Miller) and teenage daughter Helen (Jenny Schily). They have come to visit Ebbo in Cameroon, where he has been working as a doctor with the World Health Organization. He is in charge of a village clinic that provides basic health care. However, the main purpose of the WHO clinic is the eradication of a purported epidemic of sleeping sickness.

As Velten and his family try to reenter the confines of the village, the car is stopped by a police checkpoint. As it happens, Helen does not have her passport. The local police hassle Ebbo and threaten to give him trouble, but in the end, they back down. This opening scene sets the tone for how Velten is regarded, and how he operates, throughout the rest of *Sleeping Sickness*. In a potentially dodgy situation for a Western outsider, the doctor simply asserts his white privilege, behaving as though his international backing makes him untouchable. Köhler's portrait of Velten is considerably different from what we are usually given by the cinema when it comes to aid workers, NGO affiliates, or just the standard well-meaning Western volunteer. Typically, these individuals are shown

to be either heroic or blinkered, sometimes both in some combination. Instead, Velten is both competent and jaded, self-regarding and aloof. He moves unafraid through a Cameroonian culture that might well have some dangers lurking for him beneath the surface.

The first part of *Sleeping Sickness* details Velten's strained interactions with his family. He is ostensibly bringing his tenure in Cameroon to a close and preparing to return to Germany. At the same time, Velten gently hints that the whole family might benefit from leaving Germany behind, a suggestion Vera rejects in no uncertain terms. At dinner, the family meets up with an old acquaintance, Gaspard (Hippolyte Girardot), a French investor who has made a small bundle in Cameroon from explicitly colonialist ventures. By showing Gaspard's dressing-down of a black African waiter for overcharging him for a bottle of mislabeled South African wine, we can see a more extreme version of European arrogance, a harbinger of what Ebbo would most likely become if he were not leaving Cameroon. This is exemplified immediately afterward. Velten arrives home to find his home security guard asleep at his post and proceeds to bawl him out in a condescending manner.

This high-handed attitude reaches its apex in the subsequent scene, a meeting with the African doctors who are administering the WHO programs in Cameroon. Köhler quite clearly shows Velten playing the paternalistic European. After some other minor situations (in particular, Ebbo visiting Gaspard's resort, and the chief physician trying to buy Ebbo's van), the film's first section ends with Velten's tearful phone conversation with Vera. "I miss you too," he says, but something seems wrong. Köhler cuts to black, and we see an intertitle: *Three years later*.

At this point, *Sleeping Sickness* returns to Europe and the WHO. There, we meet Alex Nzila (Jean-Christophe Folly), a young physician who has been dispatched to Cameroon to audit the program there. This segment features Alex's coworkers committing casually racist microaggressions against him, joking about "whether Africans have bigger dicks." Nzila just smiles and patiently explains that he was born in Europe and is therefore not an "African." Nevertheless, *Sleeping Sickness* introduces the idea that Alex has been tasked with the Velten case because he is presumed to have more of an entrée into Cameroon (as an "African") than his coworkers. As we see from Alex's difficulty buying cigarettes from a street vendor upon arrival—exhibiting a misplaced paranoia about being ripped off, when in fact he has miscalculated the exchange rate—this is by no means the case.

Velten and his assistants actively thwart Alex Nzila's audit, for the most part by actively avoiding him. Everyone he meets has a cover story for Velten's absence. Alex is called upon to deliver a villager's baby by C-section, and faints during the procedure. Only afterward does Velten materialize. Hours later, Alex awakens in

a tent, receiving fluids, under Velten's care. Nzila is now in a vulnerable position with respect to his WHO colleague.

Once Velten begins taking Alex around to the various clinic outposts, he begins parroting the defensive language that the African administrators had tried on him three years ago. There are no cases of sleeping sickness to be found and little else for the WHO team to be doing in Cameroon. But, Velten insists, this only shows just how *effective* the program is and the degree to which the villages' health care would slide back into chaos should funding be cut. Velten picks up on Alex's discomfort in Cameroon and in particular the fact that, as a black European, Alex feels uncomfortable *about* his discomfort. Or, as Mark Peranson describes it, "Africa is a place that isn't home, and this characteristic has the ability to both attract while being repellent (in the case of Ebbo) and repel while being attractive (Alex)" (Peranson 2011). That is, the fact that Velten is more "native" or swaggeringly authoritative than Alex when it comes to African customs and protocols is a racial reversal that is lost on neither man, and a fact that Velten plays to his advantage.

Earlier in the film, Velten told a story from local lore, that someone had allegedly been eaten by a hippo. Velten, in line with Köhler's take on Apichatpong's orchestration of the mystical, is able to address mythology with a degree of seriousness, like an anthropological window into local superstition, without entirely buying into it. We see this, to an extent, when Velten warns Alex to conceal his homosexuality, because the locals might kill him. Again, this is an ambivalent position that Velten attempts to play to his advantage against Alex. Velten is frank about the fact that Nzila's audit could shut down the Cameroon operation. "My fate is in your hands," Velten tells Alex. But the tone Velten adopts is as much that of a dare as a plea, since Alex has to know *how* to exit Cameroon with the proof he needs.

This leads to the final sequence of *Sleeping Sickness*, a nighttime hunting expedition in the jungle with Ebbo, Alex, and Gaspard. Alex is offered a weapon, but declines. With only headlamps to guide them, the three men wander deeper into the dense thicket with an ever-increasing sense of anxiety. Velten and Gaspard argue, guns are pointed, and Gaspard introduces the idea that Ebbo wants Alex's report to force a return to Europe, one he hasn't the guts to undertake on his own. As tempers flare and headlamps fail, the men separate and Velten goes missing and is never seen again. The ambiguous final shot shows the lake near where Velten was last seen, with a hippo surfacing and swimming away.

Several things should be observed about Köhler's organization of *Sleeping Sickness*, not least of them the recognition that ending a politically freighted piece of cinema on a note of such pitch-perfect morbid humor is truly admirable.

More than this, Köhler's beginning of the second section—Alex's extended hunt for Velten—paired with the conclusion—the night hunt and Velten's implied demise—represents a clear albeit unconventional allusion to Conrad's *Heart of Darkness* and, by extension, *Apocalypse Now* (1979). Velten, as a modern Kurtz, is no enigma. Instead he is a self-serving international aid worker, a banal civil servant. But this is precisely what makes Köhler's intertextual maneuver so pointed. When Alex goes to Cameroon to discover that there is no sleeping sickness epidemic, he also finds that the man behind the curtain is even less of a wizard than Oz. In the European imagination, African colonialism is no more seductive or dangerous than a downtown hunt for an ATM.

But what if we brush *Sleeping Sickness* against the grain just a bit, following the logic of Apichatpong's broader influence on Köhler? We can immediately see that the specter of folk knowledge rears its head, quite literally, in the form of the hippopotamus of colonial vengeance. Marco Abel has suggested as much, quite rightly, in his reading of *Sleeping Sickness*, in which he finds very direct Apichatpongian echoes, particularly as relates to "past lives" (Abel 2013). But we can also think about the bifurcated structure of *Sleeping Sickness* in a somewhat less literal way than the "*three years later*" title card invites us to. This is not to say that we ignore the clear diegetic time lapse between the first and second section. However, reading Köhler through Apichatpong, we can also consider the two sections coterminous, at least ideologically. This helps to explain who and what Ebbo Velten is and, more broadly, what Köhler seems to be saying about Western aid in the two-thirds world.

In the first part of the film, it is Velten who is arguing that the WHO project in Cameroon has run its course. Meanwhile, local doctors affiliated with the project are trying to push for extended funding, seemingly for their own bureaucratic benefit. In the second half, Velten makes the same arguments for extending the project, barely concealing from Alex that the situation has become a sham to support the doctors involved. In conventional terms, we would read this linear development as Velten having been co-opted, or just giving up. But what if, in some more abstract sense, both of these attitudes exist simultaneously? That is, if Velten is equally capable of marshaling the prograft or proausterity argument at any given time, depending on who is listening and who the potential beneficiaries of either position might be?

History Is a Sleeping Sickness

A linear interpretation of *Sleeping Sickness*, which understands the character of Velten according to the typical canards of narrative consistency and nineteenth-century con-

vention, would lead us to think that he and his position have changed, that something "got to him," whether it be the general system of corruption, the lure of Africa, or a general depressive malaise. However, Köhler's adoption of Apichatpong's structural time frame lets us think in broader terms of history and institutionality. Colonialism is *always* beset by conflicting impulses. NGOs such as the World Health Organization are *always* benevolent and corrupt at the same time.

Instead of creating a kind of mystical, vertical time in which the living and the dead walk side by side, as in Apichatpong's films, Köhler has adapted the model for his own ends. Good intentions and self-interest as well as progressive and retrogressive impulses are made visible in *Sleeping Sickness*, crisscrossing both the local culture in Cameroon and the aid efforts of the WHO. Moreover, all of these impulses are simultaneously present in Ebbo Velten. Köhler demonstrates how the weight of colonial history is negotiated, but by no means left behind, through the intricate chicanery of institutions.

For his own part, Apichatpong has found yet another way to examine history's ongoing impact upon the living, and in a fascinating confluence of events, the Thai filmmaker has lighted upon the very same metaphor with which Köhler animated his own film. *Cemetery of Splendor* (2015) expands Apichatpong's interest in the spiritual world, deployed as a kind of literal metaphor. In the film, a group of soldiers has been afflicted with sleeping sickness, and they have been remanded to a village hospital ward. The hospital is a former schoolhouse, and the transformation is still incomplete—one of the film's many emblems of the undead past. Jen (Jenjira Pongpas Widner), a villager, takes a particular interest in one of the inert solders.

Eventually Jen is visited by two ghost princesses who explain why there is a sleeping sickness epidemic. It relates to ongoing, ancient conflicts from Thai history. "The ghosts of the dead kings are drawing on the soldiers' energy to fight their battles." With a somewhat oblique nod to *The Matrix*, Apichatpong is once again drawing on the concept of the ethereal plane to make direct commentary on contemporary politics in Thailand. Today, soldiers and other ordinary Thai citizens are being forced to enact ancient, endless battles, and it often appears as if there is no end in sight.

In a nation beset by almost regular coups, it can be difficult for an artist to find the means by which to inject dissent into the broader conversation, not only because of censorship but also because of the perpetually "moving target" of one's critique. Whether intentional or not, *Cemetery of Splendor* shows that Köhler's particular take on Apichatpong's temporal framework—a kind of bureaucratic simultaneity, or politically "stacked" time—has coincided with the latest shift in Apichatpong's own cinematic approach to time. Whether or not Köhler's film was an influence on Apichatpong is immaterial. The final image of *Cemetery* speaks to the fundamental similarity in their approach to twenty-first-century

Figure 9.2 *Cemetery of Splendour:* Jen watches for the ghosts of the past

film. Jen is told that the ghosts of the past are visible all the time, if you keep your eyes wide open (fig. 9.2).

Works Cited

Abel, Marco. 2013. "Ulrich Köhler: The Politics of Refusal." In *The Counter-Cinema of the Berlin School.* Rochester, NY: Camden House.

Apichatpong Weerasethakul. 2009. "The Memory of Nabua: A Note on the *Primitive* Project." In *Apichatpong Weerasethakul,* edited by James Quandt. Vienna: Österreichisches Filmmuseum.

Köhler, Ulrich. 2007a. "Warum ich keine 'politichen' Filme machen." *New Filmkritik* (April).

———. 2007b. "Why I Don't Make 'Political' Films." Translated by Bettina Steinbruegge. *Cinema Scope* 38 (Spring).

Laplanche, Jean, and Jean-Bertrand Pontalis. 1974. *The Language of Psycho-Analysis.* Translated by Donald Nicholson-Smith. New York: W. W. Norton.

Newman, Karen. 2009. "A Man Who Can Recall His Past Lives: Installations by Apichatpong Weerasethakul." In *Apichatpong Weerasethakul,* edited by James Quandt. Vienna: Österreichisches Filmmuseum.

Peranson, Mark. 2011. "Not Political Cinema: Ulrich Köhler's *Sleeping Sickness.*" *Cinema Scope* 46.

Quandt, James. 2009. "Resistant to Bliss: Describing Apichatpong." In *Apichatpong Weerasethakul,* edited by James Quandt. Vienna: Österreichisches Filmmuseum.

Suchsland, Rudiger. 2011. "Der Film als Hypothese, die Frage: "Was-wäre-wenn." Translated by Michael Sicinski. *Artechock,* June 22.

10

EAST OF BERLIN

Berlin School Filmmaking
and the Aesthetics of Blandness

Lutz Koepnick

It is difficult to ignore certain echoes of contemporary Asian art cinemas in the work of Berlin School directors, not least of all because filmmakers such as Thomas Arslan, Christoph Hochhäusler, and Ulrich Köhler themselves have intimated their indebtedness to the films of Hou Hsiao-hsien, Abbas Kiarostami, Apichatpong Weerasethakul, Tsai Ming-liang, and Hong Sang-soo (Hochhäusler 2013, 24). Stylistic similarities—the use of long takes and observational cinematography, a rigorous focus on the everyday and the peripheral, a pervasive absence of non-diegetic music and agitated image spaces—associate the products of Berlin School filmmakers to the output of celebrated Asian art house directors as much as an identifiable set of thematic concerns and narrative strategies such as the deflation of psychological storytelling, the presence of protagonists refraining from action and goal-oriented movement, the exploration of communicative blockages, and the hiatus between neoliberal visions of self-management and individual experiences of isolation and self-exploitation. And yet, similar to how the encounter between West and East in Maria Speth's *In den Tag hinein* (*The Days Between*, 2001) is one of uneasy passages and frequent misrecognitions, of things that need to remain unspoken or resist deliberate translation, so we do well to approach the relationship between the Berlin School and the films of Hou, Apichatpong, or Tsai as one far-less transparent as it may appear at first, as a dynamic of resonances and ricochets rather than of straightforward influences and adaptations.

Although often treated as relatively coherent groups in their own terms, neither the Berlin School nor recent East Asian art cinema is a school in any strict

sense. The former simply denotes a loose association of filmmakers whose initial training was shaped by a common set of formal, political, and pedagogical parameters. The latter owes its presumed unity largely to the promotional mechanisms, critical validation processes, and transnational funding efforts of European cinephiles, in particular the Cannes Film Festival and its section "Un Certain Regard." Whatever both may have in common is therefore less a question of direct stylistic or thematic impact than of comparable aesthetic commitments, in particular the aspiration to recalibrate contemporary modes of spectatorship vis-à-vis the present's ceaseless image flows and the ubiquity of highly disruptive registers of visual interaction at virtually all times. Although their work may draw on very distinct and possibly incompatible aesthetic traditions, what energizes the work of certain Berlin School filmmakers and representatives of recent East Asian art cinema is the effort to make viewers see and sense the world (on screen) differently, to reshuffle what can, should, and might be seen, and to enlist cinema as a medium to remodel the viewer's aesthetic experience of and durational commitments to moving images.

This essay's aim is to explore this aesthetic project in some greater detail. It will graft certain practices and concepts onto each other across existing cultural divides, not in order to colonize one cinema with the help of the other, nor to proclaim a coherent unity of vision and intent, but simply to probe whether and how we can enrich our understanding of the Berlin School if we see its films through other eyes and as part of a much larger transnational constellation.

I.

The shot, the film's third to last one, lasts—no kiddin'—almost fourteen minutes. In its first seconds, we see a woman and man entering a dark space, an architectural ruin, possibly part of an urban housing project never completed due to financial collapses and now finding itself in a state of infinite limbo. They walk toward the camera, she first with a flashlight in her hand, he a few steps behind her. The camera approaches her until her face and upper torso fill the entire right half of the frame; he approaches her to balance the frame on the left, still being slightly behind her. Her gaze is directed forward beyond the edge of the image, beyond the limits of what the camera allows us to see; his eyes, on the other hand, are directed at the back of her head, even though she gives no sign of recognizing his presence, his looking at her looking. During the next thirteen minutes, the camera remains locked onto the sight of the couple. At some point, we see tears streaming down her cheeks. A few times her eyes move slightly to the left as if

tracking something in front of her. Otherwise, however, she will remain utterly static, giving the viewer no indication of what she might see; in fact, whether she sees anything at all or whether her gaze is directed inward, is blank and void of content. No matter how hard we look and peruse her face in the many minutes to come, in the absence of a cut and a camera movement revealing the space-off and hence the possible object of her gaze, it is not for us to decide whether her look is contemplative in nature, that is, takes in "something inside so that it is retained and has influence upon our reflections and habits" (Armstrong 2000, 101); absorbed, that is, enveloped by what she sees to such a degree that she has ceded every sense of self-awareness and has entered a state of obliviousness; or completely empty or nonexpressive, that is, unaffected by whatever may be in front of her and simply embodies the transfixed stare of a vacated subject, her tears generated by what precedes the formation of subjectivity, self-expression, language, and goal-oriented action altogether (fig. 10.1).

If her face throughout the shot's many minutes refuses legibility, his posture, mien, and eyes provide greater readability, not least of all because we are able to see the very object of his look. We see him drinking from a bottle, moving his head slightly back and forth, as if readjusting the focus of his prolonged gaze. We catch him turning his head to the left so as to look at the floor for a while, his eyes teary as well. Finally, he will ever so slowly approach the woman from behind, softly touch her with his hands and rest his head on her right shoulder, his upper body slightly trembling before he finally shuts his eyes as if hoping to find a moment of solace, of rest. At which point the camera—finally—will cut, reposition itself behind the couple, and reveal what lies ahead of them and had constituted the object of her prolonged gaze: a monochromatic mural of a countryside, covering the room's entire headwall, about five meters in width. An amateur drawing or painting, what the image on the wall shows is the sight of a river in the foreground, a rocky shoreline and horizontal band of trees behind and a few mountains in the back. We had seen this image, and had seen another woman perusing this image, at some earlier moment in the film. Yet nothing in the composition of the shot discussed above allowed us initially to presume that camera, actors, and directors had returned us to this strangely extraterrestrial site again. What we had seen, and now see again, is an image of great simplicity that does virtually nothing to structure the viewer's gaze or compel our attention, an image in which individual elements gain shape and volume, yet nevertheless appear as if captured with a certain sense of detachment, of distance. Finally spotting what the woman saw during her fourteen-minute stare, finally knowing that she had something to look at in front of her in the first place, thus offers very little to *read* the various stages of her looking in retrospect and charge them with meaning. After all, the

Figure 10.1 Tsai Ming-liang, *Stray Dogs* (2013)

mural's sparseness and simplicity contains nothing to encourage prolonged acts of looking. Its blandness makes us think that the man's attentional irresolution during the previous shot may have embodied a much more appropriate reaction to the visible world in front of them than the woman's durational commitment.

No one, in our world of 24-7 media interactionism and multiscreen task management, holds their gazes as steadily as the protagonists of Tsai Ming-liang's *Stray Dogs* (2013)—Tsai is a filmmaker internationally known for minimalist narrative arrangements and prolonged scenes of seemingly static looking ever

since his daring 2003 *Good Bye, Dragon Inn*. Only few among even the most
ardent advocates of slow cinema appear able and willing to focus their gaze for
fourteen minutes on images approximating the logic of photographic still im-
ages, on barely moving images whose glacial pace frustrate our desire to sink
our teeth into the surface of the visible—to read, interpret, and unpack the sen-
sible. Although it is tempting to understand the final minutes of *Stray Dogs* as
a laborious exercise in delaying a countershot and precisely thus reshaping how
viewers attend to moving images in the first place, few spectators will greet the
final image of the image on the wall as a countershot at all anymore, as a shot that
could explain and anchor retrospectively what we just witnessed in the previous
take. In Tsai, each take remains autonomous from the next and previous; each
frame simultaneously recognizes and negates the burden of the world situated in
the space-off; any effort to read these images hermeneutically, of seeing one shot
illuminating another or mapping individual frames against the construction of
a presumed whole, appears ludicrous. Cinema here comes as close as possible to
witnessing the pure passing of time, radically evacuating narrative structures and
recursive associations as mechanisms to activate drama and meaning. Amid the
sleepless frenzy of what Jonathan Crary has conceptualized as the regime of 24-7
in which the "idea of long blocks of time spent exclusively as a spectator is out-
moded" (Crary 2013, 53), Tsai's images of durational looking praise moments of
indistinction and inactivity, of inoperativeness and stillness, as cinema's gesture of
grand refusal. Tsai's universe doesn't simply slow down the ticking of clocks. His
images of people looking suspend the very concept of quantitative measurability,
of time as a chronological, teleological, and causal chain of events.

I know of no filmmaker today as radically taxing the viewer's ability to enter
the images, minds, emotions, and narratives presented on screen as Tsai, yet his
scenes of arrested looking have found a salient counterpart in particular in the
work of Angela Schanelec and her rigorous refusal to adapt traditional models
of visual storytelling, her use of static frames and nonpsychological protagonists.
"Shot/reverse-shot," Schanelec has said, "is not an option for me because this
would return one to an image one has already seen. I have never done this. It
seems to me this does not work at all" (Abel 2013, 128). Similarly to Tsai, many
of Schanelec's films withhold shots that may answer in any conventional way the
questions asked by their preceding shots: time and again we witness protagonists
looking into the space-off without Schanelec ever allowing us to see what her
protagonists see, or delaying or displacing corresponding point-of-view perspec-
tives to such a degree that we cannot but consider the relation between seer and
seen as utterly detached and disengaged, void of anything that could suture the
viewer into the space of film and narrative. Early in *Mein langsames Leben* (*Passing*

Figure 10.2 Angela Schanelec, *Mein langsames Leben* (2001)

Summer 2001), Clara (Clara Enge) asks her babysitter Maria (Sophie Aigner) to dance to the music of Goethe's/Schubert's *Der Erlkönig*: an impossible task, as Maria points out herself, even though she then apparently does so after all because we see Clara intently looking for a prolonged period in the direction where we presume Maria to be while Schubert's sounds wander across the borders of the frame. In *Marseille* (2004), we see the film's protagonist, Sophie (Maren Eggert), staring for minutes on end at something she—according to ever-more assertive security guards—is not allowed to photograph with her camera, in spite of the fact that she makes no gesture whatsoever to take a picture of what we are kept from seeing (fig. 10.2).

In *Orly* (2010), the viewer is invited to spend precious lunch minutes with an airport counter agent, her gaze fixated pensively on something outside the frame while chewing on her sandwich (and not really seeing what she should have seen: a stray bag that may—or may not—cause a full shutdown of the airport later). And in *Nachmittag* (*Afternoon*, 2007), in what might constitute a curious reversal of a pattern, at some point late in the film our focus is on Agnes (Miriam Horowitz) as she—her eyes attached to the off—praises Irene's (Angela Schanelec) thespian ability to engage with a living dog on stage, thus recalling for us a long take from the beginning of the film in which a static camera showed a stage rehearsal with Irene and a dog being shown from a curiously dislocated backstage perspective.

There are plenty of possibilities to account for Schanelec's probing strategies of visual delay, of sealing individual frames from each other and making us look at prolonged and often unreadable stares into the off. Theorists of slow cinema may want us to see such scenes as methods to instill a sense of contemplative stillness in the viewer, opening up a space in which we can engage our own imagination, counteract commercial cinema's reign of mindless agitation, and complete the film's blanks in our mind. Critical theorists may embrace such techniques as efforts to break the spell of dominant storytelling and free the viewer from the culture industry's rule of spectacle. And Deleuzians may find at work here a startling collapse of different logics of the image and its movement, with Schanelec's deflation of narrative time and visual suture serving as a powerful means to at once reveal and unsettle how mainstream practices allocate emotion and affect and territorialize it within the confines of humanistic concepts of sovereign subjectivity. But in light of the (nondeterministic) echoes between East Asian art cinema and the work of the Berlin School posited and explored in this essay, the following pages will pursue two different angles to illuminate Schanelec's and others' aesthetic of durational, albeit nondescript, looking. The first engages what François Jullien has called and commended as the traditional Chinese aesthetics

of blandness, still operative in how Tsai pictures the look of his protagonist, and of considerable value to illuminate the aesthetic underpinnings of Schanelec's work as well. The second will draw on contemporary theories and practices of viewing screen-based installation art and how these—deliberately or not—have come to structure the compositions of contemporary long-take filmmakers such as Tsai, Schanelec, and Köhler. If both perspectives, in the end, might appear as if they pursue contradictory models of what filmmakers such as Tsai and Schanelec want cinematic images to do for and with their viewers, so only because we may still follow worn twentieth-century concepts of spectatorship that, in valorizing active over passive forms of viewing, posit the very passivity they want art cinema to overcome and are hesitant to recognize the extent to which participatory interaction has come to be essential to neoliberal societies of control and ceaseless self-management.

II.

To backtrack briefly: We have no reason to assume that the mural in *Stray Dogs* itself "causes" the extended gaze of the woman, and the man's gaze at the woman, and the camera's at both of them. On the contrary, because Tsai makes the viewer wait almost fourteen minutes to learn about the object of her gaze (and by then not really care about it at all anymore), and because the image thus revealed at first seems to own very little to arrest or energize anyone's gaze to begin with, we initially cannot but think of the relationship between diegetic viewer and image as one of relative detachment, one whose bond has to do not with the flavor, the distinctiveness, the agitation of the image, but precisely with its plainness, its lack of vivid structure, its seeming monotony and emptiness. What, if we really want to use this term, then, "causes" the woman to attach her gaze to the image is the image's very absence of causation, its refusal to do too much and engage the viewer directly, its inherent blandness, striking a curious balance between being of no real interest whatsoever on the one hand, and on the other its ability to invite gradual and never-ending processes of discovery (and self-discovery).

In his 1991 book *Éloge de la fadeur*, French sinologist and philosopher François Jullien has discussed and praised blandness as a cornerstone of traditional Chinese aesthetic practices. This is not the place to get involved in debates about possible Orientalist underpinnings of Jullien's argument. What instead matters is simply to explore the concept's heuristic force to illuminate what we see at work in Tsai and what we might learn from it about the visual

arrangements of Berlin School cinematography and editing. "First," Jullien begins his treatise, "one accepts the paradox: that to honor the bland—to value the flavorless rather than the flavorful—runs counter to our most spontaneous judgment (and elicits a certain pleasure in this contradicting common sense). But in Chinese culture, the bland is recognized as a positive quality—in a class, in fact, with the 'Center' (*zhong*) and the 'Root' (*ben*)" (Jullien 2008 [1991], 27). In Jullien's account, blandness—the absence of flavor, a lack of marked distinctions and hierarchies of taste, a state of undifferentiated continuity and contiguity—constitutes the foundations of all things, a sense of plenitude from which particular qualities, defining values, and clear distinctions may emerge in the first place. Historically developing against the backdrop of different traditions of thought such as Confucianism, Daoism, and Buddhism, the concept of the bland came to represent both an aesthetic and ethical dynamic, to be found in art forms and expressive practices as diverse as music, painting, and poetry. In the realm of sound, blandness served as a means to detach the mind of the listener not simply from the agitation of the world and the subject's attachment to physical things, but from the grasp of music itself, the way in which chords and melodies manage to stir emotion, engage the listener in ongoing patterns of tension, anticipation, and release, and thereby strip down this listener's ability to be open to the simple and essential. In the realm of painting, as most paradigmatically embodied in the work of landscape artist Ni Zan (1301–1374), the pursuit of blandness led to visual compositions drained of all opacity; a narrowing of color ranges; a certain flattening of the difference between fore-, middle-, and backgrounds allowing the eye to travel unhurriedly and evenly across the scroll; and a use of brushstrokes, not to record traces and distinction, but to allow marks to become one with forms to be represented. Nothing in Ni Zan's images of blandness agitates the viewer, strives to compel, direct, arrest, seduce, or fix the audience's gaze. Everything, instead, remains muted and quiet, allowing the viewer to remain at once detached, curious, and open to the unexpected. In Jullien's words:

> Trees on the riverbank, and expanse of water, some nebulous hills, a deserted shelter. The artist, Ni Zan (fourteenth century), painted virtually the same landscape throughout his life. He did this not, it seems, because of a particular attachment to these motifs but, on the contrary, to better express his inner detachment regarding all particular motifs and all possible motivations. His is the monotonous, monochromatic landscape that encompasses all landscapes—where all landscapes blend together and assimilate each other. (Jullien 2008 [1991], 37)

Although dedicated to local detail and a clear precision of strokes, Ni Zan's aesthetic of blandness captures a presumed balance and harmony, an archetypical distribution of elements, from which other images and landscapes could emerge in the first place. The bland, for him, constituted a quasi-primordial state of being, an ideal of unity, stability, and homogeneity, denoting nothing other than a state of pure potentiality, the world's well of ongoing becoming and transformation. In order to have and distinguish different tastes, to make and mark distinctions, to map, navigate, and involve oneself in the world, one first had to experience the simplicity of all things prior to all possible differentiation, a state of detachment produced, not by unperceptive boredom or something merely pleasing to the eye, but on the contrary by beholding the underlying familiarity of all things, including the continuity between viewer and viewed. Bland images generated the superior wisdom of bland viewership: a form of spectatorship able to freely wander across and into the image space; a mode of durational looking that recognized the reciprocal relationships between viewer and viewed and precisely therefore shunned the visual agitation, the affective back and forth, the dramatic exigencies and narrative projections, typical for those who see discriminating taste, critical judgment, or sensory excitement as the beginning and end of all things aesthetic.

Whether or not Tsai shares the philosophical underpinnings of the concept of blandness, his use of extreme long shots, and his picturing of people gazing into the space-off, may come as close to Ni Zan's choreography of the undifferentiated as moving images can. It would be foolish to compare the amateur mural in *Stray Dogs* with the art of the fourteenth-century master, yet it clearly has an effect on the female diegetic spectator similar to the one Ni Zan's paintings were meant to have on their historical audiences. What remains highly unreadable about her fourteen-minute stare, including the intermittent welling of certain emotions crystallized in her tears, is nothing other than what I suggest to call the work of bland spectatorship, the bland here not understood as a negative, but as a bottom line of perception and experience, a place of pure potentiality that allows the woman (as much as us as her onlookers) to see without feeling arrested by the seen, to behold of an image without being guided by forceful economies of attention, to experience the co-creation of viewer and viewed in the very act of looking. "I am fine," Thai director Apichatpong Weerasethakul noted in 2011, "when people say that they sleep through my movies. They wake up and can patch things up in their own way" (Carrion-Murayari and Gioni 2011, 14). Tsai's extended shot durations may cause similar responses (or either drive viewers out of theaters altogether or have them grab the remote control). But in the end, similar to Apichatpong (according to Thai naming customs), they ask the viewer

to hover somewhere along the border zone between sleep and awakening. They reconstruct the birth of seeing before the onset of structuring discriminations and affective manipulations, and they praise the absence of willfulness, judgment, and agential involvement as an inspiration to learn how to patch things up.

Among the directors and films associated with the Berlin School, the work of Angela Schanelec no doubt approximates the logic of bland images and spectatorship the closest. Her films are not tasteless (as some impatient critics are certainly eager to claim), but they clearly refrain from—to use a culinary metaphor—offering the viewer's palate distinct flavors and spiced diets. Her camera remains disengaged, her frames capture her protagonists' variegated states of disengagement as if no single shot should ever privilege a single sight or point of view, as if each shot, precisely by not revealing the off, is to recognize the off's role as the condition for the possibility of all images. In Schanelec's aesthetic of the bland, images neither want all too much from their viewers, nor are they designed as something to be desired by the viewer. Just as much as the stilted language of her protagonists undercut, as Marco Abel has argued, contemporary pressures "to participate in expressivist, psychologizing communication," (2013, 124) so do Schanelec's long takes and images of people gazing into the off praise blandness—nonpredatory and seemingly unfocused forms of looking—as an antidote to the agitation and sleeplessness of contemporary visual culture.

It is in Schanelec's *Orly* that we come across one of the most telling examples of bland looking west of Taipei. Two German backpackers (Lina Falkner, Jirka Zett), while waiting for their plane, click through the images on his Canon digital camera, captured during their trip to Paris. Each picture shows his girlfriend sitting on a stone staircase, yet the rather decentered framing makes her wonder—quite rightly—whether he actually tried to picture her or the staircase. When prompted by his girlfriend to photograph a nearby baby held in the arms of a woman, he flatly refuses. "Are you embarrassed?" she asks him. To which he responds: "It's obtrusive," using the German "penetrant," whose Latin original signifies a potent passing and permeation of given boundaries. He then nevertheless gets up, strolls halfway across the waiting hall, seems to take some pictures in one direction, then directs his camera into the direction he came from, and finally—as if nothing happened—saunters on in yet another direction. We cut to a close-up of him, his eye locked to the camera's viewfinders, his finger very hesitant to press the shutter button. After another cut we look at the display of his camera. It shows an image in which we at first can barely make out the baby, now held by a man. Only after he zooms in to the frame are we able to see with some clarity and distinction what presumably was meant to be the object of his photograph. Next, he flips forward to two more images taken after he captured

Figure 10.3 Angela Schanelec, *Orly* (2010)

the man with the baby. One shows the waiting lounge and a crowd in motion. The other turns out to have captured—to his own surprise, as we are held to believe—the sight of another female traveler he had come across at an earlier moment in the film but with whom he had not established eye contact. He zooms in to this image as well, isolates her from the surrounding crowd as it were, then turns his head as if trying to locate the woman somewhere in the lounge, finally returns to his girlfriend who after inspecting his camera thanks him with little enthusiasm for what he offers as his unobtrusive image of the baby (fig. 10.3).

The setting of *Orly* being Paris, it is tempting to think of this sequence as a re-enactment-in-reverse of Walter Benjamin's famous analysis of Baudelaire's poem "A une passante" (Benjamin 2006a, 321–24). For Benjamin, the poem's meeting of two strangers amid a fleeting crowd rested on the modern figure of the shock, staging Baudelaire's modernist ability to wrest something eternal away from the passing. Significantly, it offered a paradigmatic instance of how modern life restructured the subject's sensory systems; how the flux of urban existence recast the operation of human sight along the lines of photographic image-making and asked urban subjects to harness their perception against the penetrating force of visual overstimulation. At first reminiscent of Benjamin's beloved figure of the flaneur, Schanelec's photographer does everything at his disposal not to submit to the nineteenth-century flaneur's heightened sense of attentiveness. What we

see instead is a seemingly paradoxical attempt to intend nonintentional looking; to stage drift as a precondition for effortless seeing; to capture images that do not arrest or guide the onlooker's perception, but that in so doing open up the possibility for beholding what exceeds expectation, convention, and purpose. Although for some (such as his girlfriend), these images may count as simply boring and off the mark, they aspire to nothing less than to picturing the potentiality of blandness, the richness of the undefined. They refuse Benjamin's stress on shock and discriminating looking as the principal logics of modern visual practice, while they at the same time pursue acts of framing that recognize the continuity and contiguity between the visible and the off. Eager to show the world from the vantage point of disengagement, his images no doubt run the risk of putting some of their viewers to sleep. But exactly in so doing, they invite other viewers to leisurely explore their surface and walk around in them with their eyes wide open and without being shepherded by ubiquitous signposts.

What Schanelec's nameless photographer, then, understands as his images' unobtrusiveness, their refusal to violate spaces and penetrate boundaries, represents nothing less than an effort to lead mediated images astray again: to capture the world as if seen before human willfulness, intentionality, and desire come to organize the visual field. His images refrain from marking distinctions and making assertive judgments, they refuse as much as possible to structure the visible and compel a future viewer's gaze, not in order to declare the ineluctable blandness of all things, but to praise the undifferentiated as the common ground of viewer and viewed, as the condition of the possibility of producing images in the first place and of encountering images with a sense of surprise, curiosity, and wonder. Similar to how boredom, in Siegfried Kracauer's reading, prepared the modern subject to experience "a kind of bliss that is almost unearthly" (Kracauer 1995, 334), the photographer's—and, shall we say, by extension: Schanelec's—aesthetic of blandness reconstructs a state prior to the differentiation of subject and object, viewer and viewed, expression and expressed, image and reality, a state allowing us to look at things as if we just opened our eyes for the first time, as if neither memory and expectation, nor desire and anticipation made us quest for sovereign mastery over the sensible. I understand this ambition to produce nonpenetrant images—shots in which the bland opens a door to experiencing the rich potentiality of all things—as Schanelec's and many Berlin School filmmakers' critical answer to the agitated multitasking of contemporary spectators. Aloof and glacial, these images unsettle a world in which we no longer allow images to lead us astray. They rub against pervasive economies of attention in whose context we have come to use images as mere tools, and allow mediated images to use us as tools. They suspend the templates of a world that asks us to submit

everything to the logic of monetization and denounces moments of stillness as failures to live up to the demands of ceaseless self-management.

III.

In summer 2015, Tsai Ming-liang's *Stray Dogs* was installed in a gallery setting of the Guangdong Times Museum in Guangzhou, China, and thus was exposed to the often contingent and unpredictable viewer habits of museum audiences. Rather than merely present this as a strategy of expanding the film's reach, Tsai himself described the exhibition of *Stray Dogs* within a gallery as a probing of what may count as film today:

> I believe that the museum version of *Stray Dogs* is a liberation of film. Film is no longer a product subjected to the audience's taste and perceptions. It is an art work with a signature of the artist. At the same time, the artists have the right to decide the ways their works are accessed. Without a cinema, there are no fixed lengths, no popcorn, no sofa, no room temperature control, no story lines, no film categories, no performance. . . . Any single shot, no matter in 3 minutes, 10 minutes or even half hour, can be seen as a film in itself. Therefore, *Stray Dogs* in the museum space is both a collection of short films and a coherent single film at the same time. It is there to present that films can be shown with great flexibilities. Film art is complex since its spatial and temporal dimension is very different from installation art. We need to highlight film's specificity and the strength of the medium, so you may ask yourself: "What exactly is a film?"[1]

Similar to films such as Apichatpong's *Syndromes and a Century* (2006) and Tsai's own *Goodbye, Dragon Inn*, it might be said that *Stray Dogs* was already designed with a gallery or museum setting in mind (Kim 2010, 125–41). *Stray Dogs'* absence of a strong narrative arc and the intricate composition of each and every shot seems to situate the film as an object ideally catering to viewers with flexible temporal commitments; the film's glacial flow of images anticipates spectators eager to simply roam in and out of a given installation space independent of the work's entire length before attending to some other work on display. In *Goodbye, Dragon Inn*, Tsai in fact had explored the exigencies of roaming spectatorship— what Gabriele Pedullà calls watching moving images in "broad daylight" (Pedullà 2012) and Kate Mondloch the "exploratory duration in observing gallery-based media installations" (Mondloch 2010, 41)[2]—within a theatrical film itself.

Taking place in a theater in Taipei facing imminent closure, the film presented a handful of spectators at times straying through the theater's cavernous spaces, at other times attending with some intensity to a martial-arts film on screen, as if the classical protocols for stationary and silent viewing had already lost their normativity and been replaced by a new regime of mobile, temporally contingent, and inherently disruptive postcinematic viewing. Although some shots of the film present viewers in positions of seemingly absorbed looking, *Stray Dogs'* antinarrative aesthetic of extreme long takes inscribe the director's concern with postclassical forms of viewership into the center of filmic form, thus echoing the increasing hovering between black box and white cube, theatrical projection and museum exhibition, characteristic for other Asian auteurs and visual artists such as Apichatpong and Kiarostami during the last decade as well.

In a moment, I will explore resonances between Asian art cinema's efforts to expand cinema beyond classical theatrical settings and Berlin School concerns about the complexity of what may count as the times and spaces of filmic viewing today. Although it is alluring to discuss the exhibition work of Benjamin Heisenberg or probe the extent to which Schanelec's films—like Tsai's—emulate the dynamics of installation viewing at the level of filmic form, my focus will be on the final scene of Ulrich Köhler's *Bungalow* (2002) and how its allegorical treatment of mobile looking adds important aspects to the aesthetics of blandness discussed in the first half of this essay. But in order to prepare this argumentative step effectively, a brief digression is in order, meant to stress what German-Japanese artist, filmmaker, and theorist Hito Steyerl has called the politics of postindividual viewership and attention after classical cinema's demise (Steyerl 2012).

To counter frequent complaints that contemporary museum and installation spaces provide more moving images than individual visitors could possibly take in and hence actively promote roaming forms of spectatorship, Steyerl makes a case to elevate the concept of viewership to a new level, one liberated from the idea of monadic spectators trying to master each and every work in its entirety. As much as cinematic politics in our media-saturated world have become postrepresentational, that is, no longer please or educate the crowd but articulate it in space and time, so does contemporary moving image art replace the sovereign gaze of the classical spectator with incomplete, fractured, mobile, and common practices of viewing. Amid today's neoliberal economy of attention, viewing must be reconceptualized as a form of labor, a mode of value production in which objects are seen and constituted as such by a multiplicity of gazes, by various points of view that supplement each other even if no single viewer can achieve totality or closure: "Cinema inside the museum thus calls for a multiple gaze, which is no longer collective, but common, which is incomplete, but in process,

which is distracted and singular, but can be edited into various sequences and combinations. This gaze is no longer the gaze of the individual sovereign master, nor, more precisely, of the self-deluded sovereign. . . . It isn't even a product of common labor, but focuses its point of rupture on the paradigm of productivity" (Steyerl 2012, 23).

It has become commonplace to lament the move of cinema into museums as a loss of spectatorial intensity and durational commitment: an open invitation for impatient viewers to redress window shopping and channel zapping with the help of a museum's cultural cache. Steyerl's polemic not only makes us think otherwise, it also opens a door to see our seeing of cinema inside museums as an extension of what the first section of this essay called bland spectatorship. To view screen-based installation art is to let go of how classical concepts of spectatorship asked viewers to submit their gaze, time, space, body, and mind to the authoritative flow of images on screen, how the normative templates of theatrical exhibitions allowed films on screen to "have" us, whether they were meant to tease our fantasy or energize our criticality. To experience cinema in the museum, instead, is to behold moving images as part of an ambient environment; a space co-constructing viewer and viewed in time; a common ecology of attention that deemphasizes affective agitation and encourages viewers to freely wander in between architectural and screen spaces. Cinema in the museum valorizes blandness over the emotional push and pull of theatrical viewing, not in order to disengage the viewer totally, but to use states of relative disengagement as a ground to sample different viewpoints, watch other people watching, probe the process and performativity of spectatorship as part of a commons, and thereby disrupt the very logic of hyperactive and strategic self-administration that drives most of visual culture 24-7 today.

It is in the wondrous ending of Ulrich Köhler's *Bungalow* that Berlin School filmmaking has come perhaps the closest not only to think through what it might mean to move cinema out of its traditional habitat but also how to consider the blandness of roaming spectators as an opportunity rather than a loss.[3] Like the antiheroes of Tsai's films, the protagonist of Köhler's film, Paul (Lennie Burmeister), is no doubt a stray dog: a young soldier who for no apparent reason leaves his base and retreats to his parents' bungalow. The final sequence has Paul sleeping with his brother's girlfriend Lene (Tryne Dyrholm) in a nondescript hotel room, less in order to quench bursting desire than simply to mark the bland passing of time. The film's final shot—a three-minute long take, intricately choreographed, yet captured with a static camera—begins with Paul pensively looking out of the hotel window before we cut to what we initially must assume to be his point of view—a view through the hotel's window, its frame no

longer visible, situating the viewer as a detached witness to the complex charade of bodies that will unfold over the course of the next minutes. Initially, we will see Paul's brother Max (Devid Striesow) and Lene arrive in a car, then an army jeep, its two uniformed passengers eventually walking up to the hotel with Max closely following behind. Once they have left the frame, Paul will suddenly enter the image, first approach Lene, then walk over to the jeep while a huge gasoline truck enters the image and covers the sight of the jeep and Paul. The film closes with the return of Max and the soldiers, the departure of the gasoline truck, the soldiers' return to their vehicle, the departure of their jeep in the truck's opposite direction, the sight of Max and Lene as immobile witnesses to the exodus of both vehicles from the frame, and us in a complete state of wonder about Paul's exact whereabouts (fig. 10.4).

Its analytical detachment and theatrical tableaux notwithstanding, the final shot of *Bungalow* leaves more questions about the film's narrative conclusion than it is willing to answer. More important for our context here, however, are two aspects. On the one hand, the shot stages in allegorical form the bland, in all its disengagement, as a condition for the possibility to wander freely vis-à-vis, across, and into the image space. The "image" Paul initially beholds through the window frame contains very little to compel, direct, or seduce the viewer's gaze. Reminiscent of the mobile spectator of a video installation—of cinema beyond the theater—Paul enters the space of the image, explores it as a space of action, and in roaming through its ecology appears to come across a door toward the unexpected, unscripted, and wondrous. Paul literally disappears into the image like the Chinese painter in Benjamin's famous anecdote (Benjamin 2006b, 119). Rather than to absorb a quadrilateral image as in the classical theatrical setting, Paul allows the visual field to absorb him, its initial blandness—its lack of clear distinctions and enticing flavors—providing the very portal it takes to reshuffle the realm of the sensible. On the other hand, in substituting the viewer for Paul's own observational role at the beginning of the shot, Köhler's choreography draws our awareness to nothing less than the multiple, fractured, and mobile gaze of cinema beyond the theater. Not able or invited to walk with Paul, we experience our own gaze at what unfolds in front of the hotel as necessarily incomplete and fragmented, void of whatever it might take to assume sovereignty over the image. We are only one among other possible spectators, our gaze differing fundamentally from how Paul himself navigates the image space, all of these gazes supplementing each other without ever producing a totalizing account of what may happen. At once pushed away and pulled into the shot, we hover in between a stance of detached distance and one of projective engagement, of experiencing seeing as something individual and as something common. Although seemingly

Figure 10.4 Ulrich Köhler, *Bungalow* (2003)

aloof and utterly distant, then, we are struck by a profound feeling of wonder about the shot's image of spectatorial roaming ourselves, and it is in light of this sense of wonder—understood as something that happens to us without anticipation and concept, yet also without shocking or overwhelming our sensory systems—that we come to experience a gaze that is no longer the gaze of the individual sovereign master, a gaze straying away from the exigencies of strategic self-management and entrepreneurial agitation so typical for our neoliberal present.

IV.

In his analysis of different registers of the traditional Chinese aesthetic of blandness, François Jullien describes a bland sound as

> an attenuated sound that retreats from the ear and is allowed to simply die out over the longest possible time. We hear it still, but just barely; and as it diminished it makes all the more audible what soundless beyond into which it is about to extinguish itself. We are listening, then, to its extinction, to its return to the great undifferentiated Matrix. This is the sound that, in its very fading, gradually opens the way from the audible to the inaudible and causes us to experience the continuous movement from one to the other. (Jullien 2008 [1991], 79).

To experience differences in taste and value, to practice the art of sensing and making distinctions, requires our familiarity with and openness to the bland and undistinguished, that which neither compels nor overwhelms. Hovering at the border between the audible and the inaudible, the aesthetic of the bland entails a deeply ethical and, if you wish, political project as well: it provides the groundwork for what it might take to discriminate between things that matter and others that don't, a training space for differential forms of attentiveness at odds with reigning economies of attention.

Understood as a reworking of 24-7's regime of instant availability, nondifferential overstimulation, and hyperactive self-maintenance, praises of blandness are as much part of the long-take aesthetic of contemporary East Asian art cinemas as they are of the work of Berlin School directors such as Schanelec, Köhler, Arslan, and others. Their films engage both an aesthetics and a politics of attenuated sights and sounds, inviting the viewer to walk along the edge of where both the visible and the audible face their own extinction. They might not share similar

conceptual ambitions, but their work allows the viewer to experience moving images as something "just barely" visible, audible, and sensible; it situates motion pictures at the brink of returning to a state in which motion and stasis, viewer and viewed, image and body are not yet differentiated. Whether they (institutionally or formally) cater to the roaming gaze of the contemporary gallery viewer or hold on to the normative arrangements of the classical theatrical setting, their films are efforts to recalibrate the perceptual labor and spectatorial value production associated with visual culture under the sign of today's media economies. To go bland here means to (re)discover stillness, the fading of something into nothing and vice versa, as a means to rub against the impatient willfulness of contemporary viewership. As importantly, it means to displace twentieth-century concepts of criticality that valorized the active over the passive, interactivity over the consumptive. The transcendence of blandness, Jullien argues, "does not open to another world, but is lived as immanence itself" (2008 [1991], 143–44). Bland images, sounds, and texts tap into the empty, not to entertain faith and religious desires for redemption, but to redefine what it means to be in the world and navigate common parameters of the sensible and the agential. As unbearable as the length of Tsai's and Schanelec's, Apichatpong's and Köhler's shots and these shot's relation to the off at times might be: what they share in common is nothing less than the vision of a cinema able to undo the monetization and fragmentation of attention in the twenty-first century. What they share is their belief in cinema's power, in and beyond the theater, to undo the agitated wretchedness that dominates screenic viewing east and west of Berlin today.

Notes

1 http://www.e-flux.com/announcements/tsai-ming-liang/.
2 See Uroskie 2014.
3 For a more detailed reading of this sequence, see my chapter on "Long Takes" in *Berlin School Glossary: An ABC of the New Wave in German Cinema* (Bristol, UK: Intellect, 2013); and chapter 1 of my monograph *The Long Take: Art Cinema and the Wondrous* (Minneapolis: University of Minnesota Press, 2017).

Works Cited

Abel, Marco. 2013. *The Counter-Cinema of the Berlin School*. Rochester, NY: Camden House.
Armstrong, John. 2000. *Move Closer: An Intimate Philosophy of Art*. New York: Farrar, Straus and Giroux.

Benjamin, Walter. 2006a. "On Some Motifs in Baudelaire." In *Selected Writings*. Vol. 4, *1938–1940*, edited by Howard Eiland and Michael W. Jennings; translated by Edmund Jephcott. Cambridge, MA: Harvard University Press.

———. 2006b. "The Work of Art in the Age of Its Technological Reproducibility: Second Version." In *Selected Writings*. Vol. 3, *1935–1938*, edited by Howard Eiland and Michael W. Jennings; translated by Edmund Jephcott. Cambridge, MA: Harvard University Press.

Carrion-Murayari, Gary, and Massimiliano Gioni, eds. 2011. *Apichatpong Weerasethakul*. New York: New Museum.

Crary, Jonathan. 2013. *24/7: Late Capitalism and the Ends of Sleep*. London: Verso.

Hochhäusler, Christoph. 2013. "On Whose Shoulders: The Question of Aesthetic Indebtedness." In *The Berlin School: Films from the Berliner Schule*, edited by Rajendra Roy and Anke Leweke, 20–29. New York: Museum of Modern Art.

Jullien, François. 2008. *In Praise of Blandness: Proceeding from Chinese Thought and Aesthetics*. Translated by Paula M. Varsano. New York: Zone Books. *Éloge de la fadeur: À partir de la pensée et de l'esthétique de la Chine*. Paris: Philippe Picquier, 1991.

Kim, Jihoon. 2010. "Between Auditorium and Gallery: Perception in Apichatpong Weerasethakul's Films and Installations." In *Global Art Cinema: New Theories and Histories*, edited by Rosalind Galt and Karl Schoonover. Oxford: Oxford University Press.

Kracauer, Siegfried. 1995. "Boredom." In *The Mass Ornament: Weimar Essays*, translated, edited, and with an introduction by Thomas Y. Levin. Cambridge, MA: Harvard University Press.

Mondloch, Kate. 2010. *Screens: Viewing Media Installation Art*. Minneapolis: University of Minnesota Press.

Pedullà, Gabriele. 2012. *In Broad Daylight: Movies and Spectators after Cinema*. London: Verso.

Steyerl, Hito. 2012. *The Wretched of the Screen*. Berlin: Sternberg Press.

Uroskie, Andrew V. 2014. *Between the Black Box and the White Cube: Expanded Cinema and Postwar Art*. Chicago: University of Chicago Press.

11

POLITICS IN, AND OF, THE BERLIN SCHOOL

Terrorism, Refusal, and Inertia

Chris Homewood

Hunger (2008), the debut feature of British director, producer, screenwriter, and video artist Steve McQueen, depicts life in the Maze Prison, Northern Ireland, shortly before and after the infamous 1981 Provisional Irish Republican Army (IRA) hunger strike led by firebrand Bobby Sands. In addition to winning the prestigious Caméra d'Or at Cannes, the film garnered plaudits from international critics for its searching exploration of the interrelation between resistance, desperation, and the human body. *The Guardian*'s Peter Bradshaw, for example, applauded McQueen for his "avoidance of affect and a repudiation of the traditional liberal-lenient gestures of dialogue, dramatic consensus and narrative resolution" (Bradshaw 2008), while Roger Ebert commended the "merciless realism" that dominates the film's taught ninety-three-minute running time (Ebert 2009).

Talk of a bluntly realist, experimental approach to filmmaking that rejects cinematic consensus and resists the kind of cathartic narratives that consumers of mainstream cinema are coached to expect accords with the aesthetic approach favored by affiliates of the Berlin School. In this chapter, I therefore consider *Hunger* in relation to two films by Berlin School directors: Christian Petzold's *Die innere Sicherheit (The State I Am In,* 2000) and Christoph Hochhäusler's *Falscher Bekenner (I Am Guilty,* 2005). For readers already familiar with these films, my decision to link *Hunger* to *The State I Am In* will come as little surprise. In a direct thematic link to McQueen's text, Petzold's film also addresses domestic terrorism, albeit in the German cultural context of the Red Army Faction (RAF), a left-wing paramilitary organization that viewed the Federal Republic as a thinly veiled continuation of Nazi Germany that had to be resisted by violent means.

However, my decision to include *I Am Guilty* might appear a less obvious choice given that it takes as its propellant focus not terrorism but the conditions of subjectivity generated by neoliberal finance capitalism. But while the direct attendance of (now global rather than domestic) terrorism is perhaps less palpable in Hochhäusler's film, it nonetheless remains a perceptible phenomenon and plays a significant role, emerging as something that is contiguous to the neoliberal era.

Thus, although terrorism acts as an umbrella topic, what brings these three films together most clearly is their characters' noncompliance with the strictures they feel are imposed on them by hegemonic authority and whose divergent qualities occupy points along a spectrum of noncompliance that ranges from active, violent resistance at one end to more passive, Bartlebian acts of resistance or refusal—which has been identified by Marco Abel (2013, 20) and Roger F. Cook (2013b, 89)—at the other end. Thus, from violent challenges to political systems deemed oppressive by their opponents to quieter forms of nonacceptance intended to repel the values the new neoliberal economic orthodoxy appears to offer, these films share in common characters who attempt to disrupt and thereby liberate themselves (or a group) from what they perceive to be an unflinching social/political/economic status quo.

Before discussing the films, however, I would like to introduce the concept of inertia as this chapter's final organizing concern. In the broadest sociological sense, inertia refers to a tendency to do nothing or remain unchanged, to inaction. Inertia also describes countermovements "between stasis and movement, stoppage and flow, being and non-being" (Donald 2013, 11). In its most profound formulation, inertia is distinguished by "a stillness that connotes death" (1). Inertia can lead to uncertainty and thus suspension, but it can also be (perversely) dynamic. The characters' responses in the three films at hand are motivated by their (conscious or unconscious) nonacceptance of the existing state of affairs, that is, of the social, political, or economic inertia pervading their lives. Desiring to resist their own interpellation into situations and systems that threaten individual and/or collective goals or a sense of self, they respond in ways intended to disrupt the preservation of the status quo, albeit in divergent and sometimes paradoxical ways.

The views taken by Petzold's and Hochhäusler's films of the power of neoliberalism to radically restructure human relations accord well with the position taken by Ivor Southwood, who, writing from the postglobal crash perspective of 2011, describes a population caught in the enforced grip of what he terms "nonstop inertia." For Southwood, the appearance in the early 2000s, but especially since the global recession of 2008/9, of "overwhelming precariousness in work, in matters of money, and in culture generally" has triggered "a deep paralysis of thought and

action in neoliberal subjects" by setting them in a restless, yet indeterminate and seemingly unchallengeable state of anguished motion. He continues:

> This constant precariousness and restless mobility, compounded by a dependence upon relentlessly updating market-driven technology and the scrolling CGI of digital media, together suggest a sort of cultural stagflation, a population revving up without getting anywhere. The result is a kind of frenetic inactivity: we are caught in a cycle of non-stop inertia. (Southwood 2011, 11).

For Armin in *I Am Guilty*, the response to the unfreedom wrought by the neoliberal project is rooted in competing conceptions of inertia. As I explore below, his apparent languor is itself a point of antagonism against a system that demands ceaseless activity of its subjects, as is the way he pits precarity against the regime it ordinarily maintains. Moreover, although McQueen's dramatization of the microcosm of the Northern Ireland conflict inside HM Prison Maze stands apart from the neoliberal anxieties that suffuse the Berlin School films, the idea of nonstop inertia is an equally useful lens for exploring the political deadlock in *Hunger*.

Hunger: Inertial Limits of Violent Resistance

In 1976, the British government began phasing out the Special Category Status (SCS) that had been granted to Irish republicans convicted of "troubles" related offenses. Angered by this process of "criminalization," prisoners detained in the Maze prison's infamous H-Blocks initiated demonstrations aimed at restoring their political status. In 1981, a protest that had begun in the decade prior with a refusal to wear prison clothing (the "blanket protest") before developing into a refusal to wash or use toilets (the "dirty protest") finally escalated into a refusal to take food (the "hunger strike"), which would claim the lives of its instigator, Bobby Sands, and nine additional participants.

Rather than offering a macrolevel analysis of the political and ethno-nationalist clash that drove the Northern Ireland conflict or "troubles," in *Hunger* McQueen attends to the prisoners' attempts to regain their political status, focusing on the distinctive qualities of their different protests, all of which share the deployment (albeit in divergent ways) of the body and its most visceral functions as a weapon of political change. Here, I am especially interested in the way McQueen's aesthetic practice not only acknowledges but also renders legible the

social, political, and ontological states of inertia these protests appear either to create pathways to or (away) from.

In the first act of *Hunger*, the ecology of the HM Prison Maze is gripped by a seemingly unshakable state of inertia that (redolent of Southwood's conceptual model) is both stimulated and sustained by restless activity, albeit of a plainly truculent kind. The "blanket" and "dirty" protests are intended to create sociopolitical change, but owing to their inherently belligerent qualities they serve the inverse of their anticipated function, helping instead to nourish a self-reinforcing violent equilibrium that is incapable of granting either side of the conflict in the Maze a productive improvement of its goals. Purposely abject and palpably pugnacious in tone, the prisoners' remonstrations succeed only in provoking punitive physical penalties from the officers, whose vengeful actions (which fail to pay moral, ethical, or indeed legal consideration to the limits of state authority) in turn kindle nakedly violent reprisals from the former, and/or vice versa. Consumed by rigid enmity of thought and action, the prison population becomes engaged in a grueling war of attrition but, with neither side able to wear down the other to the point of collapse, the necessary corollary of their constant battling is an enduring condition of stasis. Through their acrimonious actions, the opposing sides unintentionally but inevitably create for themselves a perpetual sequence of detrimental cause and effect, a self-reinforcing, mutually injurious feedback loop that stifles rather than encourages political flow and institutes suspension inside prison society.

McQueen's aesthetic intervention not only registers but also explicates this violent marque of "frenetic inactivity" and its pernicious effects (Southwood 2011, 11). Frequent and near-total repetition of shots—such as those involving (fictional) officer Raymond Lohan (Stuart Graham) standing with his back against the wall in a state of quiet distress in the prison yard—produces heightened awareness of the unchanging (and innately deleterious) character of society in the Maze, as does McQueen's typically static camera, its persistent lack of kineticism within shots formally echoing the suspension engendered by the chronic violent activity it records. Even when the frame is devoid of diegetic activity, the camera often remains inert. Filmed in extended (if not long) takes, recurring one-point perspective shots of empty corridors also register the suspension of productive motion in the Maze. Divested of the sense of movement that should be a distinctive feature of such spaces of transit by the camera's fixed position (which creates the impression of a still image), these *passage*ways do not appear to lead anywhere. Although the cells to the left and right of the horizon line of these down-the-corridor POV shots may be entered and exited (for they exist within the prison environment's inertial stasis), the external doorway that simul-

taneously indicates yet conceals the space between itself and the frame's vanishing point remains tantalizingly unreachable, with the possibility of approach, let alone egress into something beyond, denied by the stoppage of (political, social, and aesthetic) flow that restless activity inspires.

McQueen further frames this bruising inertia by simulating it on the film's soundtrack. Although in recent years he has increasingly used fuller, more conventional orchestral scoring in his films (for example, *Shame* [2011] and *12 Years a Slave* [2013]), *Hunger* mostly echoes the Berlin School's favoring of ambient diegetic sound design over musical accompaniment;[1] even on the rare occasions when arranged music is to be heard it can only be termed such in the loosest sense. McQueen's use of film music may be parsimonious, even indecorous, in relation to mainstream cinematic convention, but it nonetheless fulfills its anticipated role, the lack of harmonic chord progression amplifying our understanding of the characters, of the environment they inhabit, and of the concepts intrinsic to the dramatization. Evocative of the director's view that sound "fills the spaces where the camera just can't go," it is the sparse score that lends inertia a physical presence in the film (Albrechtson 2011).

However, the idea of an enduring cycle of nonstop inertia is perhaps conveyed most succinctly in the image of the spiral. During a moment of calm, the audience is brought inside one of the many cells made purposefully putrid by a screed of the prisoners' feces. In most cases, this rancid decor has been applied in an indignantly haphazard fashion, but in this cell McQueen's camera fixes on a section of wall where the excremental render has been fashioned deliberately into a spiral, which despite its fetid constitution holds an almost painterly beauty (fig. 11.1).

A recurring image in Celtic symbolism, the spiral typically denotes expansion and growth as different goals are achieved, but in *Hunger* this helical pattern offers a different interpretation. Speaking in an interview about how the Irish Republican struggle manifested itself within the confines of the Maze, McQueen explains: "You know, it's like that spiral of shit on the cell wall; it is history repeating itself. The guards take it off, and the prisoners put it back up, and so on, and so on" (Bowen 2009). In this way, instead of symbolizing progression the rank spiral becomes a visual explication of the logic of inertia that governs the film's first act: as Sands puts it to Father Moran (Liam Cunningham), "Nothing's changing here; nothing's moved on."

The eventual impetus for movement and change arrives in the form of the titular hunger strike, called for by Sands once he realizes that active resistance is preventing rather than achieving the extraction of political concessions. By adopting the hunger protest, Sands embraces the traditional concept of

Figure 11.1 *Hunger*—Spiral of feces, of almost painterly beauty

martyrdom (that is, without the aim of physically attacking his enemies) and thus a passive(-aggressive) or nonviolent psychological weapon of change, which, as history attests, proved capable of acting more vigorously upon the unbending flow of sociopolitical current than the ceaseless application of physical force ever could. In the final analysis, the hunger strike was credited not only with stimulating a victory for the prisoners and their immediate cause (it forced the restoration of privileges associated with SCS) but also with "transform[ing] the political context of the Northern Ireland problem" (Bew and Gillespie 1999, 156) by "forcing a reluctant [IRA] leadership into electoral politics" (Richards 2009, 85).

Although the hunger strike was instituted in accordance with expediently pragmatic rather than principled uses of nonviolence, it was nonetheless able to generate an advantageous sociopsychological intervention in the Northern Ireland conflict because it seemed to provide public observers with evidence of integrity, of behavior closer in agreement with, and thus more palatable to, accepted standards of moral conduct. In particular, by casting the participants in what Paul Bew and Gordon Gillespie describe as "the unwonted role of being prepared to accept suffering for their cause rather than simply inflict suffering on its behalf" (1999, 156), the hunger protest was able to reach the public's conscience. It elicited hitherto absent feelings of pity and guilt for Irish republican prisoners, whose perceived plight and cause grew stronger as their bodies grew weaker.[2]

It is for these reasons that Irish author Tim Pat Coogan has termed the hunger strike a "powerfully weak" tactic of nonviolent action (2002, 410). It is also powerfully inert: the transformative power of this protest—perhaps paradoxically—rests on the participants' performance of stillness. Whereas hostility

and violence—characterized by intense and "noisy" activity—was capable only of generating turbulent social and political stoppage, the move to a nonviolent form of action—characterized by quietness and a (profound) lack of motion derived from purposeful inaction—is able to create sociopolitical influence and flow. In effect, the hunger protesters would escape inertia by embracing it in another form.

Through his voluntary performance of a prolonged refusal to eat, Sands deliberately drains his soma of the material energy that had nourished (his participation in) deceptively inactive cycles of bellicose activity in the Maze, thereby triggering a debilitating state of inanition and its necessary corollary, torpor. Sands is quickly confined to his bed in the prison's hospital wing, his once restless body rendered languid by self-starvation. But of course, far from signaling a loss of resolution and commitment to the cause, this willfully induced state of decreased physiological activity or stillness—perhaps counterintuitively—constitutes a new and powerful point of antagonism, which neither hegemonic forces nor the existing structures of inertia are easily able to absorb. Even before the strike's tragic conclusion, the decision taken by Sands and his acolytes to uncouple themselves from outwardly aggressive or violent acts of resistance and replace them with the passive actions of a nonviolent form of protest disrupts the mutually injurious social equilibrium in the Maze. Rather than leaving themselves open to persistent attack, the prisoners' discontinuation of hostility precipitates the same on the part of the officers, who all but disappear from view in the film's final act. Progression is created by a stoppage, by the abatement of violent action, which gives rise to a new set of social conditions that render the prison calm and peaceful, with little movement or activity of any kind. Static shots of empty corridors recur, but no longer punctuated by rancorous acts of reciprocal brutality, the air of stillness they convey becomes real and abiding rather than disingenuous.

In a bid to convey psychological trauma, McQueen combines a more modernist oneiric mode with realism. This yoking together of ostensibly "incommensurate" cinematic traditions—an impulse that, significantly, also finds expression in a great many Berlin School films and, as Galt and Schoonover note, helps to distinguish art cinema as a category (2010, 16–17)—permits McQueen to bring the spectator beyond what the camera can objectively record, the oneiric mode providing the basis for a privileged insight into Sands's cognitive experience of starvation. They also trigger the dreamlike incursion of a noisy and disturbed clamor or parliament of rooks, which appears to issue forth from his clenched stomach before darting around the room (fig. 11.2).

Figure 11.2 *Hunger*—Rooks in the oneiric mode, meaning ambiguous

The precise motive of the rooks is ambiguous, but their unmistakably agitated pattern of flight is accentuated by McQueen's camera, which takes an unexpectedly dynamic turn, abandoning its customarily fixed placement to swoop up and down and from side to side in imitative accord with the birds' movements. The superimposition over the already-existing images of Sands's rapidly deteriorating body of a species of bird acknowledged in rural superstition for its uncanny ability to predict death solemnly adumbrates further his looming demise.[3] Simultaneously, and more than simply alerting spectators to that which they surely already know, in oneiric configuration the rook becomes a multivalent symbol whose multiple layers of possible meaning operate concomitantly to explicate the maelstrom of confused and violent emotional turmoil to which the process of dying gives rise.

Brought into direct and emotive audio-visual involvement with Sands's distress, the audience is encouraged to feel the same kind of humanitarian (rather than expressly political) compassion that was manufactured by the actual hunger strike. In death, the participating republican prisoners sought to attack the British government with the unsettling spectacle of the inert corpse, with the material embodiment of what Stephanie Donald has described in the context of inertia and urban relations as "the most profound stillness humanity can imagine or perform" (2013, 143). Crucially for the prisoners' cause, the sympathetic pity and concern inspired by the suffering that arose from the hunger protesters' unwonted (in)action would lend their eventual deaths the possibility of meaning and transformative impact. Loosed from the impediments of violence, the strikers' self-deleterious performance of stillness would create a perception of right-mindedness, prevailing upon previously unsympathetic parties to no longer regard the prisoners not only directly (extra-)criminally but also ethically. The

body remains a vehement site of resistance, but redeployed as a vehicle of non-violent self-sacrifice it succeeds (in the context of the Maze at least) in restoring to the terrorist body the prima facie assumption that death is something to be avoided and thus also the identity, system, and order disturbing power of abjection that, as Julia Kristeva contends, a confrontation with the human corpse should provoke (1982, 4) but that fear and loathing of the terrorist as violently different "Other" (that is, as already abject threat to the symbolic order that needs to be purged) covers over.

Although McQueen does not dwell on the corpse's image, he nonetheless registers the appearance of dynamic change that the prisoners' accumulative performance of stillness attaches to it. The film's concluding shot—aptly enough, a final one-point perspective shot of a corridor—depicts binding stasis, only this time in the form of the deceased Sands, whose body is transported on a mortuary trolley to a waiting ambulance. However, in spite of the prevalence of stoppage (of human life), the shot is ultimately distinguished by flow and progression. The function of movement is returned to the corridor, albeit not by McQueen's camera, which remains largely static, but by the death to which it bears testimony. Sands's lifeless body travels the (imaginary) receding lines of the down-the-corridor shot, but the obdurately closed door—an emblem of the impossibility of momentum and progression—is now open. Paradoxically, it is the condition of absolute inertia that carries both Sands (whose metaphysical view of human finitude does not accept an end to conscious life in permanent physical annihilation)[4] and his cause forward. Instead of having the ambulance drive into the vanishing point of the now depth-enlarged frame, and thereby having Sands disappear into oblivion, McQueen cuts to the end title, which details the changes ushered in by the hunger protest.

The State I Am In: Neoliberal Inertia of Terrorists' Children and Teenage McJobbers

Political sacrifice is a problematic concern central to Christian Petzold's breakthrough feature. Several critics, myself included, have read *The State I Am In* as a film about the legacy of the Red Army Faction (RAF), a domestic left-wing terrorist organization that during the 1970s launched a string of attacks against the Federal Republic of Germany. The RAF's steadfast perception of the Federal Republic as a thinly veiled continuation of fascist Germany plunged the postwar state and its young democracy into a series of violent convulsions that lasted for almost a decade.[5]

Set around the time of its release, *The State I Am In* tells the story of Hans and Clara, a fictional terrorist couple whose past crimes precipitate a decade(s)-long drift across Europe that is prolonged by not only the pressures of illegality but also their recalcitrant rootedness in a failed creed. Whether unable or unwilling to acknowledge, let alone accept, that the historical moment has shifted, they cling to an alternative worldview that died along with the RAF's cessation of armed conflict in the early 1990s and compels restless mobility. Thus, despite possessing an end goal (the couple returns to Germany to source funds for a final escape to Brazil), their ideological indebtedness to the radical ferment of the protest decades divests them of forward momentum, resulting in dead-end encounters with former associates who have managed to move on from the past. In what becomes an especially terse meeting, Hans punches his old friend Achim due to the latter's interpolation into the capitalist system he once vehemently opposed.

Petzold accentuates the inertia that grips Hans and Clara by coding them in terms of the supernatural. In a move that also reflects the "undead" status of the cultural memory of the RAF in the decades between the notorious German Autumn of 1977 and the film's release, the director imbues his central characters with qualities associated with the figures of the ghost and the vampire, thereby highlighting their liminality and status as living anachronisms in the "new" Germany (Homewood 2006). Caught in an agitated, self-imposed state of limbo between existence and disappearance, they haunt what Marc Augé terms transient "non-places" (motorways, rest stops, hotels, and safe houses) and are frequently seen to occupy positions at borderlines (between nations, between urban and rural settings). Signaling their separation from the living, they emerge from the shadows of the terrorist "underground" only when necessity compels them to do so.

Hans and Clara's restless mobility holds negative consequences for their teenage daughter, Jeanne, who has been raised in the ontologically indeterminate ecology of the terrorist underground. A consequence of her abnormal upbringing, the social space that Jeanne occupies is limited almost exclusively to her parents. Home-schooled and denied friends her own age (who would pose a risk to the internal security of the family, to which the film's German title, *Die innere Sicherheit*, partly refers), she is cast into a form of suspension. Part of her life is not lived, part of her identity is not developed. The only other forms of contact Jeanne's paranoid parents readily permit are with their former associates, some of whom, such as Klaus, retain a degree of personal loyalty to Hans and Clara rather than to their outmoded cause. The situation Jeanne finds herself in corresponds to sociologist Pierre Bourdieu's understanding of social inertia. Born into a suffocating familial codex of complicity and denial, Jeanne has necessarily developed

a set of behaviors and habits that nourish her family unit's peculiar status quo, a microsociety of three that must remain fiercely resistant to change. Since birth, she has been inured to "accept [her parents'] world as it is, to take it for granted rather than to rebel against it, to counterpose to it different, even antagonistic, possibilities" (Bourdieu 1985, 728).

However, an "external" force that is as irresistible as it is unremarkable in its inevitability arrives to exert its influence on Jeanne, generating the impetus for her conflicted rejection of the aberrant social conditions that determine her existence. Viewers join the narrative at a point in time that represents social and developmental progress for Jeanne, who at around fifteen years old finds herself in the midst of adolescence, a protracted phase of refusal in a nascent adult's life as (s)he develops a new self-understanding, habits, and means of identity construction that necessarily create distance from the parents. Although for Jeanne the stages of identity formation are halting and never completely achieved, the tragedy of her family's story stems from the collision that occurs when an irresistible force (adolescence) meets an immovable object (Hans and Clara's unyielding sociopolitical inertia).

Unlike the average teenager, Jeanne's inevitable attempts to create distance from the authority and traditions of her parents is made particularly difficult by the long shadow of their terrorist past, which has at once precipitated and compels obedience to the stifling social conditions that hold Jeanne's identity development in abeyance. As Bourdieu also points out, the transmission of cultural heritage can lead to strong social inertia even during times of social progress, and in the case of Jeanne, her development is impeded by the overwhelming consequences of Hans and Clara's abnormal narrative, which has assumed the status of a toxic cultural bequest or a kind of threatening "postmemory," to use the term Marianne Hirsch developed to describe the relationship the "generation after" bears to the personal, collective, and cultural trauma of those who came before (Hirsch 1997). Jeanne's increasingly reluctant subjugation to the limited conditions created by an obsolescent but, in her case, enduring past gives rise to cognitive dissonance. The overpowering nature of the tightly regulated, peculiar social environment she inhabits and its primary constraint—silence—hinders the development of self- and social identity, burdening Jeanne's attempts to interact and forge interpersonal relationships with potential peers such as Achim's daughter, Paulina.

Drawn to the sound of contemporary urban music emanating from Paulina's bedroom, Jeanne discovers a space replete with consumer markers (CDs, posters, clothes, a phone) of not only Paulina's economic privilege in relation to herself but also a "freedom" to explore and develop identities. Lacking in self-esteem and

a positive sense of self, Jeanne hovers hesitantly at the open door in front of a full-length mirror, but the shot is angled so that, like the vampire, whose inability to cast its own image signals its exclusion from the land of the living, Jeanne is divested of a reflection. Instead, it is Paulina who fills the gap where Jeanne's image should appear, thereby highlighting the latter's unfreedom at the behest of her parents' overwhelming narrative. Paulina invites Jeanne into her room, and for a brief moment she transcends the threshold, stepping through the looking glass into a regular teenage life. The girls listen to the music, share a cigarette, and Jeanne is heard laughing for the first and only time, but this taste of normality is short-lived, since only moments later her mother enters the room, summoning her back to the shadows.

Ultimately, however, Jeanne's enforced "identity foreclosure"—her premature commitment to an unhealthy social role prescribed by her parents and fostered by the unbending consequences of their terrorist past—is unavoidably disturbed by the transformative adolescent compulsion to personal exploration of the self, or the stage of psychological development termed "identity moratorium" (Erikson 1994). To better understand Jeanne's identity formation process, it is useful to touch briefly upon Marco Abel's reading of *The State I Am In*, which he codes as a film about "the incursion of *neoliberal finance capitalism* and its effects on the constitution of postunification Germany" rather than an "RAF" film (Abel 2013, 89). In this regard, he notes: "it is important to point out that Jeanne's desire for normality is defined not in Oedipal fashion *against* her parents' RAF past but *in line with* the conditions of subjectivity shared by a generation born into the intensified logic of neoliberal capitalism, which directly targets their lives on the level of desire" (90).

Certainly, the power of this new economic logic to penetrate, as Lisa Rofel describes it, "into the sinews of our bodies and the machinations of our hearts" is evident in relation to Jeanne, whose provisional efforts to construct a sense of self are regulated by the consumer ideals that shape image and status within the teenage crowd identities she encounters (Rofel 2007, 15). Aspiring to the crowd identity Paulina is part of, Jeanne tries to mimic the "correct" taste in cool music and brand clothing, but she encounters an additional problem cultivated by her parents' inertia: their indebtedness to the past creates not only social but also economic impoverishment, which precludes access to the material markers of crowd acceptance that, in accordance with neoliberalism's production of adolescent subjects, Jeanne perceives as necessary to her identity development. Lacking the monetary means to emulate Paulina, whose crowd status is buoyed by her (father's) financial solvency, Jeanne therefore resorts to increasingly risky behavior, stealing the items she desires, in the process threatening her family

cell's survival when she is almost caught. Although Jeanne's growing refusal of her parents' influence does not constitute a direct reckoning with their RAF past, I would, however, argue for a greater degree of contingency between readings that posit *The State I Am In* as *either* a film about neoliberalism *or* the RAF. That Jeanne's acceptance of the economic logic vehemently opposed by the RAF leads to conflict with her parents institutes a historical irony, one that is redolent of how the children of the 68er protest generation (from the fringes of which the RAF developed) apparently embraced the constitutive power of neoliberalism precisely to fashion a targeted disavowal of their parents' political and cultural bequest to the Berlin Republic.[6] Throughout the film, Petzold appears to be preoccupied with the place held by the generation of '68 in the "new" Germany, offering a circumspect consideration of their legacy. In what could be taken as a bleak reflection of neoliberalism's ability to absorb all opposition, but is equally suggestive of accusations (heard frequently around the time of the film's release) that former radicals had sold out, it is the film's erstwhile 68ers who appear to have profited the most from neoliberal ideology.[7]

Dispossession of social wealth is an issue that also affects Heinrich, a teenage boy who Jeanne takes up with in secret after she returns to Germany. In truth, a penniless "McJobber" and orphan, Heinrich first courts Jeanne's attention by reinventing himself as closer in background to Paulina, as a (tragic) child of privilege who lives in a luxurious villa. But despite the power of neoliberalism to shape and produce adolescent subjectivities, it is Jeanne's instinctual psychological development of sexual feelings for Heinrich that ultimately brings an explosive, albeit unintended, halt to the inertia governing her family's interstitial existence. Eventually, Jeanne—torn between loyalty to her parents and the exploration of conscious choice, but increasingly urged toward the latter by the constitutive powers of adolescence, which impel change—finally breaks her silence and reveals the family's secret to Heinrich.

Of particular significance is the way Jeanne's disloyalty occurs during, and is nourished by, a performance of stillness. Having taken temporary leave from the precarious state of restless mobility her parents' political inertia inspires, she confides in Heinrich while their bodies rest together in his bed. Although the stillness encountered here is not as profound as that performed by Sands in *Hunger*, it nonetheless becomes an accelerant for seismic change in Jeanne's life, nurturing potent transformations within an otherwise rigid set of existing conditions. Afraid to lose Jeanne (who suggests she intends to leave her parents but understandably spirals back to them at the critical point), Heinrich sets in motion a ruinous confrontation between the state and the unwelcome visitors from its past, which we are led to believe results in the death of Hans and Clara. The

hesitant, provisional distance Jeanne creates from her parents is rendered tragically permanent by their deaths, which ultimately are triggered by her conflicted but inevitable urge to explore self-identity options. The possibility of dynamic change attaches itself once more to the inert corpse, but the potential of a new beginning comes at a cost.

I Am Guilty (2005): Deceleration and Precarious Recognition

The upshots of neoliberalism and its operational logic form the central concern of *I Am Guilty*. Unlike Jeanne, Armin (Constantin von Jascheroff), the young adult protagonist of Christoph Hochhäusler's film, remains unconvinced by the interpellating attitudes and adult identities the neoliberal machine seeks to impose on him, especially the notion that "work is now supposedly an empowering lifestyle choice and matter of individual responsibility" (Southwood 2011, 17–18). Less concerned per se with the ideologies of consumerism unveiled by *The State I Am In* than post-Fordist arrangements of labor (such as the casualization of work, the constant duty of self-selling and availability), *I Am Guilty* considers Armin's attempt to outmaneuver his socially anticipated subjection to the neoliberal system and the constellation of administered insecurities (or precarity) that sustain it. As discussed in my introduction, it is precisely this feeling of precarity that, for Southwood, sets the precarious subject in a seemingly endless cycle of agitated motion (nonstop inertia), draining him/her of the energy to resist.

When we join the narrative, Armin has seemingly become attentive to the fact that the social rituals governing his "enabling" search for employment are not intended to assist in the development of an authentic self, but instead represent veiled practices of interpellation designed to (re-)constitute individual subjects' identities in line with what Abel terms the neoliberal "*as if*" narrative (2013, 169), thereby preserving and propagating dominant ideology.[8] As Valerie Kaussen elaborates:

> We observe how Armin, ill at ease in his own skin, is scrutinized by button-down male employers, who, rather than inquire about his skills, want to know "who he really is." But Armin cannot quite figure it out, and he perceives dimly that this coveted "inner self" is merely a script that must be learned and adopted to gain admission into a rather unappealing professional word, an initiation that signifies the achievement of the fully formed "self." (Kaussen 2013, 177)

For Armin, the antimony between freedom and control triggers a deep paralysis of action that (whether adopted consciously or arising as an unintended stultifying symptom of the system itself) is worn like a protective mantle against being brought into acceptance of an ideologically determined role.

Much to the chagrin of his parents, whose own interpellation is in part signaled by how they take for granted latent precarity in the employment sector as a fixture of everyday life,[9] Armin refuses to perform the disciplined enthusiasm expected of neoliberal subjects toward their restless search for (scripted) identity in work. His noncompliance is characterized by a tendency to do nothing at all; as Abel notes, "Armin is depicted so that we perceive him as aimless, drifting, lost, not knowing how to change his situation" (Abel 2013, 170). Rather than dutifully seeking out opportunities, he roots himself to either his bed or the family sofa. But as Abel also observes, Armin's apparent languor is a part of a counternarrative he fashions in response to the "*as if*" narrative of undesirable recognition in neoliberal norms: "Armin counters this *as if* narrative not by directly opposing or trying to subvert it but rather, in Bartlebian fashion, simply by sidestepping it, by displaying utter indifference to it, by remaining completely disinterested in the totalizing claims it keeps issuing on him" (170). Instead of participating (for even by rejecting, one participates!) in this narrative, Armin ends up *inventing* a counternarrative, a new *as if* that neutralizes the very logic of the *as if* by refusing play according to its terms, by simply refusing to play at all (170).

Similarly, on those occasions when Armin does submit to interviews for entry-level positions, his obtuse "non"-answers to (what in truth are rhetorically inane) questions divest the process of its interpellative power. Unable to recognize himself in the conformist social processes and exchanges that urge him to accept dominant ideological structures, Armin's passage through the interchangeable corporate and consumer spaces of neoliberalism represents superficial movement. Disaffected, he regularly removes himself from private and public places that house ideology (such as the family home, offices, training rooms, and even the supermarket, which becomes the setting for an uncomfortable encounter with one of his interviewers), often relocating to transient non-places, which are distinguished by constant transition. For Armin, non-places such as the autobahn are valuable because they do not hold enough anthropological significance to be regarded as places, because they appear to lack the inveigling attributes of neoliberal society. Moreover, a non-place brings Armin into being, providing a space that liberates senses and provides the inventive substance to his own "as if" narrative. For it is on the autobahn where Armin's imagination comes alive. Here he imagines himself, in what we assume is a moment of oneiric fabulation, to be the recipient of sexual attention from a gang of leather-clad bikers, thereby creating a "sense of freedom that lies outside the coerced performances of his daily

life" (Kaussen 2013, 17). Close to the film's end—the audience still unsure whether the bikers are actually real or imaginary—Armin invites one of the gang back to his bedroom, creating a deliberately risky scenario: for a time, Hochhäusler leads us to believe that his parents are about to walk in on them.

However, more than Armin's "deviant" sexual fantasies, it is his fabrication of violent crimes that comes home to roost. The raw material for Armin's refusal of the status quo also stems from the supposed anthropological void of non-place the autobahn represents, where he stumbles across a crashed car, the driver apparently dead. Once more, the absolute inertia that describes the state of death actually gives rise to movement, taking Armin out of his supposed lethargy and setting him in defiant transit. In a gesture of rejection that is fraught with contradictions, Armin chases the authenticity he feels is lacking in the false identities he is pressured to adopt by embracing another form of falsehood—he becomes the "false confessor" of the film's German title (*Falscher Bekenner*), who exaggerates what is in truth a tragic accident into a deliberate act of violence. It is as though Armin believes that non-place and the imaginary realm of violent transgressions it facilitates constitute an extraideological space, from the vantage point of which he might develop a sovereign sense of "self" that is resistant to neoliberal subjection. Thus, instead of continuing either to do nothing at all or to just "go with the flow," to participate (however apathetically) in the social processes that exacerbate his numbing sense of alienation, Armin attempts to outmaneuver the operational logic of the neoliberal system by playing this logic against itself.

With no loss of irony, Armin disrupts the anguished responsibility imposed on neoliberal subjects to create their own opportunities through ceaseless "self-promotion [and] the re-making of identity as CV material" (Southwood 2011, 18) by altering the loath drafts of job application letters into the false confessions he sends to the authorities. Instead of being kept in suspense, he attempts to create it, instinctively using the confessions to create a counternarrative that taps into and manipulates the powerful feeling of precarity, which is understood in regard to not only the uncertainty and instability engendered by post-Fordist arrangements of labor but also the ideological construction of more nebulous fears for our safety: a sort of ontological vulnerability. As Paolo Virno elaborates, "It is a fear in which two previously separate things have become merged: on the one hand, fear of concrete dangers, for example, losing one's job. On the other hand, a much more general fear, an anguish which lacks a precise object, and this is the feeling of precarity itself" (Pavón 2004). Whether intentional or not, Armin's actions bait the nebulous fear of global terrorism that, since the events of 9/11, has become a part of this feeling, a part of the everyday language of insecurity and uncertainty in the West that, buoyed by the media, has been put to the service of maintaining the structural security of the neoliberal regime. The connection

between terrorism and the language of neoliberalism is not lost on Hochhäusler. After all, in *I Am Guilty*, viewers see local news outlets immediately deepen onto-logical anxiety by speculating that Armin's imaginary transgressions are the work of a global terror network: "The Terror Is Here!" a newspaper headline reads.[10]

Thus, as much as Armin is not guilty of the violent crimes to which he lays false claim, he is nonetheless responsible for inspiring in others the feeling of precarity that (in its more concrete forms) his counternarrative allows him to circumvent, his bid to gain recognition on his own terms reinforcing the doses of anxiety that, for Southwood (2011), detain the population in an anguished state of indeterminate motion. Consequently, the counterpower of Armin's counter-narrative is partly undermined, for although it brings him the recognition he craves, it does not do so entirely on its own terms but rather by operating (how-ever unconsciously) on a piece within the broader logic of the regime it counters. Unlike his earlier Bartleby-esque performance of inertial indifference (a sort of "I would prefer not . . . to do anything at all!"), which neutralized the *as if* logic of the regime by refusing to play according to its terms, Armin's move to a form of imagined terrorist activity (even if it nurtures his "self") is contingent on, and therefore nourishes, another of the regime's operational logics—that of latent insecurity and anxiety. Unlike his ungovernable performance of refusal, which causes a sort of short circuit in the operational engine of neoliberal control, his imagined reign of terror (because it is perceived as such) becomes defined transi-tively by, and therefore *is* reducible to, the terms of that which it seeks to counter. Understood by the public and the authorities as a response of rejection, of cog-nitive opposition rather than affective refusal, there is an extent to which Armin's false confessions grease the wheels of the neoliberal machine.[11]

Epilogue

The films I discussed share a slowness of form that—although often criticized as boring and hostile to audiences—reflects the notion of inertia they explore. Moreover, beyond this and other points of aesthetic correspondence between the work of McQueen and the Berlin School, from a thematic perspective all three films suggest that the precarious existence associated with both terrorism and neoliberalism (viewed by its most ardent critics *as* a form of terrorism) triggers restless activity, which conceals the undesirable sociopolitical inertia underpin-ning it. Nonetheless, and perhaps paradoxically, it is alternative performances of inertia, not least restfulness and repose, that hold the potential to return subjects to a newly figured political concern. One must decelerate to accelerate.

Notes

1 For more on the sound design in Berlin School films, see Cook (2013a, 27–34).

2 On April 10, 1981, Sands, although too weak to leave his bed in the prison hospital wing, was elected to Westminster as the MP for Fermanagh-south Tyrone. Although the IRA took Sands's bedridden victory as evidence of popular support for the "long war" strategy and thus a moral mandate for its use of violence, the truth, as Anthony Richards makes clear, "is that many voters had other motives. Sands's canvassers had campaigned on the basis that a vote for him was a humanitarian one, not a vote for the IRA" (Richards 2009, 85).

3 The rook is a persistent image throughout the film, but in most cases, exists independently of Sands.

4 For Sands, death is not the end. As he insists to Father Moran: "Next time around I'll be born in the countryside, guaranteed. Wildlife and stuff. Birds, ya know. Love all that. Paradise." This statement also offers a further interpretation of the oneiric clamor of rooks, which arrives to bring Sands to the afterlife, to the eternal countryside of his imagination, but is frustrated in its attempt by the pain Sands ensures—a pain that is not yet ready to relinquish its grip and keeps him agonizingly in the land of the living for the time being.

5 For a detailed discussion of the RAF, see Varon 2004.

6 I am referring here to the formation of the so-called *ego-* or fun society (*Spaßgesellschaft*) built on a largely apolitical and uncritical foundation of consumer-oriented instant gratification. In this regard, Jeanne's penchant for slogan T-shirts is evocative of the "Prada-Meinhof" clothing line, which elevated the RAF—the Achilles heel in the positive 68er self-understanding—to pop star status.

7 Besides Achim, we meet Clara's old flame, Klaus, who has built a successful publishing business by trading on his radical roots. Similar concerns are addressed in Hans Weingartner's *Die fetten Jahre sind vorbei* (*The Edukators*, 2004).

8 Abel defines the neoliberal "as if" narrative as: "the currently dominant narrative that interpellates subjects by both insinuating that the logic of recognition is inescapable and acting *as if* being or becoming visible within this framework were indeed desirable" (Abel 2013, 169).

9 The parents trivialize insecurity, taking a "that's just the way things are" attitude, and expect their son plays by the rule of the established game.

10 The specter of global terrorism also haunts the provinces, albeit from the frame's margins, in Ulrich Köhler's *Bungalow* (2002). When a German soldier goes AWOL from the army, his return home coincides with an explosion at a local school, which is also presumed by the media and local citizens to be a terrorist attack. In truth, the explosions resulted from a gas leak. Fear of terrorism in both *I Am Guilty* and *Bungalow* reflects the situation identified by Judith Butler in her book *Precarious Life*, in which she argues that: "Various terrors alerts that go out over the media authorize and heighten . . . hysteria in which fear is directed anywhere and nowhere, in which individuals are asked to be on guard but not told what to be

on guard against; so everyone is free to imagine and identify the source of terror" (Butler 2004, 39).

11 In a related vein, the sense of freedom Kaussen (2013) ascribes to Armin's homo-erotic "fantasy" life is perhaps dented by the unequal roles that distinguish his erotic encounter with gay biker subculture. Ordinarily disinclined to yield to authority, Armin suddenly becomes obedient, submitting willingly to the dominance of the men, his compliance possibly a blurry reflection of unconscious inculcation with neoliberal patterns of governance.

Works Cited

Abel, Marco. 2013. *The Counter-Cinema of the Berlin School.* Rochester, NY: Camden House.

Addley, Esther. 2008. "A Great Right Hook of a Role." *The Guardian*, October 31.

Albrechtson, Peter. 2011. "Paul Davies Special: Sound Design of Hunger—Exclusive Interview." *Designing Sound: Art and Techniques of Sound Design.* September 28. http://designingsound.org.

Augé, Marc. 2008. *Non-Places: An Introduction to Supermodernity.* London: Verso.

Bew, Paul, and Gordon Gillespie. 1999. *Northern Ireland: A Chronology of the Troubles, 1968–1993.* Dublin: Gill and Macmillan.

Bourdieu, Pierre. 1985. "The Social Space and the Genesis of Groups." *Theory and Society* 14 (6).

Bowen, Peter. 2009. "The Taste of Others." *Filmmaker Magazine* (Winter).

Bradshaw, Peter. 2008. "Hunger." *The Guardian*, October 31.

Butler, Judith. 2004. *Precarious Life: The Powers of Mourning and Violence.* London: Verso.

Coogan, Tim Pat. 2002. *The IRA.* New York: Macmillan.

Cook, Roger F. 2013a. "Ambient Sound." In *Berlin School Glossary: An ABC of the New Wave in German Cinema*, edited by Roger. F. Cook, Lutz Koepnick, Kristin Kopp, and Brad Prager, 27–34. Bristol, UK: Intellect.

Cook, Roger F. 2013b. "Disengagement." In *Berlin School Glossary: An ABC of the New Wave in German Cinema*, edited by Roger. F. Cook, Lutz Koepnick, Kristin Kopp, and Brad Prager, 87–91. Bristol, UK: Intellect.

Donald, Stephanie Hemelryk. 2013. "Inertia and Ethical Urban Relations: The Living, the Dying and the Dead." In *Inert Cities: Globalization, Mobility, and Suspension in Visual Culture*, edited by Stephanie Hemelryk Donald and Christoph Lindner. London: I. B. Tauris.

Ebert, Roger. 2009. "Hunger." *Roger Ebert.com.* April 15. http://www.rogerebert.com.

Erikson, Erik. 1994. *Identity, Youth, and Crisis.* New York: W. W. Norton.

Galt, Rosalind, and Karl Schoonover, eds. 2010. "Introduction: The Impurity of Art Cinema." In *Global Art Cinema: New Theories and Histories*, 3–27. Oxford: Oxford University Press.

Hirsch, Marianne. 1997. *Family Frames: Photography, Narrative, and Postmemory*. Cambridge, MA: Harvard University Press.

Homewood, Chris. 2006. "The Return of 'Undead' History: The West German Terrorist as Vampire and the Problem of 'Normalizing' the Past in Margarethe von Trotta's *Die bleierne Zeit* (1981) and Christian Petzold's *Die innere Sicherheit* (2001)." In *German Culture, Politics, and Literature into the Twenty-First Century: Beyond Normalization*, edited by Stuart Taberner and Paul Cooke. Rochester, NY: Camden House.

Kaussen, Valerie. 2013. "Interpellation." In *Berlin School Glossary: An ABC of the New Wave in German Cinema*, edited by Roger. F. Cook, Lutz Koepnick, Kristin Kopp, and Brad Prager, 173–80. Bristol, UK: Intellect.

Kristeva, Julia. 1982. *Powers of Horror: An Essay on Abjection*. New York: Columbia University Press.

Pavón, Héctor. 2004. "Creating a New Public Sphere without the State—Interview with Paolo Virno by Héctor Pavón." Generation Online, translated by Nate Holdren. December 24. http://generation-online.org.

Richards, Anthony. 2009. "Terrorist Groups and Their Political Fronts." In *Combating Terrorism in Northern Ireland*, edited by James Dingley. Oxon: Routledge.

Rofel, Lisa. 2007. *Desiring China: Experiments in Neoliberalism, Sexuality, and Public Culture*. Durham, NC: Duke University Press.

Southwood, Ivor. 2011. *Non-Stop Inertia*. Winchester, UK: Zero Books.

Varon, Jeremy. 2004. *Bringing the War Home: The Weather Underground, the Red Army Faction, and Revolutionary Violence in the Sixties and Seventies*. Berkeley: University of California Press.

12

RUNNING IMAGES IN
BENJAMIN HEISENBERG'S FILMS

A French Connection

Brad Prager

Precisely because Rettenberger's actions . . . do not seem to have a
purpose in the conventional sense does [*The Robber*] afford us the
opportunity to gain the sensation that this is his *being* itself that
somehow embodies the *force* of resistance as such—not a resistance
against something in particular but simply resistance. The very
intransitivity of Rettenberger's absolute refusal is in this respect more
akin to the one enacted by Bartleby's formula "I would prefer not to,"
rather than exemplary of a more specifically dialectical rejection *of*
something, which traditionally exhausts the radical imagination's ability
to conceptualize politics.

> Marco Abel (2013), on the protagonist of
> Benjamin Heisenberg's *The Robber*

I'd rather be like I am—always on the run and breaking into shops
for a packet of fags and a jar of jam—than have the whip-hand over
somebody else and be dead from the toe nails up. Maybe as soon as you
get the whip-hand over somebody you do go dead. By God, to say that
last sentence has needed a few hundred miles of long distance running.

> Alan Sillitoe, *The Loneliness of the Long-Distance Runner*

Newly released from prison, the main character of Benjamin Heisenberg's *The Robber* (2010), Johann Rettenberger, is both a habitual bank robber and an indefatigable athlete. He refuses to mend his ways and become a productive member of society. He robs banks and even murders his parole officer, but at no point is the basis for his denunciation of conventional morality put forward. Why does Heisenberg tell the story of this determined criminal, and what is he meant to be rejecting? As Marco Abel (2013) articulates it: we are led to wonder whether his deeds and his position vis-à-vis the law constitute a rejection *of* something, or whether he is merely going against society's grain because it is in his nature to resist. How are his relentless athleticism and his steadfast opposition intertwined, and what is it about his proclivity for running that contributes to how we understand him as a symbol of refusal?

The image of the runner has a long history in other new waves, and, in looking for a source, one could surely turn to the earliest moment of new wave film—the inception, perhaps, of all cinematic new waves: François Truffaut's *The 400 Blows* (1959). Whether one speaks of the French New Wave and its iconoclastic sprit, the British New Wave and its desire to articulate the concerns of the working classes, or of the socially critical films of the New German Cinema, such films and filmmakers have always been concerned with figures of resistance. That the French New Wave has influenced the Berlin School is well documented.[1] I would like, however, to see this influence in different terms: the Berlin School's filmmakers, like their French predecessors, maintain that to be alive is more than merely a matter of movement. Movement is constant, yet our automated means of transportation, specifically our cars and trains, are further instantiations of overadministration and our general lack of freedom. In the world of the Berlin School, the highways, the rules of the road, and the misapprehension that we are accomplishing something by moving from place to place are all parts of an assemblage of prior decisions into which passengers and drivers find themselves flung. One hardly ever moves of one's own volition, and there is perhaps no more misleading idiom than to say that one is in "the driver's seat."[2] Owing to the roads and their regulations, we have, in that position, very little control. Automobility is mobility without autonomy, and, for this reason, running appears to be an alternative. The cinematic romanticization of flight on foot has long been depicted as a response to the restraints of hyperautomated societies, particularly by new wave auteurs. The Berlin School is no exception.

The Original Runner: Antoine Doinel

Truffaut's *The 400 Blows*, which earned its director the Best Director Award at the 1959 Cannes Film Festival and which was certainly among the most defining films of the French New Wave, contributed to inaugurating a countermovement. Its protagonist, a restless adolescent named Antoine Doinel, became the New Wave's symbol. He was identified with the French filmmakers of that group, and particularly with the editors of *Cahiers du Cinéma*. They felt represented by his attitude of estrangement, his homelessness, and his unwillingness to be drawn into the postwar and progress-oriented machinery of Parisian culture. Antoine was a member of the first generation to come of age after the war, a group that would lead the movement for political change in 1968. His experience of adolescence is, in Truffaut's film, depicted in terms of his helplessness—his feeling that he is being tossed around by his parents and by a deadening French educational system. Antoine is neither a victim of war nor of violent conflict, but all of this makes his anomie that much more vexing. His teachers plague him with their anachronistic pedagogy, his somewhat sympathetic father leans on him to do more, afraid that his son will not be socially mobile ("you have to push," his father tells him, "or else you'll never get into the race [*faire le cours*]"), and he accidentally discovers that his mother is having an affair. Because of his disidentification with the ideas impressed upon him by his parents and his schools, he abandons his educational and personal progress and refuses to fall in line. Even his attempt at crime is abortive, insofar as he second guesses himself and is apprehended in the process of returning a stolen typewriter.

One of the film's most striking scenes takes place at a fairground on a day when Antoine and his friend René play hooky. They move through the streets of Paris in a sequence of long and medium shots that embed them in the rituals of city life. Like a pair of pinballs, they hit a succession of points, moving from one urban spectacle to the next. Eventually they find their way to the fairground where Antoine enters a machine known as "the rotor," a postwar attraction invented by the German engineer Ernst Hoffmeister. The contrivance was brand new at the time, exhilarating for how it spun its riders in circles, forcing them into contorted positions and, as with all carnival rides, depositing them back at their point of origin. Pressed up against the ride's walls, Antoine is thrown about like a piece of laundry in the drum of a washing machine.

The rotor's centrifugal force produces a state of weightlessness. Robert Hughes's now-canonical transcription of the film puts the sequence into words: "Antoine whizzes by, his arms outstretched and flattened against the wall. . . . Several people have been lifted off the bottom of the drum and hang against the side,

their feet off the floor. The spinning drum roars; some people scream with plea-
sure or fear" (Denby 1969, 40). As though Antoine were in the belly of a beast, he
perceives its "roar." Is this machine victimizing its patrons? On the one hand, the
rotor allegorizes the immense socializing apparatus imposed on Antoine. Jostled
about by the mechanisms of French culture, he appears to revel in this subjection,
taking pleasure in his sudden buoyancy and the accompanying lack of control.
On the other hand, this massive instrument can be said to resemble cinema it-
self. In appearance, it looks like a zoetrope, the mechanism generally referred to
as the very first cinematic device, and Truffaut is literalizing his film's narrative
machinery.[3] The forward movement of the plot pushes its protagonist along, and
we wonder whether Antoine will, at any point, take hold of his fate. The world
governed by his parents and his school is, like the film's narrative, an organiza-
tion to which he has been subjected. His progress into adulthood paradoxically
consists of realizing that he does not have control.

Antoine ultimately reaches this realization. The film presents the apparent
pleasure he takes in his subjection, and it then undercuts that pleasure. He is
compelled to come to terms with how disagreeable and oppressive his powerless-
ness is at the moment he is driven off to reform school, subsequent to his arrest
and to his parents' determination that his bad behavior has gone beyond their
capacity to contain it. On that day, he is taken away, and we see the view from the
rear of a truck—his perspective as he is carted backward. First, there is a long shot
from Antoine's point of view. The paddy wagon moves away from the camera,
which then gets tantalizingly close, and then, once again, far away. For a theft
he only half-heartedly committed, Antoine is bound and banished, and at that
moment he becomes aware of his helplessness: he sees the world through bars.
The shot from the receding vehicle tells a story of confinement. His adolescence,
at this point in the film, stands in for his wholesale lack of sovereignty. One can
only imagine the freedom that comes from running away, something Antoine
finally accomplishes at the film's celebrated conclusion, when he breaks free from
the reformatory.

The scene of Antoine's flight—his race away from the institution with no
destination apart from propelling himself *elsewhere*—has come to represent the
spirit of the French New Wave. During a soccer game, he sees an opportunity
to run and takes it. He is no longer drifting through city streets as he had with
René, but he instead finds himself in the less well-defined spaces of the country-
side. He departs on his own two legs, running past fences, fields, and farmhouses.
The camera follows him with an extended, seventy-nine-second tracking shot as
he pushes against the edges of the film's frame, rushing from the reform school to
the sea. We hear only the sound of footfalls and some birds chirping. As he runs,

Figure 12.1 A tracking shot: Antoine runs away in François Truffaut's *The 400 Blows* (1959)

Antoine appears to have just one thing in mind: to get away. There is no endgame apart from seeing the ocean, which he had once told René he would like to do. The camera is transported with him as he runs, and his seizure of agency is highlighted by Truffaut's long take: the protagonist is bringing us with him (fig. 12.1).

Antoine moves from the bounded land to the unbounded sea, in this case Villers-sur-Mer, 130 miles away from Paris. The music on the soundtrack slows, and he arrives at the water. He turns toward the camera and approaches it. The frame freezes on a medium close-up, and, as the literary critic Norman Holland writes, "in this last of a long series of regressions from city to country to primeval amniotic sea, the picture turns into a still as though the camera itself had given up motion" (1960, 273). Antoine brings the narrative to a halt and the flow of images yields. If the cinema is a spinning rotor, an enormous zoetrope, then he can now be said to have exited the ride. Dudley Andrew sees this static image in emancipatory terms, writing that Antoine "turns to stare down Truffaut and the spectator in a final freeze frame. The film fades out on the close-up of a kid who got his education on the streets, confronting the world and confronting us. He will not be entirely manipulated by [Truffaut] nor fully known by us" (Andrew 2010, xx). By this logic, the narrative is Antoine's, even if only for a moment, even if the future promises only more confinement.

Critics recognized the sequence's significance. Richard Neupert argues that the freeze frame at the end of this flight "is now as famous as the Odessa steps in *Battleship Potemkin* or the snow globe from *Citizen Kane*, and Antoine's ambivalent look to the camera now symbolizes a whole new sort of film practice" (Neupert 2007, 177).[4] Evidence of the film's impact—not that it *symbolized* a practice, but rather that it *became* a practice—was that it gave birth to another new wave: it is too infrequently pointed out that Tony Richardson's *The Loneliness of the Long Distance Runner* (1962), a film about a gifted working-class athlete that is said to have inaugurated the British New Wave, closely followed

the lines of Truffaut's *The 400 Blows*.[5] *The Loneliness of the Long Distance Runner* is no remake of Truffaut's film, but their plots unfold similarly, and it is clear why Richardson was drawn to make a film based on Sillitoe's short story: Colin Smith, the protagonist, only a few years older than Truffaut's Antoine, steals, among other things, a typewriter, and is eventually consigned to a reform school. The images of Smith running through the woods and along the shores call to mind utopian moments of freedom beyond the confines of the city, with its unfairly distributed wealth, and beyond the reformatory, a place where others wield what Sillitoe several times refers to as "the whip hand."

From the film's very beginning Smith is a runner, but when running no longer means freedom to him, he makes a decision along the lines of Melville's Bartleby. He opts out of competition and elects not to be of use. He gives up running even after having taken the lead in the film's final race, refusing to be treated as his warder's personal racehorse. The film thus turns on its athletic protagonist's decision not to run. Smith makes his choice and smiles, betraying his patron. At the start of the race he had taken the lead, but he begins to think about the system that has been unjust to him, and, right before reaching the finish line, he stops. Richardson at this point relies on montage rather than a long take, intercutting Smith's recollections of his past with images of the reformatory governor's disappointment. He weighs his options and decides in favor of resistance.

Acutely aware of its origins, *The Loneliness of the Long Distance Runner* also picked up on Truffaut's famous freeze frame, concluding with a still. At the reform school, the young men have been set to work manufacturing armaments. Smith, as punishment for his failure to cooperate, is forced to join them. The last shot is a still of an inmate working on a gas mask, the gaze of which is pointed directly out of the screen, its vacuous eyeholes challenging the viewer in a harsh indictment. Richardson here renders unambiguous the utilitarian ends to which Smith was ultimately put, as well as the passing, momentary nature of his victory. We hear on the soundtrack a chorus of Hubert Parry's "Jerusalem," England's Christian anthem based on lines by William Blake, which is used throughout this film to rebuke English patriotism.[6] The constellation produced by the scene of forced labor, the gas mask, the governor with his whip hand, and this English refrain could not be clearer: Smith, an ordinary but rebellious young man, wants no part of the hypocritical culture exploiting him.

Smith's refusal, his decision to go against the governor and against the values that have been presented to him, surely constitutes a rejection *of* something. Richardson does not suggest that Smith's natural inclination is to resist. He has, on the contrary, an untapped creative potential, one that his warders are more than likely to waste. His response is rather the result of a clash of values and of

the bleakness that accompanies the persistence of class differentiation. Although the film draws on *The 400 Blows*, these protagonists' politics are distinct: Antoine had been simply disaffected, prey to a general feeling of malaise. *The Loneliness of the Long Distance Runner* is a more specific articulation of class conflict. What the two films share in common, however, is an atavistic romanticization of running, of flight on foot, and their new wave protagonists' resistance to worlds in which they have been shuffled around like pieces on a board.

Heisenberg's Principles

Underscoring the notoriously languid pace of Berlin School films, Lutz Koepnick writes that they "are typified by their discreet camera work and their resistance against rapid cutting and reframing, against special effects and digital image manipulation" (2014, 155). He adds that Berlin School films "extol their own slowness and smallness, their lack of spectacle and affect, their patience in registering the mere passing of unstructured time" (155). It is not that these films' directors eschew editing and other techniques, nor do they renounce montage, but rather that they "seek to preserve the integrity of each cinematic frame and savor the continuity of represented action" (156). As exemplars of a countermovement that often seems to run counter *to* movement, as well as against the dual directives of acceleration and progress, Berlin School films aspire to engage their viewers in contemplation and to avoid leading them, as though automatically, down predetermined narrative paths.

Where fast movements are depicted in Berlin School films—where protagonists ride on rapid transit systems or in cars—one finds neither freedom nor self-determination. More often than not, the films and their directors choose to depict mobility as a scarcely conscious process in which passengers drift from one destination to the next, and motor vehicles appear to drive their drivers. If Truffaut's *The 400 Blows* juxtaposed motion machines such as the rotor and the paddy wagon with the freedom of travel on foot in order to depict how Antoine takes hold of his independence, we might also note the regularity with which vehicles in Berlin School films impel their drivers forward. The automobile, which so often in cinema is equated with individualism, autonomy, and the freedom of the open road, means something entirely different in these German productions. Analyzing work by Christian Petzold, Christoph Hochhäusler, and Ulrich Köhler, Koepnick writes that in Berlin School films, cars "appear to drive their drivers." He continues, "While cars move in circles or transgress nameless and seemingly identical landscapes, drivers steer effortlessly, with blank stares and little attention to what lies ahead of their windshields" (2013a,

76).[7] By the time we start our ignitions, they suggest, it is already too late: owing to the power of the machinery and the rules of the road, most of our conscious decision-making processes have long been abrogated.[8] In Berlin School films motor vehicles are not agents of liberation but rather essential parts of an overadministered world in which our ability to make individual decisions has been all but entirely eroded.

Heisenberg seems deeply aware of this. Although there are no cars at the beginning of *Schläfer* (*Sleeper*, 2005), its very first minutes thematize the erosion of his protagonist's autonomy. The camera, its gaze obscured by a tree, pans slowly from left to right, adopting the perspective of no one in particular. It seems to survey its subject without any individual focalization. We first see Johannes walking a tree-lined path, the camera eventually and indifferently alighting upon him as he approaches from the side. Abel describes this opening shot as "a rigorously framed mise-en-scène of a public park that troubles our immediate ability to apprehend what is going on because it does not provide us with a clear focus for our perceptions" (Abel 2013, 203). When our eyes finally locate Johannes, it feels as though it were accidental, as if he had merely wandered onto the scope of our radar screen. The accompanying sounds of footfalls are not clearly connected to anyone we see. It gradually emerges that Johannes is in the company of Frau Wasser, an agent working in service of the state, and that she is encouraging him to spy on his colleague Farid. She attempts to persuade him: "You decide what you tell us, and how we see [Farid]. It's entirely up to you." Her cynical contention is disingenuous. From the outset Johannes is not in the driver's seat, but rather caught in a web, controlling only the smallest corner of his world. He is the object of Heisenberg's narrative, not a freely acting agent.

The issue of the protagonist's control and autonomy is raised in sequences in the film that dwell on the multiplayer first-person shooter video games in which Johannes and his colleagues partake at Local Area Network (LAN) parties. Before meeting Farid, Johannes played computer games on his own in his elderly grandmother's home. In his modest room an automobile game appears on his computer screen. By contrast, Farid, who is self-assured, knows how to be social. Heisenberg depicts him at one of these LAN parties, participating in a multiplayer game. We see Farid in close-up staring into the screen, and then Johannes, his head initially cut off by the camera angle, lurking over Farid's shoulder. Johannes, who is seen in fragments, longs for the same illusion of control and sense of self-possession available to his colleague. These are moments of enhanced mobility, and, as Abel points out, the images we see on these monitors are among the only scenes in the film that employ the "editing clichés of action cinema," albeit in a highly mediated form (Abel 2013, 209).

The film does not suggest that game play is actual mobility. It is, after all, only a game, and as with an amusement park ride, these participants go nowhere, but Farid takes pleasure in it and is capable of sharing it with others. When, later in the film, Johannes gets an advantage over Farid by denouncing him to Frau Wasser, the situation changes. Heisenberg alternates close-ups of the two of them at a subsequent LAN party, and as it is described in the screenplay: "They play with focus. Johannes's facial expression and body language have changed. . . . The childlike tenterhooks he was once on have now vanished."[9] He has a semblance of control, owning to the illusion of freedom with which the game provides him.

The style of these particular sequences was presaged by Heisenberg's short film *Der Bombenkönig* (*Bomber King*, 2001), a fifteen-and-a-half-minute piece he conceived, shot, and directed while at the Hochschule für Fernsehen und Film in Munich. In that short nonfictional work, four boys, in turn, give commands to someone else who is off screen with a game controller, telling him or her what moves should be made in a video game. We never see the game that they see, only their faces. As though this had been a test shoot for the sequences at the LAN parties in *Sleeper*, we see close-ups from the perspective of the monitor. The viewers are thus placed in the position of the computer. The game players exhibit no self-consciousness that they are being watched. Indeed, they may not even have known that they were being filmed. Their speech barely resembles human communication; they appear to be blindly blurting out imperatives, instructing whomever holds the controls. The exchanges are akin to a system of relays and reflexes. During the silences, when the game is perhaps on pause, one can project onto the boys' reactions an awareness that that they are in the presence of a camera, or that there is a person behind it, but as they play the game, all signs of interpersonal interaction disappear.

In *Sleeper*, the illusory impression that one has control never lasts long. Johannes is forced to acknowledge that things are falling apart for him. He becomes especially aware that he is on the losing end of a romantic competition at the end of an evening out with Farid and Beate, the woman who has entered both of their lives. All three share a taxi home and Johannes is helpless to prevent his two companions from exiting together, a pretext to continue flirting in his absence. Johannes is driven away by the vehicle, headed for his lonely room in the far suburb of Obermenzing, and we watch from his perspective as he gazes backward, carted away, and forced to helplessly observe Farid and Beate getting closer to each other. He becomes aware of his isolation, and the receding image from the rear of the vehicle, similar to the shot of Antoine being carted off to a reformatory in *The 400 Blows*, is, in this case as well, a turning point[10] (fig. 12.2).

Figure 12.2 *Top*: Antoine is carted away to the reformatory in *The 400 Blows*. *Bottom*: Johannes watches helplessly from a taxi as Farid and Beate get closer to one another in Benjamin Heisenberg's *Sleeper* (2005).

The symbolic centerpieces of Heisenberg's film, however, are the sequences in which these same three protagonists go go-karting. The go-kart tracks—not the machines themselves, but rather the Möbius band-like indoor paths they travel—are akin to the rotor in Truffaut's film. The raceway on which they ride is stationary, the go-karts circle around and around, and the chief freedom a patron has is the freedom to antagonize a competitor. On the occasion of their first visit to the track, Johannes is still struggling to get Beate's attention. Heisenberg's close-ups depict this otherwise fun activity as stress inducing. The bit of control Johannes has in his go-kart is undermined by his knowledge that he cannot compete with Farid. He goes around and around, but finds himself boxed in by his companions. There is no gratification for him, no literal or metaphoric sensation of weightlessness. Only later, when they go for a second round of go-karting, after Johannes has begun to destabilize Farid in underhanded ways, does he derive a sense of power from this activity. In the first instance, the diegetic sounds convey an impression of anxiety; we hear only the erratic noise of the engines on the raceway. But revisiting the course, immediately following Johannes's long-sought tryst with Beate, the music on the soundtrack—Lorenz Dangel's ghostly string composition—hermetically closes out any unsettling diegetic sounds, any unpredictable or disquieting noises. At times Johannes seems to be ahead in this race, and Farid is, by contrast, anxious and distracted. Johannes has managed to retake a measure of control (fig. 12.3).

Figure 12.3 *Top*: Antoine pressed against the side of the rotor's drum in *The 400 Blows*. *Bottom*: Johannes's reactions to go-karting in *Sleeper*.

During that second sequence, Heisenberg's protagonist appears more relaxed, his act of betrayal having given him the false impression that he is in charge of matters. The go-kart serves as a perfect allegory for this delusion. When go-karting, one's expectations are remarkably low: one expects neither true freedom nor the open road, only a sudden feeling of propulsion that very quickly comes to an end. In Johannes's case, betraying Farid means doing someone else's dirty work for them, and he finds his own intentions, which were not initially malicious, submerged beneath the weight of Frau Wasser's plans. Heisenberg shows how things spiral out of control, but Johannes never had a chance at control to begin with. It therefore makes sense that he ends up remorseful and alone, apparently responsible for Farid's arrest and quietly praying to a God who does not answer him. Perhaps Johannes turns to God at this moment because, never having been in the driver's seat, he longs for an Olympian overview. No road map is forthcoming; the matter was never in his hands.

A Robber or a Runner?

Heisenberg's subsequent film *The Robber* is based on Martin Prinz's eponymous 2002 novel about the convicted bank robber and marathon runner Johann Kastenberger. Heisenberg, who worked with Prinz on the screenplay, was drawn to

the writer's portrait of a criminal athlete who seemed indifferent to morality. Inspired by the novel's spare and lean prose style, Heisenberg says, "morals . . . don't play any kind of role. The main thing is not so much psychology as the way an individual deals with human society through this strange natural form: robber, runner, driven man, lover" (Schiefer 2008, n.p.). In its focus on heists, escapes, and police pursuits, Heisenberg's adaptation has the hallmarks of an action film, and Michael Sicinski describes it as an "unsentimental inquiry into labor and movement," adding, "it's about the alternation between different forms of bodily activity and the figure they cut in space, the strange orbit generated by a man who functions less like a human being than a phenomenological event" (Sicinski n.d., n.p.). As a new wave work of art—a slow and deliberate film that relies on its gradualness as a strategy of resistance—what does Heisenberg's attention to "bodily activity" mean; specifically, how does he negotiate the overlap between his protagonist's marathon-level athleticism and his criminality?

Because the film begins in a correctional institution, it recalls US films from the 1970s such as Robert Aldrich's *The Longest Yard* (1974) and Michael Mann's *The Jericho Mile* (1979), both of which echo *The Loneliness of the Long Distance Runner* in the contrasts they draw between the freedom of athletic prisoners and the vainglorious agendas of their warders. Although Heisenberg's film looks like those others at its onset, it spends much more time outside the prison, and thus overlaps more profoundly with a film such as Ulu Grosbard's *Straight Time* (1978), which dealt with an ex-con's attempt keep on the right side of the law following his release. Rettenberger, whom we first encounter as he is repetitively circling the prison's track, never quite leaves his institutional frame of mind behind. As someone who is disinclined or even unwilling to reintegrate, his social and physical mobility might be described as dysfunctional.[11] Following his reentry into society, he seems benumbed, as though he were still counting the days until his release, and when we see him navigating the Viennese transportation system, he is passive and seemingly vacant. One would hardly guess that he is on the way to commit the first of the film's numerous robberies. Contrary to appearances, this crime is premeditated—he brings along his gun and his mask—yet no exposition heralds it. He does not seem desperate for money, and the film does not signal why he falls back into his old pattern.

Heisenberg avoids additional exposition because he claimed to be indifferent to his protagonist's inner dialogue. He often repeats in interviews that he meant much more for his film to resemble a documentary about an animal, the type of film no one would misidentify as "psychological." According to him, *The Robber* "is in some parts an action film with classic action movie sequences," but it is distinguished from an action film because "the movement is more observational.

And that is precisely what interests me: the close observation of activities and behaviors." He adds, "As in a good animal film, viewers build a bond with a being (*Wesen*), but do not have everything spoon-fed to them" (Seidel 2010, n.p.). He would prefer for viewers to see Rettenberger's behaviors as spontaneous, akin to those of an animal. The decisions appear unreflected, and Rettenberger makes choices the way Berlin School protagonists drive their cars: as automata, acting prior to any conscious consideration. Heisenberg wants to paint a portrait of a character who acts instinctively, and the lack of reflection is represented in how little he has invested either in his next move or in the fact that he seems to have no plans for the cash he accumulates.

In the film's initial action sequence, when Rettenberger is first seen robbing a bank, a dog interrupts, entering through an automated door. It appears as an intruder in the course of the robbery. Rettenberger acknowledges its entry, glancing over and reflexively aiming his gun at it, momentarily failing to distinguish it from a human intruder. We can recognize Rettenberger's mistake, and that it takes an instant for him to wrap his mind around what he sees, but we know nothing of the thought process that follows. One can speculate that, as a character in a film, he is meant to be seeing his likeness in this dog, that is, that the dog is a mirror and that there is a moment of self-recognition, but one can also speculate that he instead sees difference. He may be making a choice to distinguish himself from the dog in the moment he decides to continue with the robbery. He chooses to go on, to continue breaking the law, and this refusal to obey is in this sense a decision to dissent, hardly reflexive or instinctive. The presence of the dog is a simile, rather than an equivalence. It may be the case that Rettenberger runs "like an animal," but his repudiation of society and its codes are quite human. Although we are offered no backstory to explain why he opts neither to be a productive member of society nor to build fulfilling relationships, Heisenberg provides us with enough evidence to conclude that he is, in fact, making a decision (fig. 12.4).

When Rettenberger sees a newspaper story about his extraordinary accomplishments as a runner, the headline refers to him as the "Great Unknown" (*Unbekannter*). But he receives notoriety for his robberies as well, and that headline also describes "the man with the mask" as "an unknown man." His two identities converge in their inscrutability: he is a mysterious runner and a mysterious bank robber. The true story about Johann Kastenberger was that he robbed banks wearing a Ronald Reagan mask and acquired the nickname "Pumpgun-Ronnie." Heisenberg introduces the theme of the mask but chose to dispense with the contextual-historical reference, leaving Reagan behind. He explains in an interview: "We thought of using Bush. The Pope. . . . We had all sorts of funny ideas about it; but, then we noticed that politicizing the mask took us away from the heart

Figure 12.4 The Robber Johann Rettenberger encounters a dog while committing a robbery in Benjamin Heisenberg's *The Robber* (2010).

of this character. He became someone who was making a comment on society. That would mean having to create another sort of film" (Guillen 2010, n.p.). The fictional character's mask, unlike that of his real-life counterpart, is not identifiable as Reagan. Apart from representing a white male's physiognomy, the mask does not depict much of anything: a nondescript white man is robbing banks masked as a nondescript white man. It recalls the masks worn by the employees at a white-collar office in Hochhäusler's *I Am Guilty* (2005) as they conduct role-playing games, and, presumably, as they learn to suppress their individual identities. Like drivers' seats, desk chairs are designed for almost anyone to sit in. The masks worn in that workplace are only meaningful insofar as they represent highly idealized identical subjects in an excessively automated culture.

Any description of the film's showcase sequence, the extended heist at its midpoint, would have to note that the director avoided the temptation to include the type of long take championed by André Bazin. Heisenberg's approach was not formalist, and he is not afraid to edit, drawing, more or less, on average shot lengths familiar from action films.[12] We see a number of over-the-shoulder shots from Rettenberger's standpoint, integrated with medium shots of the robbery in process. Given the pace of the action, what seems like a long take, just after he enters the second of the two banks he is robbing in his one impressive spree, is really only forty-eight seconds long. We hear the audio of the robbery and are left picturing the scene inside. The anticipation of the chase that is to follow may be more powerful than the scene of the heist itself. Heisenberg strands us outside the bank, subject to the alternation between the everyday quiet on an otherwise sedate street and the sounds of police sirens, hunting in the wrong place for their suspect. As the police pick up Rettenberger's trail and chase him through a parking structure, handheld camerawork conveys the drama. Abel is correct that there is something animal-like in the main character's movements

(2013, 217–18). One has the impression of being along for a ride, strapped to the back of a rat making his way through a maze. However, only after he appears to have gotten free of the police, after he has exited the parking structure and its adjacent buildings, does Heisenberg's percussive soundtrack commence. The police have vanished from sight, and these pulsating, action-oriented drums arrive belatedly. They accompany images of Rettenberger going over a fence, through a field, past playground equipment, and deep into a wood where there is no sign of his pursuers. He passes through the less well-defined spaces associated with the countryside and appears to have only one thing in mind: to get away. He had often needed a getaway car, but here none is required. Flight on foot is his preferred mode, and because Rettenberger chooses to run, he is the symbol of this new wave's resistance. We witness a representation of his need to get *elsewhere*, or an adult's reprisal of Antoine's flight.

Eventually Rettenberger brings his own story to a standstill. Akin to Antoine, Truffaut's new wave protagonist who refused to integrate with French society and conform to its expectations, Heisenberg's Rettenberger also halts the narrative's forward motion. After he has been apprehended and has again escaped from the police station, he hides in a hole in the ground, but this is only a temporary refuge. He then finds shelter in someone's home, is stabbed by a man he has taken hostage, and he ends up bleeding to death in the driver's seat of a stolen car. The montage that accompanies this final sequence communicates a great deal about his interiority. As in *The Loneliness of the Long Distance Runner*, viewers have every reason to presume that the images they are now seeing are those that drift, one by one, through the protagonist's mind, and the montage indicates that Rettenberger's ego is involved in a decision-making process. He is surely making a choice, which was something his sometime girlfriend Erika reminded him he was capable of doing. His mind sorts through his memories: he thinks about his empty room, he indirectly recalls having murdered his parole officer, and he visualizes Erika, from behind, walking through her apartment's darkened hallway. The automated movement of the vehicle's windshield wipers remains constant throughout the scene. He pulls off to the side and his last words are as articulate as any human's: he requests that Erika not hang up her phone, hoping to be with her for as long as possible while he dies. Erika breathes intermittently, which we hear mediated by a poor telephone connection, and Heisenberg then cuts to Rettenberger's view through the windshield: an empty highway, gray and drab beneath a low cloud cover. He decides to let go, yet the wipers, the road, and all of the trappings of the hyperautomated society into which he was flung persist, continuing on, irrespective of who is sitting in the driver's seat.

The last moments of Kastenberger's life were quite different. According to Heisenberg, the real robber was finally pursued on the highway, where "he drove through a road block, was shot once from behind and shot himself before the police got to him" (Covering Media 2010/2011). Heisenberg says that this unadulterated scene of suicide did not seem like the right ending for his film, noting that his own conclusion had utopian qualities: "This person who always had to be on the move found peace in death. This is also a resolution and a kind of moment of happiness, sad as it is. He finds a resolution that he could not find in love" (Covering Media 2010/2011). At the climax of the film, we see Rettenberger breathe his last breath, but the stasis this produces resembles a release; he can finally stop running. In light of the choices he makes, it is difficult to maintain that his resistance was wholly instinctual or involuntary. He should preferably be seen as having made a choice to refuse, as having resisted others' movements with his own. However, his steadfast opposition is entwined with an image of relentless athleticism, because in the act of running he seized control of his own mobility. Acquiring money was never his goal. One should, of course, not confuse this film's main character with Antoine Doinel; Rettenberger's character murders, and his decision to kill his parole officer can even be described as sociopathic. What he shares in common with Antoine, however, is that the characters each prefer to move themselves. Otherwise manipulated by forces beyond their control, their major mode of resistance, perhaps their only mode of resistance, however fleeting the consequences, is to first say "no" and then to flee, as fast as they can, on foot.

Released twenty-five years after *The Jericho Mile*, Michael Mann's *Collateral* (2004) depicts Tom Cruise as Vincent, a resolute and indefatigable hired killer, who never misses his target. Because he is in Los Angeles, his mission calls for a vehicle, so he enlists Max, a randomly selected and mostly unwilling taxi driver, to be part of his killing apparatus. When Vincent, sporting shiny silver hair and a gray gunmetal business suit, ends up chasing Max alongside the Los Angeles subways at the end of the film, he is threatening because he appears to merge with the train. Vincent is a motor, a killing machine, and it seems that the thundering engines of rapid transit itself are bearing down. This mechanistic trope is often repeated in contemporary action cinema. Whether action films center on a "Terminator," a "Transporter," or a "Mechanic," their protagonists could not be representatives of artistic new waves, because the fascination on which such figures trade is our interest in becoming machines. These running men are allegories, exaggerated versions of the administrated forces that control our lives, moving us from place to place.

Heisenberg's Rettenberger is different. He stands apart from an automated society. His proclivity for running offers a means of conceptualizing the film's

politics: our automated modes of transportation, specifically the movements of cars and trains, are clearly discernible expressions of hyperadministration. As is similarly emphasized in Heisenberg's *Sleeper*, individual control is an illusion, regardless of whether one is sitting in the driver's seat. The runners one finds in new wave films are neither terminators, nor even human motors, they are meant as reminders that most doors now open by themselves, our cars tell us where to drive them, and the thinking that we do comes only in the interstices. That the machines precede us—that we are born into a highly automated world—is a fact. To get far enough away and bring matters to a standstill, even briefly, may require many miles of long-distance running.

Notes

1 French critics have used the term "nouvelle vague allemande" to describe the Berlin School. See, for example, Lequeret 2004. Abel discusses numerous uses of that particular term in *The Counter-Cinema of the Berlin School* (2013, 26n17). He also mentions the influence of the French journal *Cahiers du Cinéma* over the film-makers of the Berlin School and their writings, citing in particular the influence of Truffaut (153).

2 "In the driver's seat" is an English-language idiom. The German idiomatic equivalent is "am Ruder sein" (to have the helm).

3 That the rotor resembles a zoetrope is also pointed out both by Andrew (2010, xix) and by Neupert (2007, 186).

4 Truffaut recognized the importance of his protagonist's flight on foot: its centrality is highlighted in the title of the episode from his earlier film *Les mistons* (1957) titled "La fugue d'Antoine" (or "Antoine Runs Away"). *The 400 Blows* developed out of that earlier film.

5 At least one critic pointed this out at the time, writing: "When these devices step outside the realm of British 'New Wave' film-making into what can only be described as cribs (though doubtless an homage was intended) from Truffaut's *Quatre Cent Coups*, one's doubts as to the course Richardson's style is taking reach disquieting proportions. . . . And, anyway, where is Richardson's own style?" See British Film Institute (1962, 148).

6 Blaydes and Bordinat write, "When Smith is most beset by the restrictions of the establishment, the soundtrack plays 'Jerusalem.' . . . It becomes in *Loneliness* a powerful extension of the theme of the angry young man" (1983, 214).

7 Mobility is also a major theme in Fisher's study of Christian Petzold (2013), particularly where he discusses automobility in films such as *Cuba Libre* (1996), *Wolfsburg* (2003), and *Yella* (2007).

8 Laurier studies this phenomenon, arguing that less volition is involved in slamming on brakes or turning wheels than one might think (2011, 69–82).

9 "Sie spielen konzentriert. Johannes Mimik und Körpersprache haben sich ver-
 ändert. Er reagiert kaum und wirkt erstarrt—das kindliche Mitfiebernde vom
 Anfang ist verschwunden." See Heisenberg (2004, n.p.).
10 Heisenberg's style echoes other French filmmakers beyond Truffaut. Abel makes associa-
 tive connections with two canonical works of French cinema, citing Renoir's *The Rules
 of the Game* (1939) and Godard's *Masculin Féminin* (1966) as influences on *Sleeper*.
 Masculin Féminin stars Jean-Pierre Léaud, who played Antoine in *The 400 Blows*, as the
 character in Godard's film who makes the remark cited by Abel (2013, 212).
11 On dysfunctional mobility, see Cresswell and Merriman: "The mobile worlds that
 are labeled dead, irrational and dysfunctional by transport geographers and others
 come alive when they become the focus of our attention" (2011, 5). See also Berg-
 mann (2008).
12 Although long takes are frequently used in Berlin School films, Berlin School
 directors do not treat them as a necessity. For an assessment, see Koepnick (2013b,
 195–203).

Works Cited

Abel, Marco. 2013. *The Counter-Cinema of the Berlin School*. Rochester, NY: Camden
 House.

Andrew, Dudley. 2010. *What Cinema Is!: Bazin's Quest and Its Charge*. Malden, MA:
 Wiley-Blackwell.

Bergmann, Sigurd. 2008. "The Beauty of Speed or the Discovery of Slowness: Why
 Do We Need to Rethink Mobility?" In *The Ethics of Mobilities: Rethinking Place,
 Exclusion, Freedom and Environment*, edited by Sigurd Bergmann and Tore Sager,
 13–24. Farnham: Ashgate.

Blaydes, Sophia, and Philip Bordinat. 1983. "Blake's 'Jerusalem' and Popular Culture:
 The Loneliness of the Long-Distance Runner and *Chariots of Fire*." *Literature/Film
 Quarterly* 11 (4): 211–14.

British Film Institute. 1962. Review of *The Loneliness of the Long Distance Runner*.
 Monthly Film Bulletin, Published by The British Film Institute 29 (346): 148. http://
 www.screenonline.org.uk/media/mfb/973237/index.html.

Covering Media. 2010/2011. "*The Robber* (2010/2011)." Interview with Benjamin
 Heisenberg. *Covering Media*. http://www.coveringmedia.com/movie/2011/04/
 the-robber.html.

Cresswell, Tim, and Peter Merriman. 2011. Introduction to *Geographies of Mobilities:
 Practices, Spaces, Subjects*, edited by Tim Cresswell and Peter Merriman, 1–15.
 Farnham: Ashgate.

Denby, David, ed. 1969. *The 400 Blows: A Film by François Truffaut and Marcel Moussy*.
 New York: Grove Press.

Fisher, Jaimey. 2013. *Christian Petzold*. Urbana: University of Illinois Press.

Guillen, Michael. 2010. "German Cinema: *Der Räuber* (*The Robber*, 2010)—The Evening Class Interview with Benjamin Heisenberg." *The Evening Class.* November 10. http://theeveningclass.blogspot.com/2010/11/german-cinema-der-rauber-robber-2010.html.

Heisenberg, Benjamin. 2004. *Schläfer: Ein Drehbuch von Benjamin Heisenberg*, 10. Fassung, 2004, n.p. http://www.drehbuchautoren.de/sites/default/files/podcasts/drehbuecher/schlaefer-10.pdf.

Holland, Norman N. 1960. "How New? How Vague?" *Hudson Review* 13 (2): 270–77.

Koepnick, Lutz P. 2013a. "Cars." In *Berlin School Glossary: An ABC of the New Wave in German Cinema*, edited by Roger F. Cook, Lutz Koepnick, Kristin Kopp, and Brad Prager, 75–82. Bristol, UK: Intellect.

———. 2013b. "Long Takes." In *Berlin School Glossary: An ABC of the New Wave in German Cinema*, edited by Roger F. Cook, Lutz Koepnick, Kristin Kopp and Brad Prager, 195–203. Bristol, UK: Intellect.

———. 2014. *On Slowness: Toward an Aesthetic of the Contemporary.* New York: Columbia University Press.

Laurier, Eric. 2011. "Driving: Pre-Cognition and Driving." In *Geographies of Mobilities: Practices, Spaces, Subjects*, edited by Tim Cresswell and Peter Merriman, 69–82. Farnham: Ashgate.

Lequeret, Elisabeth. 2004. "Allemagne: La Génération de l'Espace." *Cahiers du Cinéma* 587: 47–51.

Neupert, Richard. 2007. *A History of the French New Wave Cinema.* Madison: University of Wisconsin Press.

Schiefer, Karin. 2008. "Benjamin Heisenberg Is Shooting *The Robber*—Interview." *Austrian Film Commission.* http://www.austrianfilms.com/news/en/benjamin_heisenberg_is_shooting_the_robber_-_interview.

Seidel, Jörn. 2010. "'Hier erfüllt sich für mich das Wunder Kino'—Interview mit Regisseur Benjamin Heisenberg über seinen Film *Der Räuber* und die Berliner Schule." *Kino-Zeit.de.* March 5. http://www.kino-zeit.de/news/hier-erfullt-sich-fur-mich-das-wunder-kino-interview-mit-regisseur-benjamin-heisenberg-uber-seinen-film-der-rauber-und-die-berliner-schule.

Sicinski, Michael. N.d. "In the Long Run: *The Robber*." *Cinema Scope Online.* http://cinema-scope.com/cinema-scope-online/in-the-long-run-the-robber.

Sillitoe, Alan. 1960. *The Loneliness of the Long-Distance Runner.* New York: Alfred A. Knopf.

13

GHOSTS AT AN EARLY AGE

Youth, Labor, and the Intensified Body in the
Work of Christian Petzold and the Dardennes

Jaimey Fisher

A Shared Afterlife of Industrial Economy and Its Tenuous Solidarities

ZEIT: You once quoted Helmut Färber: "Good films show in 20 years why and how we lived 20 years ago." What will we learn in 2029 from *Jerichow* about Germany in 2009?

Petzold: When one thinks like this, one has already lost. This sentence contains a sense of responsibility for the locations, the circumstances, the dreams in which one automatically finds oneself with the cinema. Think, for example, about *Rosetta* by the Dardenne brothers: when, in 20 years, one wants to know something about the decline of wage labor, one has to watch this film. Every sociologist or historian will be able to learn more from it than from any statistics. (Siemes and Nicodemus 2009)

Probably the best known and most celebrated member of the Berlin School, Christian Petzold seems to be more willing to cite the influences on his cinema than any other internationally renowned director.[1] He regularly speaks of his high and abiding regard for a wide range of both artistically minded and commercial filmmaking, including the indelible influences of Rainer Werner Fassbinder and Alfred Hitchcock, as well as a wide range of other genres, from westerns to horror. For example, he has, unusually for a director of art cinema,

declared John Carpenter's *Halloween* (1978) one of his favorite films, and its influence is clear in many of his works, albeit in retooled form. He does seem more hesitant when discussing filmmakers currently alive and working, but he has singled out one internationally renowned contemporary filmmaker in particular, or rather two as one: the Dardenne brothers, who have declared themselves "one person" or "one filmmaker with four eyes" (Mai 2010). The epigraph indicates this high regard: Petzold thinks film should attain certain images that will outlive their own immediate context, but when asked if his own films will achieve this, he demurs and offers the Dardennes' Palme-d'or–winning *Rosetta* (1999) instead.

This praise is, in many ways, not such a surprise, as Petzold and the Dardennes engage similarly inflected political, particularly socioeconomic, themes, owing perhaps to their hailing from similar backgrounds, at least geographically: Petzold grew up in Haan, some one hundred miles from the Dardennes' Belgian home context of Liege-Seraing, in a similarly postindustrial context. Petzold was raised in North Rhine–Westphalia, Germany's most industrial and populous part, which has seen its economic and political fortunes decline more than any other region in former West Germany with the remapping and redefinition of industry in the world economy; Seraing, as part of the wider Liege conurbation, was similarly at the heart of the Belgian-Walloon industrial sphere, with a parallel historical arc from organized labor toward increasing deindustrialization, economic struggles, and the subsequent withering of organized and spontaneous worker solidarity (O'Shaughnessy 2012). Hailing from these regions left considerable historical and socioeconomic impressions on both filmmakers, as I shall argue, predisposing them not only to social and economic themes familiar to art-cinema filmmaking at least since the 1920s but, more specifically, to themes of political and economic afterness as well as (stuttering) social continuity under the duress of these rapid and fundamental transformations (on Dardennes' afterness, see Lebrun 2010, 187; for Petzold's, Fisher 2013, 83–84).

This thematic constellation, particularly of a socioeconomic afterness, has also been arrived at in an intriguing parallel trajectory in their careers, although the Dardennes are somewhat older (Jean-Pierre, b. 1951; Luc, b. 1954) and more established on the international art-film circuit than Petzold (b. 1960). The Dardennes spent years making politically pointed documentaries in and around their home context of Seraing and then deliberately moved into fiction filmmaking with *Falsch* (1987) and *Je pense à vous* (*I Think of You*, 1987), films from which they now largely distance themselves. Like Petzold, their breakthrough to a mature and abiding style came later, with the 1996 *La promesse*

(*The Promise*), which is usually regarded as the beginning of their recognizably auteurist approach (Mosley 2013, chap. 5). Particularly interesting is how the Dardennes withdrew, or at least self-consciously drew back, from a more commercial style after moving rapidly in that direction (with *Falsch* and *I Think of You*) from their politically and social critical documentaries (Mai 2010, 13). Particularly with *I Think of You* they had the budget, established actors, and professional crew of a mainstream commercial production. After the film's critical and commercial mediocrity, however, they fundamentally reconsidered their position, especially their aesthetic approach. *The Promise*, which took four years to make as they reassessed their methods (and struggled with funding), proved something else altogether. Petzold, as I have argued elsewhere, also self-consciously navigates the more commercial genre system—both deploying and remaking it. After three fiction works for television (*Pilotinnen* [*Pilots*, 1994], *Cuba Libre* [1996], and *Die Beischlafdiebin* [1998]), Petzold's breakthrough auteurist work came around his fortieth birthday. His first theatrically released feature film, *Die innere Sicherheit* (*The State I Am In*, 2000), won him the German Federal Film Prize in Gold—Germany's equivalent of the Academy Award for Best Film; as was the case for the Dardennes with *The Promise*, *Die innere Sicherheit* similarly signals a deliberate drawing back from and reposturing vis-à-vis more commercial film parameters.

For both the Dardennes and Petzold, their somewhat deferred mature styles emerged in response to their respective dissatisfactions with the documentary form and led them toward developing a new innovative postrealist aesthetic, carried out in theoretically informed and inflected fiction filmmaking. For the Dardennes, the documentary work against which their celebrated features have been made is their own: they had established themselves as much lauded nonfiction filmmakers, whose recurring themes and advancing sophistication were then realized in their feature film work (Mosley 2013, 42, 63). For Petzold, the documentary or nonfiction work against which his features work is often defined/understood as that of his erstwhile teacher, mentor, and collaborator Harun Farocki, one of the (if not the) key figures of German documentary filmmaking from the 1960s to 2010s who is also credited on all of Petzold's film scripts, inclusively, through *Phoenix* (2014). This relationship to documentary in their works helps yield, I think, the marked sense of afterness in their cinemas: in both the Dardennes' and Petzold's films, the features reengage with themes undertaken in the documentary work, but they do so with a self-conscious sense of coming after and perhaps too late, including a clear sense of political afterness—that is, of arriving after an era of more defined political consciousness, solidarity, and organization.

The Lonely Aesthetics of Afterness: Bodies Adrift

Narratively speaking, this abiding sense of economic and political afterness yields isolated, often lonely protagonists, with the character and trajectories of these protagonists underscoring the fading forms of collectivities, both social and political. In *The Promise*, Igor is increasingly detached from a circle of friends as he is pulled more into the venal work world of his human-trafficking father; in their much lauded follow-up, *Rosetta*, the eponymous main character leads a lonely life in search of stable work, her social isolation interwoven with her unemployment to such a degree that she does not, or cannot, respond when kindly Riquet signals romantic interest in her (for a telling example, she leaves him to drown in a pond, presumably to get his job). In *Die innere Sicherheit*, Jeanne, the film's narrative center, has led a life similarly shorn of friends or even much social contact. This isolation is extended in Petzold's feature-film follow-up *Gespenster* (*Ghosts*, 2005) where Nina could easily be an extension of Jeanne, figuratively and literally (they are both played by actor Julia Hummer): similarly friendless, she strives for human contact and the putative normalcy bred of it. In all these cases, the directors deploy a conspicuously socially isolated character to register the afterness of wider political solidarities that had formerly marked their social contexts. For the Dardennes, it is the after-tremors of labor solidarity in the deindustrialized Walloon region, the withering of which they had worked out in documentaries; with Petzold, in *Die innere Sicherheit*, the afterness of former left-wing terrorists echoes (Farocki had had connections in this scene) and in *Gespenster* the aftershocks of Germany's marquee historical upheavals, seismically to the right and the left, in central Berlin (see Fisher 2013, 84–85).

In another notable parallel, these socially isolated characters of the directors' breakthrough efforts are all young people, hinting at an underdiscussed aspect of their careers, as generation and youth in society and culture have, I think, gone generally underanalyzed in Anglo-US cultural theory (Fisher 2007). In these narratives, as in other eras of rapid change, generational divides are used not merely to mark the inevitable passing of family time but also to register contingent historical transformations: the familiar stress on families in both the Dardennes' and Petzold's films is refigured, even radicalized, to register the fading of social collectivities generally. In using young people to mark and measure social and economic changes, the Dardennes are deliberately engaging the important place of young people in the socially critical tradition of Italian neorealism. Laura Ruberto has cited the parallels between *The Promise* and Vittorio de Sica's *Ladri di biciclette* (*Bicycle Thieves*, 1948), with its crucial younger character (Ruberto 2007), while Mosley references the Dardennes' placing Rossellini's *Germania*

Anno Zero (*Germany, Year Zero*, 1949) at the top of their list of films influencing them for *Télérama* (Mosley 2013, 33). *Germania Anno Zero*, as I have discussed in a piece on the use of young characters in early postwar German and Italian cinema (Fisher 2007), deploys young people, and their liminal socioeconomic agency, to explore the fraying limits of a society on, or even over, the edge. Luc Dardenne's *Au dos de nos images* (2005), a published diary/working journal from 1991, through *L'enfant* (*The Child*, 2005), confirms that the brothers were, indeed, thinking of *Germany, Year Zero* explicitly during the production of *The Promise*. If one weighs Rossellini's influence, it is notable that both *The Promise* and *Rosetta*, which broke through on the art-film circuit and then cemented their position internationally, have young protagonists at the center; the same is true for Petzold's *Die innere Sicherheit* and *Gespenster*, the latter with its similarly oneiric voyage around downtown Berlin in a milieu (both place and time) still struggling with postwar ruins.

Although these influences and trajectories would link the Dardennes and Petzold to the storied tradition of realism in cinema—an approach that has been emphasized in the scholarship on both (Mosley 2013)—this socially isolated young person in their respective breakthroughs suggests a more complicated relationship to realism. In fact, operating at a self-conscious distance from conventional realism helped them develop their breakthrough styles, even if they do engage themes (particularly economic and work conditions' impact on social life) shared with the realist tradition. For both the Dardennes and Petzold, the young protagonist served, at pivotal points in their careers, to refigure both conventional realism and the dominant Hollywood aesthetics of what Petzold critically characterized as the "cinema of identification" (Abel 2008). As one might expect of many art cinema directors, the Dardennes and Petzold criticize prevailing film aesthetics as affectively and emotionally exploitative, but both developed film styles that allow for the viewer's emotional engagement through characters while also foregrounding socially critical themes, especially the transformational aspects of work and economy.

In developing their respective styles directed against dominant film aesthetics, both speculate specifically on the prevailing images of the human body. Although other scholars have flagged the brothers' use of what they have termed the *corps-caméra* in their films (Cooper 2007, 76; Mai 2007), the centrality of the body to the development of their auteurist aesthetic has been neglected. Both the Dardennes and Petzold regard Hollywood cinema as emotionally exploitative but, intriguingly, also acknowledge the power of its use of bodies. In an unusually long entry in *Au dos de nos images* (2005), Luc Dardenne addresses how mainstream cinema represents the body and then defines their own approach against

it. Two days after he mentions seeing Simon Wincer's *Free Willy* (1993) and his astonishment at the emotionally manipulative manner in which it deploys imagery, Dardenne observes: "The consensus around the ethics of pity that dominates nowadays is nourished by an aesthetic of the biological body suffering, murdered, mutilated, disfigured, which the media never cease to propagate, especially on television" (2005, 36). Instead of considering the causes that yield these suffering, dead, and disfigured bodies—which would require, says Dardenne, letting them "speak"—this dominant visual aesthetic is satisfied to spectacularize them, thereby leaving them not only speechless but also utterly passive as mere biological material.

Dardenne's analysis strikes one as particularly pointed because the aesthetic posited and problematized pivots not on an empowered protagonist, of the heroic agency of Enlightenment and enlightening subjectivity more and more deployed in superhero battles, but rather on pity evoked, thus regularly rendering passive bodies on screen for predictable, reductive affective-emotional mechanisms in viewers. Notable, too, is that Dardenne does not afford much or any positive result from the Aristotelean cathartic function of pity: for him, it renders passive bodies on the screen while unhelpfully exploiting the audience's emotions, passifying them, in turn, in the face of the context that produces such carnage. Such images paralyze, particularly in terms of thought, since they close down most reflections on how these pitiable bodies arrived at this condition. Dardenne concludes that to film a body at odds with this ethic and aesthetic would be an act of "cinematographic resistance against the contempt for the human" (2005, 37). Resistance is an important word and concept for the Dardennes, as it is in the title of one of their more overtly political documentaries (*Au commencement était la résistance*, 1974–77) and is the conspicuous first word of the four-hundred-page *Au dos de nos images* ("Résister jusqu'à la dernière énergie..." 2005, 9). The resistance that their mature style achieves pivots on, as I detail below, this very deliberate and contrary deployment of the body of their protagonists and the camera's relation to it.

Petzold also locates the body at the core of the cinema he admires and attempts to reconstruct. Observing that German cinema had lost its way after the Nazis, not least because Nazism had in effect "taken [our] bodies from us [Germans]" (Fisher 2013, 165), Petzold renders the specifically corporeal pleasures and perils of the body toxically dangerous for the cinema. The cinema of the 1950s subsequently became, for Petzold, insufferably talky, suffused with literary adaptations and theatrical stagings. In discussing the postwar (US-driven) triumph of mainstream cinema aesthetics—the same

sort that Luc Dardenne ruminates on in the wake of *Free Willy*—Petzold focuses similarly on its effective deployment of the body for viewers: "[around 1990] I went to see *Pretty Woman* . . . [and] all these women who were watching Richard Gere, not Julia Roberts. And I was amazed: They were screaming, 'What a man!' He had been sitting in a bathtub for about two hours, and then he turned on the hot water again—with his big toe. . . . And the women in the audience just screamed. And then I realized: This is American cinema, which has a certain physicality [Physis]" (Fisher 2013, 156). One has the sense from Petzold's insights that, in the cinematic vacuum left in the wake of Nazism, the United States and its cultural agenda successfully marketed and delivered pleasurable images of the body, those that would, by the 1980s and 1990s, become tantamount to neoliberalism and its empty promises of individual freedom, mobility, plenitude. *Pretty Woman* apparently made a lasting impression on Petzold, as he included it in the spring of 2016 in a carte-blanche section accompanying the complete retrospective of his work at the Vienna Film museum.

Both the Dardennes and Petzold develop mature styles that build on these insights into the pleasures and perils of the cinematic body by seeking to "break" corporeality (Luc Dardenne's word) on its own terms. When self-consciously deployed to resist, as the Dardennes put it, cinematic bodies are able to register the historical changes in economy and society that they as well as Petzold are committed to tracking. They aim to let that body speak to the viewer: speak the historical transformations that it embodies, rather than just eliciting affective responses that fail to address whence these pitiable bodies come. Both the Dardennes and Petzold achieve this by engaging very specific bodily mechanisms that draw the viewer closer to the body of their young protagonists, evoking somatic empathy, while also creating an intellectual distance and detachment from that struggling juvenile. Although they knowingly deploy what I shall explore as corporeally intensifying images—indeed, they train their actors to foreground such images in their performances—they simultaneously conjure and then maintain a mystery to the character that keeps viewers at self-aware distance even as they are drawn close by the intensive bodily depiction. This bodily proximity simultaneously accompanied by intellectual distance puts the viewer into what the Dardennes call a "moral trance" and what Petzold terms a "Schwebezustand" (state of abeyance), in which the relation of viewers to the character remains open and undefined (Dardenne 2005, 136; also, Lebrun 2010, 194; Fisher 2013, 19). This open and undefined position yields for these filmmakers the historical, the ethical, and the political voices that they ultimately seek in their cinemas.

Ambivalent Openings: Drawing Close to the Juvenile Running Away

Both cinemas achieve a corporeally canny style by deploying specific mechanisms while drawing away from others. Even as they deploy bodily intensifying images and create what Carl Plantinga has termed "sympathetic emotion" (Plantinga 2009, 161) with their young protagonists, they also deliberately draw the viewer away from that protagonist whose body is intensified: from the outset, from the viewers' introductions to the young protagonists in *The Promise, Rosetta,* and *Gespenster*, the films simultaneously undercut what Plantinga (following Murray Smith) calls "moral allegiance" with the protagonist (Plantinga 2009, 107). In the classical system, there is usually a confluence of sympathetic emotion and moral allegiance, such that viewers experience sympathy with the main character and believe in his or her doing "good"—or being a "good" person who might be melodramatically victimized—within the narrative. But the challenging openings of these films scramble that sympathy and allegiance. With such an approach, both filmmakers avoid the double pitfalls of either excessive pity for or luxuriating in the body.

In the opening of *Rosetta*, for instance, viewers are immediately exposed not to the suffering biological "material" of the eponymous protagonist's body but rather to her fierce fighting spirit, as the film's first images track the young protagonist stomping, even storming, through the hallways of an ice-cream factory. The camera is close behind her in a tight following shot, struggling to keep up with her rapid advance through factory corridors and closed fire doors. With the camera barely able to keep up with her, viewers are left with an image only of her back: for over a minute, the film's very first, with only the streaking blur of her hair-net cap and coat visible, viewers are denied even a glimpse of her face, which presumably would offer a clue as to why she is moving so fast. The pounding of her heavy, fast footfalls on the industrial floor of the corridor and then the factory hall emphasizes how her determined forward motion recalls the march of a soldier, and, indeed, Luc Dardenne recounts in *Au dos* that they understand *Rosetta* to be a war film (Dardenne 2005, 66).

The war-film subtext is confirmed when Rosetta reaches her desired destination and verbally attacks a coworker before physically attacking her boss. It is at this moment, finally, that the camera offers a medium shot of her face, though it comes not with a hackneyed cut to close-up at a climactic moment but rather when she abruptly turns around to face her boss with a remarkable rage. In this long-take opening, the first image of her face thus arises at the moment viewers hear that she has been fired. She has been fired not for reports of her tardiness

Figure 13.1 *The Promise*—Parodies of industrial manufacturing: car carrier traffics in humans

(thus her suspicion of the coworker) but merely because, as her boss reveals now, her trial period was over—early termination was always in the cards of this stacked employment deck, no matter how well she played the game. And, indeed, she is able to confirm the irrelevant fact of her hard, effective work with both the embarrassed coworker and cruelly pragmatic boss.

Just as in *The Promise*'s opening moments that register the decline of heavy industry to a make-believe "new economy" with a multi-car-carrier delivering illicit immigrants among its vehicular wares in *Rosetta* the factory seems a whimpering echo of workplace rights and solidarity (fig. 13.1).

At realizing her carefully plotted, now insurmountable workplace fate—planned termination even before she started—she takes a swing right toward the camera, positioned next to the boss, so that a swing at him is a swing at us. Soon, however, her frenetic movement is more confined, with a series of suddenly locked doors, materializing her diminishing options in the workplace space. She is finally able to burst into a locker room, followed now not only by the camera but also by two security guards. As they grab her, she memorably clings to the lockers, resisting every inch of workplace removal with every fiber of her uniformed body.

Such images are shocking for a film's first moments, perhaps reflected most of all in the intensity of her bodily energy and power. *Rosetta's* introduction foregrounds the startling corporeal intensification of the Dardennes' cinema as the film's opening proposition, an activation of desperate action, not pitiable passivity. First, and central to their system, there is the camera's chasing after Rosetta through these corridors and then clinging closely to her as she realizes she is cornered. By refusing to cut to longer shots that would establish the space (and make viewers more comfortable in a conventional construction of more objective space), the Dardennes' camera hews close to her body, violating what Plantinga terms the proxemic patterns of cinema, namely, the standards for distance from bodies that are observed, I would emphasize, both by other characters and the camera (Plantinga 2009, 120). Such proxemic patterns are violated, varied, and played with constantly in the Dardennes' films, by both the camera and characters (as in *The Promise*'s early sequence in which father Roger requests that son Igor reach over and put drops in his ear). In this way, the famous *corps-caméra* of the Dardennes' mature style draws viewers close, but uncomfortably so, to the protagonist. Drawn close but simultaneously repelled, viewers end up simultaneously emotionally sympathetic to Rosetta's plight and distanced by the violation of such proxemic decorum: viewers are close to her, but she is too violent for such proximity.

In this manner, it is important to comprehend how their cinema's much cited *corps-caméra* functions within this wider context of traditional proxemic patterns and the Dardennes' understanding of (and resistance to) the body in conventional media. In a similarly intensifying proximity/repulsion, they use what Julian Hanich calls "corporeal shadings" to highlight parts of the body to evoke sympathy (2010, 102); this mechanism figures centrally in the openings of both *Rosetta* (as she clings to the flimsy metal of the lockers that are a lingering reality of the working class) and of *The Promise* (when the film's first minutes find Igor digging in the dirt to bury a wallet he has stolen from a hapless pensioner). Such bodily intensive images shot at proximity draw viewers close, but it is a proximity that

simultaneously distances. Viewers' moral allegiances will be confused by Rosetta's aggressive accusations and abruptly violent attack on her boss as well as by Igor's casual robbing of a senior citizen who just picked up a pension check.

Ghosts was Petzold's first major project after his breakthrough to national notoriety after *The State I Am In*. Like the Dardennes, Petzold chose to stake the message of this crucial "second film" on the central figure of an initially underemployed, then unemployed, young person. As in *Rosetta*, the film's first shot of its protagonist, Nina, finds her at work, in a tenuous and quickly humiliating situation. Donned in a reflective mesh vest of construction work, Nina is picking up garbage in a verdant park, a lovely context for menial, even lowly work. If Germany had a glorious industrial past—whose eulogy Petzold had delivered in his made-for-TV film, *Wolfsburg* (2003)—then the better-paying working-class jobs have apparently disappeared in the German capital. Nina demonstrates how, even in a very wealthy country like Germany, the younger generation, especially, has been locked out of collectively bargained manual labor amid the broader dematerialization of work. Petzold decided to focus on this figure—a young person doing a disposable job—after encountering someone like this in a park, doing a "1-Euro" job heavily subsidized by the state. The creation of these jobs was part of a broader labor reform at the time of the film's release in 2004/2005 (Fisher 2013, 80–81). Petzold was particularly shocked that these under- and temporarily employed were not "*Lumpenproletariat* or skinheads" but just young people who had elected to take a little time off after school only to suddenly find themselves at the bottom of the crushing employment pyramid (Fisher 2013, 81). In Petzold's universe, such young people have become ghosts at an early age.

If *Rosetta*'s fate is, as Petzold observes, to rip the mask off rapidly degenerating wage labor at its historical moment, the staging of Nina's German workplace humiliation similarly highlights how she is treated by management in a way that cuts her off from her coworkers, subverting traditional collective solidarities of the workplace. When her supervisor catches her (allegedly) daydreaming, he mocks her, accuses her of filling her bag from a trash can, and dumps the nearly full bag on the meadow for her to pick up all over again. Her boss's humiliation of her sets her apart from her coworkers even as she tries to rejoin the group. Petzold's staging of Nina's workplace fate, however, also underscores his divergence from the Dardennes' aesthetic approach, despite their parallel socioeconomic engagement and marking of the afterness of workplace solidarities via young people. While at work, Nina is distracted by another young woman's being pursued in the forested park by two men, apparently because she stole something. This young woman, Toni, is, in fact, pursued twice during the opening moments that introduce viewers to Nina, and both times Nina follows her, deliberately detaching her again

from her similarly vest-clad coworkers to follow Toni. Her meandering pursuit of Toni seems decidedly oneiric, since the level of violence (Toni is twice attacked while Nina watches) seems surprising and may indeed be a daydream or, as viewers later learn, a vaguely erotic fantasy.[2] Although Petzold has emphasized the economic basis of Nina's character, he has also highlighted how he had in mind both fairy tales (especially the Brothers Grimms' *Das Totenhemdchen*) and German fantastical cinema (particularly F. W. Murnau's *Nosferatu* [*Nosferatu, eine Symphonie des Grauens*, 1922]) in his staging of this memorable opening: like the Dardennes, Petzold is foregrounding socioeconomic transformations underway, but he also maintains a focus on the fantastical aspects of any individual's imagination and how cinema has always played upon, and with, them.

Petzold's staging of his young protagonists proves, similar to *Rosetta*, intensifying while also simultaneously distancing to viewers: Nina's and soon Toni's bodies are consistently emphasized in his depiction, but also, from the viewer's perspective, simultaneously perplexing. One of the notable peculiarities of *Das Totenhemdchen*—and, indeed, of many of the frequently gruesome Grimms' fairy tales—is its heightened corporeality. In the tale, not only has a young son died and his mother excessively mourned him, but his death shirt is also so soaked with her tears that he cannot ascend to heaven. Despite his ghostly return, the tale pivots on the base material aspect of earthly death. Like Rosetta—a young life unfolding in the crucible between economic humiliation and fantastical determination—Nina's introduction emphasizes her body even as she drifts through the film. First, as in *Totenhemdchen*, the film fixates on her apparel, especially her shirts. Meeting Toni in the woods—perhaps encountering her for real, perhaps starting to dream her—immediately foregrounds Nina's apparel and her repeated attempts to clothe Toni's body: Nina finds an earring on the forest floor and dons it; discovers Toni's errant shoe (another reference to the economic and corporeal overtones of fairy tales); and then removes a shirt to give one of hers to Toni, whose own has been ripped by the men attacking her. The clothing and apparel themes abide throughout the film, culminating in their stealing clothes for an audition only to have them both don T-shirts with the name of the production later. The makeover of the body and thereby of the subject is a recurring theme in Petzold's work: as in *The State I Am In*, with a similar scene of its young protagonist in the clothing section of a department store, the haptic character of our contemporary age, and neoliberal consumerism, is asserted through ubiquitously marketed clothing (Fisher 2013, 93). And these themes of clothing and makeover, as well as the tenuous subjectivities they embody, heighten the proxemic intensity of the camera and, especially in *Gespenster*, of and between the main characters.

Although Petzold's staging draws viewers deliberately close to Nina's body, they are also likely to be perplexed by her openness to Toni, both emotionally and corporeally, since the latter seems happy to dispense with Nina whenever it suits her. Moreover, Toni is associated (rather like Rosetta) with abrupt violence that can too often underpin the poor's mode of being: in addition to being attacked twice in the first ten minutes, she also threatens the mother of a former boyfriend with a large pair of scissors before abruptly scratching the latter's antique bureau with them. These are the same scissors Toni and Nina then use to cut the security badges from the clothes they steal—such abrupt crime does not invite much moral allegiance with Toni or with that part of Nina that seems ineluctably attracted to her. Toni's violent and criminal unpredictability renders mysterious Nina's attraction to her: from the prince-like shoe to the shared earring and T-shirts, Nina seems inexplicably committed to a peculiar bodily proximity—studied proxemics of bodily distance violated again—to Toni. Nina apparently takes the self-serving familiarity Toni demonstrates toward her as would-be intimacy. For example, when Toni meanders back to Nina after first abandoning her, Toni promptly helps herself to a shower in Nina's bathroom, after which they kiss, likely leaving viewers flummoxed. At that moment, the supervisor of the home where Nina lives enters and tells her she has to cooperate better at her (lowly) job or will be thrown out of the home "and lose her last chance." To this telling monologue about compelled conformity and last chances, Toni emerges from her hiding place, and Nina once again chooses to follow her, to remain physically close to Toni, although viewers are increasingly clear there will be no future with Toni or in the underemployed life Nina has had.

The Opacity of the Close-Up and the Open Endings of Youth

After their complex, brutal introduction of Rosetta, the Dardennes cut to her calm but inscrutable face, a cut that underscores another aspect of their careful depiction of the body—their very sparing use of close-ups of faces. This cut to her face after the opening sequence's intensity only stresses how little viewers saw of her face, even though the abruptly violent opening delivers one of the emotional high points for her and for the film. Given how important Emmanuel Levinas is to the brothers' cinema, this realization about their style would seem counterintuitive: the face plays a central role in Levinas's ethics of the other. Although the brothers openly acknowledge Levinas's influence on their thinking (Dardenne 2005, 56), they also cite a number of other philosophers and writers as well as develop their mature aesthetics out of a sophisticated critique of dominant visual

media. *Rosetta*'s (and Rosetta's) lacking close-ups underscores how that inherited system of cinema, which the Dardennes are cannily varying, would render Levinas's influence complicated: the face, especially in close-up, is a well-worn media currency in which mainstream cinema regularly traffics. The Dardennes' cinema would thus seem to entail a deliberate renegotiation of the close-up of the face versus the intensifying shots of the protagonist's body I sketched earlier. This renegotiation highlights how they are not merely trading the familiar system of (putative) mainstream identification for one of camera proximity (Cooper 2007, 84–85) but rather, with their mature aesthetics, critiquing and remaking the way in which contemporary media, especially cinema, depict and deploy the body.

To cut to Rosetta's calm face after the combat of work underlines how deliberately the Dardennes opted to image the back of their protagonist in that crucial sequence, just as they had frequently done in *The Promise* and would do in *Le Fils* (*The Son*, 2002). In contrast to Levinas, the back is important to their cinema, as the title of the two volumes of Luc's working journals likewise indicates (*Au dos de nos images* [on the back/behind our images]). This is a particularly provocative approach because the face and close-up shots of it have been central from cinema's earliest days: Mary Ann Doane has traced the many different theories of the face in close-up, a tradition stretching from Sergei Eisenstein and Béla Balázs to André Bazin, Roland Barthes, and Gilles Deleuze (Doane 2003). As a film initiates viewers into its particular fictional world, classical continuity would usually cue viewers to characters' emotional valence by showing their faces early and often. Such shots, at least medium shots and subsequently close-ups that can be easily read for affective and emotional cues, would be especially important if the actor was well known and part of the film's value proposition. But the Dardennes locate viewers in a different position vis-à-vis their protagonist; even as they intensify the body with their images, they consistently keep the character a bit obscure, distanced, and above all mysterious, even as the camera lingers closely.

The rationale for this variation on the classical system becomes clear as the brothers reflect on how they shot *Rosetta* the previous year and were then planning *The Son*: they suggest that they shot her back so often (which would also become the fundamental strategy for shooting Olivier in *The Son*) in part because they wanted to follow her like a soldier in war, but "without a doubt also" because they did not want to offer "the face too often seen, too often framed, too often coded, too often sold, too often advertised" (Dardenne 2005, 129). Against such excessive use of the face—too seen, too sold, too advertised—one needs, they suggest, an image that can "break the image already seen and spit out by the spectator." The image already seen and known for them is, above all, the sight of a suffering, fearful face, recalling their broader theory of the body and spectators'

reactions discussed above. The notion of the breaking (from) dominant images is richly revealing, but it seems to me remarkable that it emerges here, in considering how exactly to shoot the face and body. It is in this context in which they justify shooting Rosetta's back so often and in which they reveal the plan to shoot Olivier, similarly, from behind. Olivier's back, they suggest, will become "like a face" that speaks—a speaking body to address their theory (and lamentation) of the silent, pitiable body foregrounded above.

Even the films' endings deny the viewer the resolution of these close-ups, suspending the viewer in relation to the protagonists, achieving what the Dardennes see as a "moral trance" vis-à-vis the youth person and what Petzold characterizes as a state of abeyance. The endings of these assorted films underscore that the proximity maintained by the camera (and viewers) is precisely that: an opaque and challenging proximity rather than transparent and facile identity. The endings all remind us that these characters, fictional though they may be, remain the other and cannot be, should not be, subsumed by the viewer, their understandings, and their emotional investments therein. To achieve such aesthetic ends, the endings all conjure an abrupt narrative development, shot in corporeally intensifying, yet simultaneously elusive close-ups that mark how the abruptness generated only yields the young protagonists' inscrutability. In *Ghosts*, after Pierre has removed Françoise from her apparent reunion breakfast with Nina, Nina wanders (once again) alone in the woods of the Tiergarten. Petzold offers in her departure from the hotel and this dramatic moment only Nina's back, such that viewers cannot see her reaction to being told that her longed-for mother is deluded, that the lost daughter Marie is dead. Shorn of both Toni and Françoise, Nina recalls that Toni had thrown away Françoise's wallet nearby and retrieves it, a material and, once again, intensifyingly haptic reminder of elusive abstract relations throughout the film: the clarifying close-ups are not of her face but of her hands on the wallet as she gropes through its folds. In the wallet, she finds a series of computer-generated photographs that apparently morph from an original photo of Françoise's lost daughter into speculative images of how she would have aged into her teen and early adult years, arcing from toddler until she looks remarkably like Nina. With these startling images, the film seems to hold out hope that Nina is indeed Pierre and Françoise's long-lost daughter, although, tellingly, the reverse close-up of Nina offers only half of her face, the bangs covering the other half and her expression in its entirety.

These photos refer to one of the original inspirations that Petzold has mentioned for *Ghosts'* plot: he recounts that he was in a post office in France and saw on the wall what he came to call "ghost pictures," computer fantasized images of missing children as they age. He called them "ghostly" because they, in a familiar

facial close-up, divorced the missing children from any social context, as if people could ever develop and exist without a social world around, and impacting, them (Fisher 2013, 95–96). One of his recurring themes is exactly this misguided fantasy, that of an imagined but impossible autonomy being away from the complexity of social relations. And such pictures played upon this fantasy for grieving parents, just as cars, McMansions, and other "bubble" spaces (as he calls them) do. Nina perhaps realizes some of this: rejecting the fantasy reunion toward which her computer-generated close-up would seem to point, she discards Françoise's wallet and walks away into the park. The camera remains behind and shoots only her back, such that, despite the close-ups of the wallet and the ghost images, viewers cannot see or read her reaction: she remains, as she does to Françoise and the film director, a mystery but also, therein, her own person. The camera lingers behind, observing but not understanding her.

The end sequences of *Rosetta* achieve something similar in terms of camera, diversionary close-ups, and ultimate character mystery. After Rosetta has, in effect, cravenly stolen the job of Riquet, the only person to have shown interest and affection for her, she calls her boss and informs him she is quitting, presumably clearing the way to the precious job for Riquet or, more likely, an unknown someone like him and like her, desperate and struggling in this impossibly harsh work world. Given what is about to happen, one wonders why she bothers to inform her boss, but she is a good employee until the (near) end. In terms of this climactic moment's staging, viewers never witness any hint of drama or even detail around Rosetta's shocking decision; the camera, although still hewing close to the actress's body, typically denies a clear close-up of her face before and then as she makes the fateful call. As Sarah Cooper (2007) has argued, and as Luc Dardenne explicitly suggests in *Au dos* (Dardenne 2005, 73), Rosetta remains completely unknowable to the viewer, merely a *visage* in Levinas's sense, whose transparent close-up the Dardennes deliberately deny us.

While this is true, it is a particular unknowability balanced by her body. What Rosetta does next is even more inscrutable: she cooks a hard-boiled egg, shot in close-up detail, and then audibly turns on the propane gas before calmly plugging up the space under the cheap trailer door and lying down next to her mother, presumably to die in a completely shocking but, typical for the Dardennes, de-dramatized murder-suicide. The hissing of the open gas valve is the only sound in this highly dramatic moment, as the Dardennes almost always avoid non-diegetic sound. The preparation of her egg underlines the sort of bodily associated affect discussed above, deployed here as throughout only to underscore our simultaneous sympathy and distance from the protagonist: as she lies there, one has to wonder how she could have so calmly, so mundanely, gone through

cooking, cooling, peeling, and eating the egg (all of which viewers witness, in haptic detail inviting somatic empathy and motor mimicry; see Hanich [2010, 102], and Sobchack [1992 and 2004]), betraying nothing about her plans to kill her mother and end her own life. The camera never shoots her straight on, and viewers are denied any expressive close-up, facial or otherwise, to the momentous conclusion to her life's narrative. Viewers are, once again and indelibly, left much more with the bodily gestures that remain opaque to us, yet speak to the suffering her body has sustained over the course of the film (fired and forcibly removed twice, also pushed into the pond by her mother).

In another breathtaking narrative twist, however, viewers hear the murderous gas slowly run out: the underclass's deprivations mean that they, utterly lacking in resources, cannot even control when and where they live. Amid these shocking events, the Dardennes remind us of the materiality of something the film's middle-class viewers would probably never contemplate: the materiality of gas and heat, its physical heft and limits in a literal container. Without registering any reaction to this now third shocking development (cooks egg, kills mother/self, gas runs out), she sits up from her almost-deathbed without hesitation, slips on her bulky rain boots, and matter-of-factly undertakes dragging the heavy propane canister to the trailer park's office to buy a new one. The continued lack of close-up of her face and the conspicuously Sisyphean task of lugging the weight of the canister—body once again over visible *visage*—make it impossible to see if she is having second thoughts about the murder-suicide or whether this is just another burdensome obstacle in a life full of them.

As Rosetta struggles with the new canister, viewers hear the far-off buzz of a scooter, a distinctly continuous sound recalling, but tellingly replacing, the hissing gas. When the whining grows ever louder and is finally realized within the Dardennes' typically limited frame, viewers see a visibly angry Riquet astride a scooter, finding Rosetta for the first time since she reported his waffle side-dealing and effectively stole his job. He circles her aggressively on the machine, its whining engine now in a war scream, like angry prey contemplating a strike—it is a remarkable end, one parallel to Derek Cianfrance's memorable image of a circling, looping motorbike in a cage in *The Place Beyond the Pines* (2012): both are powerful visual metaphors for the simultaneous fury and its utter constriction of curtailed masculinity at this particular historical moment. Equally abruptly, given her benumbed response to these breathtakingly brutal events, Rosetta drops the canister and starts to weep, perhaps at the weight of the canister, perhaps at the proximity of her suicide-murder, perhaps, finally, at registering what she has done to Riquet. Riquet, unlike the office manager who sold her the canister, reaches down to help her with it, as viewers see by his hand

Figure 13.2 *Rosetta*—Building to final shot of face (second image), but nothing revealed

that enters the frame, reaches out, and helps her with her impossible burden. As he abruptly does so, she looks at the camera, and viewers see her face, a final close-up, for a moment before the film suddenly cuts to black. Although crying, the face, so often denied to viewers, remains inscrutable to the end, when one would expect so-called closure: the mystery is maintained, viewers never know why exactly she is crying, whether this is a reconciliation with Riquet or with life in general or perhaps none at all (fig. 13.2).

The Promise delivers a similar, perhaps even more mysterious conclusion in which an abrupt decision taken by the young protagonist suddenly reverses the film's apparent narrative trajectory. Although Igor has now left his father, Roger, after the latter begged him to reconsider betraying him, Igor has still not offered Assita the truth about Hamidou's death. The plan forward for Assita, endorsed by her friends, is for her to take the train to the closest family she has nearby until she can clear up Hamidou's unexplained disappearance. Viewers watch as Igor accompanies her to the train station for this final departure—from Igor's presumed perspective, as viewers understand, this plan will move her along under the protection of family (still in Europe, although closer to Africa), while simultaneously protecting Roger from facing the consequences of his murder of Hamidou. But, as Assita climbs the stairs to board what viewers assume is the narrative-concluding train, Igor abruptly breaks the silence that has lingered between them since they left the garage and, indeed, since Hamidou fell: he tells her the truth, that Hamidou is dead and that his father refused to take him to the hospital "to avoid problems," presumably any problems with his illegal exploitation of those he has trafficked. "I obeyed," admits Igor.

At this shocking news, Assita walks back down the station corridor from which they came, though, typically, viewers see only her back in reaction to what she has so long sought and just learned. Igor's abrupt and utterly de-dramatized decision and Assita's subsequent silence underscore the viewer's uncertainty about what will happen now. Notably, Igor has offered much more, but not the full truth, since he did not explain that he had taken action (with a tourniquet) to save Hamidou and that his father had then removed it, intentionally murdering the bleeding man. Viewers do not know what happens with this rather crucial detail—will Assita go to the police? Will she first tell her Burkinabe friends? Will she confront Roger? These answers, and the familiar cinematic conflicts they might provide, are all voided when, perhaps most remarkably for the film's (not so) dramatic high point, the camera suddenly stops. It just stays, lingering near the tiled wall of the train station corridor as Assita and Igor walk off down the train corridor and film frame (fig. 13.3).

The camera suddenly seems like someone resting against the wall in astonishment, watching and wondering. Most telling, perhaps, is Igor's reaction to the divergence between Assita and the now resting camera: at first stunned, he jogs to catch up with Assita just before the film cuts to black. At first it is unclear whether he will once again accompany the woman who has become an *Ersatz* for his missing mother but who could put his father away in prison. But Igor jogs to

Figure 13.3 *The Promise*'s ending—watching the backs of Igor and Assita as they depart

catch up with her in a sudden, but now much less encumbered trot (despite the literal luggage he continues to carry). His departure from the camera reminds us that the camera itself has often had to similarly jog to keep up with him and then both of them, that sticking close to the other is an ethical duty. The camera has stuck close—as with this trot, largely by its corporeally detailed depiction—yet Igor and Rosetta, like Jeanne and Nina, remain abiding mysteries to viewers, lingering long after their directors depart them (fig. 13.4).

Figure 13.4 *Ghosts*—Jeanne walks off, viewers watch her back

Notes

1 Petzold's status as the highest-profile director of the Berlin School would seem to hold true at least for the moment, although one wonders if his friend Maren Ade might soon surpass him: her *Toni Erdmann* (2016) garnered widespread praise at the 2016 Cannes Film Festival and has gone on to have over 860,000 viewers in Germany, making it the most popular Berlin School film.

2 For an extended queer reading of some of Petzold's films, see Joy Castro, "'A Place without Parents': Queer and Maternal Desire in the Films of Christian Petzold," dossier on Christian Petzold, edited by Marco Abel and Jaimey Fisher, *Senses of Cinema* 84 (September 2017).

Work Cited

Abel, Marco. 2008. "The Cinema of Identification Gets on my Nerves: An Interview with Christian Petzold." *Cineaste*, http://www.cineaste.com/articles/an-interview-with-christian-petzold.htm, accessed December 4, 2015.

Cooper, Sarah. 2007. "Mortal Ethics: Reading Levinas with the Dardenne Brothers." *Film-Philosophy* 11 (2): 66–87.

Dardenne, Luc. 2005. *Au dos de nos images*. Paris: Le Seuil.

Doane, Mary Ann. 2003. "The Close-Up: Scale and Detail in the Cinema." *Differences* 14 (3): 89–111.

Fisher, Jaimey. 2007. "On the Ruins of Masculinity: The Figure of the Child in Italian Neorealism and the German Rubble-Film." In *Italian Neorealism and Global*

Cinema, edited by Laura E. Ruberto and Kristi M. Wilson, 25–53. Detroit: Wayne State University Press.

———. 2013. *Christian Petzold*. Urbana: University of Illinois Press.

Hanich, Julian. 2010. *Cinematic Emotion in Horror Films and Thrillers: The Aesthetic Paradox of Pleasurable Fear*. New York: Routledge.

Lebrun, Jean-Pierre. 2010. "Le 'travaile social' des frères Dardenne." *Cliniques méditerranéennes* 82: 183–97.

Mai, Joseph. 2007. "*Corps-Caméra*: The Evocation of Touch in the Dardennes' *La Promesse* (1996)." *L'Esprit Créateur* 47 (3): 133–44.

———. 2010. *Jean-Pierre and Luc Dardennes*. Urbana: University of Illinois Press.

Mosley, Philip. 2013. *The Cinema of the Dardenne Brothers: Responsible Realism*. New York: Wallflower Press.

O'Shaughnessy, Martin. 2012. "French Film and Work: The Work Done by Work-Centered Films." *Framework: The Journal of Cinema and Media* 53 (1): 155–71.

Plantinga, Carl. 2009. *Moving Viewers: American Film and the Spectator's Experience*. Berkeley: University of California Press.

Ruberto, Laura. 2007. "Neorealism and Contemporary European Immigration." In *Italian Neorealism and Global Cinema*, edited by Laura E. Ruberto and Kristi M. Wilson, 242–58. Detroit: Wayne State University Press.

Sobchack, Vivian. 1992. *The Address of the Eye: A Phenomenology of Film Experience*. Princeton, NJ: Princeton University Press.

———. 2004. *Carnal Thoughts: Embodiment and Moving Image Culture*. Berkeley: University of California Press.

Siemes, Christof, and Katja Nicodemus. 2009. "Arm filmt gut? Das gefällt mir nicht." *Die Zeit*, http://www.zeit.de/2009/03/Christian-Petzold/komplettansicht, accessed June 24, 2016.

14

THE MAKING OF NOW

New Wave Cinema in Berlin and Buenos Aires

Gerd Gemünden

In the introduction to their anthology on global art cinema, Rosalind Galt and Karl Schoonover make a controversial appeal for the universality of art cinema: "If art films are to travel to international audiences, they must make the claim that their forms and stories are comprehensible across languages and cultures. Thus, part of art cinema's stake in art is an investment in visual legibility and cross-cultural translation. Unlike popular cinema, it does not claim to express a locally defined culture but an idea of (cinematic) art as such." While the authors are well aware of the ideological baggage that such claims to universal legibility entail, they insist that "the problem of universality in art cinema is too compli-cated to be addressed by a simple dismissal" (Galt and Schoonover 2010, 10). In this essay I want to probe Galt and Schoonover's controversial claim about such universality by bringing into dialogue two recent new-wave movements, the Berlin School and the New Argentinian Cinema. In doing so, I am building on my short entry "Eclectic Affinities" in *Berlin School Glossary: An ABC of the New Wave in German Cinema*, in which I sketched points of contact and conver-gence between the Berlin School and global art-house and independent cinemas (Gemünden 2013). Here, I want to offer a more systematic investigation of how the films of the Berlin School and those of New Argentinian Cinema construct and address their respective viewers through strategies of "visual legibility" that are remarkably similar. Yet the affinities between these two movements and their aesthetics are not only indebted to the above-claimed universality of art cinema but are also the result of similar political, economic, and cultural contexts that have shaped the production and exhibition of the films in question. My emphasis

will be on two key proponents of the New Argentinian Cinema, Lisandro Alonso and Lucrecia Martel, whose films I will put into dialogue with selected works by Berlin School directors.

The cultural and institutional reasons for these claimed affinities are complex and need to be briefly mapped. Like the directors of the Berlin School, those subsumed under the (equally contested) label New Argentinian Cinema—which includes, beyond Martel and Alonso, Martín Rejtman, Adrián Caetano, Pablo Trapero, Albertina Carri, Ana Poliak, and several others—were almost all trained in film schools that sprung up in Buenos Aires and elsewhere in the country during the 1990s. During the neoliberal agenda of President Carlos Menem (1989–99), which saw the privatization of many state-owned companies such as telephones and airlines, cinema, ironically, became a government-protected sector meant to showcase the cultural achievements of the nation. Comprehensive legislature to enhance the production and distribution of films, among them the passing of the "ley del cine" (cinema law) and a revamping of INCAA (the National Institute for Audio-Visual Production), brought about a fundamental revitalization of the Argentine film scene. The most visible results include such prestige-driven and nationally and internationally highly successful films as Fabián Bielinsky's *Nueve Reinas* (*Nine Queens*, 2001) and *El aura* (*The Aura*, 2004), as well as Juan José Campanella's *El hijo de la novia (Son of the Bride*, 2001), *Luna de Avellaneda* (*Avellaneda's Moon*, 2004), and the Academy Award-winning *El secreto de sus ojos* (*The Secret in Their Eyes*, 2009)—incidentally, but not coincidentally, all starring Ricardo Darín. In their shadow, a smaller, fiercely auteurist cycle of films emerged that soon won prestigious awards at national and international film festivals. One of these festivals is the BAFICI (Buenos Aires Festival of Independent Cinema), which was inaugurated in 1999 and which, as its name indicates, specifically screens recent "independent" films from the host country. (The quotation marks are meant to indicate that, in the absence of a strong national film industry, the adjective is somewhat meaningless in this context.) In addition, in 1996 the once prestigious but long defunct Mar del Plata International Film Festival was reactivated, now focusing primarily on Latin American and international art-house cinema. These two festivals today serve as the main national conduits for exhibition and, in the case of the BAFICI, also coproduction of new Argentine films. Apart from the new film schools and the state legislature regulating funding and securing exhibition, film criticism, both in print and online, began to play an increasingly important role in promoting new voices. Notable are journals such as *Film, Sincortes,* and *Haciendo cine,* which have a strong online presence and which have joined established publications such as *El amante cine.*

A particular case in point is the print journal *Las naves*, first published in 2013, because it stands today as the most direct and intentional sign of networking between the Berlin School and a foreign film movement. Founded with the explicit support of *Revolver*, and with Christoph Hochhäusler acting as important intermediary, *Las naves* is clearly modeled after the German journal, including the small, pocketsize format.[1] With a special focus on "Manifiestos/ Manifestos," the inaugural issue is made up of forty short, programmatic entries (in both Spanish and English) authored by contemporary filmmakers, including *Revolver* editors Hochhäusler and Franz Müller, a strong sampling of Argentine directors, and a smattering of highly recognized international auteurs such as Apichatpong Weerasethakul and Carlos Reygadas. Many of these manifestos had indeed first appeared in earlier issues of *Revolver*, including several by Argentine directors, indicating that Hochhäusler and company have long been keenly aware of their South American counterparts.[2] (The fact that Hochhäusler served on the jury of BAFICI in 2013 attests to his own standing in the Buenos Aires film scene.) In June of 2015, in collaboration with the well-known Argentine critic Luciano Monteagudo, *Revolver* editors Franz Müller and Hannes Brühwiler curated a series of "Films in Dialogue/Film-Wahlverwandschaften" that paired ten recent Argentine films with German counterparts, including films by Valeska Grisebach, Maren Ade, and Harun Farocki, as well as by Martel, Alonso, Caetano, and Rejtman.[3] The high standing of the New Argentinian Cinema in Germany, in turn, was indicated by an extensive 2015 retrospective at the Haus der Kulturen der Welt in Berlin, curated by Alan Pauls. In his curatorial statement, Pauls asserts, "in this at once very Argentinian and universal cinema, aesthetic innovation is juxtaposed with the crucial desire to uncover the blind spots of a society that has made crisis its virtually natural state, its empire and its passion"[4]—an observation, I claim, that holds true in certain measure for the Berlin School and that ultimately underscores the remarkable parallels between the two movements.

Besides the institutional and cultural contexts, the affinities between the Berlin School and the New Argentinian Cinema also resonate on a more personal level. The German and the Argentine filmmakers are roughly of the same generation, and their entry into film history coincided with the introduction of VHS and later DVD. They thus share access to the world of (art) cinema that is virtually a remote control button away, and, in contrast to the education of previous generations of cinephiles, this access is highly eclectic, non-systematic, and non-chronological. As has often been noted, both the Berlin School and the New Argentinian Cinema lack a manifesto or even a shared style. Hence their respective "members" have often resisted being subsumed under this label, while

nevertheless benefitting from a form of branding that opens doors on the international festival circuit. And while these "members" may ultimately make rather different films, they are in constant dialogue with each other and aware of their peers' work. Moreover, they strongly rely on, and contribute to, the international festival circuit, with particularly impressive showings by Martel and Alonso in Europe, gaining major awards and recognition in Cannes and Berlin.

Apart from the institutional framework, there are important shared political and economic contexts. Differences between Germany and Argentina clearly outweigh similarities here, but for the sake of my argument I will focus on the latter, which are still significant. In circuitous but undeniable ways, both the films of the New Argentinian Cinema and the Berlin School register the fallout of globalization. (While it is ironic, as stated, that, within the fiercely neoliberal agenda of the Menem government, the cinema became a protected entity, it is doubly ironic that this fallout became an important backdrop and hidden subtext of many of the New Argentinian Cinema films. To put it differently: the government ultimately enabled its most creative and original critics.) While German unification brought dramatic changes to both East and West Germany, Argentina experienced an unprecedented series of economic and social crises in the late 1990s and early 2000s. Both ruptures led to the erosion of the welfare state, a radically changed labor market, and a growing disparity between the haves and the have-nots. The aesthetic affinities between the two movements—the stories they tell, how they tell them, where they take place, and who features in them— must be seen as a spectrum of choices that are triggered, at least in part, by the attempt to find novel ways of storytelling in order to render comprehensible the radical changes in the world in which the directors live and work

Indeed, the political dimension of the New Argentinian Cinema—not only the way in which it represents or chooses *not* to represent the crisis but also how the crisis itself became an enabling factor of the movement—can be understood productively if compared to Marco Abel's rigorously Deleuzian reading of the Berlin School, and it is perhaps no coincidence that key critics of the New Argentinian Cinema, such as Joanna Page (2009), Jens Andermann (2012), and David Oubiña (2004), have themselves privileged Deleuze in their readings of the movement. Indeed, what Abel calls an "arepresentational realism" can clearly be detected in the aesthetic preferences of the New Argentinian Cinema, which, like the Berlin School, is a cinema of reduction and minimalism (Abel 2014, 14). It is exclusively concerned with the present, and most of the films tell stories about characters unencumbered by the past (bracketing, for the moment, developments in both movements of the last years that indicate a turn toward films set in earlier periods). While these films are never preachy, they do tally the effects

of precarious labor, the disintegration of families, or waves of new migration to Buenos Aires and other regions.

Unique to the New Argentinian Cinema is its close relation to Italian neorealism, primarily noticeable in its focus on the working class, the downwardly mobile middle class, and children. (Martín Rejtman's *Rapado*, an early precursor, is an extended homage to Vittorio De Sica's *Ladri di biciclette* [*Bicycle Thieves*, 1948]). This focus is combined with a preference for shooting on location, often seeking out locales on the margins, for example the suburbs of the Greater Buenos Aires area or the provinces (particularly in Alonso and Martel). The minimalist form of storytelling is often matched by a minimalist acting style. Many directors detest what in Argentina is called "costumbrismo," a term that describes a mannered style of acting and articulation that betrays a vicinity to theatrical traditions. Instead, we find a preference for lay actors (Trapero and Alonso), or a pairing of non-professional actors with seasoned actors, often cast against type (Martel). In a 2009 *New York Times* article, A. O. Scott coined the term "Neo-Neo-Realism" to characterize a number of recent US independent filmmakers whose films stand in stark contrast to the escapist fare that the Hollywood studios had been producing in the wake of 9/11. These films, which include Kelly Reichardt's *Wendy and Lucy* (2008), So Yong Kim's *Treeless Mountain* (2008), and Ramin Bahrani's *Man Push Cart* (2005) and *Chop Shop* (2007), reminded Scott of an ethics of representation that surfaces at critical times, and for which neorealism provided the original impulse (see also Fech's contribution in this volume). Watching Bahrani's films, Scott notes that the director's "insistence on the tiniest details of camera movement, expression and composition was a reminder to me . . . that transparency, immediacy and a sense of immersion in life are not the automatic results of turning on a camera but rather effects achieved through the painstaking application of craft" (Scott 2009). While Scott does not reference any of the filmmakers of the New Argentinian Cinema, the ethical impulse behind their aesthetics has rarely been better summarized.

Finally, as is customary for many new wave movements, the New Argentinian Cinema rejects the cinema that immediately preceded it. If the Berlin School defines itself against what, for better or worse, has been called the "German heritage film" (Koepnick 2000 and 2002) as well as the "cinema of consensus" of the 1990s (Rentschler 2000), for the directors of the New Argentinian Cinema the bad object is the post-dictatorship cinema of the 1980s, which relied heavily on allegory to tell veiled tales of torture and political opportunism, trying to explain the nation's history to a traumatized people (important examples include Eliseo Subiela's *Hombre mirando al sudeste/Man Facing Southeast* [1987] and *Últimas imágenes del naufragio/Last Images of the Shipwreck* [1990]). It is a cinema whose

tendency to teach and preach the new directors have decried as cowardly and out of touch with current viewers, countering it with films that put a premium on observation and contemplation and that end up practicing an extreme stylistic austerity. As Lisandro Alonso has put it, one of the few things that unites the diverse filmmakers of the New Argentinian Cinema is "the desire to make an honest cinema" (West and West 2011, 38).

If Christian Petzold stands out as the internationally most recognized director of the Berlin School, this honor is shared by Lucrecia Martel and Lisandro Alonso on the Argentine side. Martel's international fame rests on a trilogy of features, all set in the Salta region in northeastern Argentina where she grew up: *La ciénaga* (*The Swamp*, 2001), *La niña santa* (*The Holy Child*, 2004), and *La mujer sin cabeza* (*The Headless Woman*, 2008). All three films revolve around families from the provincial bourgeoisie at specific moments of crisis—be it the social decline of plantation owners drowning in their own inertia; the sexual awakenings of a teenager caught up in religious mysticism; or the existential crisis of a female dentist trying to cover up a hit-and-run accident. Martel's stories are rarely linear; instead we are confronted with nomadic plots heavily influenced by the conventions of oral storytelling as well as by folktales and fairytales, not unlike the narrative structure of Hochhäusler's *Milchwald* (*This Very Moment*, 2003) (Page 2013). These stories are often populated by characters whose relation to each other are left vague and whose zombie-like existences are reminiscent of horror films. Distinctive is Martel's use of the camera, which often prefers to capture people from oblique angles so as to obstruct identification. It also frequently adopts the perspective of a ten-year old, particularly so in *The Swamp*, to render the gaze of the camera with both a sense of curiosity and the uncanny. Equally idiosyncratic is her elaborate use of sound, which is made up of many layers and often contradicts or undercuts the primacy of the visual.

A case in point is *The Headless Woman*, which like Petzold's *Wolfsburg* revolves around a hit-and-run accident. (When asked during the Q&A following the screening of *The Headless Woman* at UCLA in 2009 about a connection to *Wolfsburg*, Martel said that she was not familiar with it, an indication that the German interest in recent Argentine cinema may not be reciprocal.[5]) Martel's film is an extended exercise in uncertainty and ambiguity. On a sunny day, its protagonist, the dentist Véronica, hits something with her car on a dusty road, because, like Philipp, Petzold's protagonist, she is momentarily distracted by her cell phone. She stops but does not get out of the car to check. When she drives on, a dog lying on the road comes into view in the rearview mirror. Soon thereafter, there is talk of a missing boy, and then a body is discovered in a drainage ditch close to the scene of the accident. Véronica first reacts to all of this with a mixture of

Figure 14.1 *The Headless Woman*

shock and denial, which soon transforms into an altered state of estrangement. According to Martel, the protagonist's behavior reflects what happens "when you lose the link between things, and the link between a thing and what it means to you . . . It's not about a woman who feels guilty; it's about a woman whose worlds are nearing collapse" (Wisniewski 2008). Every conversation Véronica has is a non sequitur, everything she does contradicts the little she says. The difficulty of understanding her is amplified by the fact that the film does not follow a person to whom certain things are happening; rather, we are privy to Véronica's perception and what she *thinks* is happening. Véronica's head is the point of origin, but the camera is not *in* her head but close to it, impartial and mercilessly indifferent (fig. 14.1).

Martel has commented that the film was inspired by Herk Harvey's American horror flick *Carnival of Souls* (1962), in which a woman dies in a car crash but continues her life as a living dead—incidentally also a major influence on Petzold's *Yella* (2007)—and Véronica's behavior is best described as that of a zombie. As she stumbles through life, the men around her close ranks and set out to systematically erase any traces of the accident by calling in favors from the well connected. Yet there is an important difference between *The Headless Woman* and *Wolfsburg* as well as the many other films that revolve around the same plot device of a deadly car accident, which include Juan Antonio Bardem's *Muerte de un ciclista* (*Death of a Cyclist*, 1955), Terry George's *Reservation Road* (2007), Nuri Bilge Ceylan's *Üç Maymun* (*Three Monkeys*, 2008), Matthias Glasner's *Gnade* (*Mercy*, 2012), Călin Peter Netzer's *Pozitia copilulu* (*Child's Pose*, 2013), Wim Wenders's *Everything Will Be Fine* (2015), and an episode in the 2014 Argentine surprise hit by Damián Szifrón, *Relatos salvajes* (*Wild Tales*). Martel's protagonist, and the

viewer, never learns for sure whether or not she killed a person. Unlike Petzold's film, then, this is not a melodrama about guilt and atonement but instead a portrait of a society and a class guilty of the sin of omission and for denying any personal responsibility.

While ostensibly a film about today's Germany, *Wolfsburg* contains an important historical dimension, as both Marco Abel and Jaimey Fisher have argued (Abel 2013, 71; Fisher 2013, 68). Behind the slick facade of today's German heartland of the automobile industry rises the specter of Nazism, as the town was specifically chosen as the location for the Third Reich's production of civilian and military vehicles. This historical dimension is even more central for Martel's film. Many critics have read *The Headless Woman* as an allegory about Argentina during the dictatorship: the dead indigenous boy recalls the willfully disappeared. His death is disavowed by those who, like Verónica's family, look away, pretending that nothing has happened ("no pasa nada" is a much repeated phrase in the film), yet still they cover up evidence, just in case. Theirs is a chilling demonstration of the power the privileged have over the flow of information. Such a reading is sustained by the film's many references to the 1970s, including the clothes, the men's sideburns, and the music on the radio—escapist tunes such as "Soleil, Soleil" and "Mammy Blue," which Martel calls "the soundtrack of the dictatorship" (Taubin 2009, 23).

Yet while Verónica's guilt of omission is symptomatic for a society in denial, this form of denial has not stopped with the end of the dictatorship. In other words, to read *The Headless Woman* as a specific comment on the Dirty War is too restrictive if we imply that, with the end of that war, all forms of behavior fostered by the dictatorship ceased to exist as well. In contrast to her other films, Martel has been very insistent about the political implications of *The Headless Woman*: "The social mechanism of silence that was present during the dictatorship is still alive. It is still present in the way poverty is denied. Nonetheless the methods are increasingly sophisticated and because of that more accepted." And she has added, "to me, what is most striking about the dictatorship is not the crimes of the assassins—by which I do not mean to say that they are not terrible—but the complicity of society, which is what most affects us today, because it continues to work like this. The neoliberalism of the 1990s would not have been able to succeed if the civic structures had not been undone . . . The dictatorship bears fruit in the 1990s" (D'Epósito 2008, 41). This insistence on the presence of the past clearly matches Petzold's views on politics, particularly how they come across in *Die innere Sicherheit* (*The State I am In*, 2000), *Barbara* (2012), and *Phoenix* (2014).

Next to Lucrecia Martel stands Lisandro Alonso, who studied at the Universidad del Cine and who, in many ways, is even more uncompromising in

his approach to filmmaking. His so-called ghost trilogy (note the parallel to Pet-zold's *Gespenster* [*Ghost*] trilogy), comprised of *La libertad* (*Freedom*, 2001), *Los muertos* (*The Dead*, 2004), and *Fantasma* (2006), is one of the most radical and controversial examples of the cinema of the long take. *Freedom* narrates in long, quiet shots the labor day of a woodcutter, which includes the careful selection of trunks, hauling and selling them to the local vendor, and then spending the little income garnered on fuel, food, and cigarettes before settling down at his camp-fire. *The Dead* follows a man's release from prison and his journey homeward to a remote island in the Paraná river delta. His re-immersion into nature involves short, monosyllabic exchanges with other villagers and prolonged scenes that exemplify his adroitness for surviving in the wilderness. In these films, Alonso follows neorealist tenets in his use of nonactors and location shooting but also takes such an approach much further.[6] Few directors in contemporary cinema pay such close attention to soundscape and polyphony, to counterpoint of man-made and natural sounds. He employs a dilatory style (protracted duration, static shots), often resorting to *temps mort* for heightened effect. Critics have inevitably claimed that this blurs the boundary between fiction and documentary, but such criticism tends to overlook the great effort through which he strives to make the objects of his films, including humans, appear unstudied.

With his most recent film, *Jauja* (2014), Alonso has turned toward genre and more narrative-driven cinema, while staying truthful to his "signature theme of men alone on a journey" (Quandt 2008, 331).[7] Cowritten with the poet Fabián Casas, photographed by Finnish cinematographer Timo Salminen (known for his work with Aki Kaurismäki), and featuring international star Viggo Mortensen, the film is a colonial adventure that focuses on the period of the so-called con-quest of the desert in Patagonia during the late 1870s.[8] A quasi-western, it has been compared to John Ford's *The Searchers* (1956) while its critique of the fol-lies of racism and colonialism evokes Joseph Conrad's novella *Heart of Dark-ness* (1899).[9] The choice of genre also begs comparison with Thomas Arslan's *Gold* (2013), a western about German immigrants joining the gold rush in late nineteenth-century British Columbia, as well as Kelly Reichardt's *Meek's Cutoff* (2010), a tale about settlers getting lost on the Oregon Trail in 1848.

The protagonist of *Jauja* is Gunnar Dinesen (Mortensen), a Danish engineer in the service of the Argentine Army on the deserted seacoast of Patagonia. He is accompanied by his teenage daughter Ingeborg, the only woman in a very manly crowd of wayward soldiers, commandeered by the unsavory Lieutenant Pittaluga, who lustfully ogles Ingeborg in front of her father. Pittaluga is part of General Julio Argentina Roca's "Conquest of the Desert," the purpose of which was the eradication of the indigenous population in southern and west-central Argentina,

a group of people that Pittaluga refers to as "coconut heads."[10] Early into the film, Ingeborg runs off with a young soldier and Dinesen sets out into the desert to retrieve her. Unlike Ford's Ethan Edwards, Dinesen is not fueled by racism, nor is the northerner well equipped to handle the rugged terrain, quickly turning him into a quixotic figure who loses sense of time, place, and himself. What begins as a frontier drama thus slowly changes into a dreamlike, hallucinatory journey toward the self, replete with a Danish-speaking hermit (possibly Dinesen's long-lost daughter) who bestows mysterious wisdom onto Dinesen, and a concluding (dream?) sequence that transfers us to a chateau in today's Denmark, where a lissome Ingeborg awakens to go for a pleasant walk in the woods. What the narrative may lack in coherence and logic is made up for by the film's startling look, beginning with its unexpected ratio of 1:33, reminiscent of silent cinema, which imbues the images with a painterly look. Alonso explained that "for a film about a lost period in history that takes place at the end of the world one would expect using natural light," but cinematographer Timo Salminen "opted for a form of theatricality and artificiality that creates a world apart," a strong contrast to the look of the director's earlier features (Alzalbert 2014, 34). As Richard Porton has put it, "the visual style suggests what might have happened if John Ford had made a 1960s 'acid Western.' A meticulous attention to composition succeeds in creating a palpable dreamscape that gorgeously reinforces the chimerical nature of Dinesen's futile journey" (Porton 2015, 60) (fig. 14.2).

This chimerical nature also suggests another important point of comparison, namely, Werner Herzog's *Aguirre, der Zorn Gottes* (*Aguirre, the Wrath of God*, 1972), a film much admired by Alonso (West and West 2011, 38). A colonial adventure of a different kind, this film, set in 1560, follows a Spanish expedition that leaves Peru in search of the mythic gold city of El Dorado. A doomed rebellion led by Lope de Aguirre against his leader, Don Pedro de Ursua; the hostile territory; and attacks by largely invisible Amazonian tribes contribute to the utter destruction of the expedition, its only survivor an increasingly manic and crazed Aguirre. Much of the film's power stems from its hallucinatory portrayal of human hubris and tyranny and from a landscape that is represented as both intensely beautiful and utterly indifferent, rendering ridiculous and futile any human aspirations of "conquering" it.

Yet another direct allusion to *Aguirre* is *Jauja*'s opening title card, which explains the name to refer to the elusive El Dorado, but Alonso's film does not revolve around the pursuit of gold (nor did the historical conquest of the desert). This is left for Thomas Arslan's *Gold* (2013), a western about an ill-fated trek of ethnic Germans hoping for their share of luck during the late nineteenth-century Alaskan gold rush. Like *Jauja*, *Gold* is inspired by historical sources. Between

Figure 14.2 *Jauja*

1830 and 1900, more than five million Germans immigrated to the United States to escape poverty and despair. The film follows seven of them who, in 1898, decide to immigrate yet again in the hope of finding gold and bettering their lot. Arslan has explained that, apart from journals and travelogues, he consulted amateur photographs of aspiring gold diggers, whose look cinematographer Patrick Orth tried to replicate by working mostly without artificial light (Peitz 2013).[11] The result is a bleak, forbidding mountain panorama with labyrinth-like forests that ultimately leave only one survivor, the determined and fiercely independent Emily Meyer (Nina Hoss).

Known for his portrayals of urban Berlin, Arslan's choice of genre was even more surprising than Alonso's (and far more contested, as I will address below). While *Gold* contains several plot devices often associated with the western—an unreliable guide, sinister cattle thieves, a broken wagon wheel, a grisly leg amputation, and a showdown in a deserted village—Arslan understands his film as a mere "Nachhall" (echo) of classic westerns (Peitz 2013).[12] Arslan's terminology itself echoes Petzold's claim that his films work in the cemetery of genre, as Fisher has highlighted (2013). Rather than foregrounding action, *Gold*'s main

stance is on recording the hardship and monotony experienced by the German immigrants as they try to traverse a challenging terrain. Ethnicity and landscape here produce a double displacement. How out of place the petty, gossipy, and beer-drinking German city dwellers really are in the Canadian wilderness is perhaps best expressed in the scene in which Müller steps into a bear trap and Rossmann comments on the absurdity of the accident by saying, "What cursed bad luck. Stepping onto a bear trap in such a huge land." Soon thereafter, this namesake of the protagonist of Franz Kafka's unfinished novel *Amerika* (a.k.a. "Der Verschollene," incidentally also a German immigrant who comes to New York) takes off his clothes and disappears into the woods, embracing death like Inez, Don Pedro de Ursua's wife, who lets herself be swallowed by the jungle in *Aguirre*.

The strong Danish inflection of *Jauja* equally underscores a heightened displacement, but rather than a purely existential dimension this also adds to the film's idiosyncratic sense of humor (almost entirely absent in *Gold*). An engineer by training, Dinesen tries to impose rationality on an irrational terrain and fails; as Alonso has commented, "he's trying to organize things that cannot be organized" (Ratner 2015, 30). His uniform stems from the Danish wars with Germany of 1848 and 1864, as do the songs he intones as he, hopelessly lost, rides through the Patagonia desert, rendering his character both ridiculous and pitiable.[13] Wielding a saber as he futilely chases a native (played by Misael Saavedra, the woodcutter of *Freedom* and *Fantasma*) who has just stolen his gun, horse, and hat, Mortensen's Dinesen is a far cry from the actor's role as heroic Aragon in Peter Jackson's *The Lord of the Rings* trilogy (2001, 2002, 2003), which made him world famous.[14]

In both *Gold* and *Jauja*, the awe-inspiring but hostile landscape is more than just a background; it assumes the role of a character who dominates all others. As Eric Rentschler has commented, "Arslan's undertaking, with its endless panoramas and phantasmagoric feverishness, its unpopulated landscapes and flat characters, is an evocative exercise in plot abstinence and an emptiness so radical that it gains an alluring indeterminacy . . . *Gold*'s sparseness is . . . mesmerizing in its psychedelic intensity" (Rentschler 2013, 100).

A meager plot, an empty, endless landscape, and an ill-fated expedition lie also at the core of Kelly Reichardt's *Meek's Cutoff*. As Will Fech underscores in his contribution to this volume, there are numerous points of convergence with this independent American filmmaker and the Berlin School (Reichardt's feature *Wendy and Lucy* is a personal favorite of Hochhäusler's, and the film was among the first to be issued on the *Revolver* DVD label). Like *Gold* and *Jauja*, *Meek's Cutoff* is an unconventional western that underscores the genre's unlikely appeal for art-house directors—and thus provides another example of how, as Galt and

Schoonover put it, "art cinema troubles notions of genre" (2010, 8). Reichardt's film shares with its German and Argentine counterparts not only a creative engagement with genre conventions but also a commitment to exploring historical events. The titular Stephen Meek was a fur trapper and frontier man who in 1845 was responsible for leading a wagon trip astray in the high desert when seeking a shortcut on the Oregon Trail. Working from journals, like Arslan, Reichardt and screenwriter Jon Raymond retell these events as a story of three families who hire Meek to escort them to the Willamette Valley, an undertaking that amounts to an emigration from the United States, as Oregon, like British Columbia and Alaska, was still uncharted territory in those days.

Like *Jauja* and *Gold*, *Meek's Cutoff* essentially chronicles a journey into nowhere. The film joins the group as they cross a river at an unidentified point of the trail, and it abandons them, several days later, helplessly lost in the eastern Oregon desert and desperately searching for water. Dialogue is as sparse as the terrain traversed by the emigrants—there are no spoken words during the first seven minutes—and often the camera observes the toiling individuals in medium-long shots to underscore their forlornness, further enhanced by the predominance of natural sounds such as the rustling of grass, the turning of wheels, and the clanking of tin cups. As Michael Sicinski puts it, the three films all present landscape as "a fractured map, a set of wide, flat spaces that do not forge a coherence for either viewer or protagonist."[15] At key moments, Jeff Grace's minimalist, unnerving score amplifies a mood that wavers between anxiety, exhaustion, and hope. On his blog, Hochhäusler commented that the film's style reflects the authority of its research and the strain of shooting in the desert, lending it a seal of authenticity ("Wahrheitssiegel").[16]

Reichardt shot the film in the 1:37 "Academy" ratio, which feels intentionally anachronistic in today's 16:9-dominated media landscape, and which conveys the settlers' lack of orientation amid the vast landscape that surrounds them—an effect similar to the one Alonso creates through his even more radical 1:33 ratio. As Reichardt comments, "one of the reasons for the square frame [was] to keep you right with the emigrants and not reveal what was up ahead" (Ponsoldt 2011). What might lie up ahead, and which path to follow, is the subject of increasingly intense debates among the three family patriarchs, who nurture growing suspicions about the capabilities of their scout (another similarity with *Gold*). Significantly, the women are excluded from the male realm. Reichardt repeatedly shows them in the foreground and out of earshot of the men deliberating in the background, while their bonnets impair their peripheral vision (likening them to the blinders-wearing oxen that pull the wagons) (fig. 14.3).

Figure 14.3 *Meek's Cutoff*

This double marginalization is the cause of much frustration for Emily Teth-
erow (played by Reichardt's regular Michelle Williams), who ultimately stands
up to Meek and threatens him at gunpoint. Like Hoss in *Gold*, who also knows
how to handle a gun, Williams is cast here as a woman who discovers her in-
ner strength as the men around her fail in their leadership roles. Clearly, one
of the film's strongest revisions of the male-dominated genre of the western is
to highlight the increased role of women on the trails, who assumed more re-
sponsibilities and no longer simply supported all decisions their men made. This
search for independence is shared by both the Emily Meyer of *Gold*—as in many
Petzold films, Hoss's character is eager to leave behind a dark and disappointing
past—and Gunnar Dinesen's teenage daughter, Ingeborg, who declares, "I love
the desert and the way it enters into me" ("Me encanta el desierto, la forma que
tiene de entrar en mi"), thus referencing how the landscape awakens her erotic
fantasies, only to soon thereafter elope with a soldier.

Despite their many points of contact, including the role these films play
within their directors' respective oeuvres, *Gold* and *Jauja* have been very differ-
ently received by critics, a fact that has much to say about the respective new

waves' standing in their home countries. Alonso's *Jauja*, which was coproduced by the Berlinale World Cinema Fund, won the prize of the International Federation of Film Critics (FIPRESCI) at Cannes in 2014, where it screened in the 'Un certain regard' sidebar, and was widely welcomed by both Argentine and international critics as an exciting new departure for the director.[17] Luciano Monteagudo spoke for many when he wrote, "what is unique about *Jauja*, his fifth feature, is that Alonso was able to leave his labyrinth while remaining completely faithful to himself" (Monteagudo 2014). Sicisnki felt similarly, calling the film "a logical extension of the patient, materialist cinema this filmmaker has been producing all along."[18] For Quintín, a long-time advocate of Alonso, the film "demonstrates that his cinema has a much broader range of possibilities than many previously assumed, and obliges you to look at the entirety of his work, as you would with the work of any filmmaker of grand aesthetic ambitions" (Quintín 2014).[19]

In contrast, *Gold*, the only German entry in the competition at the 2013 Berlin Film Festival, took a real beating after its premiere.[20] One particular point of contention was Arslan's turn to genre filmmaking. "Berliner Schule und Western, das will nicht richtig passen" (Berlin School and the western are not a good match), quipped Daniel Sander (2013). For this assessment, Sanders not only conveniently overlooked Arslan's much-praised thriller *Im Schatten* (*In the Shadows*, 2010), which is very much a genre-driven film; he (and many of his colleagues) completely disregarded the critically most successful films by Petzold, which all employ genre cinema in highly productive ways. If Sander did not appreciate what he perceived as an art director's turn to popular cinema, a very different undercurrent marked a general hostility toward Berlin School directors—repeatedly voiced by fellow filmmakers such as Doris Dörrie, Oskar Roehler, and Dietrich Brüggemann—for their apparent disregard for the popular, which is a widespread criticism that has long accompanied the movement, as Abel (2013) has shown. This form of hostility is completely absent in the case of the reception of the New Argentinian Cinema in Buenos Aires—but why?

One simple reason is that, despite its international success, the New Argentinian Cinema remains largely unknown at home, except to scholars and aficionados. While celebrated abroad, in Buenos Aires the films of Alonso and Martel have been mostly ignored by the wider public; *Freedom*, for example, screened for one week in one theater before it disappeared from view (until recently, Alonso's film did not even circulate on DVD).[21] While not that many people actually see Berlin School films at the movie theater, they do secure extensive exposure by virtue of the fact that they are all broadcast on television, which

invariably coproduces them. (The term Berlin School itself is widely used in Germany, though not exclusively with positive connotations.) Furthermore, the various forms of federal and public funding, which have been an essential part of German national cinema for decades, hardly exist in Argentina, with the above-mentioned INCAA providing an important exception. The petty envy for public funding, which is the unspoken impetus of Oskar Roehler's attacks on the Berlin School, is not an issue in Argentina (Suchsland 2005, 6). (While the low-budget *Freedom* was financed by Alonso's family—the director's refusal to write scripts makes him ineligible for most INCAA funding—Martel's *opera prima*, *The Swamp*, benefited from international sources, including Sundance.) As a result, the New Argentinian Cinema does not figure into domestic debates about national film, despite its canonization in the realm of global art cinema. This scenario is well illustrated by the careers of Pablo Trapero and Daniel Burman, initially two of the movement's key directors—to the degree that they have become more involved in a popular cinema, particularly through romance and comedy, they have disappeared from the festival circuit. This either/or scenario is not as pronounced in Germany, where the realms between popular and the artistic are more fluid; perhaps they even are a false dichotomy, as Rentschler has argued in response to the attacks on *Gold*, which he called "a disingenuous and perverse overreaction" (2013, 100).

The turn toward genre as one form of approaching the popular is of course a final point of contact between the Berlin School and the New Argentinian Cinema. Apart from Arslan and Alonso, there is Martel, whose latest film, *Zama* (2017), an adaptation of a novel of the same name by Antonio di Bendetto, is set in the late eighteenth century. Martel's biggest production to date, and the first based on an existing source, this digitally shot period drama proved new terrain for the director. With *Barbara* and *Phoenix*, Petzold, too, has abandoned making films exclusively located in the here and now, a trend he continues with *Transit*, after Anna Segher's 1944 novel. Hochhäusler's thriller *Die Lügen der Sieger* (*The Lies of the Victors*, 2014), Benjamin Heisenberg's comedy *Über-ich und Du* (*Superegos*, 2014), and Jessica Hausner's *Armour Fou* (Crazy Love, 2015), a costume drama about Heinrich von Kleist's suicide in 1811 (a surprisingly funny film, given the subject matter), are all indications of an overall change of direction in the two movements' trajectory. While I do not want to engage here with Hochhäusler's verdict whether or not "school is out," and with speculations about possible future developments, it is striking to note the obvious parallels in the new routes these auteurs have chosen to take (2013, 28). It will be interesting to see what waves come after these new waves.

Notes

I would like to thank Julio Ariza and Silvia Spitta for their comments on earlier versions of this essay.

1 One can get an impression of the journal from its website: http://www.tenemo slasmaquinas.com.ar/las-naves.

2 Hochhäusler has professed to be a fan of Martel, and *The Headless Woman* so impressed him that he tried to hire Martel's cinematographer, Bárbara Álvarez, for his latest film, *Die Lügen der Sieger/The Lies of the Victors* (2015), but Álvarez ultimately could not fit the project into her schedule.

3 See http://www.haciendocine.com.ar/content/cine-alemán-y-argentino-en-el-ciclo-revolver-de-la-sala-lugones and http://revolver-film.blogspot.de/2015/06/revolver-in-buenos-aires.html. Accessed September 9, 2015.

4 See http://www.hkw.de/en/programm/projekte/2015/nuevo_cine_argentino/nuevo_cine_argentino_start.php. Accessed September 9, 2015. I thank Marco Abel for bringing this retrospective to my attention. As Hochhäusler told me, there is no direct relation between this event in Berlin and the *Revolver*-curated series in Buenos Aires.

5 As Hochhäusler told me, Martel has also shown little interest in being interviewed for *Revolver*. Director Santiago Mitre (*El estudiante*) and the collective Cine Pampero have also not reciprocated the Germans' interest in their films.

6 On neorealist tenets in Alonso, see Gundermann (n.d.).

7 Ironically, Quandt used the title "Ride Lonesome" for his review of Alonso's *Liverpool* (2008), that is, before Alonso had ever put one of his protagonists on horseback (as he would in *Jauja*).

8 The role of the truly trilingual Mortensen in *Jauja* cannot be overestimated. As Alonso told me in conversation, Mortensen coproduced the film by paying 50 percent of its cost, made important suggestions to the script, is responsible for the music, and has been a most avid and eloquent advocate of the film (Hanover, NH, January 15, 2016). See also Mortensen's and Alonso's 2014 conversation with critic Kent Jones at the Lincoln Center in New York: https://www.youtube.com/watch?v=hBQ9oVoJ21U.

9 Particularly, the character of Zuluaga, an officer of almost mythical proportions and repeatedly alluded to in the film though never seen, has provoked comparisons to Conrad's Kurtz. This particular character was first introduced by Alonso in his short *Sin título* (*Carta para Serra*, 2011), which formed part of Jordi Balló's project, *Todas las cartas: Correspondencias fílmicas*, for which selected filmmakers were paired and asked to create "filmic letters" for each other (in Alonso's case, the addressee was Catalan filmmaker Albert Serra). At the end of Alonso's twenty-two-minute film, a long letter, read by Fabián Casas, describes the exploits of a certain Diego Zuluaga, "a savage in military uniform."

10 For a discussion of the literary representations of the conquest, see Andermann (n.d.).

11 An example of such an account from travelers, from 1898, can be found here: http://www.joern.de/Klondyke.htm. Accessed September 1, 2015.

12 See also Arslan's interview for the film's press kit for the 2013 Berlinale, where he calls *Gold* a "Spätwestern" (late western).

13 As Mortensen commented in the above-cited interview with Kent Jones, "during the world premiere at Cannes, I sat among a lot of Danes. Our row was laughing most of the movie."

14 Alonso has stated that what attracted him to Mortensen was his minimalist acting style (which is even on view in Jackson's trilogy): "He doesn't like overacting, he is very bodily [körperlich]." Quoted in Nehm (2013, 110).

15 See Michael Sicinski's blog: http://academichack.net/jauja.htm. Accessed June 6, 2015.

16 See Hochhäusler's blog: http://revolver-film.blogspot.pe/2011/11/filmc-lub-meeks-cutoff.html. Accessed November 11, 2015.

17 As Alonso told me in conversation, Cannes wanted to pressure him into cutting the last part of the film that takes place in Denmark, but unlike with *Freedom*, where he acquiesced to eliminate the final scene, in which Misael bursts out into laughter, he and Mortensen did not allow any alterations (Hanover, NH, January 15, 2016).

18 See Sicinski's blog: http://academichack.net/jauja.htm. Accessed June 6, 2015.

19 Elsewhere, Quintín has underscored that Alonso is "the only cineaste of his generation who is truly important" (Quintín 2009, 140).

20 Consider, for example, the following contributions: Brüggemann 2013; Sander 2013; and Young 2013.

21 As Alonso has explained, "I've always felt more respected outside of Argentina than inside of it. *Los muertos* premiered in Argentina with an audience of 3,500, which is nothing, but it makes me happy because with *La libertad* we only got 2,500. The film was shown on only one screen, and now it premieres in France on 15 different screens" (Klinger 2005).

Works Cited

Abel, Marco. 2013. *The Counter-Cinema of the Berlin School*. Rochester, NY: Camden House.

Alzalbert, Nicolas. 2015. "Les hommes de la Pampa: Entretien avec Lisandro Alonso et Viggo Mortensen." *Cahiers du Cinéma* 710 (April): 33–35.

Andermann, Jens. 2012. *New Argentine Cinema*. New York: Tauris.

———. N.d. "Argentine Literature and the 'Conquest of the Desert,' 1872–1896." http://www.bbk.ac.uk/ibamuseum/texts/Andermann02.htm. Accessed September 2, 2015.

Brüggemann, Dietrich. 2013. "Fahr zur Hölle, Berliner Schule." *Artechock*, February. http://www.artechock.de/film/text/special/2013/berlinale/02_14_brueggemann_berlinerschule.html. Accessed September 2, 2013.

D'Espósito, Leonardo. 2008. "Los noventa son el plan maestro de la dictadura: Entrevista con Lucrecia Martel." *Crítica de la Argentina*, August 20, 40–41.

Fisher, Jaimey. 2013. *Christian Petzold*. Urbana: University of Illinois Press.

Fisher, Jaimey, and Brad Prager, eds. 2010. *The Collapse of the Conventional: German Film and Its Politics at the Turn of the Twenty-First Century*. Detroit: Wayne State University Press.

Galt, Rosalind, and Karl Schoonover. 2010. "Introduction: The Impurity of Art Cinema." In *Global Art Cinema: New Histories and Theories*, edited by Rosalind Galt and Karl Schoonover. New York: Oxford University Press.

Gemünden, Gerd. 2013. "Eclectic Affinities." In *Berlin School Glossary: An ABC of the New Wave in Germany*, edited by Roger F. Cook, Lutz Koepnick, Kristin Kopp, and Brad Prager, 101–7. Chicago: Intellect.

Gundermann, Christian. N.d. "*La libertad* entre los escombros de la globalización." http://www.lehman.cuny.edu/ciberletras/v13/gunderman.htm. Accessed September 7, 2014.

Hochhäusler, Christoph. 2013. "On Whose Shoulders: The Question of Aesthetic Indebtedness." In *The Berlin School: Films from the Berliner Schule*, edited by Rajendra Roy and Anke Leweke, 20–29. New York: Museum of Modern Art.

Hughes, Darren. 2009. "'Who's John Ford?': An Interview with Lisandro Alonso." *Senses of Cinema* 50 (April). http://sensesofcinema.com/2009/conversations-on-film/lisandro-alonso-interview/. Accessed September 7, 2014.

Klinger, Gabe. 2005. "Lisandro Alonso, Mostly in His Own Words." *Senses of Cinema* 36 (July). http://sensesofcinema.com/2005/conversations-with-filmmakers-36/lisandro_alonso/. Accessed June 6, 2015.

Koepnick, Lutz. 2002. "Reframing the Past: Heritage Cinema and Holocaust in the 1990s." *New German Critique* 87 (Fall): 47–82.

———. 2004. "Amerika gibt's überhaupt nicht: Notes on the German Heritage Film." In *German Popular Culture: How American Is It?*, edited by Agnes Mueller, 191–208. Ann Arbor: University of Michigan Press.

Monteagudo, Luciano. 2014. "El desierto rojo." *Página 12*, November 27. http://www.pagina12.com.ar/diario/suplementos/espectaculos/5-34090-2014-11-27.html. Accessed November 11, 2015.

Nehm, Daniel. 2013. "Interview Lisandro Alonso." *Revolver* 29: 94–113.

Oubiña, David. 2004. "Between Breakup and Tradition: Recent Argentinean Cinema." *Senses of Cinema* 31 (April). http://sensesofcinema.com/2004/feature-articles/recent_argentinean_cinema/. Accessed April 8, 2014.

Page, Joanna. 2009. *Crisis and Capitalism in Contemporary Argentine Cinema*. Durham, NC: Duke University Press.

———. 2013. "Folktales and Fabulation in Lucrecia Martel's Films." In *Latin American Popular Culture: Politics, Media, Affect*, edited by Geoffrey Kantaris and Rory O'Bryen, 71–87. London: Boydell and Brewer.

Peitz, Christiane. 2013. "Die Pferde sind weich gefallen." *Tagesspiegel*, February 9. http://www.tagesspiegel.de/kultur/thomas-arslan-im-interview-die-pferde-sind-weich-gefallen/7758046.html. Accessed February 9, 2013.

Ponsoldt, James. 2011. "Interview with Kelly Reichardt." *Filmmaker Magazine*, November 23. http://filmmakermagazine.com/35034-lost-in-america-kelly-reichardts-meeks-cutoff/#.VkC9MelYy04. Accessed November 11, 2015.

Porton, Richard. 2015. "*Jauja*." *Cineaste* (Summer): 59–60.

Quandt, James. 2008. "Ride Lonesome." *Artforum* 47 (3): 331–35.

Quintín. 2009. "Hacia el fin del mundo: El cine de Lisandro Alonso." In *Historias extraordinarias: Nuevo cine argentino, 1999–2008*, edited by Jaime Pena, 139–49. Madrid: T and B Editores.

———. 2014. "Into the Unknown." *Film Comment* (September/October). http://www.filmcomment.com/article/into-the-unknown/. Accessed November 18, 2015.

Ratner, Megan. 2015. "People Are an Excuse to Show Locations: Lisandro Alonso on *Jauja*." *Film Quarterly* (Spring): 26–33.

Rentschler, Eric. 2000. "From New German Cinema to the Post-wall Cinema of Consensus." In *Cinema and Nation*, edited by Mette Hjort and Scott MacKenzie, 260–77. London: Routledge.

———. 2013. "School's Out?" *Artforum International* 51 (9): 99–102.

Sander, Daniel. 2013. "Deutsche Berlinale-Hoffnung 'Gold': Ein Film wie ein Marterpfahl." *Spiegel Online*, February 9. http://www.spiegel.de/kultur/kino/berlinale-wettbewerbsfilm-gold-rezension-a-882341.html. Accessed February 9, 2013.

Scott, A. O. 2009. "Neo-Neo Realism." *New York Times*, March 22. http://www.nytimes.com/2009/03/22/magazine/22neorealism-t.html?pagewanted=all&_r=0. Accessed September 9, 2015.

Suchsland, Rüdiger. 2005. "Langsames Leben, schöne Tage: Annäherungen an die Berliner Schule." *Film-Dienst* 5: 6–9.

Taubin, Amy. 2009. "Identification of a Woman." *Film Comment* (July/August): 20–23.

West, Dennis, and Joan M. West. 2011. "Cinema Beyond Words: An Interview with Lisandro Alonso." *Cineaste* 36 (2): 30–38.

Wisnieswki, Chris. 2008. "When Worlds Collide: An Interview with Lucrecia Martel, Director of *The Headless Woman*." *Reverse Shot* 25. http://www.reverseshot.com/article/interview_lucrecia_martel. Accessed April 12, 2012.

Young, Deborah. 2013. "'Gold': Berlin Review." *Hollywood Reporter*, February 9. http://www.hollywoodreporter.com/review/gold-berlin-review-420026. Accessed February 9, 2013.

15

TOWARD AN AESTHETICS
OF WORLDLESSNESS

Béla Tarr and the Berlin School

Roland Végső

According to a widely disseminated thesis, the fundamental social experience of the modern age is best described through the paradox of worldlessness: while modernity supposedly brought us closer to each other through various technological inventions, in reality the social experience corresponding to these new forms of connectedness is the shared experience of the loss of a common world. What was supposed to tie us together in an even tighter new bond actually ended up separating us from each other. Consequently, what we have in common today is that we have almost nothing in common. This historical diagnosis is so influential that we can detect its effects in the most disparate discourses. It is part of our philosophical discussions just as much as our popular political commentaries. At its worst, this narrative kindles in us the flames of an antitechnological nostalgia that dreams of a return to an earlier stage of social development. At its best, it forces us to question the often nefarious ideologies at the heart of technological utopias that promise us earthly immortality at a price we might not be ready to pay.

Given the general pervasiveness of this historical diagnosis, it is not necessarily easy to pin it down and articulate all of its variations.[1] In more recent versions of this narrative, it is contemporary capitalism that is held responsible for this worldless state of global affairs. As this argument goes, the price we pay for the global conquest of the "world market" is that we lose the common world. In this context, the best-known point of reference remains Marx's familiar description of capitalism in *The Communist Manifesto*: "all that is solid melts into air" (Marx 2008, 6). According to this analysis, the ontology of capital prevents

the emergence of any fixity, stability, or permanence: "Constant revolutionizing of production, uninterrupted disturbance of all social conditions, everlasting uncertainty and agitation distinguish the bourgeois epoch from all earlier ones. All fixed, fast-frozen relations, with their train of ancient and venerable prejudices and opinions are swept away, all new formed ones become antiquated before they can ossify" (6). Capital is, by definition, worldless. A contemporary version of this argument can be found in Alain Badiou's writings in *Polemics*: "In its circumstantial aspect, capitalist nihilism has reached the stage of the non-existence of any world. Yes, today there is no world as such, only some singular and disjointed situations" (Badiou 2011, 34).

Thus, the debate concerning the status of art in this historical situation offers us two basic positions. On the one hand, to the degree that art imagines itself to be outside of capitalist production, it is often argued that the work of art might be the last point of resistance against the general onslaught of worldlessness. On the other hand, others argue that not even art can escape this historical fate, and the horror of our contemporary situation is best expressed by the fact that art itself has become worldless.[2] This ambivalence of art as both a resistance against and an aesthetic expression of worldlessness raises the question of whether we can even speak about something like an aesthetics of worldlessness. The very term seems to confront us with a paradox. It appears that one of art's basic functions is to reveal a world to us. In this sense, speaking about the aesthetics of worldlessness might amount to speaking in contradictions. So the very limit of the aesthetic might be at stake in this debate. In a world where various historical forces threaten the very conditions of worldliness as a form of public appearance, the role of art might be to render the conditions of this disappearance visible.

The argument of this essay is that the films of the Berlin School should be interpreted in the context of this historical thesis concerning the paradoxes of modern worldlessness. It would not be an exaggeration to claim that virtually every film produced by this group of directors is a unique attempt to come to terms with some aspects of this narrative. In this regard, the works of Béla Tarr stand out as an immediate point of reference. Among the living classics of world cinema, his late works appear to be the most consistent engagements of contemporary worldlessness. Yet, the Berlin School and Tarr represent quite different sensibilities.[3] Tarr's late works (released after 1988) overlap with the rise of the Berlin School in the 1990s in such a way that we could argue that while Tarr's films represent a "residual," the Berlin School represents an "emergent" cinematic ideology. Nevertheless, it is possible to interpret these films as reactions to the same historical reality: the end of the Cold War and the rise of a new capitalist

global order. In other words, these two forms of cinema inhabit the same social spaces even if they are based on different social experiences.

In this context, films like *Szabadgyalog* (*The Outsider*, 1981), *Kárhozat* (*Damnation*, 1988), and *A torinói ló* (*The Turin Horse*, 2011), present useful points of contrast for Berlin School films like Angela Schanelec's *Marseille* (2004) and Thomas Arslan's *Gold* (2013). In fact, this comparison can allow us to outline the basic matrix of contemporary cinematic worldlessness. In what follows, first I will use Tarr's final film, *The Turin Horse*, to uncover the political and metaphysical dimensions of worldlessness in his cinema. At the same time, the aesthetic distance separating Schanelec's *Marseille* from Arslan's *Gold* will show us that the Berlin School cannot be reduced to a rigidly unified program even if there are obvious commonalities among its representatives. While Schanelec's film presents a quite traditional critique of worldlessness, Arslan's western story suggests that there might be positive forms of worldlessness. In other words, my argument is that worldlessness can be treated either (1) as a political or (2) as a metaphysical problem, and it can be given radically different meanings, as it can either be seen (3) as the radical alienation of the individual or (4) as a positive chance for new forms of self-realization that need to be affirmed rather than criticized today. But it is the tensions among the four poles of the square (politics, metaphysics, critique, and affirmation) that define the worldlessness of world cinema today, rather than one particular position taken up against the others.

The End of the World

Tarr described his last film project in an interview with these words: "I wish to make one more film about the end of the world and then I am done with making films" (quoted in Kovács 2013, 145). So what does it mean that Tarr's last film is about the "end of the world"? Or, what does it mean that the theme of the "end of the world" is something like the hidden paradigm of his whole oeuvre? Obviously, we are not dealing here with the type of clichéd apocalypticism that motivates a good deal of contemporary catastrophe fiction. In the case of the latter, the catastrophe is simply the means of salvation, and salvation simply means the preservation of the current social and political status quo. Nor are we talking about the type of theological apocalypse that literally expects the end of creation to be an imminent event. Jacques Rancière's term "the time after" appears to be a more accurate approximation of Tarr's interest in the end of the world. The "time after" refers to a prolonged and even potentially perpetual state in which the

decisive event of a history has already taken place: the world has already ended, yet existence is not over yet.

In a certain sense, Tarr's early films are closer to the aesthetics of the Berlin School than the late ones. Just like the Berlin School films, Tarr's early films are directly embedded in the historical present, in recognizable social and economic realities, and can be seen as documenting the disintegration that takes place after the world has ended. The arithmetic of worldlessness that ties these films together (but also governs his late ones) works with three basic entities: the many (society, the group, family, and so on), the two (the couple), and the one (the isolated individual). On all three levels, however, these films identify an unsettling ambiguity. The group supposedly provides necessary companionship for the individual, but the suffocating proximity of others becomes the source of unbearable conflicts that inevitably lead to the decomposition of any social formation. In this regard, the Hungarian title *Családi tűzfészek* (*The Family Nest*, 1979) is quite telling. The original title simultaneously evokes the image of the "family nest" (*családi fészek*) and the catastrophe that a fire can unleash on a family nest (the word *tűzfészek* names a fire hazard). Similarly, the couple evokes the emotion of love as the last human value left in an unlivable world. However, it is precisely the different forms of coupling that represent a major threat to the group itself. This is what we see in *Panelkapcsolat* (*The Prefab People*, 1982). The title refers to the impossibility of the couple: it names a prefabricated relationship (which is the meaning of the made-up term "Panel-kapcsolat") that cannot be maintained as a relationship. The couple, therefore, cannot be constituted as an enduring unit. Finally, the individual, who cannot inhabit either the group or the couple, is left alone in a state of radical isolation that makes meaningful action unimaginable. While isolation might first seem like the necessary condition of an empowering individualism, in the end it leads to unbearable loneliness. This is the story of *The Outsider*. Once again, the original title, *Szabadgyalog*, evokes ambiguity more directly than the translation. The term "szabadgyalog" is a technical expression borrowed from chess. It refers to a pawn whose movement is not opposed by the opponent's pawn. The ambiguity here resides in the duality between the freedom of the pawn to move forward and the predetermined path of this movement that is not free.

We can, therefore, speak about a social arithmetic of worldlessness in these films in the sense that neither the many (plurality of the social), nor the two (duality of the couple), nor the one (individuality) provide these characters with a foothold in life. Their existence is no longer tied to a meaningful totality. In this regard, *The Outsider* remains the film closest to some of the central concerns of the Berlin School. On a thematic level, this film could be easily compared to

Schanelec's *Marseille* as well as Arslan's *Gold*, since they all present stories about "outsiders." The outsider is precisely the one who no longer inhabits a shared world. The film's central character, András, is a young man who drifts through life aimlessly. In the opening scene, we see him working for a mental hospital as a nurse. But he soon loses his job, and the film goes through a seemingly unmotivated sequence of life events: András gets another job; his son (who might or might not be actually his son) is born from a woman he does not wish to have anything to do with; his brother suddenly shows up after three years in East Germany as a guest worker; he gets married to another woman called Kati; one of his drinking buddies dies; he becomes a DJ at a disco; his brother and his wife have an affair; he considers moving to Budapest to find a better job; and, finally, in the last scene, we see him and his wife at a restaurant discussing their potential future together since he had been drafted for his required two-year military service. The transitions among the sequences are abrupt and seemingly unmotivated. The cuts are first confusing for the audience as we need a few moments to figure out how the story has progressed between the different scenes. There are really only two things that provide some consistency to András's life. The first is his alcoholism. In fact, the various pubs that appear in the film are the only public spaces that provide some kind of community for him. The other is music: András appears to be a somewhat talented violinist, but he does not know how to turn this hobby into a profession. Even art is incapable of making up for the loss of the world that he already suffered.[4]

The theme of worldlessness, however, receives a more abstract existential treatment in Tarr's later films. Usually, *Damnation* is cited as the first film of the late style that also introduced an apocalyptic tone. The end of the world here has both a spatial and a temporal meaning. First and foremost, it refers to the location where the possibility of living in a world is no longer granted to human beings. Yet, it also names the temporality specific to this location: existence after the world's general disintegration has already started. For example, László Krasznahorkai (the writer whose works inspired most of Tarr's film after *Damnation*) described the worldview that he shared with Tarr by reference to the negation of the world itself:

> We wanted to express a general human existential predicament from a point of view that is, nevertheless, available only from this specific location. . . . We did not depict the world as something to which one can say only a categorical *no* because we cannot see that life has a brighter side as well, that there are pleasures, and the human being is capable of happiness every now and then. . . . The reason for this categorical no to the world was not

a hatred of humanity. Whoever sees something like this in this film is com-
pletely wrong. (Kovács 1988, 17)

Two important points can be gleaned from these words. The first concerns the
recognizably Hungarian or Eastern European settings of Tarr's films. As Kraszna-
horkai suggests, here Eastern Europe is not, strictly speaking, a geopolitical but
rather an ontological location—a way of being that is simultaneously radically
tied to a specific location and can be generalized beyond the geographical bound-
aries of what we call Eastern Europe in the ordinary sense.[5] That is, Eastern
Europe in this existential sense is something like a "concrete universal": an em-
pirical fact that functions as the manifestation of a universal predicament. But
Krasznahorkai also gives a specific meaning to this concrete universal when he
identifies it with a "categorical no to the world." This is, then, the second import-
ant point: Eastern Europe emerges as something like an ontic metaphor for the
general ontology of worldlessness. Yet, Krasznahorkai is very careful to distance
this worldlessness from simplistic forms of moral nihilism. As he insists in the
rest of the interview, the film's point is to bring about a change in the audience.
This change, however, does not concern the fact of worldlessness but only our
interpretations of this ontological fact.

We can therefore speak about the existence of a world in *Damnation* only in a
limited sense. András Bálint Kovács described this experience with the following
terms: "The world is rather static in this film; motions are repetitive, circular and
have no direction. The camera moves about in this world of objects and almost
frozen people sometimes in strange postures, revealing them one after the other,
as if it were wandering around aimlessly in a dead landscape" (Kovács 2013, 59).
Strictly speaking, the characters in these later films do not experience a "world"
(a meaningful totality as a space for human action). They do not have worlds but
only environments—immediate surroundings made up of more or less familiar
objects, landscapes, animals, and people. This terrain provides them only a very
limited field of action. The environment's components are loosely connected,
contingent fragments of existence that, in their irreducible particularity, funda-
mentally function as traps in which human existence is captured and held steady
only for a passing moment that lasts a whole life. Tarr's characters move in this
environment as if they were exploring it in only a tentative manner. Once some-
thing has proven to be real and safe, the characters inhabit that restricted domain
with the dullness of a satiated animal.

So Tarr's final film, *The Turin Horse*, is about the end of the world in that it
stages the absolute evacuation of the field of representation. The story narrates
the last six days of a father-daughter couple who live monotonous lives in an

Figure 15.1 *The Turin Horse*: The final shot of Tarr's *The Turin Horse* before complete darkness swallows the entire world.

otherwise unspecified rural location. Their house is located in a valley that designates the absolute horizon of their existence. The story suggests that beyond the hills of this valley the whole world has already disappeared or is in the slow process of complete disintegration. At the end of the fifth day, an inexplicable darkness sets in over what is still left of the world. On the sixth day, the father and the daughter exist in this almost absolute silence and darkness. In the film's final scene, we see them against a black background seated at the table trying to go through their regular daily routine of eating boiled potatoes, but the daughter is now in a state of catatonic listlessness. Slowly, the father also stops trying to engage her, and they both sit staring in front of themselves for a while before the scene fades out (fig. 15.1).

The film's aesthetic, therefore, forces us to face a strange paradox. In this final scene, cinema (the art of light) forces its audience to stare at a pitch-dark screen. All of the aesthetic components of a film can be described as disappearing right in front of our eyes: the story is dominated by the conflict between the circular repetition of the same mindless daily routine and the linear narrative of disappearance; unlike in some earlier Tarr films, dialogue is reduced to almost nothing; characters are impossible to penetrate as they are merely presented to us externally through their repetitive actions; and the setting is literally swallowed by darkness. What remains at the end, although we do not know exactly for

how long, is some extradiegetic sound: the narrator and the haunting music that dominates many of the scenes.

Sophie's World(lessness)

One of the best cinematic metaphors of the contemporary paradox of world-lessness can be found in Angela Schanelec's film *Orly* (2010). As the title already suggests, the airport (any airport in general) functions here as the quintessential symbolic location that supposedly connects us to each other by establishing the channels of the global circulation of human bodies, yet it also produces a singularly anonymous space. We go to the airport in order to be connected to other places. But while we are at the airport, our artificially enforced and often unbearable proximity to one another is actually the condition of a radical isolation.

Yet this abstract reflection on the function of airports does not fully reflect Schanelec's intentions. For, in her case, the empirical specificity of the southern terminal of the Paris airport in itself is part of the aesthetic experience. The beauty of the space becomes an occasion for the aesthetic contemplation of worldlessness. Almost the entirety of the film takes place at the airport. We follow the essentially unrelated stories of four couples: a young woman just broke up with her older lover and is on her way to leave Paris; a man and a woman, two French expats, happen to sit next to each other and start to chat—maybe even begin to flirt; a mother and a son are on their way to the boy's father's funeral; and, finally, we see a young German couple on vacation who already appear to be wholly alienated from each other. In the midst of these stories, there is only one additional character that we keep returning to who does not seem to be part of a couple: a young female airport employee who works at a ticketing counter.[6] The stories directly intersect only once, when the German man of the final alienated couple begins to stalk the young woman from the opening scene. While for a passing moment they are aware of each other's existence, this pursuit goes nowhere.

In an interview, this is how Schanelec defined the experience of the airport: "At the airport, we know that we will eventually leave, and until the moment of departure we actually do not have to worry about anything. This situation produces a specific kind of passivity. . . . People at the airport are completely undemanding and passive (laughs). Undemanding and passive! Two completely negative concepts for everything that drama must evoke" (Boehm and Lucius 2010). In *Orly*, the airport becomes a space of suspension that blurs the boundaries between speed and stillness, activity and passivity, the public and the private. This moment of suspension, however, has its own temporality, which is not quite the

same "time after" that characterized Tarr's films but the "time before" that reveals something about the human condition. The suspension of everyday activities in this undemanding passivity becomes an occasion for a set of possible revelations. Anticipating the certainty of departure, we can for a short time period step outside the everyday world in order to reflect on our place in it with a new intensity. We could even say that this suspension is the very condition of taking an aesthetic distance from the world itself.

But what this new space reveals is not something deep about the characters but an emptiness. Prompted by another interviewer, Schanelec defines the very construction of the film in terms of the emptying out of all things: "Everything is emptied out. I find it almost ideal that there are only words left and the empty screen. From the very first scene to the end, the whole film is the journey to what I really wanted. . . . And at the end, there is only the off-text and all human beings are gone" (Knörer 2010). We can, therefore, define the film's worldlessness by reference to the terms suspension, passivity, and emptying out. These categories are simultaneously terms to describe a specific set of social experiences and technical terms defining the film's aesthetics. For what the quotations above show is a parallelism between the social and the aesthetic. The final literal evacuation of the airport due to some kind of an unspecified emergency is reflected in the progressive elimination of filmic content on the screen. The journey that we follow here leads us up precisely to this void (that Schanelec described above as that which she really wanted to show).

But while *Orly* concentrated on the communal experience of worldlessness, Schanelec's *Marseille* (2004) presents us the classic scenario of the progressive isolation of the individual. In the narrative's three parts, we follow a young German woman, Sophie (Maren Eggert), who, on a whim, decides to spend a ten-day vacation in Marseille, when she responds to an ad offering to swap apartments. The film's first part narrates Sophie's otherwise quite mundane experiences in Marseilles as she devotes most of her time to photographing the city. The second part shows Sophie's life back in Berlin. These sequences eventually shift the focus from Sophie to the family of her friend Hannah, who is married and has a son. This part ends with Sophie's decision to return to Marseille. The short final part reveals the aftermath of the crime that Sophie falls victim to immediately after her return to the city.

This smooth plot description, however, does not do justice to the film's actual composition, which is mostly defined by unexpected cuts and sudden jumps. What is the logic of this composition? Early in the film, Sophie has a conversation at a bar with Pierre, the car mechanic who rented his car to her while she was exploring Marseille. Here, *Marseille* seems to suggest that there is a budding

romance between the two even if we do not see the formation of an actual couple. After Sophie returns the car keys, Pierre asks: "So did you do what you wanted to do?" Sophie's strange answer, which makes them both laugh, is: "Yes, but I found out only as I was doing it." This conversation simultaneously explains the film's narrative logic and provides a reflection on the techniques of representation used by Schanelec. Shortly after this conversation, when Pierre asks why Sophie decided to go to Marseille, Sophie's answer remains enigmatic. Of course, there was the fact that she had never been to Marseille before. But, this is not a good explanation. There are a lot of other places that she has not seen yet, so the specific choice of Marseille cannot be explained with this logic: "There is no special reason. I do as I please. I had time off."

This dialogue with Pierre reflects on motivations for human action. Both parts of the conversation cancel out commonsense versions of everyday causality. The question "why" makes very little sense in this world that appears to be ruled by the stupid fatality of the accident. The reason for an action cannot be determined in advance. Only the act can reveal its own reason. This is the logic of the retroactive projection of a cause. Sophie's claim that she did what she wanted to do, although she could not have known in advance what she wanted to do until she actually did it, suggests that things become their own justifications. So, direct logical causality is not the cement of this world: things fall apart. Not connected by clearly recognizable strong ties, they start floating away from each other like galaxies in an expanding universe.

From a social perspective, Sophie's objection to the world is that it is purely theatrical. This critique comes to the surface during a fight with her friend, Hannah, a professional actor. The conversation is provoked by Hannah, who is trying to force Sophie to admit something about her relationship to Hannah's family. Why does Sophie admire Hannah's husband and son? Such an admiration, Hannah claims, implies that she is stupid if she is not happy with her life. For a while Sophie resists engaging Hanna's provocations, but eventually she lets her guard down and speaks her mind. Her point is important because at first it appears to be counterintuitive. The problem with the world today is not merely that in the age of universal consumer culture people are forced to pretend to be happy, when in reality their lives are full of suffering and misery. Sophie's point goes further than that. She accuses Hannah of only pretending to be unhappy, claiming that she is only acting a role, as if she were still in one of the Anton Chekhov plays that she admires so much. In this world, suffering is a Chekhov play that we can choose to imitate. So, the problem with the world's radical theatricality is not that it forces us to pretend to be happy when we are really unhappy but that it spoils suffering as well. We cannot even suffer in an authentic way anymore, since suf-

Figure 15.2. *Marseille*: The final shot of Schanelec's *Marseille* showing Sophie, wearing a yellow dress, disappear into the landscape.

fering itself is merely a performance. As Sophie puts it: "You cannot stop acting!" In a world like this, we are deprived of the very possibility of having authentic experiences. This is a world that only pretends to be a world now.

Quite significantly, this conversation appears to be the moment when Sophie decides to return to Marseille. The decision's timing suggests that she remembers Marseille as the place where she could be herself without this theatricality. Her normal life in Germany is mere pretense, and to escape the burden of this fake existence she seeks to return to the place of authentic selfhood. But there is no returning. In fact, the film already demonstrated the very impossibility of returning when she returned home from her vacation. At this point, Germany feels different to her. It is certainly not a home, in the emphatic sense of the term. What ties Hannah to her world is her acting, the fact that she can pretend to live in a world. But all Sophie has is a hobby. The function of photography is perhaps to represent the world in order to convince her that the world in fact still exists (fig. 15.2).

In the film's final section, after her release from the police station in Marseille, we get two separate sequences before the film ends. First, absolutely dispossessed (even her clothes were taken away from her by the criminal who attacked her), Sophie walks into the local German consulate. This act appears to be an attempt to return to home. Yet, the exact meaning of this short scene is hard to determine, as we suddenly move on to the film's actual conclusion. We see shots of a Marseille beach at sunset, with various people enjoying themselves in the sand.

It gets increasingly darker as long static shots follow each other. But it is only in the very last shot that we can recognize Sophie walking along the seashore. The panoramic shot of the beach with the city in the background does not focus on anything specific, so it is only with some difficulty that we can first make out the bright yellow dress that Sophie had been wearing since her release from the police station. Her figure is quite small and blends into the scenery. She seems to enter the landscape (as in one of her photographs) aimlessly wandering: she is part of the scenery, yet forever isolated from her surroundings. The scene stages a tragic confrontation with the indifference of all that exists.

All That Glitters

Together with Christian Petzold's *Barbara* (2012) and *Phoenix* (2014) as well as Christoph Hochhäusler's *Die Lügen der Sieger* (*The Lies of the Victors*, 2015), Thomas Arslan's *Gold* (2013) is often treated as a sign that the Berlin School is "over" because of its embrace of genre filmmaking and historical subject matter. Yet, even though *Gold* is a western set on the Canadian frontier in the summer of 1898, it nevertheless relies on some of the Berlin School's trademark techniques. These traits come to the fore especially when we contrast *Gold* with *Marseille*. Both titles name an elusive object of desire ("gold" as a reward for earthly toils and "Marseille" as the location of impossible happiness) that has the power to organize the journey of a female protagonist toward absolute isolation. In this sense, both films narrate a heroine's exit from the world. This exit, however, takes very different shapes. In *Marseille*, it is at the very heart of society that the heroine falls through the cracks and finds herself in radical isolation; in *Gold*, it is a journey into the wilderness that provides the occasion for a reflection on human individuality. In addition, this general narrative framework is presented through a set of similar techniques dominated by long takes and elliptical transitions. However, it is also clear that in this technical regard, Schanelec's film is more daring in its experiments with the sudden cuts that heighten the viewer's sense of narrative discontinuity. Although the two films share a similar rhythm, *Gold* is more traditional in the continuity of its presentation.

Thematically, what makes *Gold* a more or less typical Berlin School film is that from the beginning it offers a sustained reflection on German identity. The story follows a group of German immigrants to America who responded to an ad posted by the shady character Wilhelm Laser, who is organizing a prospecting party to join the Klondike gold rush. Laser takes their money and, at an opportune moment, abandons them. Left alone in the wilderness, the group slowly

disintegrates until we are left with nothing but the film's would-be couple: Emily Meier (Nina Hoss) and the packer, Carl Boehmer (Marko Mandic). This reduction of the whole company to the couple, however, is not the film's final act. For the point is precisely that the couple is just as impossible to maintain as society. *Gold* ends with Emily's radical isolation from the world.

From its start, *Gold* makes clear that we are dealing with characters who experienced a double displacement. The logic of this double displacement resembles Sophie's experiences in *Marseille*: first, she leaves the home that no longer felt like one to her, but then she experiences the same isolation and homelessness in her new home. As the story of *Gold* progresses, we learn about the backgrounds of the individual characters. We are told that they are all unhappy with their lives in America. Hence the double displacement: first from Germany to America, then from America to the Canadian frontier, a location that we can justly describe in this context as the middle of nowhere. In a certain sense, we are back to the same arithmetic: the nation represents the many; the romance plot represents the couple; and Emily's final isolation represents the individual.

The opening scenes directly thematize national identity, suggesting that the seven inexperienced adventurers should keep together because they are Germans. As the party prepares to set up camp on the journey's first night, Gustav Müller, a New York journalist originally from Hanover, offers to help Emily with her tent and warns her: "We Germans have to stick together abroad." The camera then cuts to Emily's face, and her expression is not hard to interpret: she rolls her eyes silently with annoyed indifference. After the camp is set up, the group listens to Joseph Rossmann (an immigrant trying to escape the slums of New York City) play a song on his banjo: "Fare ye well, beloved homeland of mine / Oh, homeland of mine, farewell!" But the film eventually shows that national identity is not enough and reveals it to be a fiction against the reality of human desire and greed. Thus, the group's gradual erosion seems to suggest that instead of a group identity at work here there are only individuals connected by ties other than their "Germanness."

The disintegration of this miniature society, however, does not simply leave us with nothing. When the group falls apart, we are not left facing utter chaos or the pure void of existence. The loss of fellow journeymen simply reveals the couple. The formation of this couple that is in the making throughout the whole film, the budding romance of the packer and the maidservant, first suggests that the lie of national identity is going to be replaced by the truth of love. Although the desire for gold corrupted the community, the hope is still alive that love might maintain at least the minimal "society" of the two. After Rossmann disappears naked into the wilderness (he seems to have lost his mind and, abandoning all

of his clothes, literally runs into the forest never to be seen again), Emily and Boehmer have their first serious talk. The question that emerges is the following: Would you have made the decision to continue on the journey without me? They both answer, "I may have" ("Schon möglich"). The ambiguity of the answer, not quite a passionate confession of love, already foreshadows the couple's fate. Boehmer asks if she regrets her decision, but her answer is quite predictable: "There is nothing for me to go back to."

On its way toward the impending narrative closure, the story is packed with omens that directly tie the narrative to the theme of worldlessness. The most obvious of these are the various references to the setting as the "end of the world." *Gold* opens when the train carrying Emily reaches the end of the line. From here on, the journey will have to regress to a more "primitive" state on horseback. At one of the last inhabited towns that they would encounter, Emily goes to the local post office to send a letter. When she remarks that it costs a lot to mail the letter, the postal employee retorts: "You are at the end of the world." And when she tells him their intended destination, he adds: "Dawson? Do you really expect to get there?" Another warning comes later in the journey when the party is about to set up camp for the night and, suddenly, out of the middle of nowhere a man emerges, walks through the camp without saying a word, and once again disappears into the wilderness. The man looks and walks like a zombie completely incapable of human communication. It is as if he were not aware of the world around him. As he disappears, we see the Union Jack on his backpack. This lonely figure is something like a prefiguration of what awaits them at the journey's end.

But on the level of representation, the most obvious sign of the subject's exposure to worldlessness is the gradual emptying out of the visual field right before Emily and Boehmer reach the final inhabited outpost of their projected journey, the town of Telegraph Creek. This emptying out once again recalls *The Turin Horse* and *Marseille*. Here, however, the triumph of absolute darkness and the evacuation of the airport correspond to the reduction of the wilderness to a barren desert. Throughout the film, the wilderness is mostly represented through images of an endless, deep, dark forest. Yet right before reaching Telegraph Creek, the couple needs to cross a treacherous mountain range completely devoid of any sign of life. Quite significantly, this change of scenery takes place immediately after the group's reduction to nothing but the couple, a moment that also coincides with the actual formation of the couple as a couple (immediately after their first hug). For a prolonged sequence, the action's background (itself reduced to mere movement) is nothing but barren rocks, a deadly desert in which nothing grows. This is the world reduced to its absolute minimum as a mere stage for existence.

Finally, dejected and forlorn, the couple seeks shelter under a huge boulder. This is the moment of salvation: a native American scout shows up and offers to take them to Telegraph Creek.

In this sense, Telegraph Creek represents the moment of a final illusion. The couple is consummated and, for a passing moment, live as if they had a chance to inhabit this world in a fulfilling manner. Emily tells her new lover: "You look like a new man." He answers: "I feel that way too." But the point appears to be that this is not the end yet. While the group was sustained by the fiction of national identity that was eventually destroyed by the encounter with the wilderness, the reduction of the group to the couple still harbors a constitutive illusion. Love is not the answer either. To be more precise, the couple would be possible only if the two could live in radical isolation from the world. Love works as the point of access to a world only if it already accepted its worldlessness. The couple's radical isolation, however, is not possible, as Boehmer's past catches up with them. As we learned earlier, for the entirety of the film Boehmer has been on the run because he killed a man in Virginia. The dead man's brothers have been pursuing him, and in the final showdown in Telegraph Creek, the brothers kill Boehmer.

This is why *Gold*'s final scene should once again be juxtaposed to the final images of *Marseille*. Both end with the same cinematic gesture: the radically isolated heroine enters the panoramic shot of a landscape. But in spite of the visual similarities, the two endings carry radically different meanings. For Sophie, the ending signified a disappearance in the landscape. She is now forever part of this world captured in the shot as a worldless individual. This conclusion's tragic overtones are hard to miss. But Emily's entry into the landscape is better described as a triumphant exit both from the frame and from the world. Even though Boehmer's death is undeniably a tragic experience for her, *Gold* ends by evoking a very different mood. After her lover's death, Emily goes to see his grave a final time before she sets off on her journey. We see her wave goodbye to his memory with a clearly visible smile. A man in the cemetery accosts her: "Where are you heading lady?" Emily responds without even turning around: "Dawson" (fig. 15.3).

What is the meaning of this ending? Emily's final smile and the unwavering affirmation of the journey's goal suggest that it is possible to claim worldlessness as a kind of ethical victory. In Emily's response to the man, "Dawson" names the cause for which everything had been already sacrificed. It is the mysterious object for which it was actually worth leaving the world behind. When she decides to continue the journey even though she knows that the whole trip was founded on an illusion, she wants to affirm something as valuable (as worth living or dying for) that has already been revealed to be insufficient. The tragedy of the loss of the world is recast as the potential triumph of the individual over the world.

Figure 15.3. *Gold*: The final shot of Arslan's *Gold* as Emily Meyer disappears into the landscape.

Conclusion

What is common to the films discussed here, then, is the tendency toward the evacuation of the field of representation. This strategy works on the level of the represented reality (they all thematize the problem of worldlessness) as well as on the level of representation (they rely on aesthetic techniques that render the constitution of a unified fictional world increasingly more problematic). In this regard, Tarr's film stands out due to its radical conclusions. We could even say that it represents something like the peak of a late modernist exercise in worldlessness that in itself is no longer appropriate for the younger generation of directors. In Tarr's final film, he seems to reach the conclusion that cinema fulfills its paradoxical historical mission when it shows an empty dark screen to its audience sitting in a dark theater. The void from which the light of cinema emerged is now accomplished one more time as the actual goal of cinema. But, in a dialectical fashion, we must add that the darkness before cinema and the darkness that sets in after cinema are not the same. And the difference will have been the detour of the history of cinema itself. Of course, Tarr does not believe that this darkness descending at the end of *The Turin Horse* is in fact the end of everything. There is a "time after" even following this aesthetic catastrophe. But it is no longer possible for Tarr to be part of this postapocalyptic world.

So, if one of the stakes of Tarr's cinema was to articulate the concrete universality of Eastern Europe as a kind of "ontological location," as a conclusion, we

could ask whether something similar is at stake in the Berlin School films as well. To the degree that the signifier "Berlin" names something that these films have in common, would it be possible to interpret "Berlin" as an ontological location? Of course, we can no longer insist on the geographical specificity of Berlin: after all, neither *Marseille* nor *Gold* is directly about Berlin. At the same time, however, we could suggest that these films are all about "Berlin," but not as an ontic metaphor for an ontological form of worldlessness. Rather, if we follow Krasznahorkai's reasoning, we might argue that Berlin represents the specific (historically and culturally concrete) standpoint from which an existential catastrophe becomes visible for the first time. This existential drama is, then, the inherent split that divides German identity from itself in the age of radical worldlessness. As such, Berlin represents a potentially universalizable tendency today.

Notes

1 In general, we can distinguish two major philosophical approaches to the problem of worldlessness: the metaphysical and the political. Heidegger's proposition in *Fundamental Concepts* according to which "the stone is worldless" is the best-known example of the first (Heidegger 1995, 177). This identification of worldlessness with lifeless objects suggests that the specificity of the human being is that it is world-creating (*weltbildend*). Hannah Arendt's critique of modern worldlessness in *The Human Condition* is the best example of the second position (Arendt 1998, 248–320).

2 The classic formulation of the first position (according to which art is essentially a form of world-creation or world-revelation) can be found in Heidegger's essay "The Origins of the Work of Art." The second position (according to which art itself is worldless today) forms the foundation of Luc Ferry's critique of postmodern world-lessness in his book *Homo Aestheticus* (1993).

3 In addition to this common thematic concern, we need to mention the fact that ever since his 1989 DAAD scholarship to Berlin, Tarr has been a frequent teacher at the dffb (Deutsche Film- und Fernsehakademie Berlin). As a result, he had a direct influence on German cinema.

4 This hobby is what ties him to Schanelec's character, Sophie, in *Marseille*. They both relate to art (music and photography) in the form of personal hobbies. For the inherent worldlessness of hobbies, see Arendt's *The Human Condition* (1998, 117–18).

5 For more about what it could mean to treat Eastern Europe as an ontological location, see my essay "The Politics of Mood" (2008).

6 In other words, the same arithmetic of worldlessness is at work here that we identified in Tarr's works: the many corresponds to the masses of people that pass through an airport, the individual stories present different takes on the problems of

coupling, and the figure of the lonely attendant is introduced as a recurring refrain to call attention to the isolation of the individual.

Works Cited

Arendt, Hannah. 1998. *The Human Condition*. 2nd ed. Chicago: University of Chicago Press.

Badiou, Alain. 2011. *Polemics*. Translated by Steve Corcoran. New York: Verso.

Boehm, Felix von, and Julian von Lucius. 2010. "Ich hab' noch nie etwas gebaut." *Critic.de*, February13. http://www.critic.de/interview/ich-hab-noch-nie-etwas-gebaut-3002.

Ferry, Luc. 1993. *Homo Aestheticus: The Invention of Taste in the Democratic Age*. Translated by Robert de Loaiza. Chicago: University of Chicago Press.

Heidegger, Martin. 1995. *The Fundamental Concepts of Metaphysics: World, Finitude, Solitude*. Translated by William McNeill and Nicholas Walker. Bloomington: Indiana University Press.

———. 2002. "The Origin of the Work of Art." In *Off the Beaten Track*, trans. Julian Young and Kenneth Haynes, 1–56. Cambridge: Cambridge University Press.

Knörer, Ekkehard. 2010. "Am Ende gibt es nur noch den Off-Text." *Taz.de*, February 15. http://www.taz.de/1/archiv/digitaz/artikel/?ressort=be&dig=2010%2F02%2F15%2Fa0175&cHash=6420826d2c.

Kovács, András Bálint. 1988. "Monológok a Kárhozatról." *Filmvilág* (February): 16–19.

———. 2013. *The Cinema of Béla Tarr: The Circle Closes*. London: Wallflower Press.

Marx, Karl. 2008. *The Communist Manifesto*. Oxford: Oxford University Press.

Rancière, Jacques. 2013. *Béla Tarr: The Time After*. Translated by Erik Benarek. Minneapolis: Univocal.

Végső, Roland. 2008. "The Politics of Mood: Ádám Bodor and Eastern Europe." *Hungarian Studies* 22 (1–2: 181–204.

CONTRIBUTORS

Marco Abel is Professor of English and Film Studies and chair of the English Department at the University of Nebraska–Lincoln. He is the author of many essays on postunification German cinema and interviews with German film directors, published in journals such as *Cineaste, German Studies Review, Quarterly Review of Film and Video, Senses of Cinema, New German Critique*, and a number of edited volumes on German cinema history. He has published three books: *Violent Affect: Literature, Cinema, and Critique after Representation* (University of Nebraska Press, 2007); *The Counter-Cinema of the Berlin School* (Camden House, 2013), which won the 2014 German Studies Association Book Prize; and as co-editor *Im Angesicht des Fernsehens: Der Filmemacher Dominik Graf* (text + kritik, 2010). He is also the coeditor of the book series *Provocations*, published by the University of Nebraska Press. With Jaimey Fisher, he edited a dossier on Christian Petzold for *Senses of Cinema*. He is currently researching German cinema in the 1960s as well as the question of what left politics was in West Germany at the time; an early result of this work has appeared in form of a coedited special issue of *The Sixties: Journal of History, Politics and Culture* and is forthcoming as a coedited (with Christina Gerhardt) volume, *Celluloid Revolt: German Screen Cultures of the Long 1968*.

Hester Baer is Associate Professor of German and Head of the Department of Germanic Studies at the University of Maryland, where she also serves as a core faculty member in the film studies program. Baer's research focuses on gender and sexuality in film and media, historical and contemporary feminisms, and German literature and culture in the twenty-first century. Her essays on German cinema, digital media, and feminism have appeared in *Discourse, Feminist Media Studies, German Quarterly*, and *German Studies Review*. She is the author of *Dismantling the Dream Factory: Gender, German Cinema, and the Postwar Quest for a New Film Language* (Berghahn Books, 2009); the guest editor of a special issue of the journal *Studies in 20th and 21st Century Literature* titled "Contemporary Women's Writing and the Return of Feminism in Germany" (2011); and the

coeditor of *German Women's Writing in the 21st Century* (2015). She is currently working on a monograph that rethinks the history of German cinema from 1980 to 2010 in the context of neoliberalism.

Alice Bardan holds a PhD in English and a Visual Studies Degree Certificate from the University of Southern California, Los Angeles. She has taught courses on documentary film and television, film adaptation, global cinema, and television history at several universities in Los Angeles and is currently teaching at Mount St. Mary's University. She has edited submissions to prestigious journals such as *Mass Communication and Society, Studies in Eastern European Cinemas, Feminist Media Studies,* and *Wide Screen,* and her articles have been published in several edited collections, including *Work and Cinema: Labor and the Human Condition* (Palgrave, 2013), *The Cinemas of Italian Migration: European and Transatlantic Narratives* (Cambridge Scholars Publishing, 2013), *Transnational Feminism in Film and Media* (Palgrave, 2007), *Not Necessarily the News? News Parody and Political Satire across the Globe* (Routledge, 2012), *Entertaining the New Europe: Popular Television in Socialist and Post-Socialist Europe* (Routledge, 2012), *The Blackwell Companion to East European Cinema* (Blackwell, 2012), *Branding Post-Communist Nations* (Routledge, 2012) and in the refereed journals *New Cinemas: Journal of Contemporary Film* (2008), *Flow* (2010), and *Popular Communication: The International Journal of Media and Culture* (2012). In 2012, she had the chance to work as a mentor for students enrolled in the American Pavilion Program at the Cannes Film Festival, and, most recently, had the privilege to serve on the jury at the twelfth edition of the Zagreb Film Festival.

Roger Cook is Professor of German Studies and Director of the Film Studies Program at the University of Missouri. He has written extensively on New German Cinema and contemporary German film. He coedited *The Cinema of Wim Wenders: Image, Narrative, and the Postmodern Condition* (Wayne State University Press, 1996) and is coeditor of *Berlin School Glossary: An ABC of the New Wave in German Cinema* (Intellect, 2013). He has also written on eighteenth- and nineteenth-century German literature, with a particular emphasis on Heinrich Heine. He is the author of *By the Rivers of Babylon: Heinrich Heine's Late Songs and Reflections* (Wayne State University Press, 1998) and the editor of *A Companion to the Works of Heinrich Heine* (Camden House, 2003). His current work engages research in neuroscience and media theory to investigate issues of embodiment in film viewing. An article based on this research, titled "Embodied Simulation, Empathy, and Social Cognition: Berlin School Lessons for Film

Theory," is published in *Screen* (56, no. 2, 2015), and he is currently finishing a book with the title *Post-Cinematic Vision: Film and the Evolution of Spectatorship*.

Robert Dassanowsky is Professor of German and Visual and Performing Arts, and Director of Film Studies at the University of Colorado, Colorado Springs, and works as an independent film producer. He is a member of the European Academy of Sciences and Arts, Austrian Academy of Film, and European Film Academy. Additionally, he is a Fellow of the Royal Historical Society and has served as president of the Austrian Studies Association. His recent books include *Austrian Cinema: A History* (McFarland, 2005); *New Austrian Cinema*, co-ed. (Berghahn, 2011); *The Nameable and the Unnameable: Hugo von Hofmannsthal's Der Schwierige Revisited*, co-ed. (Iudicium, 2011); *Quentin Tarantino's Inglourious Basterds: A Manipulation of Metafilm*, ed. (Continuum, 2012); *World Film Locations: Vienna*, ed. (Intellect/University of Chicago Press, 2012); and *Screening Transcendence: Film under Austrofascism and the Hollywood Hope 1933–1938* (Indiana University Press, 2018). Dassanowsky serves on the editorial boards of the *Journal of Austrian Studies* and *Colloquia Germanica*, and on the jury of VIS: The Vienna Shorts Film Festival. He is currently co-producing two feature-length documentary projects and is the 2019 Visiting Scholar at the Salzburg Institute and the University of Salzburg's Salzburger Hochschulwochen Lecture Series.

Will Fech is a PhD student in Film and Moving Image Studies at the Mel Hoppenheim School of Cinema at Concordia University in Montreal, Quebec, Canada. He received a BA in English and Film Studies from the University of Nebraska–Lincoln (2008), an MLitt in European Cinema from the University of Glasgow (2011), and an MA in English from Oregon State University (2013). His book and film reviews have appeared in *Film and History, Film International*, and *Synoptique*. In 2014, he co-curated a retrospective on the extensive career of American independent filmmaker Jon Jost at the Mary Riepma Ross Media Arts Center in Lincoln, Nebraska. His research interests include global art cinema, specifically the transnational production and distribution of art film in an increasingly connected international mediascape. Other interests include exhibition studies, contemporary auteurism, the cultural currencies of new wave movements, and film pedagogy, wherein he remains committed to the simple principle that the cinema can help people lead better lives.

Jaimey Fisher is Professor of German and Cinema and Digital Media as well as the Director of the Humanities Institute at the University of California, Davis. He is the author of *Christian Petzold* (University of Illinois Press, 2013) as well

as *Disciplining Germany: Youth, Reeducation, and Reconstruction after the Second World War* (Wayne State University Press, 2007). He edited the volume *Generic Histories of German Cinema: Genre and Its Deviations* (Camden House, 2013) and has also coedited *Collapse of the Conventional: German Film and Its Politics at the Turn of the Twenty-First Century* with Brad Prager (2010); with Barbara Mennel, *Spatial Turns: Space, Place, and Mobility in German Literary and Visual Culture* (2010); and, with Peter Hohendahl, *Critical Theory: Current State and Future Prospects* (2001). His current book project analyzes war films in Germany from 1914 to 1961.

Gerd Gemünden is the Sherman Fairchild Professor of the Humanities and Professor of German Studies, Film and Media Studies, and Comparative Literature at Dartmouth. His specialties include critical theory and cultural studies, twentieth-century German literature, and the history and theory of German cinema. He is the author of *Framed Visions: Popular Culture, Americanization, and the Contemporary German and Austrian Imagination* (1998), and *A Foreign Affair: Billy Wilder's American Films* (2008). His volumes as editor include *Wim Wenders: Einstellungen* (1993); *The Cinema of Wim Wenders* (1997); *Germans and Indians: Fantasies, Encounters, Projections* (2002); *Dietrich Icon* (2007); and *Culture in the Anteroom: The Legacies of Siegfried Kracauer* (2012); as well as special issues of *New German Critique* on the director Rainer Werner Fassbinder and on Film and Exile. He serves on the editorial board of *New German Critique* and *Film Criticism* and is coeditor (with Johannes von Moltke) of the series Screen Cultures for Camden House. His most recent book is *Continental Strangers: German Exile Cinema, 1933–1951,* which was published by Columbia University Press in 2014. His latest project is a monograph on the Argentine director Lucrecia Martel, which is under contract for the Contemporary Film Directors series of Illinois University Press.

Lisa Haegele is Assistant Professor of German at Texas State University. She earned her PhD in German and Comparative Literature from Washington University in Saint Louis in 2014. Her research focuses on postwar through contemporary German cinema with a special interest in violence and politics. Her work has appeared in the special issue "1968 and West German Cinema" (ed. Christina Gerhardt) in *The Sixties: A Journal of History, Politics, and Culture* in 2017 and *Berlin School Glossary: An ABC of the New Wave in German Cinema* (Intellect, 2013). Her article on West German exploitation films of the late 1960s is forthcoming in *Celluloid Revolt: German Screen Cultures in the Long 1968* (ed. Marco Abel and Christina Gerhardt). She is currently working on a book manuscript on

violent genres in West German cinema in the 1960s and 1970s in addition to an article on the aesthetics of feminist underground comix in Ziska Riemann's teen drama film *Lollipop Monster* (2011).

Chris Homewood is a lecturer in German and World Cinemas the University of Leeds. He is the coeditor (with Paul Cooke) of *New Directions in German Cinema* (I. B. Tauris, 2011), and several articles on the cinematic representations of German left-wing terrorism. He is currently preparing a monograph on this topic, "Screening Terrorism." His most recent publications include: "From Baader to Prada: Memory and Myth in Uli Edel's *The Baader Meinhof Complex* (2008)," *New Directions in German Cinema*; "Wind," in Roger Cook, Lutz Koepnick, Kristin Kopp, and Brad Prager, eds., *Berlin School Glossary: An ABC of the New Wave in German Cinema* (Intellect, 2013); and "'Directed by Hollywood, Edited by China'? Chinese Soft Power, Geo-Imaginaries, and Neo-Orientalism(s) in recent U.S. Blockbusters," in Robert Saunders and Vlad Strukov, eds., *Popular Geopolitics: Plotting an Evolving Interdiscipline* (2017).

Ira Jaffe is Emeritus Professor and former chair of the Department of Cinematic Arts (formerly Media Arts) at the University of New Mexico. He is also former presidential lecturer and associate dean in UNM's College of Fine Arts. He is author of *Slow Movies: Countering the Cinema of Action* (Wallflower Press/Columbia University Press, 2014) and *Hollywood Hybrids: Mixing Genres in Contemporary Films* (Rowman and Littlefield, 2008) and coeditor of *Redirecting the Gaze: Gender, Theory, and Cinema in the Third World* (State University of New York Press, 1999). His essay, "Errol Morris's Forms of Control," appears in *Three Documentary Filmmakers* (State University of New York Press, 2009). Jaffe has written about Robert Altman, Charlie Chaplin, and Orson Welles in addition to Errol Morris. Essays by him appear in *Perspectives on Citizen Kane* (G. K. Hall, 1996) and *Hollywood as Historian: American Film in Cultural Context* (University Press of Kentucky, 1983) as well as in periodicals including *ARTSPACE, East-West Film Journal, Film International,* and *Film Quarterly.* Jaffe received his AB and MFA (in film, radio, and television) from Columbia University and his PhD (in cinema/communication) from the University of Southern California.

Lutz Koepnick is the Gertrude Conaway Vanderbilt Professor of German, Cinema, and Media Arts at Vanderbilt University in Nashville, where he also chairs the Department of German, Russian, and East European Studies and serves as the director of the Joint-PhD program in Comparative Media Analysis and Practice (CMAP). Koepnick has published widely on film, media theory, visual

culture, new media aesthetic, and intellectual history from the nineteenth to the twenty-first century. He is the author of *Michael Bay: World Cinema in the Age of Populism* (2018); *The Long Take: Art Cinema and the Wondrous* (2017); *On Slowness: Toward an Aesthetic of the Contemporary* (2014); *Framing Attention: Windows on Modern German Culture* (2007); *The Dark Mirror: German Cinema between Hitler and Hollywood* (2002); *Walter Benjamin and the Aesthetics of Power* (1999); and of *Nothungs Modernität: Wagners Ring und die Poesie der Politik im neunzehnten Jahrhundert* (1994). Koepnick is the coauthor of *Windows | Interface* (2007), *[Grid ‹ › Matrix]* (2006), and the coeditor of various anthologies on ambiguity in contemporary art and theory, German cinema, sound culture, new media aesthetics, aesthetic theory, and questions of exile. His current book projects include a monograph on Werner Herzog's film *Fitzcarraldo* and a book on the role of resonance in contemporary sound art.

Inga Pollmann is Assistant Professor in the Department of Germanic and Slavic Languages and Literatures at the University of North Carolina at Chapel Hill. She received her PhD in Cinema and Media Studies from the University of Chicago in 2011. Her work explores the history of film theory by examining the intersections of film, science, and philosophy and the place of the moving image within aesthetic theory. Her monograph *Cinematic Vitalism: Film Theory and the Question of Life* (Amsterdam University Press, 2018) investigates the role of vitalist conceptions of life in philosophy and biology for film theory and practice from the 1910s to the 1960s. Her essays on Russian montage cinema, German abstract cinema, German biology and film theory in the 1920s, and mood and coldness in melodrama have appeared in journals including *Critical Inquiry*, *Germanic Review*, and *Colloquia Germanica*. Her current project, *Mood, Medium, Milieu*, researches the development of an environmental aesthetic from early cinema to contemporary art cinema.

Brad Prager is Associate Professor of German and Film Studies at the University of Missouri. His areas of research include Film History and Contemporary German Cinema, Holocaust Studies, and the art and literature of German Romanticism. He is the author of *After the Fact: The Holocaust in Twenty-First-Century Documentary Film* (Bloomsbury, 2015), *The Cinema of Werner Herzog: Aesthetic Ecstasy and Truth* (Wallflower, 2007), and *Aesthetic Vision and German Romanticism: Writing Images* (Camden House, 2007). He is the co-editor of *Visualizing the Holocaust: Documents, Aesthetics, Memory* (Camden House, 2008), of a volume on contemporary German cinema titled *The Collapse of the Conventional: German Cinema and Its Politics at the Turn of the Twenty-First Century* (Wayne

State University Press, 2010), the editor of *A Companion to Werner Herzog* (Wiley-Blackwell, 2012), and, together with Roger F. Cook, Lutz Koepnick, and Kristin Kopp, of *Berlin School Glossary: An ABC of the New Wave in German Cinema* (Intellect, 2013). Professor Prager has been a DAAD Guest Professor at the University of Paderborn, where he organized the conference "The Holocaust on Screen in the 21st Century." He has been a guest at the United States Holocaust Memorial Museum, is the University of Missouri System Representative to the state's Holocaust Education and Awareness Commission, and is coorganizer of the ongoing documentary film conference "Based on a True Story," held annually at MU.

Michael Sicinski is a Visiting Assistant Professor in the Fine Arts Department at the University of Houston. He has published widely on experimental cinema and is currently completing his doctoral dissertation, "Films about You: Structural Cinema and the Legacy of Self-Reflexive Spectatorship," with the Rhetoric Department at the University of California, Berkeley.

Roland Végső is Susan J. Rosowski Associate Professor of English at the University of Nebraska–Lincoln, where he teaches literary and critical theory and twentieth-century literatures. His primary research interests are contemporary continental philosophy, modernism, and translation theory. He is the author of *The Naked Communist: Cold War Modernism and the Politics of Popular Culture* (Fordham University Press, 2013) and a number of essays on modern literature and critical theory, published in journals such as *Cultural Critique, Epoché: A Journal for the History of Philosophy, CR: The New Centennial Review*, and *parallax*. In addition, he is the translator of numerous philosophical essays as well as Rodolphe Gasché's *Georges Bataille: Phenomenology and Phantasmatology* (Stanford University Press, 2012) and Peter Szendy's *All Ears: The Aesthetics of Espionage* (Fordham University Press, 2017). He is the coeditor of the book series Provocations published by the University of Nebraska Press.

INDEX

Abel, Marco, 2, 5, 23–28, 34n7, 56n13, 56n14, 69, 72, 77–78, 99–100, 102–3, 112, 113n10, 117, 119, 124, 126–27, 132, 135–36, 138, 143, 170n15, 190, 208, 221, 233, 243, 245–46, 249n8, 253, 259, 265, 268n1, 269n10, 291n2, 296, 300, 307, 309n4; and *The Counter-Cinema of the Berlin School*, 2, 34n2, 34n4, 268n1
abjection, 240
absorption, 163, 165, 170n14
Academy Awards, 17. *See also* Oscars.
Ade, Maren, 1, 3, 4, 6, 17, 20, 23–25, 34n3, 38–42, 45–48, 53–55, 56n1, 56n3, 56n8, 59–75, 86, 291, 295; and *Everyone Else* (*Alle Anderen*), 23–24, 46, 48, 53, 55, 56n8, 59–75; and *The Forest for the Trees* (*Der Wald vor lauter Bäumen*), 38–39, 46–47, 53–55; and *Toni Erdmann*, 1, 17, 20, 25, 46, 48, 56n8, 291n1
Adorno, Theodor, 136
aesthetics of reduction, 88, 91, 97
affect, 28, 50, 54, 56n13, 61, 65, 67, 69, 73, 102, 177, 181, 183–84, 188, 217, 232, 258, 286,
afterness, 31, 272–73, 274–77
Afternoon (Schanelec), 217
Aguirre, the Wrath of God (Herzog), 32, 302, 304
Albert, Barbara, 4, 38, 41, 45–47, 56n2, 80–81, 83, 85, 92; and *Falling* (*Fallen*), 85; and *Free Radicals* (*Böse Zellen*), 83,

92; and *Northern Skirts* (*Nordrand*), 80, 83, 85
Aldrich, Robert, 263
Alonso, Lisandro, 2, 31, 32, 149, 294–310; and *The Dead* (*Los muertos*), 301, 310n21; and *Fantasma*, 301, 304; and *Freedom* (*La libertad*), 301, 304, 307–8, 310n17, 310n21; and *Jauja*, 32, 301–7, 310n7, 310n8
Alltagsfaschismus, 24, 77, 81–84, 93
American Beauty (Mendes), 188
Amour Fou (Hausner), 88–89, 92
Andermann, Jens, 296, 309n10
Andrew, Dudley, 15, 132, 256
Anger, Kenneth, 147
anti-*Hauptstadt*, 82
anti-*Heimatfilm*, 80. *See also* Heimatfilm
Antonioni, Michelangelo, 3, 26–27, 115–16, 124, 133n1, 154–73; and *The Passenger* (*Professione: reporter*), 27, 154–56, 159–61, 166, 168
Apichatpong Weerasethakul, 2, 7, 29, 193–210, 224; and *Blissfully Yours* (*Sud sanaeha*), 29, 193–94, 196–98, 200; and *Cemetery of Splendour* (*Rak ti Khon Kaen*), 210; and *A Letter to Uncle Boonmee*, 202; and *Phantoms of Nabua*, 198, 202; and political film, 194–96; and time, 196–97; and *Syndromes and a Century* (*Sang sattawat*), 193, 197, 201, 203–4, 224; and *Tropical Malady* (*Sud pralad*), 29, 193, 197, 198–201, 203–4; and *Uncle Boonmee Who Can*

Mostly Martha (*Bella Martha*, Nettelbeck), 94n7

motion, 30, 166, 190, 198, 222, 230, 234–35, 238, 244–45, 248, 256, 258, 266, 278. *See also* movement

motor mimicry, 287

movement (film movement), 1–3, 5, 13, 23, 25, 31–32, 38, 44–45, 48, 51, 56n3, 78–79, 81, 85, 89, 92, 96, 98–100, 111, 163, 174–75, 193, 254, 293, 295–97, 307–8

movement (motion), 4, 120–21, 124, 129–31, 150, 156, 184, 188, 190, 211, 217, 229, 233, 235–36, 238–40, 246–47, 253, 255, 258, 263, 265–68, 280, 316, 326. *See also* motion

Müller, Franz, 295

Müller, Richy, 146

Muller's Office (*Müllers Büro*, List), 81

Multivalence, 83, 85

Mulvey, Laura, 176–77

Murnau, F. W., 12, 194, 282; and *Nosferatu*, 282

Murnberger, Wolfgang, 80, 93n5; and *Come Sweet Death* (*Komm, süßer Tod*), 80; and *Silentium*, 93n5

Museum of Modern Art (MoMA), 1–2, 4, 11

Musil, Robert, 93n3

My Russia (*Mein Russland*, Gräftner), 84

narrative ellipsis, 21, 86, 183

narrative integration, 182, 183

national cinema, 8–9, 11, 13, 17, 36, 76–77, 84–85, 92–93, 122, 175, 308

Nazi/Nazism, 36, 77, 232, 276–77

neoliberal, neoliberalism, 10, 13–14, 20, 23–24, 26–27, 32, 38, 42–45, 50–51, 54–55, 57, 66, 74n1, 113n10, 124, 133, 138, 140–43, 151–52, 156, 158, 168–69, 170n3, 171n19, 211, 218,

225, 229, 233–34, 240–48, 249n8, 250n11, 251, 277, 282, 294, 296, 300

neo-noir, 81

neo-neorealism, 25, 37, 61, 75, 96–101, 111, 112n1, 113n5, 114, 174, 192, 297, 312

neorealism, 32, 37, 75, 81, 97–101, 105, 107–8, 112, 112n1, 113n9, 114, 132, 163, 167, 174–75, 177, 181–82, 184, 192, 274, 291–92, 297, 301, 309n6, 312

Nettelbeck, Sandra, 94n7

Netzer, Călin Peter, 299

Neumann, Rüdiger, 4

neuroscience, 28, 177

New Argentinian Cinema, 14, 31, 293–98, 307–8

New Austrian Film, 14, 24, 76–93

New German Cinema, New German Film, 2, 8, 10–13, 32, 37, 43–44, 78, 81, 93n3, 95, 175, 253, 312

New Media Studies, 10–11, 36–37

New Munich Group, 8

New York Film Festival, 1

New York Times, 37, 61, 75, 96, 114, 152, 174, 192, 297, 312

New Yorker, 100, 113–14

Nietzsche, Friedrich, 136

9/11, 96, 97, 101, 106, 113n11, 247, 297

9 Lives (Speth), 46, 48

Nine Queens (Bielinsky), 294

non-diegetic, 5, 61, 97, 101, 105, 211, 286

nonfiction. *See* documentary

non-place, 52, 133, 137, 158, 241, 246–47, 250

nonstudio filmmaking, 44, 46, 49

Northern Skirts (Albert), 80, 83, 85

North Rhine-Westphalia, 272

Nosferatu (Murnau), 282

Nouvelle Vague Viennoise, 79. *See also* New Austrian Film

CPSIA information can be obtained
at www.ICGtesting.com
Printed in the USA
BVHW03s1625190518
516611BV00002B/3/P

9 780814 342008